Edward Hopper

Edward Hopper

Edited by
Sheena Wagstaff
with contributions by
David Anfam
Margaret Iversen
Brian O'Doherty
Sheena Wagstaff
Peter Wollen

Tate Publishing

Exhibition sponsored by

AmericanAirlines®

Foundation Supporter:
The Henry Luce Foundation

First published 2004 by
order of the Tate Trustees
by Tate Publishing,
a division of
Tate Enterprises Ltd,
Millbank,
London SW1P 4RG

www.tate.org.uk

on the occasion of the
exhibition at

Tate Modern, London
27 May –
5 September 2004

and

Museum Ludwig, Cologne
9 October 2004 –
9 January 2005

British Library Cataloguing
in Publication Data
A catalogue record for this
publication is available from
the British Library

ISBN 1 85437 533 4
(hardback)
ISBN 1 85437 504 0
(paperback)

Distributed in the
United States and Canada
by Harry N. Abrams, Inc.,
New York

Library of Congress
Cataloging in Publication
Data
Library of Congress Control
Number 2004102570

Designed by Gareth Hague
and David James

Printed and bound in
Great Britain by
Balding + Mansell, Norwich

Cover: Edward Hopper,
Nighthawks 1942 (detail,
pp.178–9). The Art Institute
of Chicago

The photographs on pp.10,
32, 50–1, 66, 80–1, 98–9,
224 and 237 were taken by
Hans Namuth in and around
Edward Hopper's studios at
Truro, Massachusetts, in
1963, and at Washington
Square, New York, in 1964.

Measurements of artworks
are given in centimetres,
height x width, followed by
inches in brackets.

Works by Edward Hopper in
oil and watercolour are fol-
lowed by catalogue numbers
from Gail Levin's *Edward
Hopper: A Catalogue
Raisonné*, New York 1995,
in the form O-XXX for oils
and W-XXX for watercolours.
Etchings are followed by
the plate number from Gail
Levin's *Edward Hopper: The
Complete Prints*, New York
1979.

Contents

Sponsor's Statement

American Airlines is delighted to be sponsoring this major retrospective of Edward Hopper at Tate Modern.

As America's premier airline, it is particularly fitting for us to be supporting an exhibition that brings the work of such an important American artist to the UK public. Edward Hopper is one of the most significant painters of twentieth-century America. He has been admired by and influenced generations of artists and we are extremely pleased to be involved in such a major contribution to the scholarship of his work.

American Airlines has a long history of supporting the arts but this sponsorship at Tate Modern is unique for us. We are not only the exhibition sponsor but have also worked closely with Tate to provide specialist transportation of the works from numerous US locations to London.

I hope you enjoy Edward Hopper and that this catalogue will provide a reminder for years to come.

Craig Kreeger
Vice President,
American Airlines Europe & Pacific

Foreword

Edward Hopper's paintings have the inescapable mark of the present. They have a timeless quality that allows them to lodge in our memories. It would be difficult to overestimate Hopper's decisive effect on the art that has followed since his first retrospective at The Museum of Modern Art in 1933, just four years after its founding. There is a curious and poignant symmetry in this major exhibition devoted to Hopper being conceived by Tate Modern four years after its own founding. With one of the most prestigious and comprehensive collections of twentieth-century American art in Europe, the Museum Ludwig is particularly proud to position Hopper within the context of Abstract Expressionism and Pop art, which constitute a significant part of its important holdings.

This retrospective of a major twentieth-century realist painter offers audiences the first opportunity to reassess Hopper's work nearly a quarter of a century after the last important survey of Hopper's work in a touring exhibition in 1981 from the Whitney Museum of American Art.

We are deeply grateful to the many private owners, in all parts of the United States, and to the directors and trustees of twenty-nine museums who have generously allowed us to borrow their Hopper works. We join an appreciable number of viewers in London and Köln in thanking them profusely for allowing us to experience Hopper's art in all its reality.

It has been this project's good fortune to have had the passionate scholarship, energy and imagination of Sheena Wagstaff, Tate Modern's head of exhibitions and display, at its helm. She has been enormously helped by her Tate colleagues, particularly Maeve Polkinhorn, assistant curator. In her preface, Sheena Wagstaff expresses her gratitude to other colleagues who have contributed to the exhibition both inside and outside our museums. With great enthusiasm and flair, Ulrich Wilmes, the Museum Ludwig's deputy director, has taken on organisational responsibility for the exhibition's realisation in Köln.

To undertake such a vast international project, our museums have depended not only upon dedicated and insightful scholars, enthusiastic and patient lenders, and our staff who work long hours during months of preparation and intense activity to serve the exhibition's huge public, but also on corporate sponsors and foundations for the interest they have taken in the Hopper retrospective as a project of great significance for audiences in the United Kingdom and Germany.

We would like to express our sincere thanks to American Airlines for its commitment to the exhibition and for providing both funds and transportation of works between the United States and Europe. Our profound gratitude is also extended to The Henry Luce Foundation, whose generous grant to the exhibition is the third such demonstration of faith in and support of Tate exhibitions, including *Jackson Pollock* and *American Sublime*. We would particularly like to thank Luce program director for the arts Ellen Holtzman for her personal support of the project.

The belief of all these organisations in the importance of supporting and underwriting this exhibition in a climate of international restlessness, straitened finances and increased risk is both impressive and much appreciated.

We are most grateful to the Department for Culture, Media and Sport for granting government indemnity to the exhibition. *The Times* and *The Sunday Times* are supporting the Hopper exhibition as media sponsors, for which we are most appreciative.

Hopper's intensity of thought and feeling is equalled by the simplicity of his visual language. We hope visitors to this exhibition will look anew at the work of this extraordinary artist.

Vicente Todoli
Director,
Tate Modern

Kasper König
Director,
Museum Ludwig

Preface and Acknowledgements

Edward Hopper's work sets a standard for our time – he is one of the great realist painters of the twentieth century. Few artists in the last hundred years have presented the human predicament with such insight and feeling. The challenge of bringing this show together was driven by the desire to unite the most representative and important of Hopper's works into an exhibition that would provide an opportunity to reassess the full measure of his genius: his extraordinary way of seeing the world, his obsession with staging each picture in exactly the right way, his deft ability to render light as well as states of being through paint, and his passion for nature – the extraordinary nature of humankind – around us and within us.

Despite the abundant literature that has praised, studied, denigrated, interpreted (and over-interpreted) him, Hopper remains an infinitely mysterious artist. The exhibition and the accompanying catalogue make some claim to revealing new aspects of Hopper, whose impact on generations of artists has always been more readily apparent than the intentions behind it, and which has become more comprehensible with the passing of time.

Without the enormous goodwill of so many lenders, public institutions and private collectors, this exhibition could never have come into being. Collectors and collections tend to be deeply attached to their Hopper paintings, so we were gratified by the fact that there were few who were unable to consider surrendering their Hoppers for this major exhibition presented in two European venues. On behalf of Tate, I extend deep gratitude to the many lenders to this exhibition. They are listed on page 249.

In particular I would like to single out the Whitney Museum of American Art, which has been exceptionally generous in extending works to the exhibition, and I thank Director Adam Weinberg, as well as former Director Maxwell Anderson, for their kind collegiality in this respect. Having first encountered the art of Hopper as a young art historian on the Whitney Museum's Independent Study Program, I have held both artist and museum in special bond for more than twenty years. My appreciation also goes to the Whitney staff, which has been so very helpful over many aspects of the exhibition, in particular curator Barbara Haskell and assistant curator Evelyn Hankins.

I am also grateful for the kindness of those colleagues and collectors who went an extra mile on our behalf in order to facilitate vital loans, including Andrew Cohen, Ronald Feldman, Larry Gagosian, Antony Griffiths, Lila Harnett, Erica Hirshler, Ellen Josefowitz, Robert and Arlene Kogod, Dorothy Kosinski, Melissa Lazarov, Tomàs Llorens, Ned Rifkin, James Rondeau and Amy Stack.

We are heavily and happily indebted to authors David Anfam, Margaret Iversen, Brian O'Doherty and Peter Wollen, each of whom has contributed an excellent essay to the catalogue, exploring new trains of thought and broadening the critical field for understanding Hopper's work. The help of Gilles Poizat from the Archives des Musées Nationaux de France was invaluable in providing crucial information for the catalogue, which is beautifully designed by Gareth Hague and David James. We have not provided the customary notes on each picture as this has been done in *Edward Hopper: A Catalogue Raisonné* (1995) through the heroic efforts of Gail Levin, to whom any Hopper project is indebted for her exhaustive research into the artist's life and work.

Richard Gluckman's intelligent architectural response to Hopper's work uses the light axes of the galleries' spatial arrangement as the principal design element of the exhibition plan. I am deeply grateful to him and to Nicholas Serota for their help in thinking about different ways of seeing – and using – space. John Johnson and his team have created a sensitive lighting schema for the show.

The exhibition has been augmented by a film, produced and directed by Brian O'Doherty, which has never before been seen in relation to a show of Hopper's work. *Hopper's Silence* offers rare interviews with Edward Hopper, illuminating the process of his paintings as well as casting light on the man himself.

To complement the exhibition, a programme of feature films has been kindly selected by Todd Haynes. An additional series of vintage films drawn from the British Film Institute collection has been generously expedited by Karen Alexander and Margaret Deriaz. Both programmes, coordinated by the indefatigable Stuart Comer, demonstrate through their diversity the direct relevance of the film medium to Hopper, as well as the artist's extraordinary and wide-ranging influence on film-makers to the present day.

For the privilege of being able to choose a selection of beautiful photographs by Hans Namuth of Edward Hopper in his studios in Washington Square North, Manhattan, and Truro, Cape Cod, from the original negatives I extend sincere thanks to Peter Namuth who has generously made special prints for the exhibition.

Very special appreciation goes to many Tate colleagues who have worked to bring this retrospective to fruition. In particular, I would like to salute Maeve Polkinhorn, assistant curator, with whom it has been a pleasure to work after she took on the exhibition as primum mobile from the good ministrations of her predecessor Sophie McKinlay. Maeve's curatorial intelligence, humour and quiet tenacity, along with her prodigious powers of organisation, have effectively moulded the exhibition into shape. Throughout the show's development, the curatorial team has benefited greatly from the sleuthing skills of intern Kathleen Madden and administrative assistant Michele Smith, with additional research by Jorg Garbrecht and Dorothee Dines.

Sincere thanks are extended to John Jervis for his marvellous management of the catalogue and contributors, wielding deadlines with gentle encouragement, and to his colleagues at Tate Publishing, especially Alessandra Serri, Sarah Tucker and Katherine Rose.

Different interpretations of Hopper have been ingeniously devised through an extensive programme of film screenings, educational programmes and interpretive projects complementing the show by interpretation curators Stuart Comer, Sophie Howarth, Dominic Willsdon, Jane Burton and Jemima Montagu and by assistant curator Simon Bolitho. Elegant graphics for the exhibition have been designed by Silke Klinnert of Mr & Mrs Smith.

Logistical, contractual and installation arrangements for the exhibition have been handled with customary efficiency and attention to detail by exhibition coordinator Stephen Mellor, art handling manager Phil Monk, paper conservators Matthew Flintham, Brian McKenzie, Calvin Winner and Tim Green, audio-visual manager Anna Nesbit, senior art handling technician Mary Taylor and the art handling team. To the core team responsible for administrative and registral matters, I extend special warm thanks to administration manager Rebecca Lancaster for her profes-sionalism and good humour, shared in equal part by registrar Stephen Dunn. They were well supported by Michele Smith and assistant registrar Gillian Smithson.

I would also like to recognise the efforts of many individuals in Tate's departments who have contributed to the exhibition in myriad ways. These include the communications team, particularly head of media relations Nadine Thompson and press officers Callum Sutton, Sioban Ketelaar and Ruth Findlay, marketing manager Caroline Priest and design and print manager Jane Scherbaum; the special events team, particularly Brad Macdonald, Emily Paget and Karen Tombleson; the development team, particularly Nicky White, Camilla Miesagaes and Tanya Taggart.

In developing this Hopper show after so many articles and catalogue essays which have already examined aspects of his oeuvre, I have counted upon the knowledge and counsel of many friends and colleagues. I am grateful particularly to Benjamin Buchloh, Bice Curiger, Bruce Ferguson, Mark Francis, Ellen Holtzman, Mark Lewis, DeCourcy McIntosh, Linda Nochlin, Nicholas Serota, Robert Storr, Richard Thomson, Luc Tuymans and Alan Yentob. It has been an especial privilege to know Brian O'Doherty and Barbara Novak, whose close friendship with Edward Hopper has given the exhibition the benefit of a unique insight and critical dimension to understanding Hopper's work.

Sheena Wagstaff

Great art is the outward
expression of an inner life
in the artist, and this inner
life will result in his personal
vision of the world ...
The inner life of a human being
is a vast and varied realm

Edward Hopper,
statement in *Reality*, no.1,
Spring 1953, p.8

There are two powers of
imagination, one of knowing
the symbolic character of
things and treating them as representative;
and the other, by [that]
treament, demonstrating that
this figment of thought is as
palpable an object ...
as is the ground on which
[the artist] stands, or the walls
of the houses about him.
Ralph Waldo Emerson

There is a sort of elation about
sunlight on the upper part of
the house. You know, there are
many thoughts, many impulses,
that go into a picture ... I was more
interested in the sunlight on
the buildings and on the
figures than in any symbolism.[1]
Edward Hopper

The Elation of Sunlight
Sheena Wagstaff

Nearly forty years after his death, Edward Hopper's images still excite the imagination in a profound and memorable way. The pensive inflections of life, captured within the seedy, obdurate architecture of automats, diners, motel rooms, gas stations, movie palaces, offices, hotels, restaurants, brownstones and frame houses, are well-known settings for Hopper's paintings. He throws light into their interiors with a penetrating beam as unwavering as moonlight or sunlight, high-keyed and relentless, to reveal people isolated in stark rooms, portraits of aloneness, absorbed in themselves, detached from their world.

Hopper's work is exceptional for its continuing appeal to a broad public, as well as successive generations of painters, sculptors, photographers, conceptual artists, film-makers and cameramen. A partial list would include Dick Bengtsson, Roger Brown, Victor Burgin, Gregory Crewdson, Willem de Kooning, Jim Dine, Peter Doig, Richard Estes, Eric Fischl, Robert Frank, Robert Gober, David Hockney, R.B. Kitaj, Mark Lewis, Mark Rothko, Ed Ruscha, George Segal, Stephen Shore, Luc Tuymans, Jeff Wall and Tom Wesselmann, along with film directors such as Chantal Akerman, Todd Haynes, Alfred Hitchcock and Wim Wenders.[2] From the early oil sketches, cautiously defined by strips of light and shadow, to the final gloriously serene paintings of old age, his life's work is remarkably consistent and self-contained. Despite the fact that his career stretched across arguably the most eventful sixty years in the history of American art, his work never quite fitted into any one of the movements, schools or artistic attitudes to which it has been attributed at various stages. The diverse antecedents and affinities that have been found for Hopper's works include French Symbolism, the Ash Can School, American Scene painting, Regionalism, Surrealism, film noir, Abstract Expressionism, Pop art, photo-realism, Conceptual art and recent photo-based art practice, particularly urban photography. His work has been subjected – through different levels of expertise – to feminist, Marxist, Freudian and semiological analyses, as well as cultural studies of social history, power and gender relations and film theory.[3]

At various points, however, Hopper issued a series of well-aimed blows at the efforts of critics, historians and museum curators to connect his artistic identity to these trends, baulking particularly at the American Scene label: 'I don't see why I must have the American Scene pinned on me,' he complained in 1962, 'Eakins didn't have it pinned on him. Like most Americans I'm an amalgam of many races ... Though I studied with Robert Henri I was never a member of the Ash Can School. It had a sociological trend which didn't interest me.'[4] He later reiterated his objections with the comment: 'The thing that makes me so mad is the American Scene business. I never tried to do the American Scene as Benton and Curry and the Midwestern painters did. I think the American Scene painters caricatured America. I always wanted to do myself.'[5]

However, despite his protestations, the inclination to locate Hopper's work within an American Scene, Regionalist or Ash Can context persists. As recently as

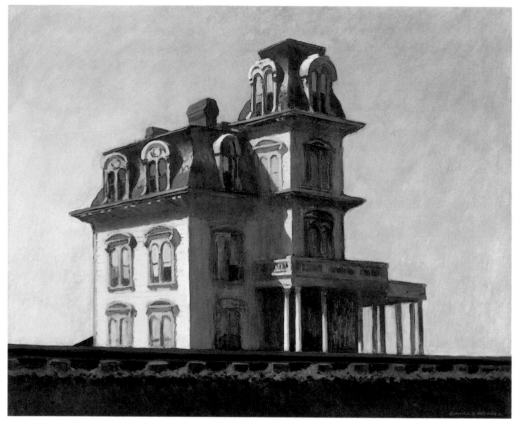

Fig.1
House by the Railroad 1925
Oil on canvas 61 x 73.7
(24 x 29)
The Museum of Modern Art,
New York
O-245

2000, a national museum's interpretative text for Hopper's painting *Chop Suey* 1929 (fig.28) placed him within the tradition of Robert Henri and his Ash Can followers, while a recent museum installation situated him as a luminary of Robert Henri's group The Eight, with which Hopper had little involvement or sympathy.[6]

For an artist whose paintings have become modern icons, however, vital substantive literature is surprisingly sparse, apart from a catalogue raisonné and a handful of catalogues.[7] While much of the writing about Hopper tends to misread his paintings by offering reductive literal or anecdotal interpretations of the emotional states of his figures, or indeed of the artist himself, some of the more penetrating and thoughtful analyses can be found in transcripts of interviews and panels or in magazine articles.

Just as curious is the fact that, notwithstanding ongoing attempts to fix Hopper's 'place' within the history of twentieth-century art, he has been consistently classified by most camps as a 'realist'. This is a term that has proved infinitely elastic,

particularly where it coincides with notions of modernism, whether international or American. Realism as a form of modernism is also an expandable term whose definition, from its inception in the nineteenth century, changed as the twentieth century wore on, both alongside Hopper's creative output and beyond. It is the intention here to examine Hopper's understanding of realism, exploring its roots in his early training and fascination with the art of his European and American modernist antecedents, which was to be developed in his mature years via an adept use of twentieth-century filmic techniques, underpinned by a sensibility honed by his lifelong adherence to nineteenth-century philosophic and literary thought.

Hopper was a slow starter. The turning point in his career at the age of forty-four was a sell-out exhibition of his watercolours at the Frank K.M. Rehn Gallery in 1924. His subsequent acceptance by the art world was rapid, and his work's value rose swiftly in the art market. The onset of the Depression as a result of the monumental stock-market crash in 1929 exactly coincided with the opening in New York

of the Museum of Modern Art. Hopper did far better than most American artists during the hard-scrabble Depression years, and his reputation as a major artist was secured when his painting *House by the Railroad* 1925 (fig.1) was the first work to enter MoMA's collection in 1930. The following year, the Whitney Museum bought *Early Sunday Morning* 1930 (fig.2) and the Metropolitan Museum purchased *Tables for Ladies* 1930. By the end of the 1930s, the Boston Museum of Fine Arts, the Brooklyn Museum, the Chicago Art Institute, the Fogg Art Museum and numerous other American museums all held examples of Hopper's work.

One of MoMA's earliest monographic exhibitions, held in 1933, was devoted to the work of Hopper, who was presented as the quintessential American modernist. No longer characterising the earlier definition of modernism as an art of focused formal experimentation, MoMA's founding director Alfred Barr saw Hopper's work as part of a new international progressive trend emerging within modernism, represented by a 'balance between "form" and "content"' in

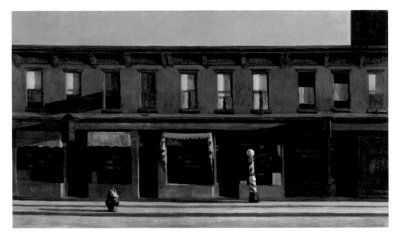

Fig.2
Early Sunday Morning 1930
See pp.156–7

Hopper's work.[8] Another loyal advocate of Hopper, Lloyd Goodrich (who joined the staff of the Whitney Museum in 1930) also regarded Hopper's painting within this alternative modernism, involving both realism and abstraction. In contrast to this aesthetic definition, the work of major European hard-line modernists such as Fernand Léger, Giorgio de Chirico and Pablo Picasso were seen through the eyes of Goodrich as a new academicism.

Hopper's work has recently been re-examined within a larger critical discourse informed by new scholarship. Historians and critics are beginning to understand that he was more innovative than he seemed in the context of his immediate contemporaries. His success in the 1930s has been lucidly assessed by the art historian Andrew Hemingway through examination of interpretations of modernism during those years in America, including critical literature about painting contemporaneous with Hopper's own statements, through which his work was legitimised at that time.[9] Allied with the advent of American modernism, as

defined by Barr, Goodrich et al., was a renewed emphasis on the revitalisation of the 'American tradition' in art. Pervasive in critical writing around 1930 was a heated debate that distinguished native American tendencies from French ones. This separated American modernism both from its European antecedents and from 'over-theoretical' contemporaries through 'a cultural chauvinism sustained by an ethnically exclusive conception of American identity'.[10]

Hopper's early assertion in his 'Notes on Painting' in the 1933 MoMA catalogue has often caused him to be interpreted in these terms. 'In general it can be said that a nation's art is greatest when it most reflects the character of its people. French art seems to prove this ... [But] we are not French and never can be and any attempt to be so, is to deny our inheritance'.[11] However, a statement made twenty years later gives what was originally interpreted as jingoistic regionalism a more emphatic international emphasis: 'American art doesn't want to be American. It wants to be universal. It doesn't want to attach any

importance to national, local or regional traits. You can't get away from these.'[12]

In another essay in the MoMA catalogue, the artist Charles Burchfield suggested that his friend's rise to fame was due to his 'bold individualism ... In him we have regained that sturdy American independence which Thomas Eakins gave us, but which for a time was lost.'[13] Such insistence on the artist's individualism and self-reliance, in addition to the notion of an authenticity of vision, relates to a central tenet of nineteenth-century realist aesthetics. In particular, it reiterates Ralph Waldo Emerson's doctrine of individualism and his emphasis on the importance of truth revealed intuitively. This is echoed by Hopper himself when he states: 'My aim in painting has always been the most exact transcription possible of my most intimate impressions of nature ... I have tried to present my sensations in what is the most congenial and impressive form possible to me.'[14]

In his review five years earlier of an exhibition by Burchfield, Hopper had stressed that the latter's work was

Fig.3
Excursion into Philosophy
1959
See p.210

Fig.4
Second Story Sunlight 1960
See pp.212–13

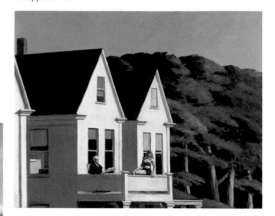

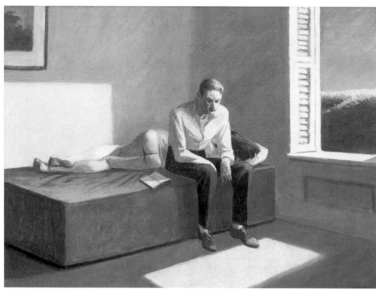

'decidedly founded, not on art, but on life ... By sympathy with the particular he has made it epic and universal.'[15] In support of his point, he quoted from Emerson's essay 'Self Reliance' (1841): 'In every work of genius we recognise our own rejected thoughts; they come back to us with a certain alienated majesty. Great works of art have no more affecting lesson for us than this.'[16] He had already cited Emerson's observation – on which he clearly based his 'Notes on Painting' – that: 'To believe your own thought, to believe that what is true for you in your private heart is true for all men – that is genius. Speak your latent conviction, and it shall be the universal sense.' It was Hopper's belief, then, that the artist's goal should be to reveal the 'truth' of everyday life and the interior life of ordinary people – and that the artist's challenge lay in his inherent ability to convey that authenticity of vision.

Such was Hopper's enduring passion for Emerson that three decades later he told Brian O'Doherty: 'I admire him greatly ... I read him over and over again.'[17] Emerson's thoughts on the qualities of noteworthy

artists in his collection of essays *Representative Men* (1850) are key to understanding the development of Hopper's artistic credo. Here, Emerson expressed the two approaches available to the artist: 'There are two powers of imagination, one of knowing the symbolic character of things and treating them as representative; and the other, by [that] treatment, demonstrating that this figment of thought is as palpable an object ... as is the ground on which [the artist] stands, or the walls of the houses about him.'[18] Of Emerson's six 'representative men' – Goethe, Montaigne, Napoleon, Plato, Shakespeare and Swedenborg – the one whom he most revered was Plato. Emerson's philosophical quest to find a means of bridging the gap between the two modes of expression described above found a solution in Plato's proposition that it is possible to reconcile opposing notions such as fact and abstraction, unity and identity, society and solitude, the many and the one.

Plato is referenced in Hopper's painting *Excursion into Philosophy* (fig.3), completed in August 1959. We know anecdotally from

the diary of Hopper's wife, Jo, written three months after the painting was finished, that Hopper considered the work possibly 'his best'. She recorded that the painting, which included a 'book of Plato on couch', was first referred to as 'Excursion into Reality'.[19] In a letter to Lloyd Goodrich the following month, she wrote: 'It may be that Edward won't stand for naming the new picture "Excursion into Philosophy". You know E. Hopper. He'll call it "Sunlight on the Floor" or something equally non-committal. But "Excursion into Philosophy" is its true name, that's how he referred to it himself.'[20] The reference to Plato and the implication that Hopper's alternative titles for the work made 'reality' and 'philosophy' interchangeable suggest that Plato's reconciliation of two poles – or indeed the 'two powers of imagination' that Emerson described in his essay on Plato – find a sympathetic balance in the painting.

A corollary to this point can be found in the fact that Hopper always carried around in his wallet a copy of his favourite quotation by Goethe – another of Emerson's six representative men:

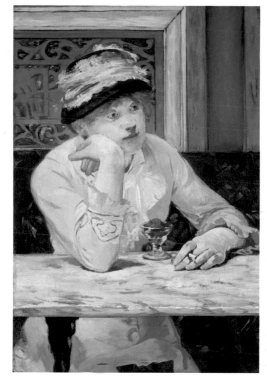

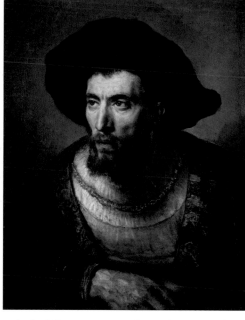

The beginning and the end of all literary activity (for literary, substitute artistic, it works for that too) is the reproduction of the world that surrounds me by means of the world that is in me, all things being grasped, related, re-created, moulded and reconstructed in a personal form and an original manner.[21]

In January 1961, a little over a year after painting *Excursion into Philosophy*, which was followed by *Second Story Sunlight* (fig.4), Hopper pointed out that Goethe's quote could also 'apply to painting'.[22]

Most of Hopper's characters are so immersed in thought that they seem completely unaware of their surroundings. They are posed in dramatic scenes of distraction, absorbed in private thought and sober musing, where Hopper's graphic drama creates a thrall of spectatorship that makes potent the compelling mystery of their mental state. From Rembrandt, whose work he valued highly alongside that of Degas,[23] Hopper learned the art of conveying a profound internalisation, dramatised by radical lighting effects and

deep shadows. Of all the paintings that he saw while in the Rijksmuseum in Amsterdam on his journey through Holland in 1907, it was Rembrandt's epic *Nightwatch* 1642 that impressed Hopper as 'the most wonderful thing of his I have seen, it's past belief in its reality – it almost amounts to deception.'[24] Although he clearly knew through reproduction Rembrandt's brooding portrait of *The Philosopher* c.1653 (fig.7),[25] it was not until 1951 on a visit to the National Gallery of Art in Washington that he excitedly discovered it in the flesh.[26]

Hopper's major paintings do not refer to specific places, but are 'types' of places – the projections of his imagination, his 'interior vision'. Like his contemporaries, he was committed to finding a way to picture modern life that could best express the contemporary issues in which he was interested. Indeed, he was intent on achieving his ambition, expressed so succinctly by Goethe, to reproduce 'the world that surrounds me by means of the world that is in me'. However, instead of following the deliberately chauvinistic

Fig.8
Summer Interior 1909
See pp.114–15

focus or committed social realism of his peers, or indeed the modernist tendencies of his international counterparts, he looked to modernism's earlier artistic and philosophic origins in the deep currents of nineteenth-century realism, from the wellsprings of Gustave Courbet, Adolph Menzel, Edgar Degas, Edouard Manet and Thomas Eakins. He then pursued them along a particular channel of artistic practice that ran through to the birth of the cinema.

In the second half of the nineteenth century the seeds of realist principles had been transplanted from Europe to America by artists such as Eakins, returning from their 'grand tour' sojourns of study and travel. Eakins himself studied at the Ecole des Beaux-Arts in Paris from 1866 to 1870, returning to Philadelphia to teach at the Pennsylvania Academy of Fine Arts. It was there, subsequently, that Hopper's teacher Robert Henri studied with Thomas Anshutz, an associate and follower of Eakins whose curriculum was notable for emphasising a philosophy of aesthetics over the craft of painting.

An influential mentor for Hopper at the New York School of Art from 1903 to 1906, Robert Henri expounded a realist doctrine that strongly reflected the moral consciousness and aesthetic views of Manet, Courbet, Degas, Eakins and their contemporaries. Hopper's fellow student and great friend Guy Pène du Bois described Henri as 'preaching art for life's sake' as opposed to art for art's sake.[27] Hopper recalled later that 'At Chase school we had painted like Manet. Henri was a great admirer of Manet.'[28] It was Henri who encouraged Hopper to follow his own example by making three trips to Europe between 1906 and 1910 in order to experience directly both the art and environment of his European predecessors.

The influence of French artists on Hopper's work is particularly clear. His use of dramatic cropping, emphatic diagonals and unusual perspective brings to mind the work of Degas, whose prioritisation of the 'framing' of the subject in relationship to its composition was of considerable importance for Hopper, who stated emphatically to Brian O'Doherty 'The frame? I consider it

very forcibly.'[29] Just after his second trip to Paris, Hopper painted *Summer Interior* 1909 (fig.8), a work that marks the first appearance in his work of partially clothed or completely nude women. A vignette of erotic tension, it is a crowded framework of interlocked planar forms, abrupt diagonals and tilted floor where a woman is slumped on a tangle of sheets, her foot dipping into a rectangular pool of reflected light. A vertical panel on the left suggests a window or curtain through which we view the bedchamber. The painting acknowledges the particular influence of Degas and Vuillard through which Hopper determined some of the basic elements of his formal vocabulary. This was refined in his later work by the gradual emptying out of interior spaces and the elimination of objects and other details that might play a counter role to the main 'narrative' of his paintings. 'One reproduces only that which is necessary', wrote Degas.[30]

Five years later, Hopper completed an extraordinary painting entitled *Soir Bleu* 1914 (fig.9). Considered an anomaly in his oeuvre, this work has been compared to

Fig.9
Soir Bleu 1914
Oil on canvas 91.4 x 182.9
(36 x 72)
Whitney Museum of
American Art, New York;
Josephine N. Hopper
Bequest 70.1208
O-191

Fig.10
Edgar Degas
(1834–1917)
Women in Front of a Café
1877
Pastel over monotype on
paper 40 x 60 (15³/₄ x 23⁵/₈)
Musée du Louvre,
Département des Arts
Graphiques

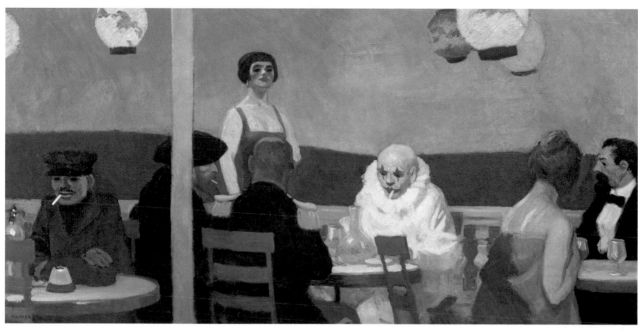

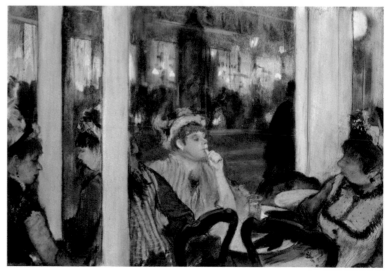

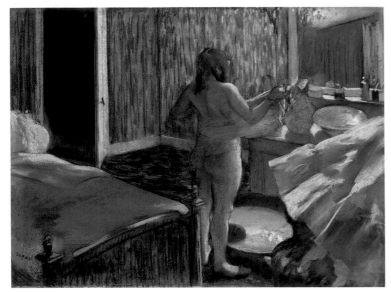

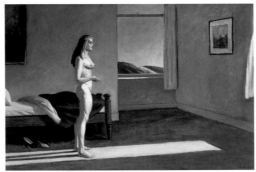

Fig.11
Edgar Degas
(1834–1917)
*Woman Drying Herself
after the Bath* 1876–7
Pastel over monotype
on paper 45.7 x 60.3
(18 x 23 ³/₄)
The Norton Simon
Foundation

Fig.12
A Woman in the Sun
1961
See pp.214–15

earlier compositions by Toulouse-Lautrec and Watteau.[31] However, its more obvious antecedent can be found in Degas's *Women in Front of a Café* 1877 (fig.10), which was already well known in Paris, having been exhibited in the Impressionists' third group exhibition. At the time of Hopper's visits to Paris, it was on view at the Musée du Luxembourg.[32] Apart from the coincidence of café subject matter, the startling vertical bisection of *Soir Bleu* finds a precedent in the two parallel vertical bands of the Degas pastel. Hopper's pole-like element visually disrupts the café scenario. It creates a narrow plane that 'fixes' the compositional space at the same time as situating us at the very perimeter of the circle of café action, in the midst of which sits the surreal figure of a smoking pierrot. The spatial ambiguity of the background wall with two contrasting planes of blue, however, may owe more to Manet's propensity to flatten and problematise the perspective of café subjects in works such as his 1881 pastel *A Café on the Place du Théâtre Français* (Musée du Louvre, Paris), which it has been proposed is itself

indebted to the same Degas pastel,[33] or indeed *Bar at the Folies-Bergère* 1882 (fig.46), in which thick columns are reflected in an age-tarnished mirror behind the young female bartender.[34] Although this was the first use by Manet of the compositional power of reflection, the 'mirror effect' had already been adopted by Degas in compositions such as *Woman Drying Herself after the Bath* 1876–7 (fig.11), where a nude woman towels herself dry in front of a mirror in which her reflection, however, does not appear.

Throughout his career, Degas consistently recognised the nude's power as a vehicle of emotional expression. Degas scholar Richard Thomson points out that 'Degas found a consistent interest, even satisfaction, in the notion of the nude not as some aesthetic ideal of unearthly purity but as the bodily articulation of psychological intensity.'[35] The muscular tension of Degas's nude figure, both feet firmly on the ground, squarely facing the mirror before her, is echoed in Hopper's haunting nude in his 1961 painting *A Woman in the Sun* (fig.12), in which the implication

of a window replaces the mirror. The interchangeability of mirrors with windows is a well-known formal device, like an eye or a lens, used by artists as diverse as Manet and Magritte as a common denominator to denote a threshold, a transition place between two contrasting or opposite states, inside and outside, object and subject, a signifier of consciousness offering either a literal reflection or a metaphorical self-portrait. An intense beam of sunlight streams through the window to illuminate the woman, who stands perfectly framed within a brilliant yellow rectangle of reflected light.[36] While direct in their emphasis on reality, both images are oblique in terms of their preoccupation with the formal relationship between figure and composition and between figure and reflection/reflected light. It is known that Hopper kept a reproduction of a Degas nude on his dressing table in his house in Truro, Massachusetts, and that his wife gave him a volume of Degas paintings around the time of their marriage in 1924. From both Degas and Manet, Hopper

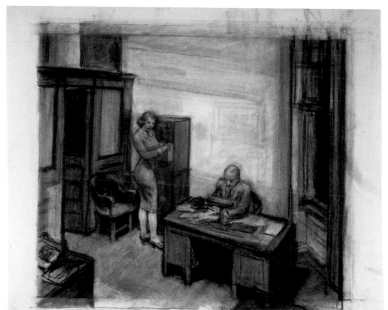

Fig.13
Study for Office at Night
1940
Conté crayon and charcoal
with touches of white on
paper
38.42 x 46.67 (15⅛ x 18⅜)
Whitney Museum of
American Art, New York;
Josephine N. Hopper
Bequest 70.341

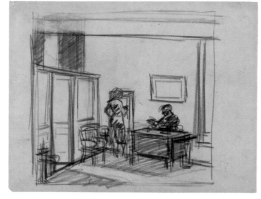

Fig.14
Study for Office at Night
1940
Conté crayon on paper
21.59 x 27.94 (8½ x 11)
Whitney Museum of
American Art, New York;
Josephine N. Hopper
Bequest 70.167

derived the idea of settling on an image that provokes the need for interpretation and that is susceptible to multiple formal and interpretative readings.

Hopper's paintings do not report an actual event in the world but rather stage a re-imagined event in narrative pictorial terms. We are face to face with a painting that is presenting a staged drama, pulsating with emotional energy held in check – at the same time as intensified – by the physical composition. A painting by Hopper presents a world over which the artist has almost total control, preconceived and ordered to create the illusion of reality. Hopper's desire was to reach a kind of plausibility, offering the minimum amount of information necessary to suggest to us that the scene in front of us is the kind of thing that could actually happen: a painterly manifestation of Goethe's 'reproduction of the world that surrounds me by means of the world that is in me'. From the 1930s onwards, it was this intermeshing of emotional reality and narrative fiction that became increasingly important for Hopper, that saw him gradually devoting more

attention to the physical nature of the essential properties of the drama itself.

On 1 February 1940, Jo Hopper reported in her diary:

E. has his new picture drawn in charcoal. He is doing things with no end of pre-paration – had 2 highly finished crayon sketches. Seems to seek delays for beginning a canvas. It's a business office with older man at his desk & a secretary, female fishing in a filing cabinet. I'm to pose for the same tonight in a tight skirt – short to show legs. [37]

Some years later, Hopper recalled that *Office at Night* 1940 (fig.15) was:

probably first suggested by many rides on the 'L' train in New York City after dark glimpses of office interiors that were so fleeting as to leave fresh and vivid impres-sions on my mind. My aim was to try to give the sense of an isolated and lonely office interior rather high in the air, with the office furniture which has a very definite meaning for me. [38]

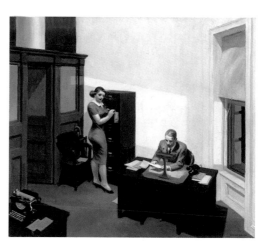

Fig.15
Office At Night 1940
See pp.172–3

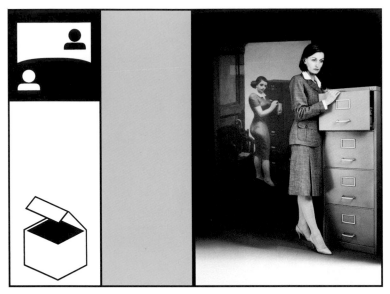

Fig.16
Victor Burgin (born 1941)
Office at Night 1986
one of six sections
183 x 244 (72 x 96)
Courtesy the artist

A series of fascinating studies (see figs.13–14 and pp.174–5) for *Office at Night* reveal Hopper's obsessive experimentation with the *mise-en-scène*, the internal architectural framework of the office, as well as the viewpoint that it offers us. The drawings show Hopper proposing different scenarios by altering the room's structure of walls, moving a door within the glazed wooden partition panelling, offering different glimpses of an exterior window – the rhomboidal flood of street light reflected on the office wall interplaying with the room's own general illumination – changing the size and height of a framed picture or mirror on the wall, depicting either one figure in isolation or two in altered positions in relation to one another and so on. In addition, Hopper conceives the office from a range of contrasting viewpoints – very high, at eye level and at low level – then spins the composition around to examine the same scene from a ninety-degree angle. Hopper identified three sources of light in the picture:

indirect lighting from above, the desk light and the light coming through the window.

The light coming from outside and falling on the wall in back made a difficult problem, as it is almost painting white on white, it also made a strong accent of the edge of the filing cabinet which was difficult to subordinate to the figure of the girl.[39]

After Hopper had completed his sketches and begun working on the painting, Jo confided to her diary three weeks later that 'Each day I don't see how E. can add another stroke ... & each day he goes right on & this picture becomes more palpable – not fussy ... reduced to essentials ... so realised.'[40]

Office at Night is a painting that has incited many analyses, such as 'a narrative of ambiguous and unresolved power/gender relations',[41] or as a means of interpreting 'the alienation of the worker from the instruments and products of his labour'.[42] The conceptual artist Victor Burgin, who has made a photographic piece directly based on the painting (fig.16),[43] has suggested that the picture may be read in terms of 'the organisation of sexuality within ... and for capitalism'.[44] He describes his own work as:

a very enclosed space ... The fantasy is that the woman explores the space of Hopper's painting, appropriates that space for herself. The pictograms were then added ... as a sort of analogue of the universe surrounding the office ... of the Law – the inescapable social order ... It's the very index of the omnipresence of control, authority.[45]

However, the plethora of meanings constructed around Hopper's work by critics, historians and artists needs to be seen within particular historical and ideological frameworks – and not treated as an effect of some inherent intention or quality in the paintings themselves. Hopper himself remarked of *Office at Night*: 'I hope it will not tell any obvious anecdote, for none is intended.'[46] Such is its compelling power, that – in a similar manner to other iconic paintings such as *Nighthawks* 1942 (pp.178–9) and *New York Movie* 1939 (fig.67) – its intriguing nocturnal 'narrative' continues to provoke speculation.

The exhilarating exercise of following Hopper's creative thought through his

graphic sketches for *Office at Night* reveals that his emphasis on the logical spatial relationships within the room's structure and contents, as well as the different qualities of light that he limns, powerfully heighten its erotic tension and emotional import. The work's meaning is intrinsic to its own internal logic, unifying its compositional structure with the intense interiority of its characters. It is the result of art direction taken to the most superb degree, creating a convincing but none the less fictional world.

Undoubtedly, stage design and the effects of stage lighting on a constructed set constituted an important part of contemporary urban nature for Hopper – he was as passionate about going to the theatre as he was about seeing films, many of which were screened in converted theatres in New York known as 'movie palaces'.[47] Hopper achieves a cinematic effect in his paintings by drawing on the vocabulary and techniques of film – *mise-en-scène* and lighting – to aid the believability of narrative.

However, the most cinematic aspect of Hopper's work may be found in his adept interweaving of fact and fiction. Cinema is a fusion of these two components, a finely balanced meshing of reality and story into a seductive and irresistible hybrid art form – a filmic manifestation of the Emersonian 'two powers of imagination'. It was Hopper's understanding of the relatively new medium of film, and his grasp of cinematography, that allowed him to release painting from convention, freeing him up to establish light and space on his own terms. Moreover, it gave him a modern means by which to infuse his paintings with the complex narratives of early modernists such as Degas, Manet and Eakins – a narrativity that had either been misread or expelled by Hopper's immediate contemporaries in their quest for a wholly indigenous, regional or sociologically motivated art. It also enabled him to revisit the notion of artist as observer that had characterised the works of his nineteenth-century artistic forbears. Works such as Manet's *Bar at the Folies-Bergère* and Degas's *Woman Drying Herself after the Bath*, which questioned

the artist's relationship with the subject (and by extension the viewer's), are antecedents to film's self-reflexive nature as exemplified by European film auteurs like Jean-Luc Godard, whose film *Breathless* (1960) Hopper eagerly anticipated seeing.[48]

In an interview of 1964,[49] Hopper asserted that even 'greater than Manet' was Thomas Eakins, whom he called 'our greatest American painter'.[50] He would undoubtedly have seen the Metropolitan Museum's 1917 memorial exhibition to Eakins, as well as the first group show at the Museum of Modern Art in 1930, which was devoted to the work of Eakins, Homer and Ryder. The selection of the Eakins section was made by Lloyd Goodrich at the request of Alfred Barr. Three years later Goodrich published a major book on Eakins – the same year that Hopper's retrospective was presented at MoMA. In his catalogue, Hopper stated that 'It might here be noted that Thomas Eakins in the nineteenth century ... is one of the few painters of the last generation to be accepted by contemporary thought in this country.'[51]

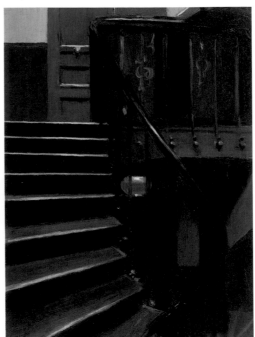

Fig.18
[Stairway at 48 rue de Lille, Paris] 1906
See p.113

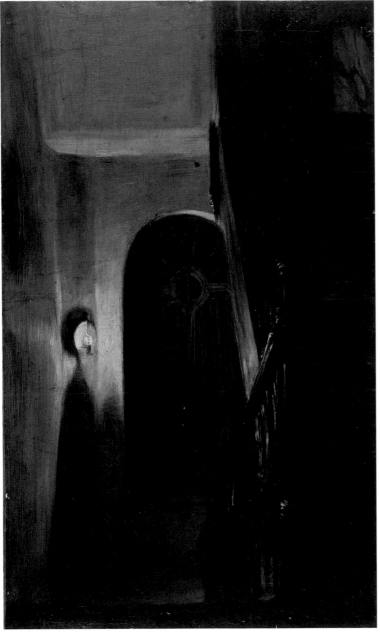

Fig.17
Adolph Menzel (1815–1905)
Stairway Landing in Nocturnal Lighting 1848
Oil on paper with board backing
37 x 22 (14 1/2 x 8 5/8)
Museum Folkwang, Essen

The art historian Michael Fried has called Eakins, Courbet[52] and Adolph Menzel 'the three great realist painters of the nineteenth century'.[53] Their paintings, he claims, are structured by an unresolvable tension or conflict between two fundamentally different representational systems. In the first, we are 'led to peer ever more closely "into" the painting ... engaging imaginatively with individual personages and their actions and states of mind.' The second, which Fried calls pictorial, puts us at a sufficient distance from the picture surface to grasp it in its entirety – a distance that effectively rules out the intimate, in effect empathic, engagement with the depicted scene called for by the first. The viewer (the first 'viewer' of course being the painter himself) 'is both embodied and in a state of considerable uncertainty with respect to his or her imagined position in front of the painting as well as to the mode of seeing that the latter seeks to elicit'.[54]

This representational conflict can be found in paintings of similar subjects by both Menzel and Hopper. Menzel's early painting *Stairway Landing in Nocturnal Lighting* 1848 (fig.17) was among his so-called 'private' paintings, produced in the mid-nineteenth century. The point of view of *Stairway Landing* is of someone pausing on the landing, from which a flight of stairs can be seen descending to the floor below; the sense conveyed is unmistakably of a descent. Hopper's own work *[Stairway at 48 rue de Lille, Paris]* 1906 (fig.18) is a similarly dark, partially lit composition, where the viewer has paused while climbing the stairs to the floor above, offering the opposite point of view to that of Menzel's painting. In both works one experiences 'the almost phantomlike evocation of a viewer – in the first case the artist – who is not just embodied but ambulatory and ... transitional, implying a brief arrest in any otherwise uninterrupted descent (ascent).'[55] Following the example of Menzel – as well as that of Courbet, Eakins, Manet and Degas, all of whom forged extraordinary compositions that went beyond the structural and perceptual norms of contemporaneous French and German art – Hopper's work also invites the viewer to perform feats of imaginative projection.

The first public unveiling of Menzel's 'private' paintings was at a vast commemorative exhibition of 1905 at the Royal National Gallery in Berlin, where they attracted considerable international attention. Menzel was reassessed as a precocious modernist and quasi-Impressionist. In an interview in 1962, Hopper stated that 'I did a lot of work [in Europe]. They are in a high key, somewhat like impressionism ... I think I'm still an impressionist ... I am most interested in the third dimension, of course. Some of the impressionists were too.'[56] Due to their new-found popularity, the gallery then put a selection of Menzel's paintings on permanent display, including *The Balcony Room* 1845 (which it had acquired in 1903) (fig.19) and *Stairway Landing*. Both were on view during Hopper's visit to Berlin from 26 June to 1 August 1907.[57]

The Balcony Room has long stood as the most emphatically forward looking of the 'private' works with regard to both style and motif. The main incident in the painting is the implied movement, the gentle inward

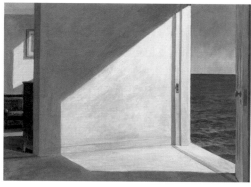

Fig.19
Adolph Menzel
(1815–1905)
The Balcony Room 1845
Oil on board 58 x 47
(22 7/8 x 18 1/2)
Nationalgalerie, Berlin

Fig.20
Rooms by the Sea 1951
See p.93

wafting of the light-filled muslin curtains as a breeze enters the room through the open windows. This lyrical evocation of wind features in several Hopper works, such as *Evening Wind* 1921 (p.119), *Night Windows* 1928 (pp.152–3) and *Summertime* 1943 (pp.186–7), where the billowing curtains – a traditional indicator of carnal sensuality – can be seen and felt in bodily terms. They give a certain tangible expression – or 'body' – to the inrush of light, which we feel enters the room along with the flow of air.

The early painting *Summer Interior* 1909 (fig.8) attests to Hopper's ambition from the very beginning of his career both to paint light as a compositional balance to representations of people and (as his mature work demonstrates) to render light as a non-literal device of representation. Hopper said himself that 'Light is an important expressive force for me, but not too consciously so. I think it is a natural expression for me.'[58] Painted following his second trip to Europe, the agitated impasto of the parallelogram of light in *Summer Interior* hesitantly echoes the bravura rectangle of reflected white light

on the floor of Menzel's painting of *The Balcony Room*.

The curator of a major retrospective of Menzel's work in 1997, Claude Keisch, has referred to *The Balcony Room*'s various 'instabilities and ambiguities', including 'the meaning of the light patch on the bare (rear) wall', which 'remains an enigma: a reflection of sunlight?'[59] Hopper's own depiction of light – whether the golden reflections of radiant sunlight of *Cape Cod Morning* 1950 (pp.194–5), *Morning Sun* 1952 (pp.198–9), *Hotel by a Railroad* 1952 (pp.200–1), *Office in a Small City* 1953 (pp.204–5) and *New York Office* 1962 (pp.216–17), or the unyielding brightness of electric light of *Hotel Room* 1931 (fig.81) and *New York Movie* 1939 (fig.67), or the dazzling rectangular lightfalls matching each of the two figures in *Summer in the City* 1949 (fig.44) and its companion piece *Excursion into Philosophy* 1959 (p.210) – appears increasingly as a geometric form. It takes the shape of a rectangle, parallelogram, rhomboid or trapezoid that always invokes a window or door – the aperture that demarcates inside from outside, literally and metaphorically.

These abstract forms of light are compositional figures themselves, a carefully positioned painted presence in bedchambers, offices, lobbies and sitting rooms, sharing occupancy of a room or space with painted human characters. It is useful to regard the paintings as stage or film sets, where the grand narrative includes passages of painted light which can be considered as much a form and pictorial presence as the interlocking geometric architectural elements of rooms and buildings through, or on, which they shine – windows, walls, facades – and which, in turn, define the shape and form of those reflections. These passages of light come to emblematise those architectural apertures which are positioned between inside and outside, representing the relations of emptiness and possibility, of within and without – all of which contribute to and enhance the power of Hopper's paintings of characters absorbed by their own meditative interior reflection.

As the poet and critic John Hollander has pointed out, light playing inside a room is an ancient metaphor for thought in a

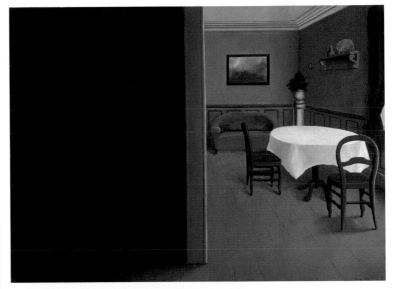

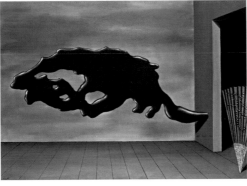

Fig.21
René Magritte
(1898–1967)
Let out of School 1927
Oil on canvas
73 x 100 (28³/₄ x 39³/₈)
Private Collection

human head. It could be seen that in occupying Hopper's carefully constructed architectural interiors or exteriors, Hopper's figures of light 'enter into a dialectic with the painted human figure to make points about consciousness itself.'[60] The duality of outer and inner worlds – Hopper's painterly manifestation of Emerson's 'two powers of imagination, one of knowing the symbolic character of things and treating them as representative; and the other, by [that] treatment, demonstrating that this figment of thought is as palpable an object ... as is the ground on which [the artist] stands, or the walls of the houses about him' – is a theme that finds its apotheosis in a work painted near the end of his life.

Perhaps following Menzel's example with *Balcony Room*, Hopper painted two canvases of rooms in which no people play a part. The first was *Rooms by the Sea* 1951 (fig.20), allegedly based on a view of the sea from Hopper's studio in Truro, Cape Cod,[61] but none the less a curious composition which perhaps also owes its stark internal divisions and surreal outlook to a Magrittean vision within paintings such as *The Secret Double*

1927, *Let out of School* 1927 and *The Voice of Silence* 1928 (figs.21–3). There is a little evidence to suggest that Hopper had sympathy with Surrealist principles. After visiting the seminal exhibition *Fantastic Art, Dada, and Surrealism* curated by Alfred Barr at the Museum of Modern Art in 1937, a little over three years after his own exhibition, Hopper was reported to comment that the Surrealists 'were better artists than they realised'.[62]

A massive rhomboid of intense light reflected through the open door dominates most of the composition, occupying the space of the empty principal room in the foreground. A second room can be seen beyond the first, through a long rectangular aperture to the left of the painting. Like a tiny *mise-en-scène* contained within the larger composition, it offers a tantalising glimpse of a sofa, a painting on a wall and a chest lit by an intense parallelogram of light. A remarkably similar evocation of a different type of space beyond that of the main room is evoked in Menzel's *The Balcony Room*, via a long rectangular mirror in which is reflected a glimpse of a sofa and a painting

Fig.22
René Magritte
(1898–1967)
The Voice of Silence 1928
Oil on canvas
54 x 73 (21¹/₄ x 28³/₄)
Private Collection

Fig.23
René Magritte
(1898–1967)
The Secret Double 1927
Oil on canvas
114 x 162 (44⁷/₈ x 63³/₄)
Musée national d'art moderne, Paris

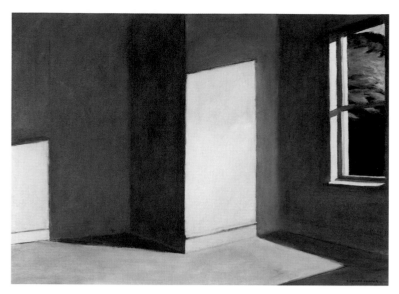

Fig.24
Sun in an Empty Room
1963
See pp.220–1

on the wall. The spatial and organisational similarity of Hopper's second 'beyond' room with Menzel's reflected room creates both a compositional – and perceptual – tension.

Painted four years before Hopper's death, the second of the two paintings refines the spatial logic of the first. Hopper had originally added a figure to a sketch for *Sun in an Empty Room* 1963 (fig.24), which he subsequently removed. To Brian O'Doherty Hopper recalled that he'd 'always been intrigued by an empty room ... When we were at school, [we] debated what a room looked like when there was nobody to see it, nobody looking in even ... I'd done so much with the figure I decided to leave the figure out.'[63]

In an uncharacteristically frank explanation of his artistic process – a rare expression of the dichotomy fundamental to his work – he went on to describe the 'problems of positive and negative areas here on the right that I have to think about. A negative window with a positive tree outside. They're opposed to each other right there ... It's hard to counteract each other ... It's hard to paint outside and inside at the same time.'[64]

The final painting projects us out of the window to take up the position of that brilliant sun whose forceful rays unremittingly illuminate the interior, making the light rather than the wall the compositional anchor for the picture. Without characters to act as mediators, this painting challenges the viewer to get to grips with the painting's own logic of abstraction. Through our intuitive tracing of the light's origin, we are led to feel the artist's own presence and subjective relationship to the scene, oscillating between identification with our 'actual' presence looking into the room and the artist's self-reflexive embodiment as light source. In response to the question of what he was trying to achieve, Hopper responded 'I'm after ME'.[65]

The total exposure of artistic self in *Sun in an Empty Room* is a consummate performance, a carefully choreographed event in which the room, empty of the human figure or its traces, is filled with pure 'figuration'. A glorious painting of his old age which glows with luminous sunlight, *Sun in an Empty Room* completes his life's work, in which Hopper suggested 'the germ

... is always found in the earlier. The nucleus around which the artist's intellect builds his work is himself ... and this changes little from birth to death. What he was once, he always is.'[66]

Over the course of sixty years, Hopper's stoic and consistent aim to synthesise realism has resulted in an oeuvre that offers a distinctive and original vision. The inventive purity of his work continues to problematise the charting of American modernism, in which the pre-eminence of revolutionary twentieth-century abstraction came to tower over representational art by mid-century – the years of Hopper's greatest achievement. Like the great nineteenth-century realists Menzel, Eakins, Degas and Manet, Hopper was concerned with abstract values as a means to a figural end. After Hopper's death, the art historian William Seitz wrote that he 'held a position of esteem among American artists that was unique, for he was highly regarded by advocates of both representational and abstract painting, and by avant-gardists as well as conservatives.'[67]

The enduring mystery of his narratives and the sustained contemporary interest in Hopper's work stems from his achievement in having placed both the modern condition of painting and the modern human condition under the light, literally and metaphorically. A compulsive director who uses the language of film to hone the structures of his scenes to their bare essentials at the same time as packing the emotional intensity tighter by the use of light as a dramatic agency, Hopper offers us a modern metaphysics, a philosophy of being and knowing. As he said the year before completing *Sun in an Empty Room*, 'The whole answer is there on the canvas. I don't know how I could explain it any further.'[68]

[1] Ralph Waldo Emerson, *Representative Men* (1850), Cambridge, Massachusetts 1987; Edward Hopper, quoted in Katharine Kuh, *The Artist's Voice. Talks with Seventeen Artists*, New York 1962, pp.140, 134.

[2] Documented statements by each artist can be verified through the following sources:
Chantal Akerman: See http://www.bfi.org.uk/sightandsound/archive/innovators/akerman.html: 'Akerman described the narrative progression [of *Hôtel Monterey* (1972)] as "an ascent through space and time" beginning on the ground floor in the evening and ending on the roof at dawn. The camera moves inexorably through the lobby, into the elevator as the doors open and close on different floors, down corridors that are often empty and sometimes into a room where someone might be sitting. The sense of waiting without a specific objective is overwhelming, something like Hopper's paintings to which *Jeanne Dielman* [1976] would be compared. "I was shocked when I saw that hotel," Akerman said. "If I had made something right away, it would have been like a news report. But I thought about that hotel for six months: through that *mise-en-scène* and that work on language, I attained ten times more truth."'
Dick Bengtsson: He appropriated Hopper's *Early Sunday Morning* in a painting from 1970, adding a swastika to its reproduction, presumably referencing the perceptions of certain writers in the 1940s, such as the historian H.W. Janson who in an incendiary article in the *Magazine of Art* in May 1946 equated the proselytising of Regionalists such as Wood and Benton with Nazism: 'Many of the paintings officially approved by the Nazis recall the work of the regionalists in this country'.
Roger Brown: See Sidney Lawrence, *Roger Brown*, New York 1987, p.102.
Victor Burgin: See Jon Bird, 'Postmodern abjection – interview with Victor Burgin' (recorded in London, October 1986), in *Victor Burgin*, exh. cat., Knight Gallery, Charlotte, North Carolina 1988.
Gregory Crewdson: See *Tate Etc.*, launch issue, May 2004.
Willem de Kooning: See Irving Sandler, 'Conversations with de Kooning', *Art Journal*, vol.48, no.3, Fall 1989, p.217.
Jim Dine: See G.R. Swenson, 'What is Pop Art? Answers from 8 Painters' (1963), in Ellen H. Johnson (ed.), *American Artists on Art from 1940–1980*, New York 1982, p.81.
Peter Doig: In conversation with the author, March 2004.
Richard Estes: See 'Interview with John Arthur', in *Richard Estes: The Urban Landscape*, exh. cat., Museum of Fine Arts, Boston 1978, p.18.
Eric Fischl: See interview by Gail Levin, 23 August 1994, quoted in Gail Levin, 'Edward Hopper: His Legacy for Artists', in Deborah Lyons, Adam D. Weinberg and Julie Grau (eds.), *Edward Hopper and the American Imagination*, exh. cat., Whitney Museum of American Art, New York 1995.
Robert Frank: On recently seeing his photograph of a diner scene taken in California in 1955–6, Frank stated that it now reminds him of Hopper's work. Conversation with Vicente Todoli, March 2004.
Robert Gober: Confirmed by artist Charlie Ray in a conversation with the author, February 2004.
David Hockney: He considered Hopper 'the greatest American realist painter of the twentieth century'. See 'No Joy at the Tate: David Hockney talks to Miriam Gross', *The Observer*, 4 March 1979.
R.B. Kitaj: 'Hopper is my favourite American painter. One of the hardest things to do in art is to achieve a subject that will stay in the memory, and, in my view, Hopper does that more often than any American. *Automat* is a crucial image for me ... I just love this painting as one of the daring and unsung dynamos of art.' See 'The Best of America: Favourite Works from the Art Show of the Season', *Telegraph Magazine*, 11 September 1993, pp.36–7.
Mark Lewis: In conversation with the author, November 2003.

Mark Rothko: See David Anfam, 'Rothko's Hopper: A Strange Wholeness' in this catalogue.
Ed Ruscha: See Richard D. Marshall, *Ed Ruscha*, London 2003, pp.10, 181, 212.
George Segal: See Gail Levin (moderator), 'Artists' Panel: Joel Meyerowitz, George Segal, William Bailey', *Art Journal*, vol.41, no.2, Summer 1981, p.154.
Stephen Shore: In conversation with the author, May 2003.
Luc Tuymans: In conversation with the author, May 2003.
Jeff Wall: In conversation with the author, October 2003.
Wim Wenders: See fig.71 on p.77 in this catalogue.
Tom Wesselmann: See Slim Stealingworth (Tom Wesselmann), *Tom Wesselmann*, New York 1980, p.58.
Other contemporary artists, many of whom engage in direct quotation or appropriation of Hopper works, have been painstakingly researched by Gail Levin in *Edward Hopper and the American Imagination*.

3 See bibliography in this catalogue.
4 Kuh 1962, p.135.
5 Brian O'Doherty, 'Portrait: Edward Hopper', *Art in America*, vol.52, no.6, December 1964, p.72.
6 *Chop Suey*: See Bruce Robertson, *Twentieth-Century American Art: The Ebsworth Collection*, exh. cat., National Gallery of Art, Washington 2000. Museum installation: The Cummer Museum, Jacksonville, Florida, in its installation of *Edward Hopper and Urban Realism*, a touring exhibition from the Whitney Museum of American Art, 5 February – 23 May 2004.
7 Mostly from the Whitney Museum of American Art and from German museums such as the Museum Folkwang, Essen, and the Schirn Kunsthalle, Frankfurt.
8 Alfred H. Barr Jr, 'Post-War Painting in Europe', *Parnassus*, vol.3, no.5, May 1931, pp.20–2.
9 Andrew Hemingway, 'To "Personalize the Rainpipe": The Critical Mythology of Edward Hopper', *Prospects*, 1992, pp.379–404.

10 Ibid., p.385.
11 Edward Hopper, 'Notes on Painting', in Alfred H. Barr Jr (ed.), *Edward Hopper: Retrospective Exhibition*, exh. cat., Museum of Modern Art, New York 1933, p.18.
12 Suzanne Burrey, 'Edward Hopper: The Emptying Spaces', *Arts Digest*, vol.29, 1 April 1955, p.10.
13 Charles Burchfield, 'Edward Hopper – Classicist', in Alfred H. Barr Jr (ed.), *Edward Hopper: Retrospective Exhibition*, exh. cat., Museum of Modern Art, New York 1933, p.16.
14 Hopper 1933, p.17.
15 Edward Hopper, 'Charles Burchfield: American', *The Arts*, vol.14, no.1, July 1928, p.6.
16 Ralph Waldo Emerson, *Essays: First Series* (1841), Cambridge, Massachusetts 1980.
17 From 'Invitation to Art' (a televised interview of Edward Hopper by Brian O'Doherty), Museum of Fine Arts, Boston/WGBH-TV, Boston, 10 April 1961.
18 Ralph Waldo Emerson, *Representative Men* (1850),

Cambridge, Massachusetts 1987. See F.O. Matthiessen, *American Renaissance: Art and Expression in the Age of Emerson and Whitman* (1941), London and New York 1969 (eleventh printing), p.28.
19 Jo Hopper, diary entry for Summer 1959, written November 1959, quoted in Gail Levin, *Edward Hopper: An Intimate Biography*, New York 1995, p.523.
20 Jo Hopper, letter to Lloyd Goodrich, 23 September 1959.
21 As told to Brian O'Doherty: See O'Doherty 1964, p.72. Quotation from a letter from Goethe to Jacobi, Frankfurt, 21 August 1774, *Letters from Goethe*, New York 1957, p.41.
22 Edward Hopper, letter to Raphael Soyer, 2 January 1961.
23 'Rembrandt is tremendous. I also like Degas very much.' Kuh 1962, p.135.
24 Edward Hopper, letter to his mother from Berlin, 27 July 1907, quoted in Levin *Intimate Biography* 1995, p.71.
25 Hopper owned a book of Rembrandt reproductions,

to which he referred in 1951. Jo Hopper, diary entry for 1 February 1956, quoted ibid., p.496.
26 Jo Hopper, diary entry for 2 March 1951, quoted ibid., p.437.
27 Guy Pène du Bois, *Artists Say the Silliest Things*, New York 1940, p.75.
28 William Johnson, unpublished interview with Edward and Jo Hopper, 30 October 1956, quoted in Levin *Intimate Biography* 1995, p.40.
29 O'Doherty 1964, p.78.
30 Ibid., p.77.
31 Gail Levin, *Edward Hopper: The Art and the Artist*, exh. cat., Whitney Museum of American Art, New York 1980, pp.29–30.
32 Verified by the Archives des Musées Nationaux, Palais du Louvre, Paris, February 2004.
33 See Charles Moffett et al., *Manet: 1832–1883*, exh. cat., Metropolitan Museum of Art, New York 1983, p.410.
34 See Margaret Iversen, 'Hopper's Melancholic Gaze' in this catalogue.
35 Richard Thomson, *Degas – The Nudes*, London 1988, p.11.

36 For another potential formal precedent for *A Woman in the Sun*, see the composition by Degas's friend Jean-Leon Gerôme, *Phryne before the Areopagus* 1861 (Hamburger Kunsthalle).
37 Quoted in Levin *Intimate Biography* 1995, p.322.
38 Edward Hopper, statement attached to letter of 25 August 1948 to Norman A. Geske, director of Walker Art Center, which had acquired the painting that same year.
39 Ibid.
40 Jo Hopper, diary entry for 19 February 1940, quoted in Levin *Intimate Biography* 1995, p.324.
41 Ellen Wiley Todd, 'Will (S)he Stoop to Conquer? Preliminaries Toward a Reading of Edward Hopper's *Office at Night*', in Norman Bryson, Michael Ann Holly and Keith Moxey (eds.), *Visual Theory: Painting and Interpretation*, Cambridge 1991, pp.47–53.
42 A term first introduced in Parker Tyler's article, 'Edward Hopper: Alienation by Light', *Magazine of Art*,

vol.41, no.12, December 1948, pp.290–5. Tyler points out (on p.295) that 'This artist paints a genre of social relations along with a genre of chiaroscuric relations ... '. The topic is developed by Linda Nochlin in 'Edward Hopper and the Imagery of Alienation', *Art Journal*, vol.41, no.2, Summer 1981, pp.136–41.

43 *Office at Night* 1986, reproduced in *Victor Burgin: Passages*, exh. cat., Musée d'Art Moderne de la Communauté Urbaine de Lille, Villeneuve d'Ascq 1991, pp.79–83.

44 Victor Burgin, *Between*, exh. cat., Institute of Contemporary Art, London 1986, p.184.

45 Burgin 1991, p.95 (originally appeared in Jon Bird, 'Postmodern abjection – interview with Victor Burgin' [recorded in London, October 1986], in *Victor Burgin*, exh. cat., Knight Gallery, Charlotte, North Carolina 1988).

46 Hopper 1948.

47 Gail Levin in *Intimate Biography* 1995 records movies Hopper saw, including:

The Keys of the Kingdom (1944), directed by John M. Stahl; *A Tree Grows in Brooklyn* (1945), directed by Elia Kazan; *The Picture of Dorian Gray* (1945), directed by Albert Lewin; *The Heiress* (1949), directed by William Wyler; *The Third Man* (1949), directed by Carol Reed; *Orpheus* (1950), directed by Jean Cocteau; *The Fallen Idol* (1948), directed by Carol Reed; *Come Back, Little Sheba* (1952), directed by Daniel Mann; *Rebel Without a Cause* (1955), directed by Nicholas Ray; *Mister Roberts* (1955), directed by John Ford, Mervyn LeRoy and Joshua Logan; *Les Diaboliques* (1955), directed/produced by Henri-Georges Clouzot; *Bus Stop* (1956), directed by Joshua Logan; *Moby Dick* (1956), directed by John Huston; *Twelve Angry Men* (1957), directed by Sidney Lumet; *Mon Oncle* (1958), directed by Jacques Tati; *Breathless* (1960), directed by Jean-Luc Godard; *The Savage Eye* (1960), directed by Ben Maddow and Sidney Meyers.

48 Hopper mentioned to

Brian O'Doherty on 10 April 1961 that he was eager to see Godard's *Breathless* ('An Invitation to Art' [a televised interview of Edward Hopper by Brian O'Doherty], Museum of Fine Arts, Boston/WGBH-TV, Boston).

49 O'Doherty 1964, p.70.

50 Edward Hopper, letter to Mrs Frank S. Davison, 22 January 1947.

51 Hopper 1933, p.18.

52 During his first trip to Paris, in 1906, Hopper had visited a retrospective of Courbet's work, which he later told Lloyd Goodrich that he greatly admired, citing Courbet's mechanical strength. Lloyd Goodrich, notes of conversation with Edward Hopper, 20 April 1946.

53 Michael Fried, *Menzel's Realism: Art and Embodiment in Nineteenth-Century Berlin*, New York and London 2002, p.109.

54 Ibid., p.111.

55 Ibid., p.26.

56 Kuh 1962, p.135.

57 Confirmed by the archive of the Nationalgalerie, Berlin, to the author, February 2004.

58 Kuh 1962, pp.135, 140.

59 Claude Keisch and Marie Ursula Riemann-Reyher (eds.), *Das Labyrinth der Wirklichkeit: Menzel, 1815–1905*, exh. cat., Nationalgalerie, Berlin 1996, p.188.

60 John Hollander, 'Hopper and the Figure of the Room', *Art Journal*, vol.41, no.2, Summer 1981, p.159.

61 A description by Jo Hopper in her diary of 17 September 1951 describes Hopper as 'struggling to get new canvas started – having such a bad time. It is an open door with sea outside & strong pattern of light inside house. Looks like only a diagram as yet.' Jo reported on 3 October that Hopper had made some important changes to his canvas by removing the steps outside the door and putting the horizon back on the sea. Levin *Intimate Biography* 1995, p.442.

62 Jo Hopper, diary entry for 15 December 1936, quoted in Levin *Intimate Biography* 1995, p.274.

63 O'Doherty 1964, p.79.

64 Ibid., p.80.

65 Ibid., p.79.

66 Edward Hopper, 'Edward

Hopper Objects' (letter to the editor, Nathaniel Pousette-Dart), *The Art of Today*, vol.6, February 1935, p.11.

67 William C. Seitz, 'An Evaluation: Edward Hopper, Painter of the American Scene', *Sun*, Lowell, Massachusetts, 28 May 1967.

68 Kuh 1962, p.142.

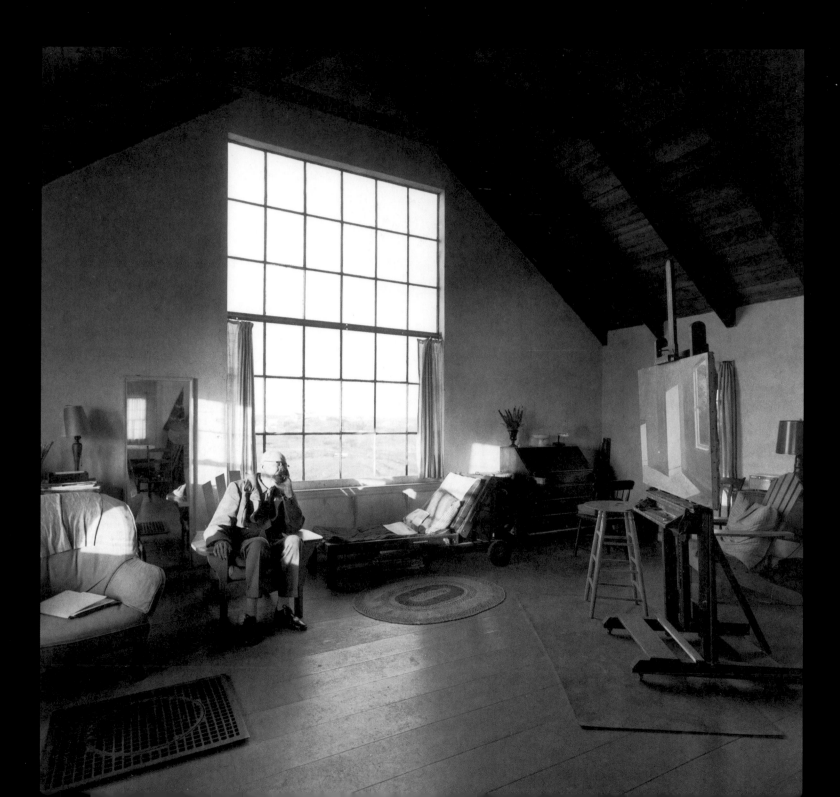

My aim in painting has always
been the most exact transcrip-
tion possible of my most
intimate impressions of nature.
If this end is unattainable, so,
it can be said, is perfection in
any other ideal of painting or
in any other of man's activities. Edward Hopper, 'Notes on
Painting', in *Edward Hopper:
Retrospective Exhibition*,
exh. cat., Museum of Modern
Art, New York 1933, p.17

I was always interested in
architecture, but the editors
wanted people waving their arms[1]
Edward Hopper

In the roaring traffic's boom
In the silence of my lonely room
I think of you[2]
Cole Porter

Wyeth is about the pursuit
of strangeness.
But he is not whole as Hopper
is whole[3]
Mark Rothko

Rothko's Hopper: A Strange Wholeness
David Anfam

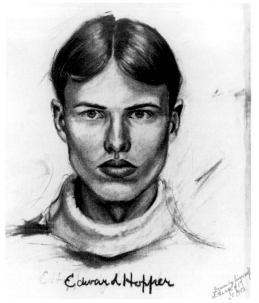

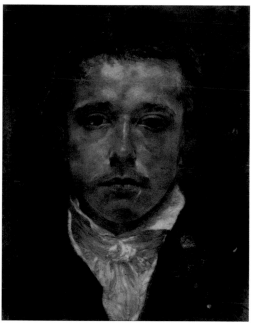

Fig.25
[Self-Portrait] 1900
Conté on paper 35.6 x 30.5
(14 x 12)
Collection of Mr and Mrs
Joel Harnett

Fig.26
Samuel Palmer
(1805–1881)
Self-Portrait 1827
Black chalk heightened with
white on paper 29.2 x 22.8
(11½ x 9)
Ashmolean Museum, Oxford

So much has been written about Edward Hopper that perhaps one of the few remaining royal roads by which to approach him is via another massively interpreted artist – Mark Rothko. A symmetry between the two is clear. Rothko is to American abstract painting in the twentieth century what Hopper is to its figurative side: they are major figures without whom any history of either trend would be incomplete. Just as Rothko is currently nearing every art fancier's 'top ten' for a poster, a personal favourite or an exhibition – at least when something more representational is not sought – so Hopper's icons are held to symbolise a particular strand in whatever supposedly constitutes the modern 'American experience'. Attempting to extract either from the preconceptions in which they are embedded is therefore a Sisyphean task, a search for some 'real' Hopper or Rothko in a labyrinth of mirrors.

By comparison, Rothko's view of Hopper helps to reveal why these two ostensible opposites shared common ground. Indeed, there is a sense in which Rothko's 'Hopper' – a tactician who cloaked inwardness under a well-wrought cover – yields a more rounded summing-up than the testimony of the famously taciturn older man himself. While Hopper seems not to have left us any evidence of his opinion of Rothko (although one might speculate upon his verdict from the negative views he expressed about abstraction), Rothko lavished substantial praise on his peer. Comparing him to the popular American painter Andrew Wyeth, for example, he declared: 'Wyeth is about the pursuit of strangeness. But he is not whole as Hopper is whole.' He also commented: 'I hate diagonals, but I like Hopper's diagonals. They're the only diagonals I like.'[4] Now that the various battle lines between high modernism and its opponents have long since dissolved, we may better discern the 'Rothko' in Hopper and the 'Hopper' in Rothko.

Overall, this reciprocity fits. Thus, a ubiquitous common denominator uniting the otherwise diverse commentary on Hopper is a consensus about his pictorial 'silences'.[5] Aptly, it was Rothko who said, 'Silence is so accurate.'[6] On a deeper level too, their ideologies are closer than they once sounded. In 1953 Hopper declared: 'Great art is the outward expression of an inner life in the artist, and this inner life will result in his personal vision of the world … The inner life of the human being is a vast and varied realm.'[7] Eight years earlier, Rothko had likewise asserted that 'if previous abstractions paralleled the scientific and objective preoccupations of our times, ours are finding a pictorial equivalent for man's new knowledge and consciousness of his more complex inner self.'[8] Each statement betrays a romantic reliance on interiority, heightened consciousness and subjectivity.[9] It is a platform that not only underlies Abstract Expressionism, but also stems from mutual roots in nineteenth-century Romanticism, and its legacy in fin-de-siècle Symbolism. Little wonder that a precursor for the frontal, wide-eyed gaze – paradoxically hinting at visionary introversion – with which Hopper portrayed himself at the age of eighteen (fig.25) should be a Samuel Palmer Self-Portrait (fig.26).[10] Equally, the different times of day depicted in works like Hopper's Early Sunday Morning 1930

(pp.156–7), *High Noon* 1949 (The Dayton Art Institute, Ohio) and *Railroad Sunset* 1929 (fig.36) were prime Romantic symbols for the phases of being.[11]

Symbolism's enduring impact upon Hopper has been established beyond doubt by Gail Levin and others.[12] Yet it is less often remarked that the crux of the transmission concerns aesthetic idealism: a belief that the source of art is an 'idea' located in the interiority of the mind or psyche. By the first decade or two of the twentieth century, this was a *doxia* as vague as it was widespread. Such assumptions infiltrated even someone as pragmatic as Hopper's esteemed teacher, Robert Henri. He was a founder-member of the Ash Can School, active in New York in the decade before World War I, who believed that 'art cannot be separated from life'. Henri's influential book, *The Art Spirit* (1923), contains such tell-tale remarks as 'every element in the picture will be constructive, constructive of an idea', and 'the artist should have a powerful will. He should be powerfully possessed by one idea.'[13] Here is an echo – embedded in Henri's empirical

practice – of an idealism that was overt in Symbolist theory. It ranged from Georges-Albert Aurier's germinal 1891 text on Gauguin ('in the last analysis, the only thing existent [for art is] – the Idea') to the Platonic doctrines involving two worlds (the visible and the invisible) of Arthur Symons's *Symbolist Movement in Literature* (1899).[14] In turn, Rothko was later so absorbed by this kind of idealism that he asserted: 'all of art is a portrait of an idea'.[15] But to isolate this philosophical strand alone as the link binding Hopper to a European background and Rothko to Hopper is to miss the wood for the trees.

The point about the *fin-de-siècle* recourse to idealism is that it was a reaction against capitalism's materialist vicissitudes as they relentlessly eroded individual autonomy. Why else should one of Rothko's first paintings, *Composition I* [recto] 1929–31 (fig.27) paraphrase Hopper's *Chop Suey* 1929 (fig.28), even to the 'Ch ... Su ...' lettering at upper right? The reason is that in *Chop Suey* Rothko presciently recognised the solitariness and kindred emotions that permeate Hopper's vision.[16]

Thereafter, his output until the 1940s paralleled Hopper's dramaturgy. *Street Scene* 1936–7 (National Gallery of Art, Washington), *Entrance to Subway* 1938 (Private Collection) and their companion works explore Hopper-esque urban realms of loneliness, estrangement, impersonality, interior versus exterior implications, silence and moodiness.[17] In the work of both artists, figures are framed by architecture or imprisoned in blind fields, paired with spectral doubles and mirrored, set within awry perspectives, dwarfed by emptiness, cut by the picture edge or by objects, and reduced to mannequins. These traits comprise revisions of a much-studied European problem. In influencing the young Rothko (among others), Hopper's own sources had therefore conveyed this malaise – as a fecund subject for art – across the Atlantic. What was its nature?

Scholars such as Anthony Vidler and Susan Sidlauskas have traced a crisis in European culture from the late nineteenth century onwards concerning human relationships to space, architecture and the domestic or urban sphere.[18] Of course

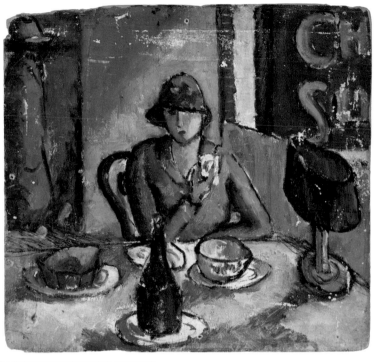

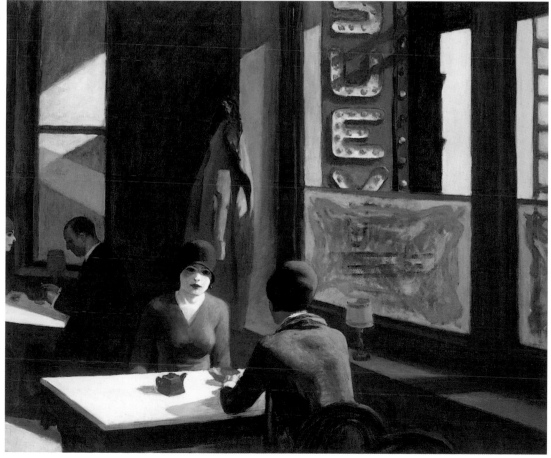

Fig.27
Mark Rothko
(1903–1970)
Composition I [recto]
1929–31
Oil on board 32.7 x 34.9
(12 7/8 x 13 3/4)
Collection of Kate Rothko
Prizel and Christopher
Rothko

Fig.28
Chop Suey 1929
Oil on canvas 81.3 x 96.5
(32 x 38)
Collection of Mr and Mrs
Barney A. Ebworth
O-265

Fig.29
Mark Rothko
(1903–1970)
No.4 1953
Oil on canvas 269.2 x 129.2
(106 x 50⅞)
Whitney Museum of
American Art, New York

Fig.30
The Bridle Path 1939
Oil on canvas 72.1 x 107
(28³/₈ x 42¹/₈)
San Francisco Museum
of Modern Art;
Anonymous gift
O-308

Karl Marx first analysed this rupture as a consequence of capitalist technocracy, associating it with alienation, mass-production, reification and commodity fetishism. Crucially, as the environment became ever more dominated by mass-produced entities, and dehumanised by technocracy and *anomie*, so objects and emptiness were felt to acquire their own momentum. The rise of photography – sapping 'aura' from people while creating charismatic lifelike simulacra – added another dimension to these unsettling reversals between the vital and the inanimate, presence and negation.

Many other thinkers chronicled this turmoil: Friedrich Nietzsche (with his sensitivity to metaphysical twists of time and reality);[19] Georg Simmel (who researched the anxiety-laden socio-spatial dilemmas of urban conduct); Walter Benjamin (with his scrutiny of the strangenesses faced by the modern *flâneur* as well as those surrounding the new mechanical means of reproduction); and Sigmund Freud (who, in his essay 'The Uncanny' of 1919, delved into the loss and duplications of selfhood caused by unconscious drives).[20] By 1935, the

disruptions to bourgeois normalcy had reached a point where Virginia Woolf could complain of home: 'There'll be no settled life within these walls.'[21] The artistic counterparts to these disturbances were the depictions of frozen, rootless, bored or marginal humanity poised amid artifice by Edouard Manet, Edgar Degas, Georges Seurat and Walter Sickert – to name a few who probably influenced Hopper when he visited the Continent in 1906–7 and 1909–10 or, afterwards, via reproductions. Given Hopper's sometimes erotic subjects (epitomised by *Girlie Show* 1941, fig.86) and his troubled marriage, it may also be significant that this spatial-cum-psychological unrest melds with the period's anxiety over all things female.[22]

So far we are in well-charted territory. The 'strangeness' that Rothko discerned in the mature Hopper has its matrix in this European climate of angst, ennui and the uncanny.[23] After all, a striking detail of *Chop Suey* is that its female subject faces her doppelgänger.[24] The repetitions of Rothko's own mature idiom (fig.29) – wherein hallucinatory

rectangles, split by ominous voids, multiply and mutate as if the paint were forming itself – are nothing more than a brilliant play on an uncanny scenario. On the other hand, it may be surprising that Rothko's signature abstractions had an almost identical goal to that sought by Hopper. In short, the convergence between certain of their comments is striking. Rothko: 'Often, towards nightfall, there's a feeling in the air of mystery, threat, frustration – all of these at once. I would like my painting to have the quality of such moments.'[25] Hopper, on the enigmatic, apprehensive *Bridle Path* 1939 (fig.30) and *Approaching a City* 1946 (fig.54): 'There is a certain fear and anxiety, and a great visual interest in the things that one sees coming into a great city.'[26] Rothko was to greatly admire Michelangelo Antonioni's haunted cityscapes, and not only was the esteem reciprocal,[27] but the Italian film director's barren vistas were also an acute rendition of Hopper's *mise-en-scène* in another medium.

The city wherein Hopper first broached this 'fear and anxiety' was Paris. To paraphrase his claim, the germ of a later

Fig.31
Xavier Mellery
(1845–1921)
The Stairway c.1889
Conté and sanguine on
paper 57 x 45 (22¹/₂ x 17³/₄)
Koninklijk Museum voor
Schone Kunsten, Antwerp

Fig.32
*[Stairway at 48 rue de Lille,
Paris]* 1906
See p.113

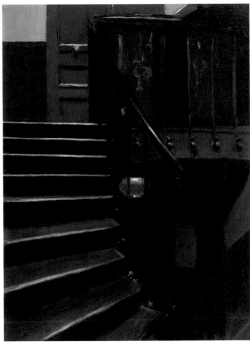

universe was latent in these early French scenes. Their iconography (which also anticipates key elements in Rothko such as his penchant for architectural motifs) skirts rarely acknowledged quasi-existentialist foundations – well before that philosophy flourished in the World War II epoch – which corresponded with Hopper's outlook. To cite one example, the similarity between Hopper's Parisian stairway (fig.32) and Xavier Mellery's same subject (fig.31) appears as noteworthy as it is coincidental. Coincidental because Hopper probably never knew a relatively obscure figure such as the Belgian Mellery; notable because it bespeaks the Symbolist impetus behind the later Hopper. In scenes exemplified by *New York Pavements* 1924 or 1925 (p.126), *Gas* 1940 (fig.62), *Office at Night* 1940 (pp.172–3), *[Stairway]* 1949 (p.192) and *Intermission* 1963 (pp.218–19), objects – furniture, petrol pumps, a cornice, a nun's mantle – assume the role of protagonists as the human actors are frozen or absent. A prototype for this animistic slippage lies in Mellery's own words: 'All life around us is a subject for study, everything is living

even if it does not move: a chair, a door, a wall are so many organs, making up the true, ordinary life of men and things.'[28] Moreover, the acute resemblance between Hopper's Paris and that of Rainer Maria Rilke's *Notebooks of Malte Laurids Brigge* (1910) must again be chance since the apposite pictures mainly pre-date the novel. None the less, both testify to a European 'existentialist' dynamic *avant la lettre* and its hallmark polarities – a persuasion that had counterparts in the United States and which, tellingly, also exhibits distinct affinities with Hopper's mentality. One aspect of Rilke's Paris has the qualities Hopper pursued – in *Le Parc de Saint-Cloud* 1907 (fig.33), *Ecluse de la Monnaie* 1909 and *Le Bistro* 1909 (all Whitney Museum of American Art, New York), with their breezy, spacious and radiant sheen. Unknowingly, as it were, Rilke encapsulates the mood:

There are days when everything around you is luminous, scarcely intimated in the bright air, and yet quite distinct. The foreground takes on the colours of distance, is remote

Fig.33
Le Parc de Saint-Cloud
1907
Oil on canvas 59.7 x 72.4
(23 1/2 x 28 1/2)
Whitney Museum of
American Art, New York;
Josephine N. Hopper
Bequest 70.1180
O-144

and merely shown from far away, not given to you. And everything related to expanse – the river, the bridges, the long streets, and the extravagant squares – has taken that expanse behind it, is painted on it as if on silk.[29]

In contrast, another side to Rilke's writing is dark, introspective. Isolated buildings loom anthropomorphically: 'Then I saw a house that was peculiarly blind, as if from a cataract', or 'suddenly a black cornice pushed forward overhead … and a high wall leans forward, soundlessly'.[30] This foretells Hopper's many personified buildings such as Haunted House 1926 (p.137) and Two Puritans 1945 (p.189). Yet it also repeats an American context established long before, in which architectural metaphors stand for the mind, typified by the poet Emily Dickinson:

One need not be a Chamber – to be Haunted
– One need not be a House –
The Brain has Corridors – surpassing
Material Place[31]

In Henry James's American Scene (1907), of which W.H. Auden remarked 'Outside of fairy tales, I know of no book in which things so often and naturally become persons',[32] buildings even speak. There perhaps lurks in these literary precedents a clue to understanding Hopper's fundamental assertion 'I was always interested in architecture, but the editors [of his magazine illustrations] wanted people waving their arms.' Architecture, not people, should have a voice.

Since at least the time of Vitruvius, architecture has been envisaged as a model of human space, proportion and sentience. Hence Vasari could praise an edifice by saying that it seemed 'not built but born'.[33] By the same logic, Hopper's many blank walls, vacant windows and dramatic facades eventually 'speak' in lieu of his mute inhabitants, climaxing in the statuesque House by the Railroad 1925 (fig.1). They enunciate an ultra-materialist American era in which things – invented, mass-produced by assembly line, consumed, bought, sold and discarded – gained the edge over people.[34] Again, the similarity

Fig.34
Caspar David Friedrich
(1774–1840)
Cross in the Mountains
(Tetschen Altar) 1807–8
Oil on canvas 115 x 110.5
(45¼ x 43½) without frame
Gemäldegalerie Alte Meister,
Dresden

Fig.35
Mark Rothko
(1903–1970)
Street Scene c.1937
Oil on canvas 73.5 x 101.4
(29 x 40)
National Gallery of Art,
Washington. Gift of the
Mark Rothko Foundation

with Rothko is revealing. Inspired by the monolithic walls of the J.P. Morgan bank in Paul Strand's photograph *Wall Street New York* 1915, Rothko conceived another *Street Scene c.1937* (fig.35) where a facade dominates the huddled group beside it.[35] Subsequently, he deemed his classic abstractions 'facades', which would still, through their poignancy, 'defeat' what they were hung upon.[36] In the end, his murals for the Seagram Building, Harvard University and the Houston Chapel supplant those walls. If Hopper's humanisation of architecture targeted the site-specific vernacular (with, as he stated apropos of Charles Burchfield's houses, its 'hideous beauty'), Rothko's was the abstract apotheosis of the same impulse (inflected with a monumental bias).[37]

As an intellectual guidebook of sorts, Rilke's Paris maps the most important thematic structures that weave back and forth throughout Hopper's career and, later, Rothko's. Indeed, these strike to the heart of each artist's concerns – evidence perhaps of a mostly unintentional yet, for that very reason, all the more compelling *pas-de-deux*.

These *idées fixes* are predictable: light (and, naturally, its opposite), spatial enclosure and spectatorship. What triangulates them is more elusive.

Almost from first to last, Hopper obsessively revisited a partly enclosed space. The literary critic John Hollander judges this trope central to the artist's evolution, neatly describing it as 'enchambered'.[38] While Rilke noted a special charge felt in Paris 'under bridges in late autumn',[39] what caught Hopper's eye was analogous: 'The light [in Paris] was different from anything I had known. The shadows were luminous, more reflected light. Even under the bridges there was a certain luminosity.'[40] Originating as the vault that is the focus of a 1906 oil study (fig.55), the motif recurs throughout the Paris scenes and, once Hopper had returned to the United States, became a major feature in *The Bridle Path* and *Approaching a City* (fig.54). Subtly, it also modulated into countless further enclosures: myriad rooms; the porch of *New York Pavements*; *Compartment C, Car 293* 1938 (fig.61); the surrounding framework of *Dawn in Pennsylvania* 1942 (pp.182–3); and

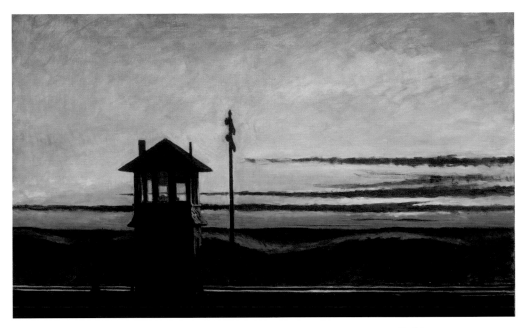

the loci of *Drug Store* 1927 (pp.146–7) and *Nighthawks* 1942 (pp.178–9) – partial confines insofar as they radiate outwards into their nocturnal ambience. Above all, these are zones where luminosity mediates darkness, sometimes nurturing shadow (the bridge vaults), sometimes trapping radiance, as in *Nighthawks* and *Rooms by the Sea* 1951 (fig.85), or else presenting a complex interplay between artificial illumination and light outside, as with *Chop Suey* (fig.28) and *Automat* 1927 (pp.138–9). What should we make of this veritable ur-setting, a blueprint as constant as its guises are protean?

The metaphor of an enclosure – bounded by a portal or vault and contrasting light with night – as a threshold between the here-and-now and an otherworldly domain, is ancient (one has only to recall the venerable religious-architectural typology of the vault of heaven or the doors to the underworld depicted on Roman sarcophagi). Rothko summoned that past in the portal-like openings that fill the Seagram murals, and wished, following Michelangelo's claustrophobic Medici

Chapel, to make 'viewers feel that they are trapped in a room where all the doors and windows are bricked up, so that all they can do is butt their heads forever against the wall.'[41] Less melodramatically, his first pendants had been a *Sketch in the Shade* and a *Sketch Done in Full Sunlight* (respectively July and August 1925, National Gallery of Art, Washington, and Private Collection), while gloom and glare held within rectangular bounds are the essence of his classic icons. Hopper's thresholds anchor this same metaphysics in actual locations, thereby evoking the strategies of Romantics such as Caspar David Friedrich, who investigated the dialectic between interiors or foregrounds and external, unlimited vistas.[42] Whether or not Hopper knew Friedrich, *Railroad Sunset* (fig.36) is a Tetschen Altar (fig.34) for commerce-driven 1920s America – an afterglow that speaks more of loss and severance (literally in the light's fading and the railway line slicing between us and nature) than of redemption (the lurid 'happily ever after sunsets' of Westerns and pulp fiction). Even Hopper's telegraph

Fig.36
Railroad Sunset 1929
Oil on canvas 71.8 x 121.3
(28 1/4 x 47 3/4)
Whitney Museum of
American Art, New York;
Josephine N. Hopper
Bequest 70.1170
O-268

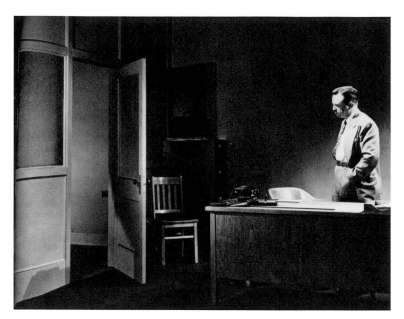

Fig.37
Photograph from industrial
film produced in the 1950s
by the Jam Handy
Organisation

pole emulates Friedrich's crucifix.[43]
Here the sacral becomes terrestrial.

A topical reading would yoke this
drive to a native existential sensibility that
only recent studies have uncovered in any
depth: for instance, George Cotkin's survey
of 'the "drizzly November" of the American
soul' in *Existential America* (2003).[44] True,
Hopper himself perhaps encouraged an
exegesis of *Nighthawks* through the lens of
Ernest Hemingway's 'The Killers' (1927).[45]
Yet this may have diverted attention from
the fact that *Nighthawks* is at least as in
synch with Hemingway's more overtly
philosophical 'A Clean, Well-lighted Place'
(1933) as it is with the earlier tale. Stark in
its luminescence, *Nighthawks* emulates
Hemingway's characters in the latter:
'"I am one of those who like to stay late
at the café," the older waiter said. "With all
those who do not want to go to bed. With
all those who need a light for the night."'[46]
The night surrounding the pristine diner
betokens Hemingway's oblivion or *nada*:
'It was all a nothing and a man was nothing
too. It was only that and light was all it
needed and a certain cleanness and order.'[47]

In another vein, Walter Lippmann's
disquiet over the 'acids of modernity' in
A Preface to Morals (1929) chimes with
Hopper's contemporaneous nostalgia for
bygone pre-industrial days.[48]

Whatever the angle, we are in a noir
landscape – notwithstanding the proviso
that noir in film and fiction remains a tricky
genre indexed to the beholder's situation.[49]
By the time film noir had caught up with
Hopper, the temper of American discourse
was riven with enough tensions for even a
commercial sales manual – a sure gauge of
'low' cultural attitudes – effortlessly to
assimilate noirish suspense through stark
lighting and actors frozen in enigmatic
poses (fig.37). The historical cross-currents
between Hopper, noir and the lingua franca
of everyday America are in any case
tangled. This is especially so if we recall a
still more demotic formula that pre-dates
noir by a decade while offering an equation
between loneliness, silence, the 'figure of
room' and desire, which Hopper – attuned
to these qualities – could hardly have
missed. Song lyrics are the mundane
script for an age's higher stagecraft:

In the roaring traffic's boom
In the silence of my lonely room
I think of you …

One component remains to complete
the triangle of themes referred to above.
[Solitary Figure in a Theatre] c.1902–4
(fig.38) initiates what the late *Two*
Comedians 1966 (pp.222–3) finishes: a life-
long rumination on spectatorship in which
dark blankness and blank lightness are flip
sides of one coin. Again, Rilke adumbrates
this aporia of the 'theatrical' impasse:

Let's suppose this. All at once you feel the
unnatural emptiness of the theatres; they
are bricked up like dangerous holes; only
the moths from the rims of the box seats
flutter through the unsupported void. The
playwrights no longer enjoy their elegant
townhouses. All the detective agencies are,
on their behalf, searching in the remotest
corners of the world for the irreplaceable
third person, who was the action itself.[50]

That the world might be a theatre
and we the actors is a *topos* older than

Fig.38
[Solitary Figure in a Theatre]
*c.*1902–4
See p.101

Shakespeare's Renaissance conceit of the *theatrum mundi*. Relatively modern, however, is the neurosis that we may have lost the plot. This realisation goes towards explaining many traits in Hopper. If reality is driven by narrative, is itself a story, then the loss of a rationale must suspend the medium in which events occur. Simply put, this vacuum induces what Hopper saw in the works of Burchfield: 'Time was arrested.'[51] So too is the 'action' of Rothko's mature paintings condensed into a momentary chromaticism – sudden, sheer and encompassing.[52] As Rothko's format is laden with allusiveness – a gambit that induces viewers to read in everything and nothing – Hopper's always encourages the search for a plot, no matter that he unfolds few, if any, legible stories.[53] Indeed, instead of stories we seem to behold situations.

Photography and cinema transform reality into flatness, light and shade. The first is silent, the second enacted in a dark chamber. Early on, Rothko painted a *Movie Palace* 1934–5 (Private Collection) and Hopper his outstanding *New York Movie* 1939 (fig.40). Both men were keen cinema-goers. Desire played a decisive part in their makeup. Hopper channelled this into fantasies such as the nude of *Evening Wind* 1921 (p.119) and that clunky amorous encounter, *Sunlight in a Cafeteria* 1958 (fig.84). Guy Pène du Bois observed: '[Hopper] should be married. But can't imagine to what kind of woman. The hunger of that man.'[54] Rothko's twin aesthetic goals included 'sensuality' and 'tension'. He defined the first as 'the basis for being concrete about the world', the second as 'conflict or desire which in art is curbed at the very moment it occurs'.[55] Though there is ample stuff here for Freudianism, it merits a less clinical analysis.

To the element of desire in Hopper and Rothko, it is imperative to add the rejoinder that both are pre-eminently melancholic artists for whom silence is action. Hardly a touch of *jouissance* marks Hopper's dramatis personae, while Rothko's stress on the 'tragic' is proverbial. Julia Kristeva's notion of melancholia suggests their truest mode. In Kristeva's account, 'beauty' constitutes the depressive's 'other realm' and that word best summarises the impression that their

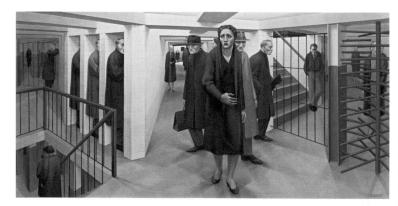

Fig.39
George Tooker
(born 1920)
The Subway 1950
Egg tempera on board
46 x 91.8 (18¹/₈ x 36¹/₈)
Whitney Museum of
American Art

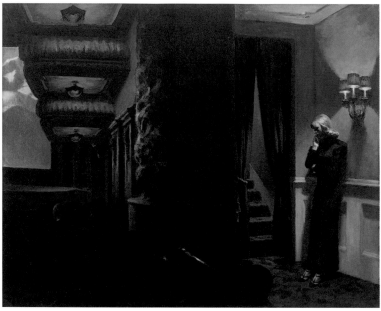

Fig.40
New York Movie 1939
See p.75

strongest achievements convey: fullness and formal order arising from some potent lost focus of longing, visual grace wrested from dejection.[56] Coining the oxymoron 'black sun' as a metaphor for the negative-positive pull of melancholic creativity, Kristeva invokes Gérard de Nerval: 'It is a well-known fact that one never sees the sun in a dream, although one is often aware of some far brighter light.'[57] How better to describe the omnipresent refulgence in Rothko that somehow seems forever penumbral or covert, as well as Hopper's glaring, chilly light of which the sources are either artificial or lie outside the picture? His sun-watchers embody Wallace Stevens's melancholy paradox:

The exceeding brightness of this early sun
Makes me conceive how dark I have become[58]

The film critic Parker Tyler described Hopper's strategy as 'alienation by light'.[59] 'Alienation' implies loss, a condition that Hopper joined to light: 'Maybe I'm not very human. What I wanted to do was to paint sunlight on the side of the house.'[60]

Rothko's analogue to this displacement meant expressing his 'not-self' – the studied rigour that his austere, repeated designs uphold.[61] And these are 'whole' in that all their parts lock together into a single organic nexus: 'I guess I am pretty much of a plumber at heart'.[62] Equally architectonic are Hopper's planes, which (as many critics note) are parsed two-dimensionally across the picture surfaces. Contemporaries such as George Tooker, whose *The Subway* 1950 (fig.39) depicts Hopper-like alienated souls in New York's latter-day inferno, instead veered into anecdotal illustration. Furthermore, Hopper's masterstroke is to subvert the mimesis that he feigns to serve: his colours incline to improbable tones, his perspectival systems are irrational, his buildings toy-like and his faces masks. Art, Hopper whispers, is all make-believe.[63] The mask, as Roland Barthes said of photography's fixity, is the message.[64]

Illusion, illumination, darkness, loss, desire, stillness, time suspended, wholeness and enclosure all meet in one place: the cinema theatre. Films trade in trickery and

make-believe, immobilise the audience in their seats, arrest real time in the course of virtual reality, exploit absence (why bother to behold a mere flat shadow-play if not on account of some inner lack?), satisfy desire (thus the term 'dream palaces'), enclose us in a dark chamber and turn life into a single luminous whole. Film theorists propose that this process recapitulates early mental experiences of separation from the maternal body and a concomitant desire to regain that lost unity. Be that as it may, Ingmar Bergman's *Persona* of 1966 (fig.41) presents an extraordinary sequence that bears on both Hopper and Rothko. A child reaches to touch a woman's face in extreme close-up, before this hazy field slowly modulates into a two-dimensional, back-projected screen.[65] Here of course Bergman also probes how we watch films.

Is it far-fetched to compare Bergman's mind-screen with Rothko's images which – besides having the rectangular glow of a film-frame – hover, as cinema does, between hallucination and perception?[66] Not if we recall that the cinema at its inception in the United States was

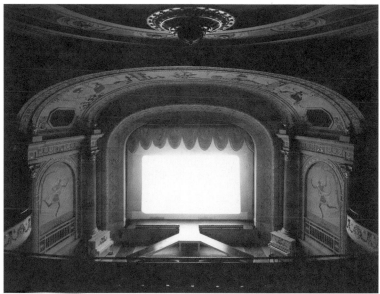

Fig.41
Ingmar Bergman (born 1918)
Still from *Persona* (1966)

Fig.42
Hiroshi Sugimoto
(born 1948)
*Cabot Street Cinema,
Massachusetts* 1978
Black and white photograph
51 x 61 (20 x 24)
Courtesy Sonnabend Gallery

portrayed as a mind-screen. The once-popular pioneer of film theory, Hugo Münsterberg, wrote in 1915: 'The photoplay tells us the human story by overcoming the forms of the outer world, namely, space, time and causality, and by adjusting the events to the forms of the inner world, namely attention, memory, imagination, and emotion.'[67] We are back to an 'inner self' akin to those of Hopper and Rothko that began our discussion – one that makes a graphic drama from the thrall of spectatorship. Also, Bergman's set piece exhibits a curious congruence with Hopper's early insight into what he most prized in Burchfield: 'an attempt to reconstruct the intimate sensations of childhood, an effort to make concrete those intense, formless, inconsistent souvenirs of early youth whose memory has usually long since faded by the time the power to express them has arrived, so close to dreams that they disappear when the hand tries to fix their changing forms.'[68]

In the end, Hopper's works may be 'strange' because they are, by his own account, representations of ideas or thoughts – 'intense, formless souvenirs' conjured as though they were reality.[69] Much often seems to depend on what is not visible – things in shadow, outside the image and so forth. Is there a metaphysic at stake? Yes, according to *Excursion into Philosophy* 1959 (p.210). The open book beside the man there is Plato, 'reread too late'.[70] Plato unlocks Hopper's stage machinery of artifice and universals, light and its hierarchies, gloom and alienation, sun-seekers and shadowed enclosures, the liberated who bask in bright air, the disillusioned who watch and wait, as no other philosopher can.[71] For, of course, these are the terms of the human condition for the prisoners in Plato's allegory of the cave.[72] There the sun represents a timeless order and totality, an elsewhere beneath which humanity lingers in its tenebrous chamber spellbound by artificial lights. Rothko too read Plato, wrote a youthful poem entitled 'Walls of Mind – Out of the Past' about 'the feel of the cave' and, as noted, equated his art's core with 'the idea'.[73] Moreover, Plato's cave has often been likened to the cinematic experience and occurs in the United States as an existential parable as early as the 1930s.[74] From there to the magical light screens that a contemporary such as Hiroshi Sugimoto has photographed from the 1970s onwards (fig.42) is a long journey.[75] Yet these postmodern revisions of Hopper's movie theatres and Rothko's hypnotically glowing fields are reminders that their unity and silent eloquence still speak to a new century.

[1] Edward Hopper, 'Edward Hopper Objects', *The Art of Today*, vol.6, February 1935, p.11.
[2] Cole Porter, 'The Gay Divorce' (1932).
[3] Rothko in Brian O'Doherty, *American Artists: The Voice and the Myth*, New York 1973, p.231. Rothko also said that George Segal's sculptures looked like a 'walk-in Hopper'. Gail Levin, 'Edward Hopper: His Legacy for Artists', in Deborah Lyons, Adam D. Weinberg and Julie Grau (eds.), *Edward Hopper and the American Imagination*, exh. cat., Whitney Museum of American Art, New York 1995, p.113.
[4] O'Doherty 1973, p.24.
[5] See, for example, J.A. Ward, *American Silences: The Realism of James Agee, Walker Evans, and Edward Hopper*, Baton Rouge 1985.
[6] Elaine de Kooning, 'Two Americans in Action', *Art News Annual*, vol.27, 1958, p.174.
[7] Edward Hopper, statement published in *Reality*, no.1, Spring 1953, p.8.
[8] Mark Rothko, 'Letter', *New York Times*, 8 July 1945, section 2, p.X2.
[9] See David Anfam, *Abstract Expressionism*, London 1990,

pp.15–16, and Michael Leja, *Reframing Abstract Expressionism: Subjectivity and Painting in the 1940s*, New Haven 1993. But Leja's flypapering of Abstract Expressionist 'subjectivity' to the discourse of twentieth-century 'modern man' is mistaken insofar as the former rests upon nineteenth-century Romanticism, especially its offspring in American transcendentalism with its Platonic/idealist bases. Hopper ultimately relates to this tradition.

[10] This staring frontal demeanour (significantly never repeated) was a Symbolist stand-by prevailing as late as the central figure of Piet Mondrian's *Evolution* 1911 (Gemeentemuseum, The Hague).

[11] For example, Philipp Otto Runge's *Times of Day* cycle.

[12] Gail Levin, *Edward Hopper: The Art and the Artist*, exh. cat., Whitney Museum of American Art, New York 1980, pp.61, 264ff.

[13] Robert Henri, *The Art Spirit* (1923), Philadelphia 1951, pp.9, 190.

[14] Georges-Albert Aurier, 'Symbolism in Painting: Paul Gauguin', in Herschel B. Chipp, *Theories of Modern Art*, Berkeley 1968, p.89; Arthur Symons, *The Symbolist Movement in Literature* (1899), New York 1908, p.12: '[In Symbolism] the visible world is no longer a reality, and the unseen world no longer a dream.' Levin 1980, p.62, suggests that Hopper possibly knew Symons's book.

[15] Rothko and Adolph Gottlieb, 'The Portrait and the Modern Artist', Radio WNYC broadcast, 13 October 1943. On Rothko's neo-Platonic idealism, see David Anfam, *Mark Rothko: The Works on Canvas – A Catalogue Raisonné*, New Haven and London 1998, pp.50, 98–9. Later, Rothko was delighted when a fellow painter described one of his works as 'pure mind'.

[16] Both works highlight the irony of a mute commercial sign presiding over the human.

[17] See Anfam 1998, pp.150, 167. Another paradigm is the architectonic *Interior* 1936 (ibid., p.142).

[18] Anthony Vidler, *The Architectural Uncanny: Essays in the Modern Unhomely*, Cambridge, Massachusetts 1992; *Warped Space, Art, Architecture and Anxiety in Modern Culture*, Cambridge, Massachusetts 2000; Susan Sidlauskas, 'Psyche and Sympathy: Staging Interiority in the Modern Home', in Christopher Reed (ed.), *Not at Home: The Suppression of Domesticity in Modern Art and Architecture*, New York 1996.

[19] This, in turn, influenced the quiescent, empty streets of Giorgio de Chirico, whose distorted perspectives, unnatural light and temporality compare with Hopper's. Wieland Schmied cursorily links them in *Edward Hopper: Portraits of America*, Munich and New York 1995, pp.36–9.

[20] Vidler 1992, p.7, adds Georg Lukács's concept of 'transcendental homelessness' to these symptoms of the modern condition, while Robert Musil's novel *The Man Without Qualities* (1930–42) attests to the dilemmas of blind space.

[21] Virginia Woolf, 'Tuesday, September 12, 1935', in Leonard Woolf (ed.), *A Writer's Diary*, New York 1953, p.246, cited in Sidlauskas 1996, p.80.

[22] Sidlauskas 1996, p.74. For an updating of this sociological interpretation, see Vivian Green Fryd, *Art and the Crisis of Marriage: Edward Hopper and Georgia O'Keefe*, Chicago 2003.

[23] The detective story-like denizens of *Nighthawks*, *Office at Night* and so on also dovetail with the theory that the uncanny is pivotal for this genre. See Ernst Bloch, 'A Philosophical View of the Detective Novel', in *The Utopian Function of Art and Literature: Selected Essays*, Cambridge, Massachusetts 1988. Revealingly, Hopper read Edgar Allan Poe.

[24] Margaret Iversen, 'In the Blind Field: Hopper and the Uncanny', *Art History*, vol.21, no.3, September 1998, p.419.

[25] Rothko to David Sylvester, quoted in Sylvester, 'The Ugly Duckling', in Michael Auping (ed.), *Abstract Expressionism: The Critical Developments*, exh. cat., Albright-Knox Art Gallery, Buffalo and New York 1987, p.140.

[26] John Morse, 'Edward Hopper: An Interview', *Art in America*, vol.48, no.2, March 1960, p.63.

[27] See Anfam 1998, p.77.

[28] Quoted by Francine-Claire Legrand, 'Xavier Mellery', in Jane Turner (ed.), *The Dictionary of Art*, vol.21, London 1996, p.86.

[29] Rainer Maria Rilke, *The Notebooks of Malte Laurids Brigge* (1910), trans. Stephen Mitchell, New York 1982, p.18.

[30] Ibid., pp.4–5. Compare especially Rilke's totally isolated house (p.46) and Hopper's *Lonely House* 1923 (p.121).

[31] Emily Dickinson, untitled poem, c.1863, in Thomas H. Johnson (ed.), *The Complete Poems of Emily Dickinson*, Boston 1961, p.333. On American mental or psycho-logical architectures, see Tony Tanner, *Scenes of Nature, Signs of Men*, Cambridge 1987, pp.33–6.

[32] W.H. Auden (1946) in Bill Brown, *A Sense of Things*, Chicago 2003, p.178. Gail Levin, *Edward Hopper: An Intimate Biography*, New York 1995, pp.277–9, details the Hopper-James comparison.

[33] Geoffrey Scott, *The Architecture of Humanism: A Study in the History of Taste* (1914), New York 1974, p.164.

[34] This was the age in which Fordist mass-production first triumphed. For an overview, see Brown 2003.

[35] See Anfam 1998, pp.34–5, 159.

[36] Rothko, lecture at the Pratt Institute, Brooklyn 1958; Rothko, letter to Katharine Kuh, 1954, Archives of the Art Institute of Chicago.

[37] The theatre set for Elmer Rice's play *Street Scene* (1929) – one influence on Hopper's *Early Sunday Morning* – possibly also informed Rothko's own *Street Scene* 1936–7.

[38] John Hollander, 'Hopper and the Figure of Room', *Art Journal*, vol.41, no.2, Summer 1981, pp.155–60.

[39] Rilke 1982, p.73.

[40] William Johnson, interview with Hopper, in Levin *Intimate Biography* 1995, p.66. Hopper again remarked upon the 'blue-grey ... under

the arches of the bridges' in Paris, letter of 29 November 1906; ibid., p.56.

[41] John Fischer, 'The Easy Chair, Mark Rothko: Portrait of the Artist as an Angry Man', *Harper's Magazine*, no.241, July 1970, p.16. The enclosed room emerges in Rothko's iconography thirty years earlier, as does the vault motif (*Discourse* 1933–4; Anfam 1998, p.124).

[42] Robert Rosenblum initiated the connection in *Modern Painting and the Northern Romantic Tradition: Friedrich to Rothko*, New York 1975, p.130.

[43] Both are depicted in identical vanishing perspectives.

[44] George Cotkin, *Existential America*, Baltimore 2003.

[45] See Levin *Intimate Biography* 1995, p.350.

[46] 'A Clean, Well-Lighted Place' (1933), in Ernest Hemingway, *The Short Stories*, New York 2003, p.382. The story was first published in *Scribner's Magazine* – for whom Hopper drew various illustrations.

[47] Ibid., p.383. This tale could also rationalise the presence of the third, withdrawn character, i.e. Hemingway's terminally despairing night-owl.

[48] Lynne Dumenil, *The Modern Temper: American Culture and Society in the 1920s*, New York 1995, p.148.

[49] See the competing historical constructions of noir analysed in James Naremore, *More Than Night: Film Noir in its Contexts*, Berkeley 1998.

[50] Rilke 1982, p.22.

[51] Edward Hopper, 'Charles Burchfield: American', *The Arts*, vol.14, no.1, July 1928, p.7.

[52] See Rothko's claim: 'Look again. I am the most violent of all the New Americans. Behind the color lies the cataclysm.' To Brian Corney (1959), quoted in Chris Stephens, *Mark Rothko in Cornwall*, exh. cat., Tate St Ives 1996, p.10.

[53] On this affinity, see David Anfam, 'Interrupted Stories: Reflections on Abstract Expressionism and Narrative', in David Thistlewood (ed.), *American Abstract Expressionism*, Liverpool 1993.

[54] Du Bois (1918) in Levin *Intimate Biography* 1995, p.14.

[55] Rothko 1958.

[56] Julia Kristeva, *Black Sun: Depression and Melancholia*, trans. Leon S. Roudiez, New York 1989, chapter 4. Robert Gibbons kindly returned my own focus to Kristeva.

[57] Ibid., p.13.

[58] 'The Sun This March' (1930), in Wallace Stevens, *The Collected Poems of Wallace Stevens*, New York 1954, p.133. Like Hopper, Stevens was indebted to Symbolism and many of his apothegms, the 'Adagia', virtually paraphrase the artist's ethos – for instance, 'Realism is a corruption of reality'. And Stevens eulogised 'wholeness': see 'A Primitive Like an Orb'.

[59] Parker Tyler, 'Edward Hopper: Alienation by Light', *Magazine of Art*, vol.41, no.12, December 1948.

[60] Lloyd Goodrich file note, 20 April 1946.

[61] Rothko quoted in Harold Rosenberg, *The De-definition of Art*, London 1972, p.105.

[62] Fischer 1970, p.21.

[63] See Rolf Gunter Renner, *Edward Hopper: Transformation of the Real*, San Diego 1997, p.60: 'The very process of representation is made to appear a fraud, a deceitful fiction.' The same applies to Hopper's sketchy brushwork and minimal detailing.

[64] Roland Barthes, *Camera Lucida: Reflections on Photography*, New York 1981, p.35.

[65] Marilyn Johns Blackwell, *Persona: The Transcendent Image*, Urbana 1986, pp.11–38. Rothko's *Thru the Window* 1938–9 (National Gallery of Art, Washington) equates the artist's gaze with the window, a blank canvas and a cryptic rectangular screen or framework.

[66] On Rothko, Parker Tyler (who wrote on Abstract Expressionism) and the cinema, see Anfam 1998, pp.11, 61, 69, 77.

[67] *The Photoplay* in Allan Langdale (ed.), *Hugo Münsterberg on Film*, New York 2002, p.129. My thanks to James Naremore and Kent Minturn for leading me, respectively, to this text and to Baudry's (below). According to Langdale, 'around 1915 ... [Münsterberg] was probably the most famous academic in the United States.'

[68] Hopper 1928, p.7. The movies are also an exemplary paradigm of psychological 'reading-in', of collective wish-fulfilment.

[69] Repeatedly, Hopper's statements stress the primacy of the mind and/or the 'idea' – as did another 'realist' concerned with memory whose roots lay in Symbolism, Pierre Bonnard. In turn, Bonnard influenced Rothko in the late 1940s.

[70] Levin *Intimate Biography* 1995, p.525, takes this as alluding to 'Platonic love'.

[71] The streamlined refulgence of Hopper's nautical scenes, such as *Ground Swell* 1939 (Corcoran Gallery of Art, Washington), carries distinct connotations of a *Gatsby*-like, fantasised Edenic state of grace. The Platonic rift between illusory and ideal reality was an important component of Scott Fitzgerald's novel.

[72] I first raised the comparison with Plato in 'Edward Hopper – Recent Studies', *Art History*, vol.4, no.4, December 1981, p.460. It is reiterated in Robert Hobbs, *Edward Hopper*, New York 1987, pp.142, 193. Hopper's esteem for Emerson would have alerted him to Plato.

[73] Anfam 1998, pp.98–9. See also Rothko: 'the idea of scale/intimacy/the whole man' in 'Fair Play', undated notebook, Rothko Archive. Compare, also, Hopper 1928, p.9, on Burchfield: 'A simple unity of expression that the artist has not surpassed'.

[74] F.M. Cornford, *The Republic of Plato*, New York 1945, p.228, compares the cave to an underground cinema. See Delmore Schwartz's poem, 'In the Naked Bed, In Plato's Cave' (1937). Jean-Louis Baudry, 'The Apparatus', in Philip Rosen (ed.), *Narrative, Apparatus, Ideology*, New York 1986, pp.299–318, aligns Plato, Freud and the cinema.

[75] A drawing by Robert Smithson, *Toward the Development of a Cinema Cavern* 1971, bridges several of the ideas at stake, and more: the movie theatre as temple, the movie goer as spelunker, Plato's cave, structuralist self-referentiality and cave painting.

So much of every art is
an expression of the
subconscious, that it seems
to me most of all of the
important qualities are put
there unconsciously,
and little of importance by the
conscious intellect. But these
are things for the psychologist
to untangle.

Edward Hopper, quoted in
Lloyd Goodrich, *Edward Hopper*,
New York 1971, p.164

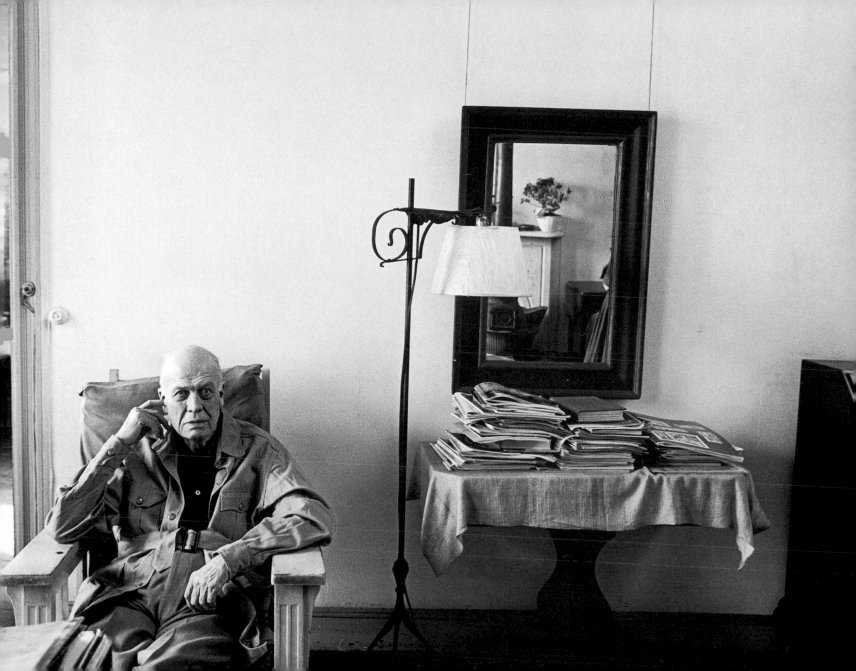

Hopper's Melancholic Gaze

Margaret Iversen

These pleasures, Melancholy, give
And I with thee will choose to live.
John Milton, 'Il Penseroso'

Fig.43
Albrecht Dürer
(1471–1528)
Melencolia I 1514
Engraving
23.9 x 16.8 (9 3/8 x 6 5/8)
Guildhall Library, London

Given Edward Hopper's status as one of the most celebrated of American artists, it is surprising to learn that he gained recognition relatively late in life, when he was forty-two. For twenty years he was forced to earn money by producing illustrations for books, magazines and posters. He hated the work and it's easy to understand why. While Hopper's paintings are masterpieces of narrative understatement, the illustrator's art demands total legibility. Hopper despaired of magazine editors who wanted anecdotal scenes with people waving their arms about and 'grimacing and posturing'.[1] Although he felt frustrated by this work that went so completely against the grain of his temperament, he did manage to reserve time for his art.

During those lean years, Hopper's neighbour and fellow illustrator was a man called Walter Tittle, who painted a remarkable verbal picture of the young artist at work. He describes Hopper as 'suffering ... from long periods of unconquerable inertia, sitting for days at a time before his easel in helpless unhappiness, unable to raise a hand to break the spell.'[2] This description accords well with many other accounts of Hopper's periods of depression and the slow progress of his paintings.[3] Yet Tittle's depiction of him is particularly striking because it calls to mind an actual picture: Albrecht Dürer's print of the allegory of Melancholy, *Melencolia I* 1514 (fig.43). Dürer's fascinating engraving has been the subject of intense scholarship by some of the most distinguished art historians, including Heinrich Wölfflin, Aby Warburg and Erwin Panofsky, and also by the philosophical literary critic, Walter Benjamin. I want to invoke the Dürer print and this associated literature as a means of arguing that Hopper thought of himself as a melancholic artist. I do not mean by this that his personality could be described as clinically melancholic, that is, depressive, or that this condition determined the style and subject matter of his work, although both may be partly true. Rather, I suggest that Hopper was aware both that his cast of mind could be described as melancholic and that there was a long artistic and poetic tradition invoking Melancholia. He created out of these a vision of the world that was uniquely his own, but one that clearly finds resonance with the great many lovers of his work.

From Antiquity to early modern times, 'Melancholia' was a term within medical discourse referring to one of the four 'humours', corresponding to bodily fluids, that were supposed to govern a person's temperament. Ideally these fluids would be in perfect balance, but inevitably one predominates. The Sanguine humour, produced when blood is the body's dominant fluid, was regarded as the most favourable: it was associated with air, Spring, youth and cheerfulness. Melancholia, the effect of an excess of black bile, was the worst, associated with earth, Autumn, evening and late middle age. The Melancholic person is surly and miserly; he or she shuns company and is inclined to solitary study. It is this last attribute upon which Marsilio Ficino, the Renaissance Humanist scholar and translator of Plato, seized when he elevated Melancholia from a temperament that, in the Middle Ages, was closely allied to the deadly sin of sloth, into an equivocal inheritance combining both the blessing of genius and the curse of

madness. It was a more anguished version of Plato's conception of the artist's divine frenzy, that is, a gift both sublime and dangerous.[4] When the theory of humours was crossed with astrology, the Melancholic temperament was linked to Saturn, hence our adjective 'saturnine', a near synonym of melancholic. The ambivalence of melancholy is combined in the attributes of this planet, which was thought to be both the slowest and the highest in the firmament.[5]

The idea of Melancholia survived through to modern times as a literary trope, for example, in Milton's 'Il Penseroso' (1632), in Keats's 'Ode to Melancholy' (1820) or in Baudelaire's poems called 'Spleen' (1857) after the organ that produces black bile. The poets developed the Renaissance concept of melancholy genius. Freud revived the term for psychoanalysis in his 1917 essay, 'Mourning and Melancholia', in which he distinguished between normal mourning and Melancholia. Mourning is the painful process of severing emotional attachments to someone loved and lost. Melancholia, by contrast, is a pathological condition in which a person unconsciously

keeps the lost object (often, the mother) in a sort of internal crypt, and then inflicts punishment on that introjected object for betrayal and abandonment. As Freud so poetically put it, 'the shadow of the object fell upon the ego'.[6] Because the complex is unconscious, it can seem as though the person is sad without cause. The continuities with the old forms of Melancholia are clear: the symptoms are dejection, lassitude, withdrawal from society, and potentially, withdrawal from life altogether. Freud also notes that the melancholic's self-loathing indicates, as in Hamlet's case, 'a keener eye for the truth'.[7]

Dürer's *Melencolia I* shows a somewhat dishevelled woman sitting heavily on a stone plinth, her head propped up on a clenched hand. In her other hand is a compass and on her lap a closed book, but her face, in deep shadow, is lost in thought. Her raised eyes look into the empty distance. Clearly, this is neither a depiction of the base melancholy of morose inactivity, nor the lethal melancholy of madness and death, but rather melancholy as an allegory of profound thought. She is paralysed not

by lack of energy, but by an intellectual problem, by reason momentarily blocked. Panofsky persuasively argued that the attributes littering the area around the figure refer to geometry and measuring and thus indicate an intelligence tied to the imagination, struggling but unable to transcend the earthbound, spatial world to attain the realm of pure abstract ideas.[8] Although Dürer's Melencolia is winged, she seems unlikely to take flight. Hence her frustration.

Excursion into Philosophy 1959 (fig.45) is, I believe, Hopper's attempt at a modern allegory of Melancholia. Although it is not one of his best paintings, it may provide a key to understanding his sense of the nature of his own work. The painting shows a man sitting dejectedly on the edge of a bed; he leans forward and props his weight on his forearms. A book he has been reading is cast aside. His back is turned on a sleeping, semi-naked woman. With marks of puzzlement on his brow, he seems to contemplate the luminous rectangle projected on the floor by the morning sun streaming through the window. In a letter

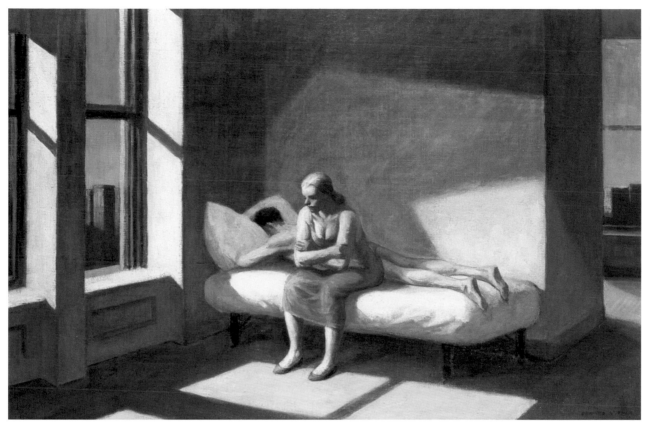

Fig.44
Summer in the City
1949
Oil on canvas
50.8 x 76.2 (20 x 30)
Private Collection
O-341

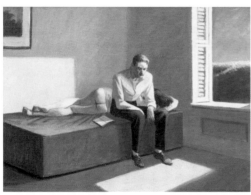

Fig.45
Excursion into Philosophy
1959
See p.210

that Hopper's wife, Jo, wrote to the first serious Hopper critic, Lloyd Goodrich, she informed him about the progress of this painting, which was coming along well: 'It's a new note for him. I'm so happy he could do it. It's a valiant thing to fight down inertia.'[9] Presumably she was referring to Hopper's inertia, but the term could just as easily apply to the man in the painting. In the record book of Hopper's work kept by Jo and Edward Hopper, Jo also noted that 'the open book is Plato, reread too late'. As is often the case, it is difficult to establish whether this is Jo's gloss or something that Hopper said.[10] Since Hopper was a highly intellectual artist and a voracious reader, it is most likely that this is his own conception. In any case, it highlights two features of the work. First, 'too late' means 'late in life' and explains why the man's hair is greying, thus conforming to the melancholic's affinity with older age. Second, the comment points to the connection between what is depicted and Platonic philosophy. Plato argued that we are deluded if we believe that satisfaction and happiness can be attained

through material things (food, wealth, sex). Plato's philosopher, in search of the real and the true, must turn away from this transitory realm and contemplate the eternal Forms or Ideas. The pensive man in Hopper's painting is positioned between the lure of the earthly domain, figured by the woman, and the call of the higher spiritual domain, represented by the ethereal lightfall. The pain of thinking about this choice and its consequences, after reading Plato all night, is evident. He is paralysed by the fervent inner labour of the melancholic.[11]

Despite Jo's comment, it is not true to say that *Excursion* represents a 'new note'. Ten years earlier, Hopper painted an almost identical composition, but inverted spatially and in terms of the gender of the figures. In *Summer in the City* 1949 (fig.44), a woman sits heavily, leaning forwards, on the edge of the bed while her partner sleeps. With her face cast down, she seems to contemplate the patches of light on the floor while her thoughts turn inward. Gail Levin rightly points out the similarity of this painting and the later *Excursion into Philosophy* to Rembrandt's *Saint Paul in Prison* 1627

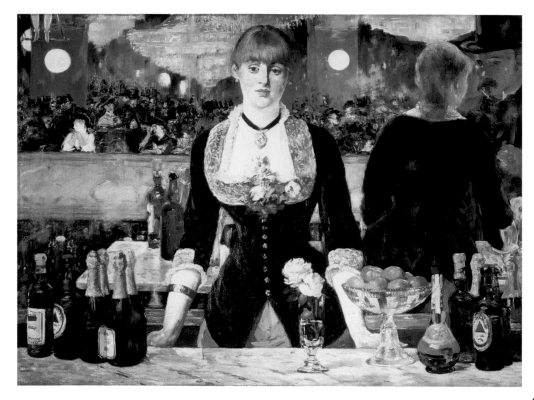

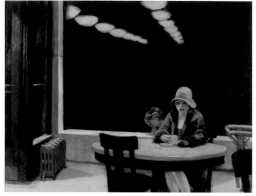

Fig.46
Edouard Manet
(1832–1883)
Bar at the Folies-Bergère
1882
Oil on canvas
96 x 130 (38 x 51)
Courtauld Institute Gallery,
London

Fig.47
Automat 1927
See pp.138–9

(Staatsgalerie, Stuttgart), which shows the Apostle with his writing material, seated on a narrow bed, plunged in thought, his head framed by a trapezoidal lightfall on the wall behind him.[12] What she doesn't mention is that the saint's pose, with his head resting on a hand, is closely related to Dürer's canonical depiction of intense thought, *Melencolia I*, except that Saint Paul's face is illuminated by the rays of heavenly inspiration, not cast in shadow. Together, these references unequivocally indicate that the kind of melancholy Hopper wishes to represent goes far beyond a simple case of post-coital sadness.[13] It is often observed that Hopper painted many pictures of disaffected, inert couples – the motif of 'the melancholy of lost desire', as Levin puts it. While the observation is correct, I would argue that this motif should be seen as yet another aspect of both the ancient humour and the clinical pathology of Melancholia, which, as Freud put it, causes the 'loss of the capacity of love'.[14] In the classical understanding of Melancholia, this loss is the price paid for the solitary and inward life of the thinker.

If the sadness of lost love and failed relationships seems an inadequate interpretation of Hopper's vision, then so too does the widespread theory that his pictures are about the alienation and loneliness caused by living in the big industrialised city. This is a reiterated theme in Hopper studies, beginning with Lloyd Goodrich's observation in 1949 that his paintings of interiors reveal how 'loneliness can be experienced most intensely among millions', in the 'vast impersonality of the city'.[15] It is the theme of a whole book in German called *Der Melancholische Blick: Die Grossstadt im Werk des amerikanischen Malers Edward Hopper*.[16] The author, Hubert Beck, pursues an interpretation of Hopper's work similar to the one that T.J. Clark offered in his book about Manet and the city of Paris in the late nineteenth century, *The Painting of Modern Life*.[17] And, indeed, there is good reason to compare, say, Manet's *Bar at the Folies-Bergère* 1882 (fig.46) and its 'blasé' barmaid with some of Hopper's women in the city, but, in my view, only in order to bring out their differences. I'm thinking particularly

Fig.49
Rembrandt van Rijn
(1606–1669)
*Bathsheba with King David's
Letter* 1654
Oil on canvas
142 x 142 (55⅞ x 55⅞)
Musée du Louvre, Paris

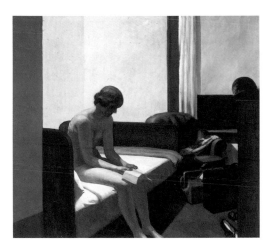

Fig.48
Hotel Room 1931
See p.90

of the contrast between the Manet and Hopper's *Automat* 1927 (fig.47), where a fashionable young woman sits at a café table. The title obviously identifies the setting as a coin-operated restaurant, where no social intercourse with waiters or servers is necessary. This would seem to support the interpretation of the scene as a critique of urban alienation. Beck stresses this point and notes how the woman is pinned in a narrow space behind the steeply inclined tabletop. Overwhelmed and conditioned by her environment, exposed to the gaze of the viewer, she is depicted as a victim.[18] Behind her, instead of Manet's large mirror reflecting a tumultuous café scene, there is a big window, blackened by the night outside and reflecting only the rows of ceiling lights in the interior. Almost identical decorative glass bowls of fruit are prominent in both pictures. Yet if *Automat* is supposed to be a depiction of urban alienation, it is pushed to a further extreme than that shown in Manet's painting. Here, Hopper makes an allusion to the Manet painting, but suggests something much darker at work. As with Hopper's other melancholics,

the woman's eyes are downcast and her thoughts turned inward. The steep recessional convergence of the reflected ceiling lights suggests the vertiginous lure of nothingness – the slide into malignant Melancholia and the depths of depression. The threat of suicide looms large. As Julia Kristeva wrote in her book, *Black Sun: Depression and Melancholia*, the melancholic tends 'to lose interest in words, actions and even life itself'.[19]

The isolation and muteness of Hopper's figures is not, in my view, best interpreted as the result of the dehumanisation of urban life.[20] His subjects are not presented as listless victims or lifeless automata. Rather, I suggest, their condition is temperamental: their withdrawal from life is at least partly voluntary, their solitude self-imposed. This is difficult to demonstrate on the basis of a single canvas, but gains support when it is set in the context of Hopper's other 'philosophically' reflexive figures. For example, in the large, ambitious painting *Hotel Room* 1931 (fig.48), a woman, undressed, is seated on the edge of a bed in an anonymous hotel room with unpacked

bags on the floor. Her face is in deep shadow as she gazes down on a timetable. What raises this picture above the level of some cheap story of disappointed love in a rootless society is the figure's monumentality and the clear allusion to Rembrandt's great painting of *Bathsheba with King David's Letter* 1654, which hangs in the Louvre (fig.49). The painting depicts an episode from the Old Testament (II Samuel 11): King David sees Bathsheba bathing and, seduced by her beauty, sends for her; he then has her husband, a prominent soldier in his army, killed in battle so as to make her his wife. That story is not sentimental; it is tragic, and Hopper's painting, which is roughly of the same size and proportions, borrows something of its grandeur and seriousness. Both paintings are attempts to represent the unrepresentable – a reflexive consciousness deep in thought. They do this in the context of the female nude, thus bringing together the earthly and the intellectual.

Returning to *Automat*, then, I want to press the case that the window behind the woman is a metaphorical image of her mood

of dejection and inward reflection. Apparently, during his periods of inertia, Hopper himself frequented an automat around the corner from his New York apartment.[21] This suggests that he identified with the dejection of the woman in *Automat* and carries with it the further implication that, like the painter, she is struggling for some thought or some means of expression beyond her grasp. Like Dürer's *Melencolia*, she is brooding in the midst of an enigmatic, fallen world.

Many commentators have noted that the theme of death in Hopper's work is connected to the empty space or void.[22] This connection seems to have been a preoccupation for Hopper, even in his youth. The first painting that looks recognisably like his mature work dates from 1902–4 and shows a solitary figure seated in a theatre facing a featureless curtained stage, which takes up half the composition (p.101). Hopper repeated this curious motif several times. David Anfam remarks: 'It is difficult to ignore the implication that the void, before which spectators come to deliberate interminably, has symbolic

potential. In his last painting, *Two Comedians* [fig.50], the long awaited performance finally materialises. Edward and his wife Jo take their last bows beside artificial foliage and darkness.'[23] The uncanny mood that colours so much of Hopper's work can also be subsumed under the general rubric of Melancholia, for the melancholic is haunted by death.

Another repeated motif in Hopper's work is that of a figure, usually a woman, looking out of a window. Although windows are supposed to be a view onto the outside world, they don't really function that way in Hopper's paintings. A frequent motif in his work is the open window that lets in the wind and this is always associated with eroticism.[24] Beck stresses the way in which Hopper's windows appear as the only access to the outside in an otherwise imprisoning interior – a point of connection with the public domain that only serves to underline the overriding sense of separation. This reinforces a point made in 1981 by Linda Nochlin: 'the windows and the light from the windows tend to lock the static figures into place.'[25] But this is to assume that

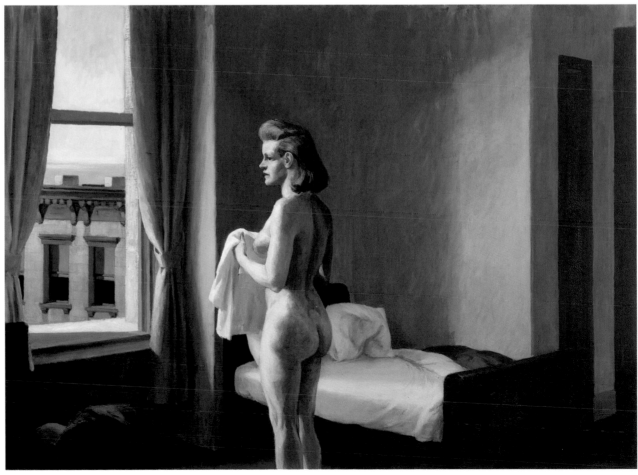

Fig.50
Two Comedians 1966
See pp.222–3

Fig.51
Morning in a City 1944
Oil on canvas 112.5 x 152
(44 5/16 x 59 13/16)
Williams College Museum
of Art, Williamstown.
Bequest of Lawrence H.
Bloedel,
Class of 1923
O-326

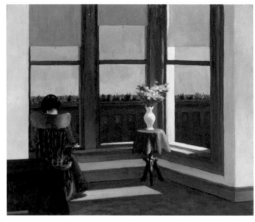

the gaze out of the window expresses a thwarted desire to engage in the public domain. It might rather be argued that the window, like the lightfall in *Excursion into Philosophy*, represents a connection with the realm of abstract thought. There is, after all, a long tradition of window iconography that has nothing to do with its status as an aperture onto everyday reality or a metaphor of sexual longing. Windows are also associated with spirituality and the soul. In Romanticism, say in the painting of Caspar David Friedrich, they represent a more generalised longing. Furthermore, the stress in Hopper's paintings is not so much on the gaze outward as on the light that falls into the room in an almost tangible form. This light has attracted divergent interpretations. Philip Leider contends that Hopper's 'sunlight is cold and sterile'; for him, the light in *Morning in a City* 1944 (fig.51) 'is like radiation'.[26] I am more in sympathy with John Hollander's view that the parallelogram of light in *Morning Sun* 1952 (pp.198–9) becomes 'an image of the meditative gazer's mind as the cast shadow on the bed is of her body'.[27] In the magnifi-

cent painting *Sun in an Empty Room* 1963 (pp.220–1), the spectator takes up the position of the figure in the earlier paintings. Here, the complex geometry of light and shade on the wall doesn't represent a meditative mood; it is an occasion for our meditation.

Although Hopper commented very little on his own work, he wrote an eloquent appreciation of the painting of his friend, Charles Burchfield. In it, he catalogues some of Burchfield's motifs, many of which overlap with his own:

No mood has been so mean as to seem unworthy of interpretation. The look of an asphalt road as it lies in the broiling sun at noon, cars and locomotives lying in God-forsaken railway yards, the steaming summer rain that can fill us with such hopeless boredom, the bland concrete walls and steel construction of modern industry, mid-summer streets with the acid green of closecut lawns, the dusty Fords and gilded movies – all the sweltering, tawdry life of the American small town, and behind all, the sad desolation of our suburban landscape.

Fig.54
Approaching a City 1946
Oil on canvas 68.9 x 91.4
(27¹/₈ x 36)
The Phillips Collection,
Washington, DC
O-332

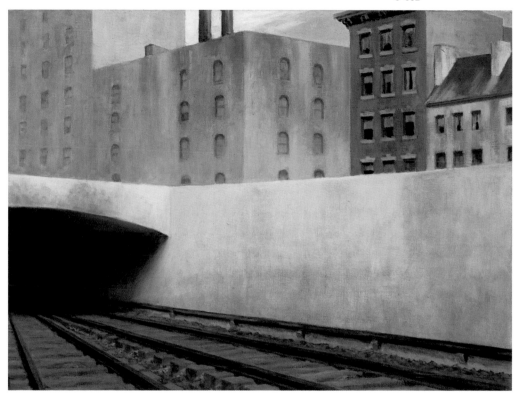

Fig.55
[Bridge in Paris] 1906
Oil on wood
24.4 x 33 (9⁵/₈ x 13)
Whitney Museum of
American Art, New York;
Josephine N. Hopper
Bequest 70.1305
O-130

He derives daily stimulus from these, that others flee from or pass with indifference.[28]

This passage offers a way of moving from an analysis of Hopper's representation of persons in a melancholy state, to a discussion of his painting 'under the sign of Saturn' – a world painted under a melancholy gaze. In the poetic tradition of Melancholia, the disposition was transferred from person to object so that a room or landscape could be described as melancholic. Certainly the evocation of melancholic landscapes in Hopper's description of Burchfield's work above is patent. It describes scenes full of blanks and voids – an asphalt road, a concrete wall – and calls up moods of hopeless boredom and sad desolation. Something ineffably sad permeates the landscape. But the language of mood doesn't seem to be critically adequate. What is also noteworthy in the passage is the way in which it piles up fragments of a fallen world. As other critics have remarked, Hopper's urban scenes couldn't be further from the new crisp architecture and machinery of the

Precisionists. Hopper's cityscapes are the flipside of progress.

Ironically, the first recognisably Hopperesque cityscapes, of 1906, were painted in Paris. His little painting known as *Bridge in Paris* (fig.55), for example, shows part of the powerful stone edifice that forms an arch creating a tunnel of dark space. This is a motif that Hopper was to repeat in later life, for example, in *Approaching a City* 1946 (fig.54). *[View Across Interior Courtyard at 48 rue de Lille, Paris]* 1906 (p.108), which shows a series of blank windows seen from the opposite balcony, initiates another constantly repeated motif. Hopper was clearly inspired by the city of Paris itself, but also by its artistic milieu. Levin suggests that the work of photographer Eugène Atget, who took as his task the documentation of *Vieux Paris* before it succumbed to development, may have been influential. However that may be, and I think it rather unlikely, it is certainly true that in Paris and elsewhere photography was permeating the painted image, and that Hopper's cropped compositions and unusual points of view attest to his interest

Fig.56
Cape Cod Afternoon
1936
Oil on canvas
86.8 x 127.2 (34 3/16 x 50 1/16)
The Carnegie Museum of Art,
Pittsburgh;
Patrons Art Fund
O-302

in these aspects of the medium.[29] Atget, nevertheless, is an interesting point of reference for Hopper, not because of any direct influence, but because his work was admired by that well-known intellectual melancholic, Walter Benjamin.[30] His reflections on Atget may cast light on Hopper's work as well.

In the mid-1920s, Benjamin wrote a book on the subject of the German baroque form of drama known as the *Trauerspiel,* or mourning-play. It includes an excursus on Dürer's *Melencolia I* that draws on a monograph on the same subject written by Panofsky and Fritz Saxl in 1923.[31] Benjamin's account, however, differs from theirs because he was interested not only in the iconography of the subject, but also in the form of the allegory. The allegory, for Benjamin, differs from the symbol: while the symbol is born and is understood in an inspired flash of insight that coalesces meaning and figure into a unified totality, the allegory is more earthbound and composite; its meaning unfolds in a series of moments.[32] The melancholic is a born allegorist for, as Benjamin notes, 'the light-

ning flash of intuition is unknown to him'.[33] Interestingly, Hopper expressed reservations about artistic 'inspiration' and described his 'composite' works as 'the culmination of a thought process'.[34] Benjamin is also sensitive to what might be called the 'performative' aspect of deciphering an allegory. Whereas Panofsky and his colleagues undertook a total interpretation of Dürer's print, they failed to see that the enigma, the very difficulty, the ambiguities, the piece-by-piece accumulation of meanings, are intrinsic to the allegory. In other words, *Melencolia I* is not just a representation of intense, conflicted thought; it is an occasion for it.[35] In a well-known phrase, Benjamin associates allegory with the fallen world left behind by history: 'Allegories are, in the realm of thoughts, what ruins are in the realm of things.'[36] The mute, mourning world, abandoned by God, is rescued by the allegorist who 'lends speech to things'.[37]

This brief excursus may help us to understand why Hopper was attracted to the old, deserted, windswept building. So also may the anecdote reported by Raphael

Soyer who visited the Hopper's Cape Cod cottage one day in late summer. When he found that the artist had produced no paintings, Hopper explained that he was 'waiting for November, when the shadows are longer and the landscape is more interesting, in fact, beautiful'.[38] The beauties of summer, the roses and hydrangeas, were clearly inadequate for his more serious aesthetic. In this respect he resembled the Surrealists, the 'discoverers' of Atget, who also loved long shadows and who found meaning in the ephemeral, neglected and outmoded.[39] Goodrich appreciated this when he noted the artist's tendency to paint outmoded architecture: 'No one has caught more accurately the peculiar melancholy of architectural pretentiousness that is no longer fashionable.'[40]

Atget is mentioned in both of Benjamin's essays on photography, and, although it is not made explicit, Benjamin clearly saw him as an allegorical photographer. In the 1931 'Little History of Photography', he applauds Atget for refusing to present the world as ordered and meaningful, which in our times is a lie

Fig.57
Nighthawks 1942
See pp.178–9

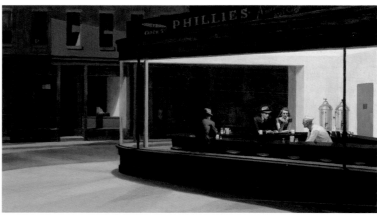

or, at best, myth. Instead, 'he looked for what was unremarked, forgotten, cast adrift'. Atget passed by the great sights and landmarks, but 'what he did not pass by was a long row of boot lasts; or the Paris courtyards; or the tables after people have finished eating and left, the dishes not yet cleared away'.[41] His empty street scenes were described by Benjamin as 'scenes of a crime'.[42] While allegory has a corrosive effect upon myth, it is also a way of going beyond nihilism and despair towards a creative reconfiguration of the fallen world.[43] Allegorical photography or painting must have both the destructive, fragmenting moment that shatters mythical beauty, leaving behind 'a petrified, primordial landscape', and a productive moment of finding meaning in the fragments.[44] Hopper combined these moments. He was both an acute observer of the everyday vernacular of contemporary American life, a realist and, as Goodrich said, a 'visionary'. In one of his few statements, written for the exhibition of his work at New York's Museum of Modern Art in 1933, Hopper referred both to his vision and to his sense of frustration:

'I find, in working, always the disturbing intrusion of elements not a part of my most interested vision, and the inevitable obliteration and replacement of this vision by the work itself as it proceeds.'[45] Goodrich remarked in response to this: 'These are the words of a deeply introspective artist – a visionary of a very individual kind – in search of his own inner image and his own form of perfection.'[46]

Realist or visionary? These are the extreme poles of a central antagonism that has informed the reception of Hopper's work. It is an antagonism that Hopper's own statements do nothing to resolve. But if I am right that he was a self-consciously melancholic artist, then Hopper's work must be marked by both the highest spiritual activity and attachment to the cold dark earth. His task was precisely to struggle with the oppositions between the high and the low, the earthbound and the transcendental, reflexive thought and concrete reality, the light and the dark, the inner and the outer. Hopper once remarked on the difficulty of combining interior and exterior views in a single painting.[47] Despite

this difficulty, he persisted in painting views into windows, which, for me, have nothing to do with voyeurism. Rather, they bring together two separate but interpenetrating domains where the pale yellows of the interior light and the cool blues of the exterior co-exist. *Nighthawks* 1942 (fig.57) is the apotheosis of this motif. But there is also in this picture, and many others, a sense of exclusion, of someone passing by, withdrawn from engagement in the world the better to observe and understand it. Sometimes it is the buildings themselves that seem withdrawn, uncommunicative, especially when every window is opaque or shuttered. Hopper sought out the deserted, soulless house so that he could redeem it. He painted Cape Cod in November so that he could rescue the landscape from a wintery death. He did this, not in order to integrate them into the old mythical totality, but in order to find meaning in the fragments of a fallen world.

1 Lloyd Goodrich, *Edward Hopper*, Harmondsworth 1949, p.31.
2 Walter Tittle, 'The Pursuit of Happiness', memoir; transcript in the Wittenberg University Library, Springfield, Ohio, chapter 22, p.1. Cited in Gail Levin, *Edward Hopper: A Catalogue Raisonné*, New York and London 1995, vol.1, 'Perspectives on his Art and Life', p.29. Tittle was Hopper's neighbour from 1913–26 when Hopper was in his thirties and forties.
3 See, for example, Goodrich: 'Painting does not come easy to him; he works long over his oils, producing only two or three a year'. In Goodrich 1949, p.10. See also Brian O'Doherty, *American Masters: The Voice and the Myth*, New York 1973, p.16.
4 See Marsilio Ficino, *The Three Books on Life (Libri de Vita Triplici)* (1489), Arizona 1989. The books offer advice on how to cope with being born under the melancholic sign of Saturn, hence turning a fate that could lead to madness and death into the source of the most elevated thought.
5 For an authoritative account of this complex of ideas from Antiquity to the Renaissance see Raymond Klibansky, Erwin Panofsky and Fritz Saxl, *Saturn and Melancholy*, London 1964. For an overview and pertinent extracts from the entire history of the idea see Jennifer Raden (ed.), *The Nature of Melancholy from Aristotle to Kristeva*, Oxford 2000.
6 Sigmund Freud, 'Mourning and Melancholia' (1917), *Standard Edition*, vol.14, trans. James Strachey, London 1957, p.249.
7 Ibid., p.246.
8 Erwin Panofsky, *The Life and Art of Albrecht Dürer*, Princeton 1995, pp.168ff. An expanded version of this analysis is in Klibansky, Panofsky and Saxl 1964. See also Aby Warburg, 'Pagan-Antique Prophecy in Words and Images in the Age of Luther' (1920), in *The Renewal of Pagan Antiquity*, Los Angeles 1999, pp.597–651, and Heinrich Wölfflin, *The Art of Albrecht Dürer* (1905), London 1971.
9 Levin *Catalogue Raisonné* 1995, vol.3, p.362.
10 In 1977, Levin interviewed John Clancy, Hopper's dealer, who confirmed that this was Hopper's idea. See Levin *Catalogue Raisonné* 1995, vol.1, p.90. The record-book entries, mostly written by Jo, are printed next to the reproductions. Because Edward was so taciturn and Jo so voluble, there is inevitably a temptation to treat her notes and remarks as if they were his.
11 Levin does mention a possible link to the idea of Platonic love, but sees the painting more as a conflict between licentious sexuality and Puritan morality (book or buttocks). Gail Levin, *Edward Hopper: An Intimate Biography*, New York 1995, p.525.
12 Levin *Catalogue Raisonné* 1995, vol.3, p.330.
13 The Hoppers did, however, toy with the idea of calling the painting *Triste après l'amour*. Levin *Intimate Biography* 1995, p.419.
14 Freud 1957, p.244.
15 Goodrich 1949, pp.3–14.
16 Hubert Beck, *Der Melancholische Blick: Die Grossstadt im Werk des amerikanischen Malers Edward Hopper*, Frankfurt 1988.
17 T.J. Clark, *The Painting of Modern Life: Paris in the Art of Manet and his Followers*, London 1985. The classic text, referred to by both, is Georg Simmel, 'The Metropolis and Mental Life' (1903), in Donald N. Levine (ed.), *On Individuality and Social Forms: Selected Writings*, Chicago and London 1971, pp.324–39.
18 Beck 1988, pp.167–70.
19 Julia Kristeva, *Black Sun: Depression and Melancholia*, trans. Leon S. Roudiez, New York 1989.
20 In any case, his figures in rural or seaside settings are equally dejected. See, for example, *Cape Cod Morning* 1950 (pp.194–5) and *Sea Watchers* 1952 (pp.202–3).
21 Levin *Intimate Biography* 1995, p.292.
22 See for instance Levin *Catalogue Raisonné* 1995, particularly the section called 'Death' in her exploration of themes, vol.1, pp.83–7, and Margaret Iversen, 'In the Blind Field: Hopper and the Uncanny', *Art History*, vol.21, no.3, September 1998, pp.409–29.
23 David Anfam, 'Edward Hopper: Recent Studies', *Art History*, vol.4, no.4, December 1981, p.459.
24 See for example the early etching, *Evening Wind* 1921 (p.119) or the famous painting *Office at Night* 1940 (pp.172–3).
25 Linda Nochlin, 'Edward Hopper and the Imagery of Alienation', *Art Journal*, vol.41, no.2, Summer 1981, p.139.
26 Philip Leider, 'Vermeer and Hopper', *Art in America*, vol.89, no.3, March 2001, pp.96–103, p.101.
27 John Hollander, 'Hopper and the Figure of Room', *Art Journal*, vol.41, no.2, Summer 1981, pp.155–60, p.159. I criticised this article in my essay, Iversen 1998, pp.409–29, for its relentlessly sunny interpretation of Hopper. I still think that it is one-sided, for it ignores the negative charge of Melancholia.
28 Edward Hopper, 'Charles Burchfield: American', *The Arts*, vol.14, no.1, July 1928, pp.6–7.
29 He did not, however, find it an adequate medium for his purposes. According to the artist Raphael Soyer, who painted a portrait of Hopper in 1963, Hopper said, 'I took a photo of a landscape once and I couldn't use it. Photography is so light. No weight to it.' See 'Six Who Knew Edward Hopper', *Art Journal*, vol.41, no.2, Summer 1981, pp.125–35, p.131.
30 See Susan Sontag's appreciation of Benjamin in 'Under the Sign of Saturn' (1972), *Under the Sign of Saturn*, London 1972, pp.109–36.
31 Walter Benjamin, *The Origin of German Tragic Drama*, trans. John Osborne, London 1977. The 1923 publication on Dürer's *Melencolia I* was incorporated in Klibansky, Panofsky and Saxl 1964.
32 Ibid., p.165.
33 Ibid., p.153.
34 Katharine Kuh, *The Artist's Voice. Talks with Seventeen Artists*, New York 1962, p.131.
35 Ibid., p.166. Joseph Koerner makes this point emphatically in *The Moment of Self-Portraiture in German Renaissance Art*, Chicago 1993, p.23ff. I am

grateful to Dr Sandy Sullivan, who generously shared her work on pictures of melancholy in seventeenth-century England.

[36] Ibid., p.178.

[37] Ibid., p.224.

[38] 'Six Who Knew Edward Hopper', *Art Journal*, vol.41, no.2, Summer 1981, p.132.

[39] In 1926 four of Atget's photographs were published in *La Révolution surréaliste*.

[40] Goodrich 1949, pp.3–14.

[41] Walter Benjamin, 'Little History of Photography', in Michael W. Jennings (ed.), *Selected Writing*, vol.2 (1927–34), Cambridge, Massachusetts, and London 1999, pp.507–30, p.518.

[42] Walter Benjamin, 'The Work of Art in the Age of Mechanical Reproduction', in Hannah Arendt (ed.), *Illuminations*, New York 1978, p.228.

[43] See Max Pensky, *Melancholy Dialectics: Walter Benjamin and the Play of Mourning*, Amherst 1993, especially chapter 3, 'Melancholia and Allegory', pp.108–50.

[44] Benjamin 1977, p.166.

[45] Edward Hopper, 'Notes on Painting', in Alfred H. Barr Jr (ed.), *Edward Hopper: Retrospective Exhibition*, exh. cat., Museum of Modern Art, New York 1933, p.17.

[46] 'Six Who Knew Edward Hopper', *Art Journal*, vol.41, no.2, Summer 1981, p.127.

[47] O'Doherty 1973, p.26.

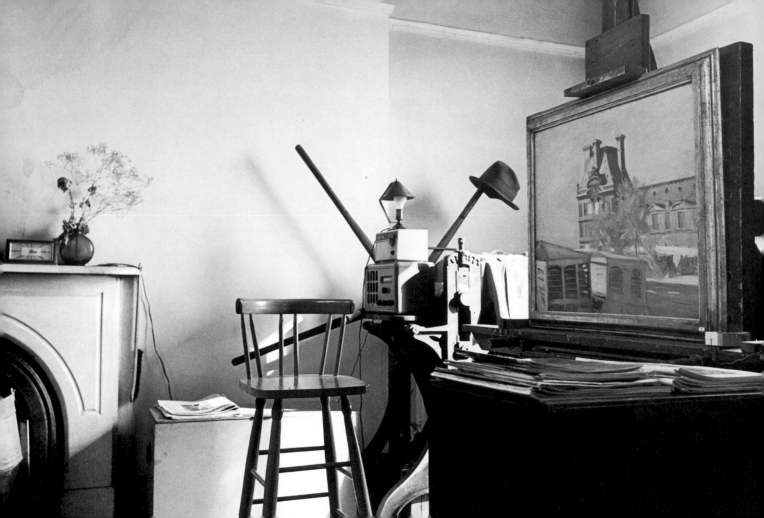

Our native architecture with its
hideous beauty, its fantastic
roofs, pseudo-Gothic, French
Mansard, Colonial, mongrel or
what not, with eye-searing
color or delicate harmonies
of faded paint, shouldering
one another along interminable
streets that taper off into
swamps or dump heaps –
these appear again and again,
as they should in any honest
delineation of the American
scene. The great realists of
European painting have never
been too fastidious to depict
the architecture of their native
lands in their pictures.

Edward Hopper,
'Charles Burchfield: American',
The Arts, vol.14, no.1,
July 1928, p.7

Two or Three Things I Know About Edward Hopper

Peter Wollen

Fig.58
Jeff Wall
(born 1946)
The Quarrel 1988
Transparency in lightbox
119 x 176 (47 x 69)
Musée d'art contemporain
de Montréal

Fig.59
Jean-Luc Godard
(born 1930)
Still from *Two or Three
Things I Know about Her ...*
(1966)

Edward Hopper was above all a painter of rooms – interior spaces within which one or two characters, naked or clothed, female or male, sit or stand. The woman looks into a mirror or out of a window, reads a book or plays the piano, opens a filing cabinet or works at a sewing machine, stands in a doorway or stretches out on a bed, while the man reads a newspaper or sits at a desk, perches on a table or peruses a document, smokes a cigarette or tries to understand Plato, arrives at the office in a coat and hat or sprawls out pathetically on a bed, his head buried in the pillow. In these rooms the window is the most important feature. It lets the sunlight into the room, but it also casts dark shadows. It provides a view of the outside world, sometimes of the city, sometimes of the countryside or close to the ocean: landscapes with wide expanses of grassland and views of the forest, or seascapes with rolling waves. But it also provides a spectacle for outsiders, as they walk the streets or ride the El, the elevated railroad that winds its way through New York, up above street level at just the right height for looking through a bedroom window, glimpsing a secretary still at work in the office, or trying to make sense of what seems to be some kind of domestic quarrel.

Sometimes the spaces are set at street level, in shop windows or in restaurants. A man and a woman converse at a table, while a solitary woman drinks a cup of coffee or eats a bowl of chop suey as she talks to a friend. In an expensive restaurant she talks to a well-dressed man; while working late in the office she pays attention to another man, whom we presume to be her boss. In one of Hopper's best-known paintings, *Nighthawks* 1942 (pp.178–9), a young woman is sitting at the counter holding what looks like a sandwich, with a cup of coffee in front of her, while she and the young man sitting next to her appear to be having a conversation with the man behind the counter. In a similar painting, *Sunlight in a Cafeteria* 1958 (fig.84), a young woman seems to be lost in thought, while at an adjoining table a man gazes out of the window, ignoring her completely. In Hopper's works communication always seems to be difficult and at times impossible.

Fig.60
Night on the El Train 1918
Etching
19.1 x 20.3 (7 ½ x 8)
Philadelphia Museum of Art:
Purchased with the Thomas
Skelton Harrison Fund, 1962
PL. 56

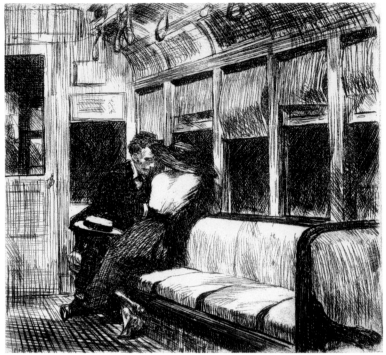

There is something somehow uncanny about Hopper's paintings of rooms, whether they are private or public spaces. The characters seem isolated, and yet some kind of relationship is developing, positive, negative or, as yet, undecidable. The fact that so many of Hopper's paintings depict scenes that take place after sunset and in rooms illuminated by electricity creates a sense of confusion between the roles of light and darkness, which seems to echo the models' own confusion as to whether they are isolated characters, confined within a single room, or figures in a crowd, denizens of the city, with its busy spaces and opportunities for meeting others. In some ways their situation appears banal, ordinary and unexciting – the rented apartment, the empty office, the table for two – but we can feel a sense of tension, the unease of the secretary asked to stay late in the office by her boss, the loneliness of the woman staring out of the window, surrounded by uninhabited buildings and empty streets, often with a grim expression, as if alerted to something we can never see.

Whether we like it or not we, as the viewers, are placed in the position of the voyeur, the Peeping Tom. We have all the time in the world to gaze at the young women and their male companions. Sometimes, as in *Western Motel* 1957 (fig.80), they seem to be returning our stare. Sometimes they seem almost to be challenging us to respond to them in some way, to suspend our voyeuristic gaze and to change our vantage point, in our imaginations at least, so that we can draw closer to the models or imagine how they might look from a quite different viewpoint. Supposing we were in that room ourselves, what difference would it make? Or are we forever to be left staring into the room, uninvited, intruding on their private space from our privileged position in the wide world, the world outside? In many different contexts – the apartment, the hotel, the office, the restaurant, the diner, the bedroom – they seem self-consciously posed for us to view, drawing attention to themselves in their own way and yet seemingly relaxed in their solitude, as if committed to the space, occasionally disturbed by an intrusion,

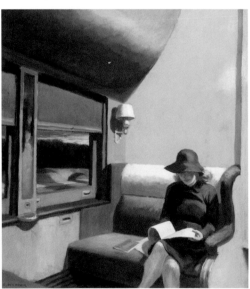

Fig.61
Compartment C, Car 293
1938
Oil on canvas
50.8 x 45.7 (20 x 18)
Private Collection
O-306

Fig.62
Gas 1940
Oil on canvas
66.7 x 102.2 (26¼ x 40¼)
The Museum of Modern Art,
New York;
Mrs Simon Guggenheim Fund
0-315

Fig.63
David Lynch
(born 1946)
Still from *Twin Peaks: Fire
Walk with Me* (1992)

occasionally trapped within it, occasionally negotiating the space with an intruder, a companion, a visitor or, disconcertingly for us, a Peeping Tom, the invisible night watchman who speculates on the model's desires, her inmost thoughts, her dramatic role.

In this context it is important to realise that Hopper's wife Jo served as the model for all of his paintings of women, acting so to speak not only as his helpmeet but also as his muse. She acted as the model for a series of initial sketches, which then served as groundwork for the final version of the work, which of course was in oil. During this process it seems that the original concept would change in accordance with Hopper's response to Jo's series of poses. The secretary, for instance, in *Office at Night* 1940 (pp.172–3), became increasingly buxom and curvaceous as her body began to show through her tight-fitting dress. However, Jo apparently insisted on her having a 'New Woman Look' and firmly rejected her husband's suggestion of the 'Girlie Show Look'. There is no doubt in my mind that Hopper's use of models was often related to his own sexual fantasies. In this context

it might be instructive to remember that he was interested in psychoanalysis and had even sketched himself in a caricature format, carrying an oversize book labelled 'Freud'. According to Jo, who noted it in her diary, Hopper talked about Freud most of the time during an evening out with a friend in March 1935. In a letter dated October 1939, according to Gail Levin, Hopper observed that 'So much of every art is an expression of the subconscious that it seems to me most of all the important qualities are put there unconsciously, and little of importance by the conscious intellect.'

For me one of the most intriguing aspects of Hopper's work is his fascination with travel, the exact opposite of his obsession with housebound solitude. Hopper bought his first car in 1925, a second-hand Dodge, and then promptly drove it all the way from New York to Mexico. He spent several months on the road every year from that time on, sketching and painting outdoors, in motel rooms, in diners, and in the back of his car. As Alain de Botton notes in his fascinating

book *The Art of Travel* (2002), Hopper stayed in Best Western motels, Del Haven cabins, Alamo Plaza motor courts and Blue Top lodges. For meals he would stop at diners, at Hot Shoppe Mighty Mo Drive-Ins, Dog'N'Sudds and, last but not least, at Steak'N'Shakes, while filling up at gas stations that displayed the emblems of Mobil, Standard Oil, Gulf and Blue Sunoco.

Although he travelled with Jo, it seems that loneliness was one of the travel themes that fascinated Hopper most. His characters wait on the platform at the El Station, they sit in Compartment C, Car 293 (fig.61), reading a magazine. In yet another hotel they look out of the window as the trains roll by, or they stay in a roadside motel or ride in a chair car (reading yet another magazine). In other paintings, we see the railroad at sunset, with light glistening on the tracks. In 1918 Hopper had made etchings of the view from the El Train, anticipating his own subsequent view of a room as seen from the El, an experience which gave him one of his most successful paintings (pp.152–3). One of his most memorable automobile paintings was *Gas* 1940 (fig.62), a work that

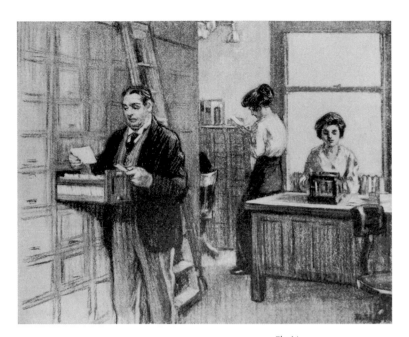

Fig.64
Illustration by Hopper
for Carroll D. Murphy,
'Buying More with Each
Wage-Dollar', *System:
The Magazine of Business*,
no.23, March 1913
Whitney Museum of
American Art, New York

shows a brightly illuminated filling station, while the forest beyond – into which the road disappears – is deep and dark. It is as if, once the tank has been filled, the car will disappear into nature.

At the very outset of his career Hopper worked for *System: The Magazine of Business,* which required illustrations of people in offices (fig.64), a subject to which he subsequently returned in much later paintings – *Office at Night*, *Office in a Small City* 1953 (pp.204–5) and *New York Office* 1962 (pp.216–17). Taken alongside his later work for *The Methodist Magazine*, which gave Hopper the opportunity to depict cinema interiors, it seems strange somehow that two of his favourite genres should have originated with his commercial work publicising office work and film-going. Hopper's later paintings, after all, do not really provide a very alluring vision of life in the office. On the contrary, the female secretary or assistant seems to be subordinate or even harassed, as marginal to the main action as an usherette in the cinema. And her boss, too, seems far from confident.

In regard to *Office at Night* Jo not only posed as 'Shirley' but also noted in her detailed ledger of every item in her husband's work that 'Figures stand out in space, not fastened to background'. It is this standing out in space of Hopper's figures that gives them their weight as characters. The dream-like nature of Hopper's paintings is given a degree of solidity by the three-dimensionality of the characters. In the 1930s, prior to *Office at Night* or *Nighthawks*, Hopper had also become interested in Surrealism, particularly after he and Jo visited Alfred Barr's notorious museum show, *Fantastic Art, Dada, and Surrealism* (1936–7). Hopper was a diehard Republican, but there was also a radical dimension to the way in which he deployed his imagination, perhaps without knowing exactly what it was that he was doing. In fact, Hopper sometimes abandoned both his conservatism and his Puritanism for reasons which apparently escaped the attention of his superego, the guardian of his latent machismo, a trait that became apparent in his role-playing through painting as 'Captain Ed Staples',

an imaginary New England sea captain who, according to the ledger, later transmuted into the father of the man at the pump in his painting *Gas*, an alter ego whom he imagined as meeting his death tragically in a train wreck, on his way home from an art show.

However, the Captain surfaced once again in *Nighthawks*, perhaps Hopper's best-known work, this time in the guise of the blond boy who is in charge behind the counter and who Jo describes as 'practically "Capt. Ed Staples", as dreamed up by E. himself'. It is at this point that I began to wonder what was really going on in this strange game of painting and role-playing, complete with its macabre intimations of death and resurrection. To what extent was Hopper simply having fun, enjoying his game of charades, and to what extent was he trying to distinguish himself from his rivals by creating his own idiosyncratic blend of unsettling realism and imaginative drama? We should not forget that Hopper was one among many American painters who had already cut themselves off from the grand master tradition and entered a period that

Fig.65
Study for Morning Sun 1952
Conté crayon and graphite
on paper 30.48 x 48.1
(12 x 18 15/16)
Whitney Museum of
American Art, New York;
Josephine N. Hopper
Bequest 70.291

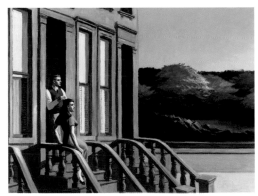

Fig.66
Sunlight on Brownstones
1956
Oil on canvas 77.2 x 102.2
(30 3/8 x 40 1/4)
Wichita Art Museum, Kansas;
Roland P. Murdock Collection
0-353

encompassed both Realism and Surrealism long before geometrical abstraction and Abstract Expressionism.

Perhaps the most crucial element in Hopper's work was his depiction of light. Interior spaces are lit by sunlight as it streams through the windows. Hopper organises the shafts of light geometrically so that they create diagonals both on the wall and on the floor. Light, of course, also creates shadows whenever a body or an object blocks its natural path. In Hopper's night scenes the light often enters the room from exterior sources, gas lights perhaps, or even electric bulbs. In his paintings of offices at night the light is cast from interior sources, ceiling lights which operate in an automat, a hotel lobby or the bar in *Nighthawks*, which provides the only light source in an otherwise darkened street. Hopper's own annotations to preliminary sketches for his tableau paintings are full of notes such as 'warm shadows in ear' or, more generally, 'light against wall shadow', 'reflected light', 'darker shadow' and so on, occasionally becoming more specific, as with 'cool reflections from sheet', or even

'thighs cooler' (fig.65). Hopper's wife Jo noted details in the ledger such as 'sad face of woman unlit', 'flood of sunlight in bare room', 'electric light from ceiling' and, apropos of *Nighthawks*, 'brilliant interior', 'bright items', 'brilliant streak' and 'bit of bright ceiling', as well as 'sign across top of restaurant, dark'.

In a strange way Hopper's view of things seems to have been dominated by the importance of glass on the one hand, and shadow on the other. Or, put in another way, Hopper oscillates between an aesthetics of clarity and vision on the one hand, and an aesthetics of darkness and gloom on the other. It is interesting to note, for example, that the notorious *House by the Railroad* 1925 (fig.1) has the blinds drawn on all of its windows, as does the house portrayed as *Sunlight on Brownstones* 1956 (fig.66). Neither of these buildings is located in the city. On the other hand, buildings that *are* in the city often have their windows uncovered, eager to let the sunlight in, with nothing to hide. Lamps are visible in a number of interiors – in *Eleven A.M.* 1926 (pp.132–3) or *Rooms for Tourists* 1945 (Yale

University Art Gallery). Others conceal their light source, as for example in *Nighthawks*. Some of the buildings have no windows – for example, the theatre and the movie palace, neither of which allows in daylight, although both stage and screen are strongly lit from interior sources – footlights and projection booth. Moreover, the powerful beam of light that makes the viewer's view of a film possible travels from the back of the auditorium to the screen at the front, dominating the field of vision.

Hopper was fascinated by the theatre, as well as being a film-goer. In 1914 he began his professional career as an artist by working for a film company – not as a film-maker or even as a set designer, but as a publicist, an illustrator, drawing and colouring advertising posters, mostly for films produced for Eclair in New Jersey, melodramas with titles like *Dance of Mammon*, *The Master Criminal*, *She of the Wolf's Brood*, *The Lunatics*, or *The Horrors of War*. Then, in 1918, Hopper was commissioned by *The Methodist Magazine* to depict the interior of a cinema, which was offered as an alternative to the saloon and

illustrated the slogan: 'Movies give cheap, democratic amusement'. These were the early years of the cinema, of course, as well as formative years for Hopper himself. His enthusiasm for theatre and cinema was subsequently translated into paintings that illustrated theatrical settings, many converted into movie theatres. Early in his career Hopper had painted *[Solitary Figure in a Theatre]* c.1902–4 (p.101), with its curtained stage, its rows of seats and its single solitary and shadowy theatre-goer. These were interior spaces, of course, but quite different from those which later dominated his work. Rather than being everyday spaces, domestic apartments or cheap eating places, these were specialised spaces, luxurious in their size and their emphasis on comfort, prestigious in their dedication to drama and to the arts.

Another theatre painting, *Two on the Aisle* (p.140), followed years later in 1927. It is similar to *[Solitary Figure in a Theatre]* in its visual structure, with a single woman seated alone, but this time in a luxurious box. In 1937 Hopper painted an interior view of New York's Sheridan Theatre (pp.168–9)

and then, in 1939, he produced *New York Movie* (fig.67), a much larger work, with two light sources – one shining down directly on a single usherette, the other illuminating the almost empty theatre through light reflected from the film being screened. The usherette is standing alone, looking pensively downwards, showing no special interest in the film, seemingly concerned with some anxiety of her own. Although most of Hopper's image is shrouded in darkness, the lighting focuses attention on this solitary figure, another of Hopper's enigmatic women. In 1941, Hopper painted yet another theatrical subject, *Girlie Show* (fig.86), with a nude model prancing across the stage in a shaft of light. Ten years later, he returned to the theatre with *First Row Orchestra* (pp.196–7) and subsequently *Intermission* 1963 (pp.218–19), yet another painting focused on a solitary woman in an empty yet illuminated space. In these paintings private space gives way to public space, yet the voyeurism is still there – explicitly in *Girlie Show*, implicitly in our own acceptance of our role as spectator.

In December 1915 a pioneering book,

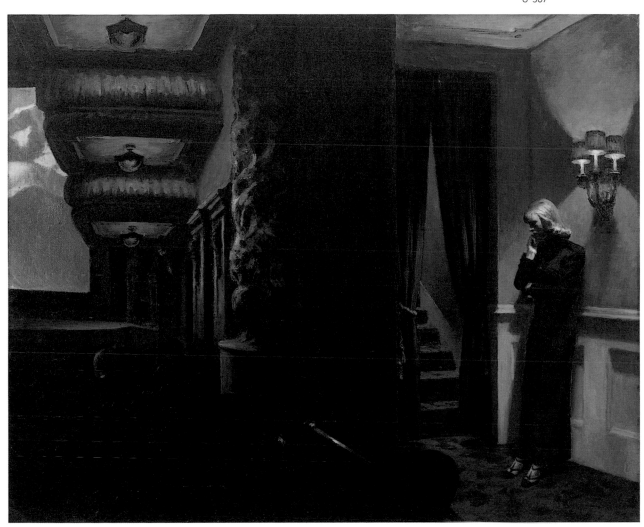

Fig.67
New York Movie 1939
Oil on canvas 81.9 x 101.9
(32 1/4 x 40 1/8)
The Museum of Modern Art,
New York
O-307

Fig.68
The Balcony 1928
Drypoint
20.3 x 25.4 (8 x 10)
Whitney Museum of
American Art, New York;
Josephine N. Hopper
Bequest 70.1507
PL. 108

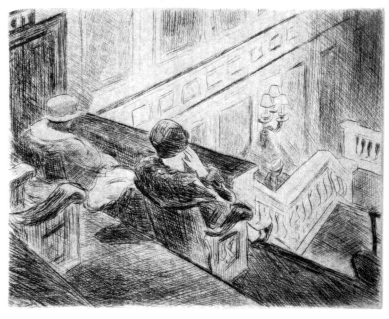

Fig.69
Alfred Hitchcock
(1899–1980)
Still from *Psycho* (1960)

Fig.70
House on a Hill 1920
Etching 20.3 x 25.4
(8 x 10)
Philadelphia Museum of Art:
Purchased: The Harrison
Fund PL. 75

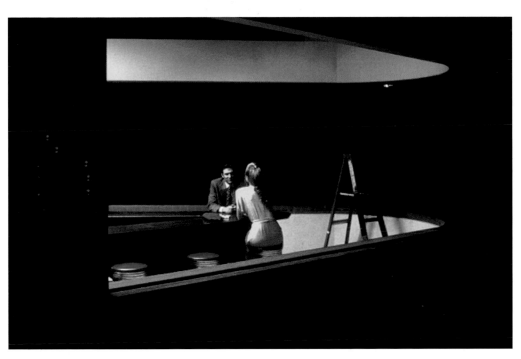

Fig.71
Donata Wenders
(born 1965)
Photograph from the set of
The End of the Violence by
Wim Wenders (1997)

The Art of the Moving Picture by Vachel
Lindsay, was published in New York. It is
fascinating, the first serious attempt to
grapple intellectually with the cultural role
that cinema might play in the future. Three
of the chapters are clearly relevant to
Hopper's own later work as a painter. One
is titled 'Sculpture-in-Motion', another
'Painting-in-Motion' and a third,
'Architecture-in-Motion'. Lindsay begins
by discussing the role of gestures in the
'Motion Picture' and then goes on to make
comparisons, for example, between the
elasticity of gesture in the cowboy film
and the 'sculptural harmony' of hero and
heroine in films of storm and stress –
cinematic melodramas based on a hero,
a villain and a lady in distress, stock
characters whose movements culminate
in monumental groupings. Lindsay even
goes on to describe the sculptural quality
of a film set in an office, where the hero is
caught with incriminating papers and
accused of theft by a furious woman,
supported by her attorney. The scene is
strangely reminiscent of many of Hopper's
later paintings, with their office setting,

their confrontation between male and
female, their sculptural nature within
architectural settings.

Lindsay and Hopper had been class-
mates together, enrolled as students at the
New York School of Art in the early years
of the century. During this period Hopper
was busily at work sketching the sculpture
casts installed in New York's Metropolitan
Museum of Art. He was also painting from
'costume models', a premonition of his use
of models in his later paintings. Vachel
Lindsay, beside being interested in the
relationship of sculpture to motion picture,
was particularly enthusiastic about the
tableau, describing it as a mix of colour,
pattern, scene and texture, in which
characters were grouped and positioned,
using film – or 'motion picture' – as his
primary example of how sequential move-
ment could be used to add dynamism to
an otherwise static tableau. In fact Lindsay
anticipated the use made of Hopper's
paintings as jumping-off points for film
sequences, a process described by the
German film-maker Wim Wenders, an
admirer of Hopper, whose own photographs

are much influenced by Hopper's paintings. In Wenders's view, Hopper's own paintings could also be expanded into imaginary sequences as the viewer imagines a 'before' and an 'after' to each still scene. Hopper's tableaux thus contain a temporal dimension which, in each viewer's mind, could be vitalised and set in motion (fig.71).

Hopper's most intriguing relationship with film, and also with travel, came with his painting *House by the Railroad* (fig.1), completed in 1925 and viewed very favourably by the critics, one of whom characterised it as 'poignant and desolating', words which certainly did Hopper justice. The painting later received a further boost, a kind of windfall, when Hopper learned that Alfred Hitchcock had credited it as the inspiration for the house of horror in *Psycho* (1960), a film that also, famously, foregrounded a motel. As an enthusiastic film fan Hopper was delighted to learn of the Hitchcock connection. The *Psycho* house (fig.69), designed for Hitchcock by Joseph Hurley and Robert Clatworthy, was indeed reminiscent of Hopper's painting, with a similar garret storey, roof-cresting, oculus

window, cornices and pilasters, as Stephen Rebello has noted in his book, *Alfred Hitchcock and the Making of Psycho* (1990). As Rebello observes, 'One might almost expect to glimpse Mrs Bates silhouetted in the window of the sloping dormer in Hopper's 1925 painting.' In 1963 Hopper took care to go and see *The Birds*, another dark Hitchcock classic involving the persecution of a young woman.

In fact, not only was there a link between Hopper's architectural painting and Hitchcock's architectural stage set, but there was another odd twist to the story. The Bates House was built on the same soundstage previously used for Rupert Julian's *The Phantom of the Opera* (1925), starring Lon Chaney, the monster specialist, who appeared as the menacing 'Red Death' – a replica of the Paris Opera House, including its underground catacombs, had been constructed on the site. This double cinematic reference, had Hopper been aware of it, would surely have delighted him.

This was a time when many artists began to be interested in cinema, setting

Fig.72
Reginald Marsh
(1898–1954)
Twenty Cent Movie 1936
Egg tempera on board
76.2 x 101.6 (30 x 40)
Whitney Museum of
American Art, New York

Fig.73
John Huston
(1906–1987)
Still from *The Maltese Falcon*
(1941)

out to re-create American painting in
narrative form, as the product of a story-
telling imagination. They were attracted to
the world of film, intrigued by its use of
technology and its dramatic power. In 1935
Stanton MacDonald-Wright completed his
massive mural, *A Motion Picture Studio*,
which was followed the next year by
Reginald Marsh's *Twenty Cent Movie* (fig.72),
a vivid painting of movie-goers fighting to
get tickets at the kiosk. Two years later
Thomas Hart Benton produced *Set
Designing, Dubbing in Sound* and *Director's
Conference* (a somewhat Hopperesque
piece), as well as his massive *Hollywood*,
a painting that depicted cinematography,
sound recording and other technical
aspects of film-making as they took
place on the studio set. In 1945 Doris Lee
completed her paintings of Grauman's
Chinese Theatre, an architectural
extravaganza, and Schwab's Pharmacy,
the hang-out for would-be stars.

Hopper too must have felt the pull of
Hollywood. Certainly his odd perspectives,
his lonely diners and eerie chiaroscuro are
often linked to cinema and to film noir in

particular. We know that Hopper saw John
Huston's first film, *The Maltese Falcon,*
a classic noir film, released in 1941 (fig.73).
But if Hopper's paintings reveal a personal
obsession, it is with architecture rather
than cinema, however much film-going
appealed to him as a viewer. Most of
Hopper's paintings depict either cityscapes
or individual buildings, often in places
Hopper had visited by train or, in his motor-
ing days, by car. His paintings of buildings
are like still photographs, mostly uninhabit-
ed. Looking at these buildings the viewer
inevitably begins to wonder who is living in
the house, to hypothesise about who might
have left and who might be arriving.
Perhaps Wim Wenders was right to suggest
that Hopper's paintings invite us to imagine
a 'before' and an 'after', to speculate on
who inhabits the buildings, what goes on
inside them, but also what has happened in
them in the past and what might occur in
the future. Does Mrs Bates live in the
'House by the Railroad'? Will Captain Ed
Staples suddenly appear, walking down
the street? Or is he planning to leave on a
very long train journey? Hopper's paintings

invite us to speculate, to imagine our own
screenplay, our own interpretation of past,
present and future, our own re-organisation
of time and space.

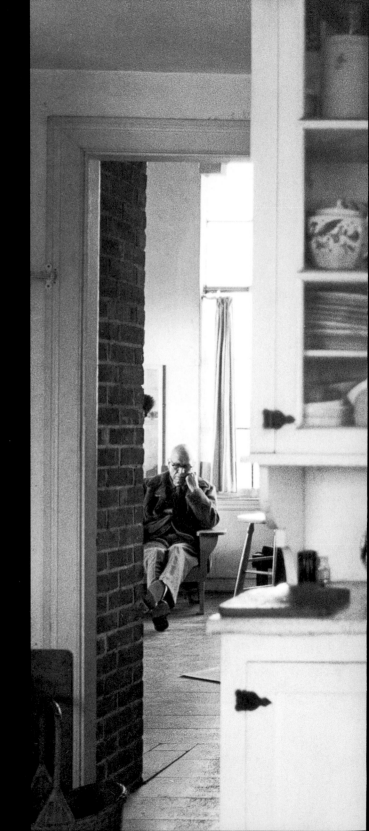

I find, in working, always
the disturbing intrusion of
elements not a part of my
most interested vision,
and the inevitable obliteration
and replacement of this vision
by the work itself as it proceeds.
The struggle to prevent this decay is, I think, the common lot
of all painters to whom the
invention of arbitrary forms
has lesser interest.

Hopper's Look
Brian O'Doherty

Fig.74
Summer Evening 1947
Oil on canvas 76.2 x 106.7
(30 x 42)
Private Collection
O-336

It has come down to this: some two-score master-images, stamped into the popular imagination. Their iconic status, to which the work offers a mild and steady resistance, is reinforced with each generation. Hopper's images now voyage across decades, cultures and geographies, as if each were accompanied by passport and visa. As with images from some movies, the master-image paintings have become coin of the imagination, easily accessible referents that frequently project themselves on everyday experience.[1] Once, Hopper's wife asked him – Napoleon had cropped up in the conversation – if he wanted to conquer the world, to which Hopper responded with a definite 'No'.[2] The word 'conquer' has an unpleasant aura of subjugation. Hopper's images have not conquered but quietly infiltrated large tracts of the world, East and West, with a stealth consonant with the way in which he realised a painting.

The twentieth century was not a remarkable time for realism – if realism is what Hopper did. Realism is here defined as a depicted universe that is imaginatively continuous with our own, where the physics of things and their perception behave synonymously with what we see every day and can be so tested. Among the important twentieth-century realists, Morandi is gratefully present, as is Balthus, with his poetics of pubertal narcissism. It can now be argued that Hopper was the twentieth century's greatest realist artist, though that may not be high praise. Better to say that Hopper is one of the twentieth century's greatest artists, great in terms of the rewards he promises and delivers.

Coming to so large a conclusion is unsettling, in part because, given Hopper's aesthetic origins, it is so unlikely. We may well ask, how did this happen? The changing way Hopper and his work have been perceived accounts for some of it. For the sense we have of Hopper now is remote from the mythologies that hovered around his name until his death in 1967. That year, William Seitz, for his exhibition at the São Paulo Bienal,[3] elected Hopper as an ancestral figure to the new generation of Pop artists. This was the first serious attempt to point out that Hopper had lived through the stirring decades of post-war American art, working in a city where Rothko and de Kooning (both admired his work), Rauschenberg and Warhol were his contemporaries. As were Jack Levine, the Soyer brothers, Joseph Hirsch, William Gropper, Isabel Bishop and numerous names that remain un- and under-celebrated in museums and art journals.

Between the aesthetic dispositions of these two groups is an abyss. Yet Hopper, who occupied a neighbourhood in the vicinity of the latter names, was cherished by all. This ability to appeal to artists – and public – of widely different interests and ages is a durable phenomenon in the reception of Hopper's work. Decade by decade, he has been exempted from criticism (though early on in his career there were some reasonably cogent dissents made by commentators of different political and aesthetic persuasions).[4] Criticism has now been replaced by the ingenuities of exposition, implicitly assuming full acceptance.

Hopper's work has made a vigorous liaison with popular culture in several countries.[5] His legendary marriage to

Fig.75
Winslow Homer
(1836–1910)
*Searchlight on Harbour
Entrance, Santiago de Cuba*
1901
Oil on canvas 77.5 x 128.3
(30 1/2 x 50 1/2)
The Metropolitan Museum
of Art, New York.
Gift of George A. Hearn,
1906

Josephine Nivison[6] has been the subject of a psychologically obtuse opera. He has a following among movie cameramen, particularly John Bailey, Ed Lachman and Vilmos Zsigmond, and among such directors as Paul Schrader, Wim Wenders and Todd Haynes. It is assumed that Hopper was influenced by film, which he in turn has influenced, the closure of a cycle that would, I think, have given him as much pleasure as he allowed himself. This for a man who thought success hollow.

How did an artist originally seen in the context of Reginald Marsh, William Glackens, John Sloan and Guy Pène du Bois, among others, become a regnant figure in the international pantheon? The only transcendence connected to Hopper's work is the transcendence of his reputation. Curiosity, celebrity's camp-follower, has now attached itself to Hopper's person, his marriage, his habits, his myth. It might more profitably attach itself to the composition of his unusual mind.

Hopper and his wife, Josephine, kept to themselves. So it was a surprise to many in New York when it was revealed that he was a man of great sophistication, even though he had trained with two highly literate teachers, Robert Henri and William Merritt Chase. Hopper was a great reader, though few books were visible in his studio. He read Emerson closely and repeatedly, as he did Goethe. He read J.E. Renan's demystification of Jesus with approval.[7] He liked the essays of E.B. White, and, unlike Nabokov, thought Thomas Mann a great writer. His closest literary friend was John Dos Passos. He admired Hemingway's sparse reductivism, with its inverse richness of implied content. In Robert Frost he found a poet whose words he could trust. Once, in a dismissal of substantial acres of English poetry, he made his point by quoting, with disapproval, Coleridge's 'Kubla Khan' (1798).[8] All this has a somewhat conservative cast. Counterposed to it, perhaps, was the taste he formed for some Symbolist poetry during his Parisian stays in 1906, 1909 and 1910. Much of what he read could be brought quickly to bear during a conversation.

Among artists, he admired Manet (whom he copied), Degas, and he frequently

Fig.76
Charles Meryon
(1821–1868)
The Petit-Pont, Paris 1850
Etching 26.5 x 18.5
(10³/₈ x 7¹/₄)
Hamburger Kunsthalle

referred, with admiration, to Courbet's 'weight', which he did not find in Cézanne. Among his American predecessors, he honoured Thomas Eakins and Winslow Homer (fig.75). He wrote in deliberate cadences about his contemporaries, John Sloan and Charles Burchfield. He felt passionately about the virtues of Charles Meryon, the etcher of Parisian scenes (fig.76). The one movie he mentioned and strongly approved, Ben Maddow's *The Savage Eye* of 1960, provided no convincing model for his paintings, though it expressed a forceful dystopian vision of the metropolis. Republican in politics and conservative in social matters, he admired tradition and felt that most aesthetic excursions, particularly abstraction, were compromised, because they withdrew from commerce with the secular, quotidian world.

His mind was composed of curiosity, fatalism frequently modified by humour, and – his most consistent trait – an ongoing alternation and equivocation between certainty and doubt. He declined to argue a point much beyond making his dissent known, and often ended matters by conceding that the opposing view might well be right. Despite this, he seemed mostly to dwell in quiet certainties, which, however, he was always willing to test. An excellent listener (head slightly tilted, eyes downcast), he looked at you directly when he spoke, always in well-formed sentences. He moved his large body with deliberation; in his chair, he was upright, alert and still. A quiet sense of humour, never far away, was sometimes called upon to mitigate a passionately expressed opinion from his wife, for whom humour tended to be a foreign territory. The depressive aura with which subsequent commentators (who never met him) have surrounded him was unknown to me. He was excellent company, and was unafraid of extended silences. If there was nothing to be said, there was nothing to be said.[9] His scepticism did not proceed to satire, nor did it mask any discernable idealism. He dispensed completely with irony, or at least with the scathing variety through which modernism tested established conventions. A stoic, he bore his vicissitudes without complaint. He accepted things as they were, whether he approved of them or not. He did not think matters were subject to much improvement.

To everything, including visitors, he applied a frank, though not very sustained, stare. His judgements of writers and artists, when solicited, tended to be positive or severe, both views expressed in the same deliberate tones. Though he was always courteous, indeed gentle, his presence was formidable, with some of that weight and sobriety (gravity and *gravitas*) that he admired in Homer's painting. One was aware, in his presence, of a slight displacement in his experience of his own person, something that most of us have occasionally felt, when we are strange to ourselves, and become objects of our own contemplation.[10] Over several years of visits, this was a consistent impression, and I believe, despite the hazards of such personal readings, it may illuminate his work. For his curiosity was applied not just to the external world, but to sounding his unknowable self, a solitary exploration that frequently led commentators to read alienation and loneliness into the paintings. The strangeness in Hopper's work is

Fig.77
Sun in an Empty Room 1963
See pp.220–1

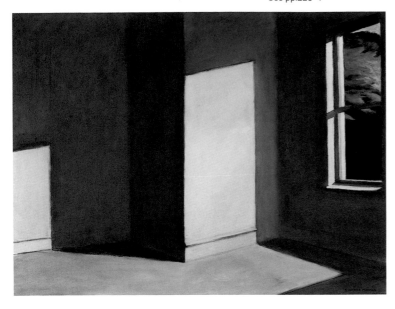

Fig.78
A Tough Jesus (after reading Renan)
Graphite on paper
13.97 x 21.59 (5¹/₂ x 8¹/₂)
The Arthayer and
Ruth Sanborn Collection

connected to the way in which he observed his own thought processes and feelings as if they belonged to someone else. Since this habit was intrinsic to him, he did not consider it unusual or strange. It was, if anything, completely matter-of-fact, though facts, when assimilated by that level stare, were tested and brought into equivocal precincts of uncertainty. 'Most of the important qualities' in art, he wrote to Charles W. Sawyer in 1939, 'are put there unconsciously, and little of importance by the conscious intellect'.[11] But he was unwaveringly conscious of one thing: the mission of the artist. He emphasised this so repeatedly that it has been, if not ignored, certainly not fully acknowledged. It had to do with what Hopper called 'personality', a word he put to frequent use in his statements.

He believed that 'personality' was an unalterable *donnée*. It was his one certainty. The artist's 'inner life will result in his personal vision of the world'.[12] He also spoke of 'definite personalities that remain forever modern by the fundamental truth that is in them'.[13] And again, 'Every artist has a core of originality – a core of identity that is his own.' He quoted Goethe on 'the reproduction of the world that surrounds me by means of the world that is within me, all things being grasped, related, re-created, moulded and reconstructed in a personal form and an original manner'.[14] When the conversation turned to that world within, he characterised it as a 'vast and varied realm',[15] implying that much of it was unknown to him, part of what one might be justified in calling his puzzlement about himself, or rather his self. For he could know that self only through his work, which returned to him some reassuring echo. Thus, Hopper's work, according to him, is a search for a definition of that self in which he fervently believed, but of which he had imperfect knowledge. When I asked a question about what he was after in *Sun in an Empty Room* 1963 (fig.77), he was silent and, on further interrogation, responded, emphatically and with some exasperation, 'I'm after ME'.

I recall sitting with Hopper, hatted, hands clasped on stick between legs, at his Whitney Museum retrospective in 1964, surrounded by his paintings, each of them locating him, as it were, through the convergence of their gazes. I had a sense of how necessary the perceived world was for him, how intense was his appetite for it, how, without it, he remained locked within himself. Where that self sought its own definition was clear. He abhorred the picturesque city, laden with pre-emptive content, and sought out ignored places in which to pursue his self-knowledge; an isolated task perhaps, but one often mistaken for loneliness by those who rehearse his journey.[16] The mystery of the city paintings – his best, in my view – proceeds from that search for an identity that remained unknowable, except indirectly. The gas stations, the single women at their windows, the hushed movie houses, the people in the sun, the empty rooms, the train compartments, the cafeterias become, if we believe his declared intention, a cumulative self-portrait. If this is self-expression, it is without any manifest solicitations of emotion. The paintings are presented with a neutrality that has invited contradictory readings. How he gained

access to his interior 'realm' is documented in his 1933 statement for the Museum of Modern Art on his creative process. The operations of the self are described in a typically clear *and* mysterious statement.

When this statement was published in the catalogue of his 1933 retrospective, Hopper was fifty-one. His best work, his career as a major artist, was ahead of him. An unhurried pulse marked the inner evolution of a picture and to that process Hopper applied his detached curiosity. Starting a painting was always difficult, especially in his later years. He suffered the anxiety of waiting for it, since the past offered no certainty of renewal. There was a long internal process of testing and clarification. When a notion of it had crystallised, its first appearance could be a few pencil strokes, followed by detailed drawings. He then spent a long time looking at an empty canvas, already sized to the dimension of his idea. Eventually the painting was delivered through the trials of process, which winnowed it into a somewhat laconic and often epigrammatic concision.

The city and its anonymity, which Hopper welcomed, was the text for what I believe are his greatest pictures. (Hopper as *flâneur* is a mildly surprising thought.) The city seemed to have provided him with his most intimate sensations. It (and other subjects) donated what he called an *idea*, presumably hovering in the mind in a way that is familiar to those of us given to occasional introspection, when residues of observation intersect with cycles of memory and feeling, whisking away when directly addressed. He thought the idea through, fully possessing it before he attempted to realise it.[17] This process was interior and deeply private, gathering accretions of feeling from that buried self to which he referred.

This illustrates the most obvious dialectic in Hopper's work: that between inside and outside. His mild stare gathered sufficient information before dropping away to process what his very contained person had received. The sense of a reserved interior realm was, in his presence, acute. To him, the world seems to have presented itself in phenomenological

terms – examined visually in what might be described as a kind of natural science of empirical picture-making. The many windows in his work, monitoring the transactions between inside and outside, inviting almost balletic exchanges of glances, perhaps serve as proxies for his observing and inward eyes.

Hopper's statement for the 1933 exhibition identifies three zones: the interior clarification of the idea; the hazardous process of its externalisation; and the final product, embodying (in a phrase reminiscent of Cézanne describing his sensations) 'the most exact transcription possible of my most intimate impressions of nature'. The word 'transcription' is telling – the artist as secretary to his own vision.

Hopper was eloquent about the middle zone, which articulates a resistance to realising the idea from 'the technical obstacles of painting', which 'dictate [the] form'. He was acutely conscious of losses – and unwanted additions – during this process:

I find, in working, always the disturbing intrusion of elements not a part of my most

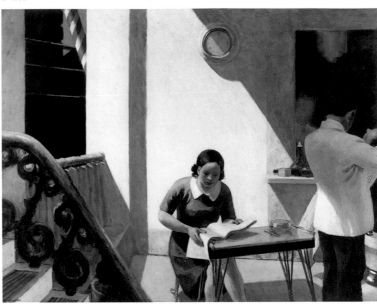

interested vision, and the obliteration and replacement of that vision by the work itself as it proceeds. The struggle to prevent that decay is, I think, the common lot of all painters to whom the invention of arbitrary forms has lesser interest.[18]

Apart from its courteous rejection of abstract art, this statement insists on a tenacious rearguard action to preserve the original idea, generating a conflict within the matrix of Hopper's practice, which always included some element of dissatis-faction.[19] The medium through which the work is realised must restrict itself to advancing the idea – explaining the frugal quality of the paint, sometimes looking, as it did to Clement Greenberg, close to indifferent painting.[20] Hopper's prose didn't waste words either, and the MoMA statement is notable for its precision about imprecise things. The same statement suc-cinctly mentions desired 'simplifications', the psychological unity of opposites, the unattainability of perfection, the dynamics of memory (the curious matter of 'decay'), the determining limitations of personality,

and how great painters 'with their intellect as master, have attempted to force this unwilling medium of paint and canvas into a record of their emotions'. That emotional record is, however, negotiated in Hopper's case into a kind of neutral potency that leaves the spectator alone before the paintings, various interpretive scenarios at the ready. A founding paradox of Hopper's art is the impersonality with which what is deeply personal is conveyed.[21] But if ever a certificate of sophistication and intelligence were required for presentation to some jury of his great predecessors – he also cites Molière, Ibsen, Giotto, Cézanne and Eakins – this statement will do.

Such a statement ushers us into the hushed and secretive precincts of Hopper's art, and beyond it, into his silence, from which the work began its voyage. We are on the verge of a dangerous literalism, which Hopper's statement encourages: that the work – as much thought as painted into being – is in exact consonance with an interior life that to the artist remained mysterious and partly inaccessible. And that the work itself reveals phases of a

self-investigation that many interpretations deny to it, proffering instead repeated disquisitions on loneliness and the city. Hopper could be seen as a lonely figure but, as far as I could tell, he was completely comfortable in his isolation, if isolation it was. Which brings us to what is supposedly a lonely, but more accurately, isolated activity: reading.

It is startling to see how many people in Hopper's paintings read. They read in hotel rooms, lobbies, offices, shops, trains, their bodies parked, surroundings temporarily mislaid. In Hopper's actionless universe, reading is the closest to action that we get.[22] Apparently passive but absorbed, Hopper's subjects echo the artist's disen-gaged engagement. Hunched over the text, they follow the mildly staccato trajectory of the words as the horizon of each line drops away and the eye, ever the athlete, leaps backwards, with absolute precision, to the presenting word of the next rising line. Like most of us when we read, they are in a state of attentive neutrality, whether they are reading a train schedule (*Hotel Room*

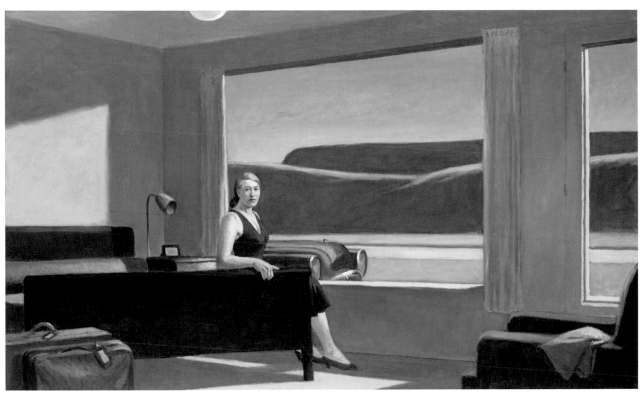

Fig.80
Western Motel 1957
Oil on canvas 76.8 x 127.5
(30¼ x 50⅛)
Yale University Art Gallery,
New Haven.
Bequest of Stephen
Carlton Clark, B.A. 1903
O-355

1931, fig.81), book (*Hotel by a Railroad* 1952, pp.200–1), magazine (*Barber Shop* 1931, fig.79), or theatre programme (*Two on the Aisle* 1927, p.140). They appear completely comfortable with themselves. Loneliness is not an issue. They model Hopper's reversals: remote but intimately engaged, focused but apparently indifferent; passive but internally active. Such contiguity, indeed superimposition, of oppositions, cancels out that potent neutrality, as their process of reading parallels our process of reading them.

The focused action of the readers is not replicated in most of Hopper's other people, who are detained in various forms of reverie, and in reverie's medium: waiting. All, in their separate ways, are passing time, and it has often been remarked how temporal anxiety is disguised in Hopper's work; everything seems massively stable but, if you look closer, is transient or in transit. Whether contemplating the unseen coffee cup or the blank night window, all are adrift on reverie's surface, where random synapses scribble day-dream scenarios. In terms of their inner unavailability, they mirror their author's privacy.

The eyes of the only person in Hopper's mature art who returns our gaze (*Western Motel* 1957, fig.80) are filmed and sightless.[23] We are acknowledged but virtually unseen. Indeed, so powerful is the inner removal of Hopper's people that we take on some of their intimate distance as we look. He has donated to us a kind of abstracted, slightly hypnotic gaze that is more usually directed to the internal pastures of reverie.

This is particularly true in his paintings of women. Hopper, like Vermeer, is one of the great observers of women alone. Hopper's women, all grown from his wife's tidy and well-proportioned body, were clearly creatures of considerable interest to him. Some are middle-aged women of a quiet and unremarkable demeanour, notable for their dresses and hats, which return to us the fashions of 1920s and 1930s movies. They too are abstracted in oceanic reveries, and seem part of their habitats, even when that habitat is temporary (hotels, restaurants, theatres, movie houses). Other women display a kind of vernacular voluptuousness, floozies or femmes fatales in waiting. The gesture of the body speaks

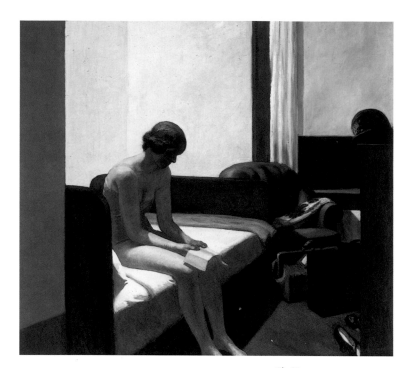

Fig.81
Hotel Room 1931
Oil on canvas 152.4 x 165.7
(60 x 65 ¼)
Fundación Colección
Thyssen-Bornemisza, Madrid
O-280

as clearly as the faces, which are, with few exceptions, neutral in expression. This shrewd observation of bodily gestures may have been instructed by silent movies, in which actors, deprived of words, schooled themselves in the art of being noticed.[24] Sound came to movies when Hopper was forty-seven.

Hopper and the movies is an obvious subject and one that, to my regret, I did not discuss at length with him. There was a time in his art, around 1940, when there seems to be a slight change in his modality of looking, possibly previewed in some of the etchings. It lay dormant as Hopper went through what might be called his outdoor phase – the portraits of houses, lighthouses, boats, landscapes.[25] The first notable paintings of interiors begin in 1921, and continue each year up to 1931 (the great *Hotel Room*), when they became scanty until 1939 (*New York Movie*, fig.67). Beginning with *Office at Night* in 1940 (pp.172–3), the interiors and occasionally the feeling are recognisably film noir, a cycle completed with *New York Office*

1962 (pp.216–17), with perhaps a mysterious coda, *Sun in an Empty Room* 1963 (fig.77). This influence, or affinity, shows in four ways: three tangible – the figures (already mentioned), the light, and the interiors; one intangible – the way in which Hopper induces the spectator to rehearse his 'look'.

Before the early 1960s, after which movies became 'film', people frequently entered the theatre 'in the middle of the movie'. The new arrival attempted to decipher the story, working through, as it happened, various hypotheses. When the film ended, then restarted, the place 'where I came in' was recognised and the narrative flow could be smoothed out by sitting through the rest of the film again. But in mid-film, the actors, actions and words are mysteriously suspended. Some of Hopper's paintings provoke this curious feeling, but in reciprocal Hopper fashion that curiosity is both stimulated and blocked. His figures, though resolutely undramatic, exist in a situation that has aspects of drama – suspense, imminence, a half-promise of some resolution. Hopper, after decades of reluctant illustration, must have enjoyed

removing cues to easy readings, which has sometimes been mistaken for an alienation among his painted characters that supposedly mirrored his own. Hopper dead-ended the spectator's escape into anecdote, and avoided drawing attention to paint and process. The aim was to keep the spectator right there, looking.

Did Hopper sympathise with the aesthetic of the many noir films he undoubtedly saw?[26] Their content was certainly in accordance with his unimpressed view of his fellow-creatures. I do not know whether he read the classic 'hard-boiled' novels of Raymond Chandler, Dashiell Hammett and James M. Cain that provided attitude and text for a cinematic style that never quite became a genre. Noir's uncertain dates are usually placed between 1940 and 1960, and if a lonely anti-hero was required, noir certainly provided it. Its angst was a vernacular summation of existential dilemmas, criminal transgressions, nuclear paranoia, pop Freud, red-baiting, Cold War anxiety and city alienation, presided over by an indifferent deity. The anti-hero, often confused by a femme fatale and

Fig.82
Conference at Night 1949
Oil on canvas 72.1 x 102.6
(20 ³/₈ x 40 ³/₈)
Wichita Art Museum, Kansas.
Roland P. Murdock Collection
O-338

Fig.83
Night Shadows 1921
Etching
17.8 x 21.3 (7 x 8 ³/₈)
Whitney Museum of
American Art, New York;
Josephine N. Hopper
Bequest 70.1048
PL. 82

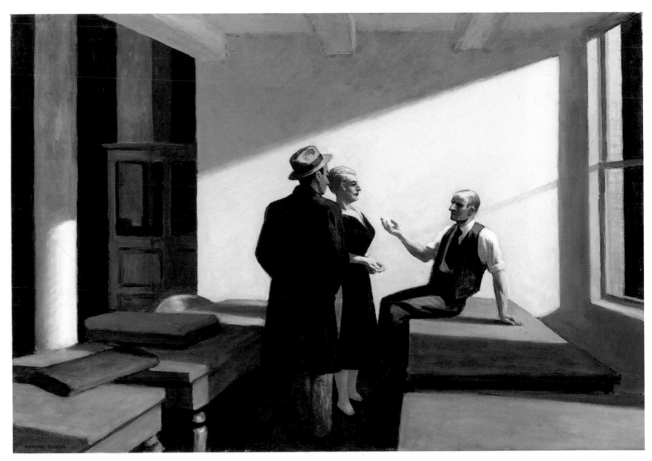

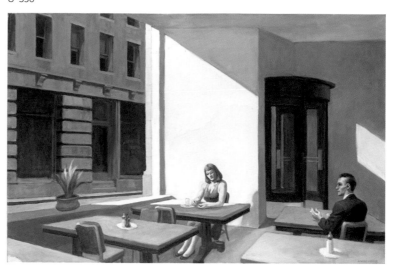

manipulated by forces he does not understand, skids through a skewed moral universe. Hopper, in his dystopian moments, would, I suspect, have been pleasurably entertained by such darkness.

And by the light. The lighting in some of Hopper's paintings echoes the lighting in noir films. A noir signature is the oblique cut of light across a background wall, its edge sharp as a guillotine's. These obliques track across the wall, as much part of the noir atmosphere as the swinging light bulb, the on-and-off neon sign, the slats of the venetian blind casting undulating ribbons of light. The rhomboids and parallelograms of light, much favoured by cameramen, have a distinguished Expressionist pedigree, and are not confined to noir films. But they emblematise noir's Manichaean oppositions. The logical way in which the light falls offers one of noir's few reassurances – at least the light isn't crazy. How fascinating the crepuscular fibrillation of those light-struck walls on the screen must have been to the artist who said he simply wanted to paint light on a wall.

The most noirish paintings in Hopper's oeuvre are *Conference at Night* 1949 (fig.82), its cousin of nine years earlier *Office at Night*, *Summer in the City* 1949 (fig.44), and of course *Nighthawks* 1942 (pp.178–9). They are the closest to the arrested narratives of movie stills. The oblique deposition of light occurs in several other paintings,[27] and is often a major player (*Sunlight in a Cafeteria* 1958, fig.84), sometimes a marginal, soft-edged imminence (*Hotel by a Railroad*). What is noticeable is the variety of ways in which the light is painted. The pleasure is as palpable as the light itself. An inventory of painted walls reveals a virtuosity not usually associated with Hopper's touch. They have a variety of moods that argue against Hopper's belief in the limitations of abstract painting. The wall, flattened corner and triangle of ceiling in *Nighthawks* have a hard, yellow glare. The soft, two-toned pale cream of the wall in *Office at Night* blooms outward, as does the great rhomboid of light in *Rooms by the Sea* 1951 (fig.85), quietly active with intimations of process, a mode repeated again in the lighted wall in

Sunlight in a Cafeteria. The surface of the rectangle of sunlight in *Morning Sun* 1952 (pp.198–9) dissolves into depth, then flattens with the sophistication of great abstract painting. The wall under the descending bar of shadow in *Intermission* 1963 (pp.218–19), with its casual pentimenti, has a palpable vibration. Each painted wall contributes to a poetics of sunlight, expressed in a vocabulary from luminescent outpourings to hard trajectories of steady velocity.[28] The noir lighting has been brought into the precincts of those abstract but laden zones in Hopper's work, where pillars of architecture, soft columns of curtain, now stand in powerful abstract reverie, consonant with figures and light.

Hopper's connoisseurship of domestic buildings so common as to be unseen is part of his pursuit of neglected (i.e. usable) subjects. The same is true of his interiors, all of which have to do with temporary occupancy – railway carriages, bars, offices, restaurants, gas stations, hotels, the latter a fascination of his younger colleague (also born in Nyack, New Jersey), Joseph Cornell.

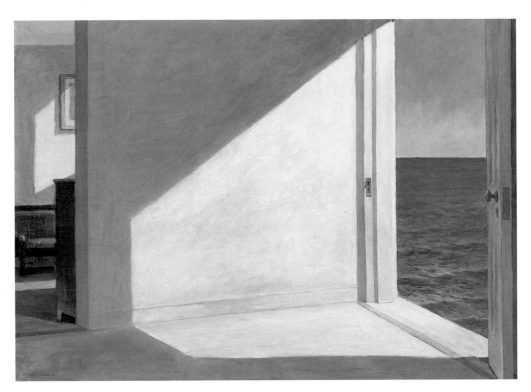

Fig.85
Rooms by the Sea 1951
Oil on canvas 73.7 x 101.9
(29 x 40 ⅛)
Yale University Art Gallery,
New Haven.
Bequest of Stephen Carlton
Clark, B.A. 1903
O-345

Such interior spaces have some of the unloved patina of public usage, and their transitory occupants are surrounded by an envelope of reserve appropriate to public decorum. There is a stage in Hopper's oeuvre when these interiors include areas of what one might call deferred interest, which again recalls film noir. A few examples will suffice. Behind the naked (not nude) woman in *Morning in a City* 1944 (fig.51), two dark pillars present an enigmatic spatial conundrum of flatness and depth. Similar pillars of shadow and light in *Conference at Night* may trap the wooden doorway, but they keep emancipating themselves from an easy reading, and pose – when isolated and bereft of perspectival clues – as abstract, an oscillation between modes of perception that adds to the enigma of Hopper's spaces. Particularly telling is *Summer in the City*, in which the lighted sides of the windows on the left are as powerful a magnet as the prone and sitting figures. But around to the right, across another dark, semi-abstract pillar of shadow that quietly says 'wall', are a complex of illuminations – a spill of light on a floor, a window framing sky (a pillar of

blue) and a few touches of decanted reds that say 'apartment building'. These spaces occur often enough to establish hierarchies of attention, so that focusing on them seems slightly illicit. The primary motifs defer attention from these marginal excursions; it's a bit of an effort to see them and stay there. Yet if we are tracking Hopper down, they are echo chambers for the pursuit of his identity that was his declared intention. As such they are mysterious, i.e. structurally legible, but emotionally elusive. In noir films, which frequently use this device of divided interiors, off-centre spaces become menacing.[29] How Hopper cues attention, a kind of stage management, if you will, distributes the watcher's gaze in modes that quietly subvert the obvious. Invitations are offered, and there is a constant testing of the invited. Just as Hopper sought the unofficial and unimportant to paint, he included enough of it in his paintings to further blind the casual gaze.

It would be difficult (or too easy) to connect specific films with specific Hopper paintings, not because there is a scanty list

of candidates but because there is a generous plenitude. Again and again, the fall of light on a wall in a movie, or a dark doorway or window, summons an abrupt memory of a Hopper interior. How directly film influenced Hopper's work is not too mysterious. Hopper, like the rest of us, collected a casual file of images from a lifetime of looking at films. Hovering between lost narratives and vanished contexts, they conjugate other images in memory's ceaselessly undulating terrain. Hopper's early work consummated faithful marriages with what he called 'the fact'. As he got older, his method changed. Facts were internalised. Memories of buildings, streets, rooms are recalled and readied for use. Eventually, he put compositions together from several sources,[30] including, undoubtedly, film images. I would place the zone where this change began around 1940, when he painted *Office at Night*, and it codified with *Conference at Night* in 1949. This interior method (so clear in the last few paintings) explains the increasing simplicity of his compositions, their pentimenti, and slight transgressions of perspective. Fidelity

to the fact is still important, but the fact is now primarily internal and conceptual. Many of the late interiors assemble simple blocks of 'furniture', which announce themselves as 'chair', 'window', 'street', 'houses' with some of the abstract quality of language in naming things. These late paintings, in their reductivism, clarity and expressive force, signal not so much a change in style as a style of old age: when literal accuracy gives way to emotional imperatives. The point made here, however, is that they have the directness of some film images, with particular attention paid to the framing edges.[31] As such, they recall the un-prefaced look we cast at the movie screen.[32]

How does Hopper's mild stare (more apt in his case than 'gaze') relate to the vexed question of the camera's eye? The camera's oculus is heated by competing theories, from foregrounding its mechanics to emphasising its supposedly omnipotent surveillance. These notions may tend to neglect the way in which each film re-defines the camera, the blank resistance of which is mobilised through a variety of

usages. Both the camera's and Hopper's eye are often charged with voyeurism. The unseen spy peering through windows carries an unpleasant taint of exploitation, reinforced, in Hopper's case, by his few paintings of naked, harshly sexual women. Does Hopper's male gaze reify its object, remove it from its discourse with its setting? In Laura Mulvey's classic exposition with regard to film, the male gaze, given voyeuristic opportunities, halts the flow of narrative time.[33] The internal brokerage of glances monitored and shared by the observer who 'parallels' the film's time is forestalled. How does this apply to a painting, where the same image is recycled moment to moment, the 'movie' perma-nently stopped? And particularly to the paintings of naked women alone?

These paintings run an increasingly stark gradient, from the ruminant woman with a towel in *Morning in a City*, past the tough dame on her plank of light in *A Woman in the Sun* 1961 (pp.214–15), her environment bare as herself, to the blatant stripper in *Girlie Show* 1941 (fig.86), something of a surprise in Hopper's work.[34]

Two of these women are in the familiar reverie, though its content obviously differs. The third, the stripper, is at work, body lacquered, eyes professionally glazed.

The last two paintings, particularly, test Mulvey's proposition as transferred to painting, where the figure's context is immediately and permanently readable. What applies to all Hopper's interiors with figures still applies to these paintings. Everything in the picture weighs into its sum; all of the picture matters. Attention circulates on and around the women. The window in *A Woman in the Sun* is a powerful void. The sinewy bodies in both paintings are balanced between attraction and repulsion (though this is always a matter of individual taste). Intimacy and distance are each made available through the operations of the other, a familiar Hopper strategy. How well this works in *Girlie Show*, which is redolent with the proper (or improper) atmosphere of unapologetic distaste and open fascination, is questionable. Hopper felt the need to test his method (somewhat to his posing wife's puzzlement) on the most loaded of subjects: blatant sexual

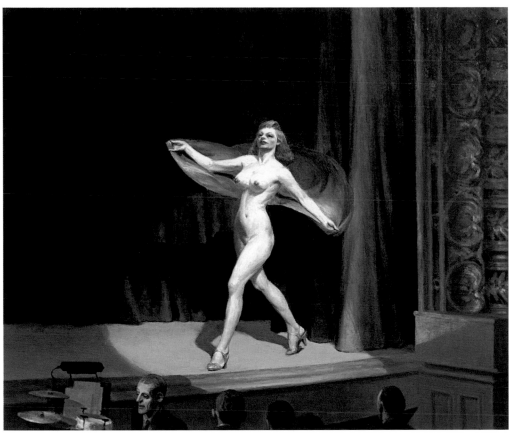

Fig.86
Girlie Show 1941
Oil on canvas 81.3 x 96.5
(32 x 38)
Private Collection
O-319

desire. The watcher here is urgently male, and, despite Hopper's relatively calm stare, conjures up the classic amalgam of contempt, fear and otherness that attended ritualised desire in these vanished cathedrals of lust, which also attracted the attention of Edmund Wilson and Roland Barthes.[35] The vulpine face of the drummer, a portrait of bored lechery, disinvites the watcher from identifying with the four 'jerks' to the right. Both paintings are remarkable for the nakedness of the stare with which they are accessed, and in *Girlie Show*, for the naked power of the stripper in mid-strut. The absent artist has been replaced by the watcher (a more apt term here than 'spectator') who, often bereft of foregrounds, is generally an eye.

Hopper's eye and the camera's eye, superimposing, sliding apart, describing the nature of their common and separate observation, seems an apt conjunction for an artist who has gathered a legion of movie cameramen behind his 'lens'. Christian Metz's theory of the camera, despite its many revisions, is always useful – as the spectator 'identifies with himself as look,

the spectator can do no other than identify with the camera ... which has looked before him at what he is now looking at'.[36] While this tends to confirm the watcher's omnipotence, the transcendent obverse of the peeping spy, it does not suffice to describe the nature of Hopper's observation, though the omnipotence notion may be supported by the variety of frequently elevated view-points. The nature of Hopper's observation is instructed by his discussion of the self, an artificial entity that he variously named 'personality' and 'identity'. That self seemed to have been dispersed and provisional, temporarily reconstituted in his subjects.[37] That, perhaps, is a key part of Hopper's enigma – the ability to entertain a continuing state of calm dispersal while awaiting the arrival of an idea that he had not met before – and which recognised him, rather than the opposite.

[1] A master-image 'is one that assumes an iconic status with the public by immediately conveying shared values in a striking form. A masterpiece may be a master-image, but a master-image may not be a masterpiece – in fact most are not.' Barbara Novak invented the term and definition in 1972 to describe many of Andrew Wyeth's paintings.
[2] This and subsequent references are from conversations between Edward Hopper and the author, henceforth cited as 'Conversation'. Most of them appear in Brian O'Doherty, American Masters: The Voice and the Myth, New York 1974, reprinted 1988.
[3] William C. Seitz, 'Edward Hopper', in São Paulo 9, United States of America, Washington, DC 1967. When Barbara Novak congratulated Hopper on this honour while visiting him at St Vincent's Hospital during his last stay there, he was unimpressed: 'Do you think it matters?'
[4] Andrew Hemingway's 'To "Personalize the Rainpipe": The Critical Mythology of Edward Hopper', Prospects, 1992, pp.379–404, is an excellent summation of early Hopper criticism.
[5] Several of Hopper's paintings have appeared as tableaux in movies, which then dissolve into action. The most frequently re-enacted is Nighthawks 1942, one of two paintings represented in Pennies from Heaven (1981; directed by Herbert Ross). It also appeared in the television series The Simpsons, the seats at the counter now occupied by the cartoon characters. Nighthawks has sold thousands of posters with James Dean, Humphrey Bogart, Elvis Presley and Marilyn Monroe substituted for the characters. Turner Classic Movies (TCM) frequently prefaces its films with a montage derived from Hopper paintings, including Maccomb's Dam Bridge 1935 (The Brooklyn Museum, New York); Chop Suey 1929 (partly animated – the lady lifts her cup); Summertime 1943; and the barber's pole from Early Sunday Morning 1930. A restaurant in Vienna has

transferred Hoppers into large wall murals, including People in the Sun 1960 (Smithsonian American Art Museum, Washington, DC). I am most grateful to the incomparable Tom Luddy who generously provided much information on cameramen, directors and Edward Hopper, and to John Ptak of the Creative Artists Agency for his always helpful advice.
[6] Josephine Hopper, the artist's constant companion, a passionate pre-feminist of electric charm, both loved and resented her husband. Very well read, with a quick-silver intelligence, she was always a vivid presence, ever ready to attack her husband whose work so overshadowed her own. She viewed such attacks as evidence of her affection. A sympathetic discussion of her career as an artist by Elizabeth Thompson Colleary is 'Josephine Nivison Hopper: Some Newly Discovered Works', Woman's Art Journal, Philadelphia, Spring 2004.
[7] Joseph Ernest Renan, Vie de Jésus (Life of Christ), Paris 1863.

[8] Selden Rodman, Conversations with Artists, New York 1957: 'As far back as Coleridge, real emotion has been sacrificed to beautiful words.'
[9] Barbara Novak describes sitting with Hopper for several hours 'in very companionable silence' during his last hospital stay.
[10] See C.G. Jung: 'The more uncertain I have felt about myself, the more there has grown up in me a feeling of kinship with all things. In fact, it seems to me as if that alienation which so long separated me from the world has become transferred into my own inner world, and has revealed to me an unexpected unfamiliarity with myself'. C.G. Jung, Memories, Dreams, Reflections, recorded and edited by Aniela Jaffé, trans. Richard and Clara Winston, London 1963, p.330. The 'unfamiliarity' fits, but the 'alienation' does not, in my view, apply to Hopper.
[11] Edward Hopper, letter to Charles H. Sawyer on Manhattan Bridge Loop 1928 (Addison Gallery of American Art, Phillips Academy,

Andover), 29 October 1939.
[12] Edward Hopper, statement published in Reality, no.1, Spring 1953, p.8.
[13] Edward Hopper, 'Notes on Painting', in Alfred H. Barr Jr (ed.), Edward Hopper: Retrospective Exhibition, exh. cat., Museum of Modern Art, New York 1933.
[14] Conversation.
[15] Hopper 1939.
[16] 'The loneliness thing is overdone. It formulates something you don't want formulated.' Conversation.
[17] Hopper 1939. 'The picture [Manhattan Bridge Loop] was planned very carefully in my mind before starting it.' Also: 'It's a long period of waiting, and arising emotion.' Conversation.
[18] Hopper 1933.
[19] 'I was never able to paint what I set out to paint. That's a very crude statement in the popular mind.' Conversation.
[20] Clement Greenberg, 'Review of Whitney Annual', The Nation, 28 December 1946; reprinted in John O'Brian (ed.), Clement Greenberg: The Collected Essays and Criticism, vol.2, Chicago 1986, p.118.

'Hopper's painting is essentially photography, and it is literary in the way that the best photography is. Like Walker Evans's and Weegee's art, it triumphs over inadequacies of the physical medium ... Hopper simply happens to be a bad painter. But if he were a better painter he would, most likely, not be so superior an artist.'
[21] This conclusion recalls Flaubert's well-known comment on Madame Bovary: 'The illusion ... comes ... from the impersonality of the work.' He would seem to contradict Hopper's practice with his next comment: 'A writer must not be his own theme', then converges with Hopper again as he concludes: 'The artist in his work must be like God in his creation – invisible and all-powerful: he must be everywhere felt, but never seen.' The Letters of Gustave Flaubert, 1830–1857, ed. and trans. Francis Steegmuller, Cambridge, Massachusetts 1979, pp.229–30.
[22] The shouting woman in Four Lane Road 1956 is Hopper's most actively

engaged figure, apart from a flourish of horsemen in *Bridle Path* 1939 and a figure raking leaves in *Pennsylvania Coal Town* 1947.

[23] In early paintings of the artist's parents, the subjects meet the viewer's eye, particularly his father's exophthalmic stare. Several graphic trials for a self-portrait culminate in the painted *Self-Portrait*, done in the late 1920s (p.129). Much could be made of this self as Other, a doppelgänger wary of inspection.

[24] Once, discussing movies, Hopper said to me, 'people don't hop and jump like they do in movies'. This puzzled me until I realised that Hopper had probably seen decades of silent movies, where less skilful actors attract attention with exaggerated body language. Then, Hopper may have seen the rhythms of daily life as slower even than the stylised economy of movement in sound films. Among the silent films that Hopper saw was King Vidor's *The Crowd* (1928).

[25] The watercolours, which engaged Hopper from 1923 to around 1948 (with a few later additions), are almost exclusively of landscapes and seascapes. Interiors were apparently the domain of the oil paintings. It was his wife, Josephine, who introduced Hopper to watercolour. They were shown in an inclusive exhibition at the Smithsonian American Art Museum, Washington, DC, in 1999. See Virginia M. Mecklenburg, *Edward Hopper: The Watercolors*, exh. cat., Smithsonian American Art Museum, Washington, DC, 1999.

[26] Among the films that Hopper saw were Mervin LeRoy's *Little Caesar* (1930); Howard Hawks's *Scarface* (1930); William Wyler's *Dead End* (1937); Edward Dmytryk's *Murder, My Sweet* (1944); Alfred Hitchcock's *Notorious* (1946); Orson Welles's *The Lady from Shanghai* (1948); Carol Reed's *The Third Man* (1949); and several others of noirish persuasion. Of course he also saw *The Gold Diggers of 1935* (1935); *The Keys of the Kingdom* (1944); *A Tree Grows in Brooklyn* (1945); and *Mister Roberts* (1955). He saw Robert Montgomery's *Lady in the Lake* (1946) in

which the camera's eye is the eye of the never-seen Phillip Marlowe character. The camera movements, deliberate to the point of ponderousness, may have slowed things down in a way that intrigued him. See Lucy Fischer, 'The Savage Eye: Edward Hopper and the Cinema', in Ludington Townsend (ed.), *A Modern Mosaic: Art and Modernism in the United States*, Chapel Hill 2000.

[27] 'I hate diagonals, but I like Hopper's diagonals. They're the only diagonals I like.' Conversation with Mark Rothko.

[28] The film director Sam Mendes has illuminating insights into Hopper's work: 'You look at an Edward Hopper painting and you can study where the light sources are. Often the key to his paintings is where he places the light sources.' Ray Zone, 'A Master of Mood', *American Cinematographer*, vol.83, no.8, August 2002. For this reference and other invaluable research I am grateful to Japonica Sheridan.

[29] A fine demonstration of noir lighting is staged by the

cameraman John Bailey in the 'Film Noir' segment of the thirteen-part series, *American Film: One Hundred Years of Filmmaking* (1995; produced by The New York Center for Visual History).

[30] Lloyd Goodrich: 'He selected the subject with extreme care, spending a long time looking at actual motifs and pondering them. From these various sources, elements were taken, combined, and transformed into the image that was to be realised on canvas. Of *Cape Cod Evening*, for example, he wrote: "It is no exact transcription of a place, but pieced together from sketches and mental impressions of things in the vicinity. The grove of locust trees was done from sketches of trees nearby. The doorway of the house comes from Orleans about twenty miles from here. The figures were done almost entirely without models, and the dry, blowing grass can be seen from my studio in the late summer or autumn".' 'The Process of Creation', in Lloyd Goodrich, *Edward Hopper*, New York

1971, p.129.

[31] 'Do you consider the frame?' 'I consider it very forcibly.' Conversation. The film director Sam Mendes: 'Compositionally, Hopper constantly ensures that your imaginary eye is guided off the frame of the picture. You begin to imagine what's on either side of the frame. In other words, what's important is what is off-camera.' Ray Zone 2002. This holds true for several paintings (including *Early Sunday Morning*) and reflects Hopper's declared intention with respect to *Manhattan Bridge Loop*: 'Carrying the main horizontal lines of the design with little interruption to the edges of the picture, is to ... make one conscious of the spaces and elements beyond the limits of the scene itself.' Hopper 1939. Most paintings, however, are firmly locked within their bounding edges.

[32] Katherine Manthorne, 'John Sloan: The Connoisseurs and the Cinematograph', scheduled for publication in *American Art*, Winter 2004. Manthorne discusses Sloan's move from a pictorial to a

filmic mode of perception in his etchings of New York City.

[33] Laura Mulvey, 'Visual Pleasure and Narrative Cinema', in *Film Theory and Criticism*, 4th edition, ed. Gerald Mast, Marshall Cohen, Leo Braudy, New York 1992.

[34] Vivien Green Fryd, 'Edward Hopper's *Girlie Show*: Who is the Silent Partner?', *American Art*, vol.14, no.2, Summer 2000, pp.52–75.

[35] Edmund Wilson, 'Burlesque Shows', in *The Shores of Light*, New York 1952, pp.279–81; Roland Barthes, 'Striptease', in *Mythologies*, trans. Annette Lavers, New York 1972, pp.84–7. One of the last – and most famous – burlesque houses was the Old Howard Casino in Scollay Square in Boston, a venue favoured by connoisseurs of this lost 'performance' art. As practised, an ultimate modesty prevailed – lights dimming as the final, but never fulfilled, exposure approached.

[36] Christian Metz, 'The Imaginary Signifier', *Screen*, vol.16, no.2, Summer 1975, p.51.

[37] 'I don't know what my identity is.' Conversation.

It takes a long time for an idea
to strike. Then I have to think
about it for a long time. I don't
start painting until I have it all
worked out in my mind. I'm all
right when I get to the easel.

Edward Hopper, in conversation
with Suzanne Burrey, 'Edward
Hopper: The Emptying Spaces',
The Arts Digest, vol.29,
1 April 1955, p.8

[Solitary Figure in a Theatre]
*c.*1902–4
Oil on board
31.8 x 23.3 (12^1/$_2$ x 9^3/$_{16}$)
Whitney Museum of American Art,
New York;
Josephine N. Hopper Bequest 70.1418
0-37

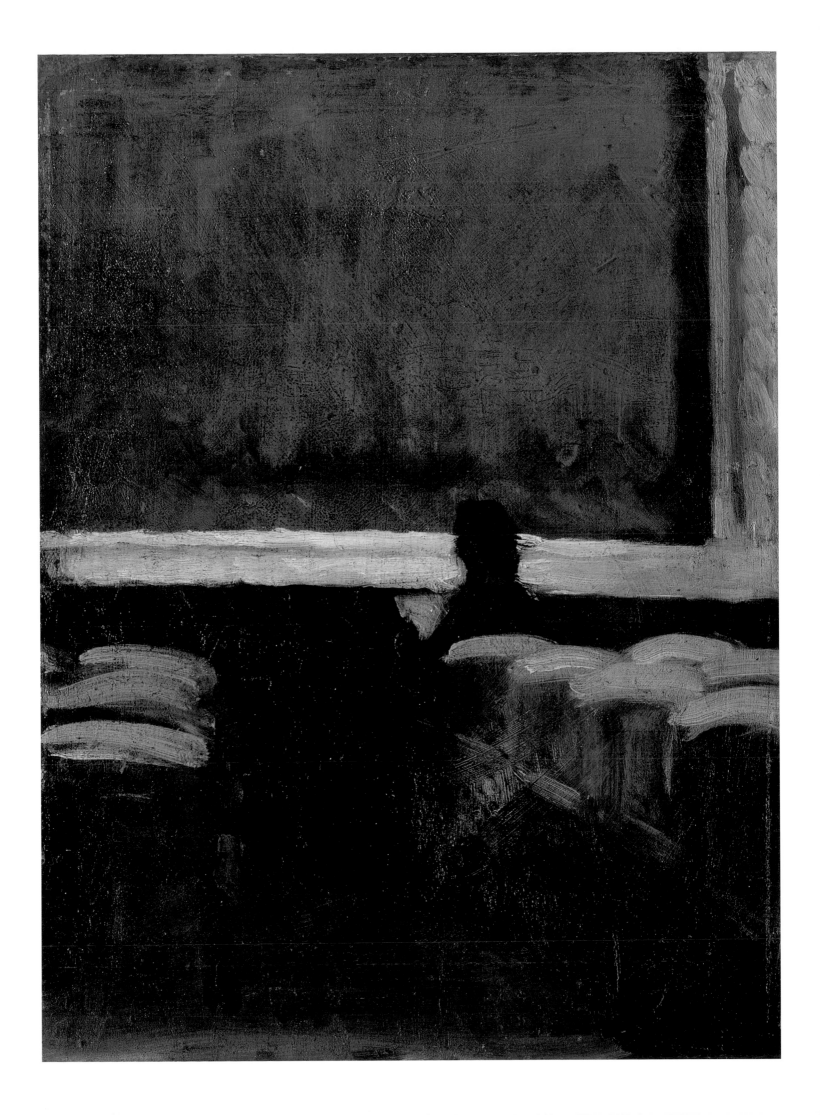

[Self-Portrait]
1903–6
Oil on canvas
66 x 55.9 (26 x 22)
Whitney Museum of American Art,
New York;
Josephine N. Hopper Bequest 70.1253
O-69

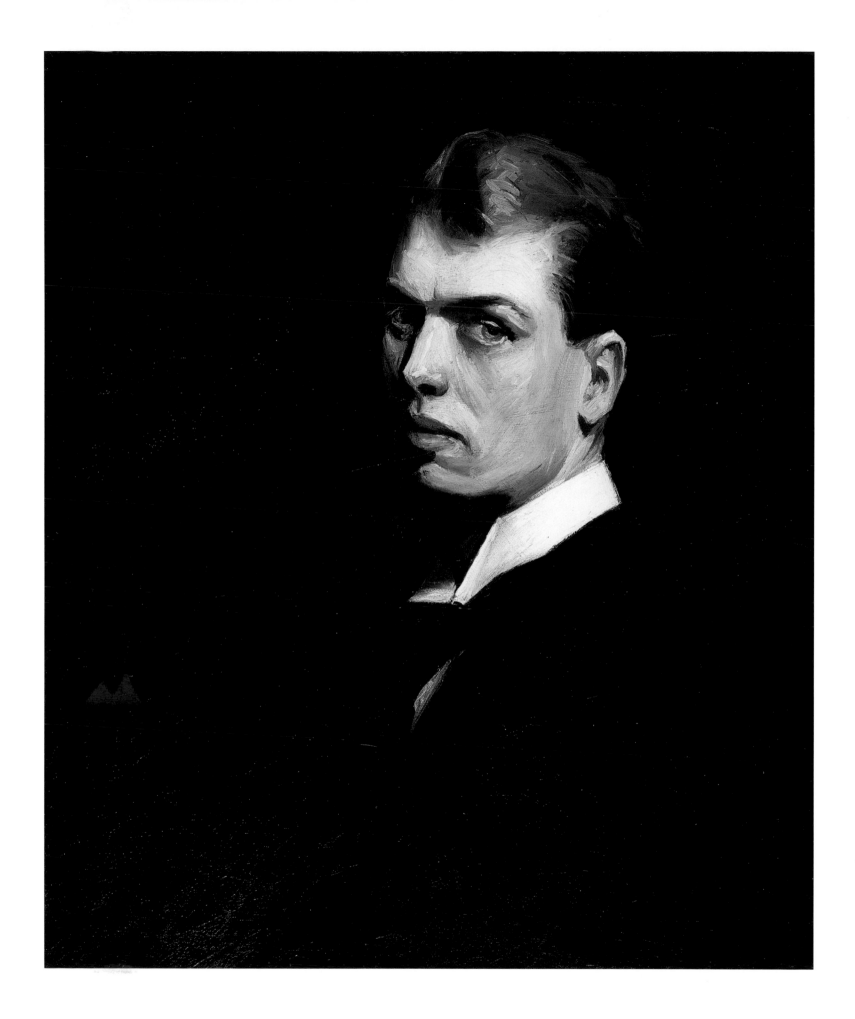

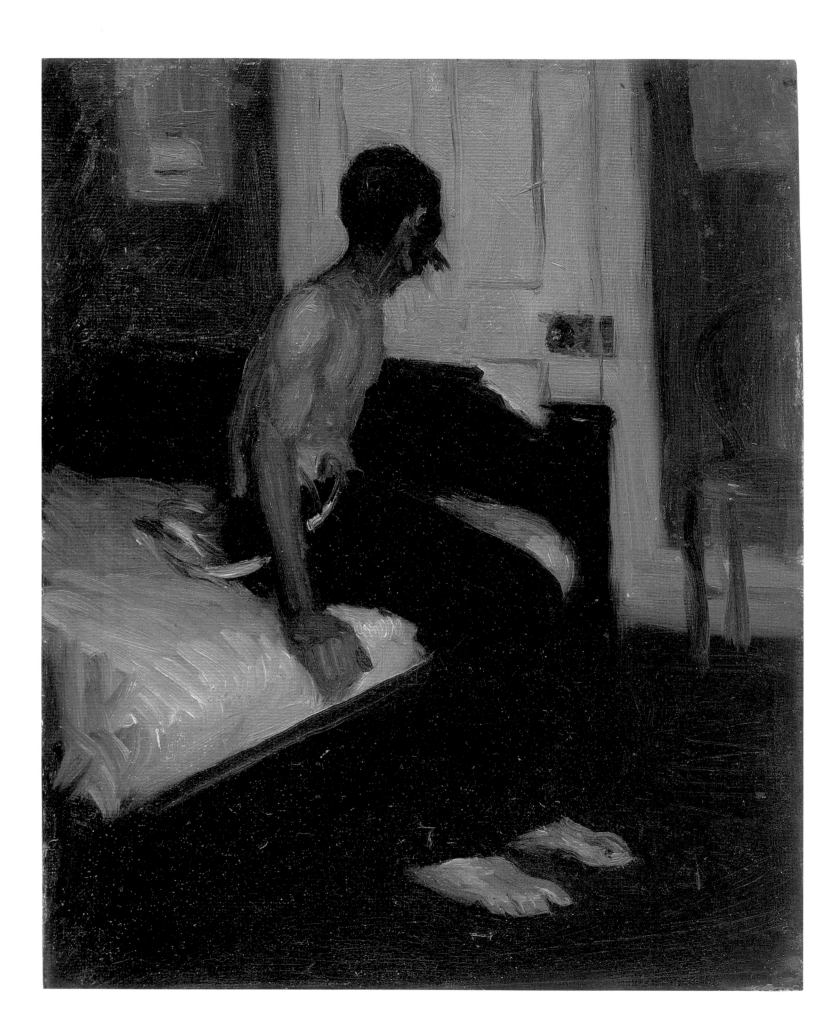

[Man Seated on Bed]
c.1905–6
Oil on canvas mounted
on wood
28.4 x 23.2 (11³/₁₆ x 9¹/₈)
Whitney Museum of American Art,
New York;
Josephine N. Hopper Bequest 70.1424
O-123

[Steps in Paris]
1906
Oil on wood
33 x 23.3 (13 x 9³/₁₆)
Whitney Museum of American Art,
New York;
Josephine N. Hopper Bequest 70.1297
O-128
Cologne only

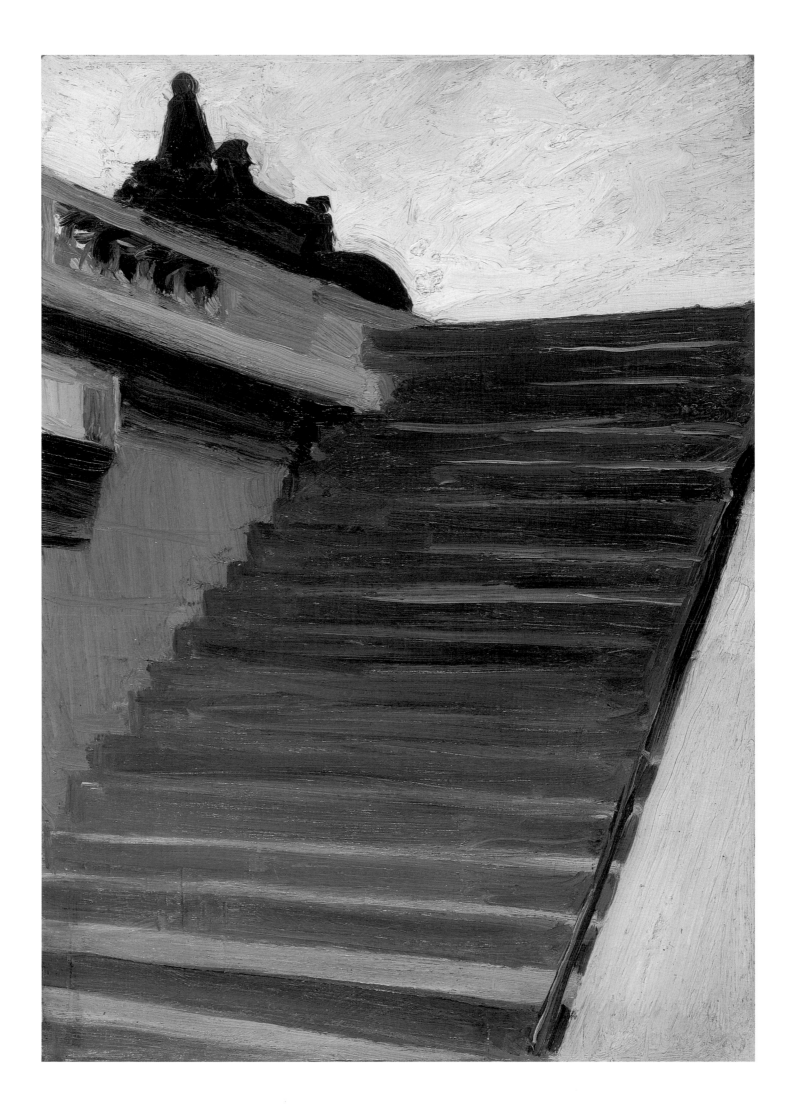

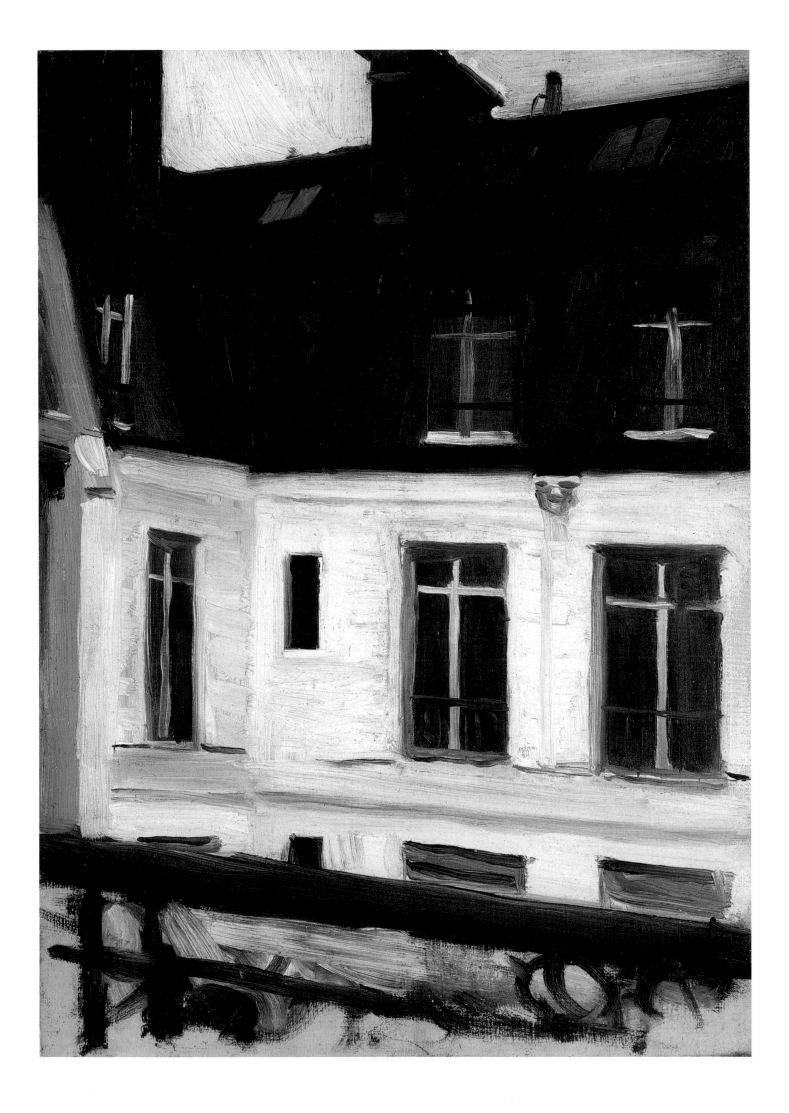

[View Across Interior Courtyard
at 48 rue de Lille, Paris]
1906
Oil on wood
33 x 23.5 (13 x 9¼)
Whitney Museum of American Art,
New York;
Josephine N. Hopper Bequest 70.1307
O-131
Cologne only

[Interior Courtyard at
48 rue de Lille, Paris]
1906
Oil on wood
30.5 x 23.5 (12 x 9¼)
Whitney Museum of American Art,
New York;
Josephine N. Hopper Bequest 70.1304
O-132

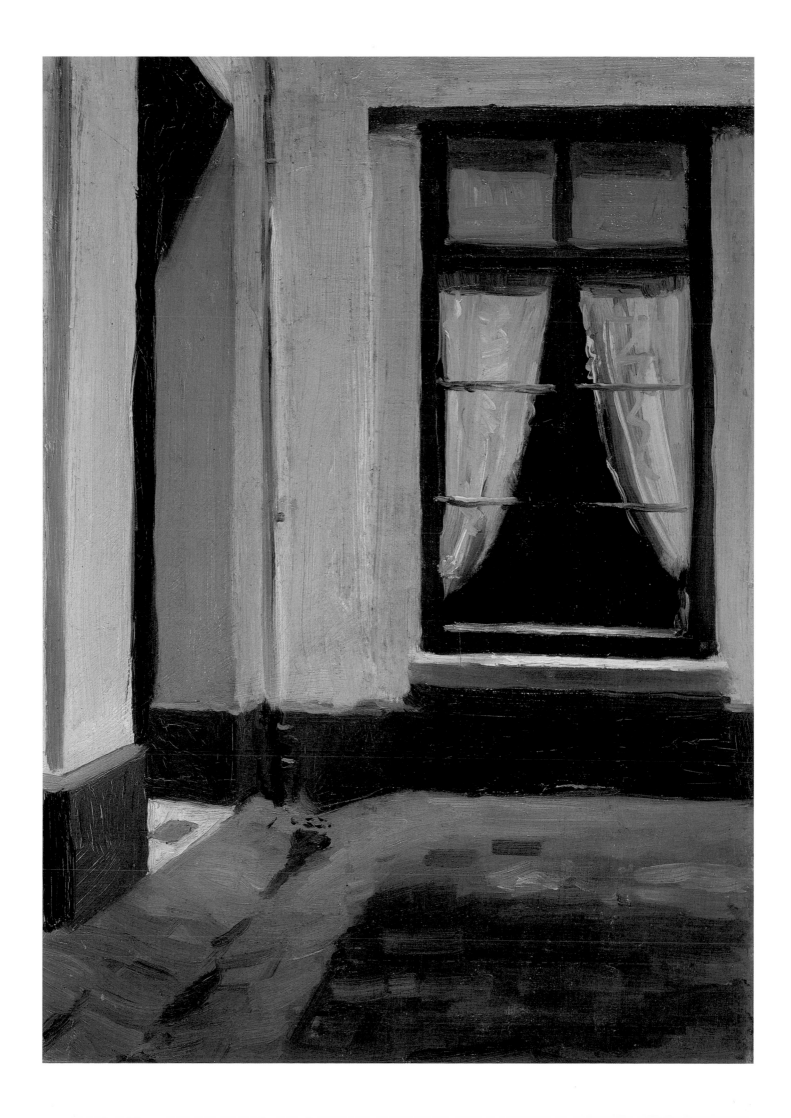

[Stairway at 48 rue de Lille, Paris]
1906
Oil on wood
33 x 23.5 (13 x 9¼)
Whitney Museum of American Art,
New York;
Josephine N. Hopper Bequest 70.1295
O-133

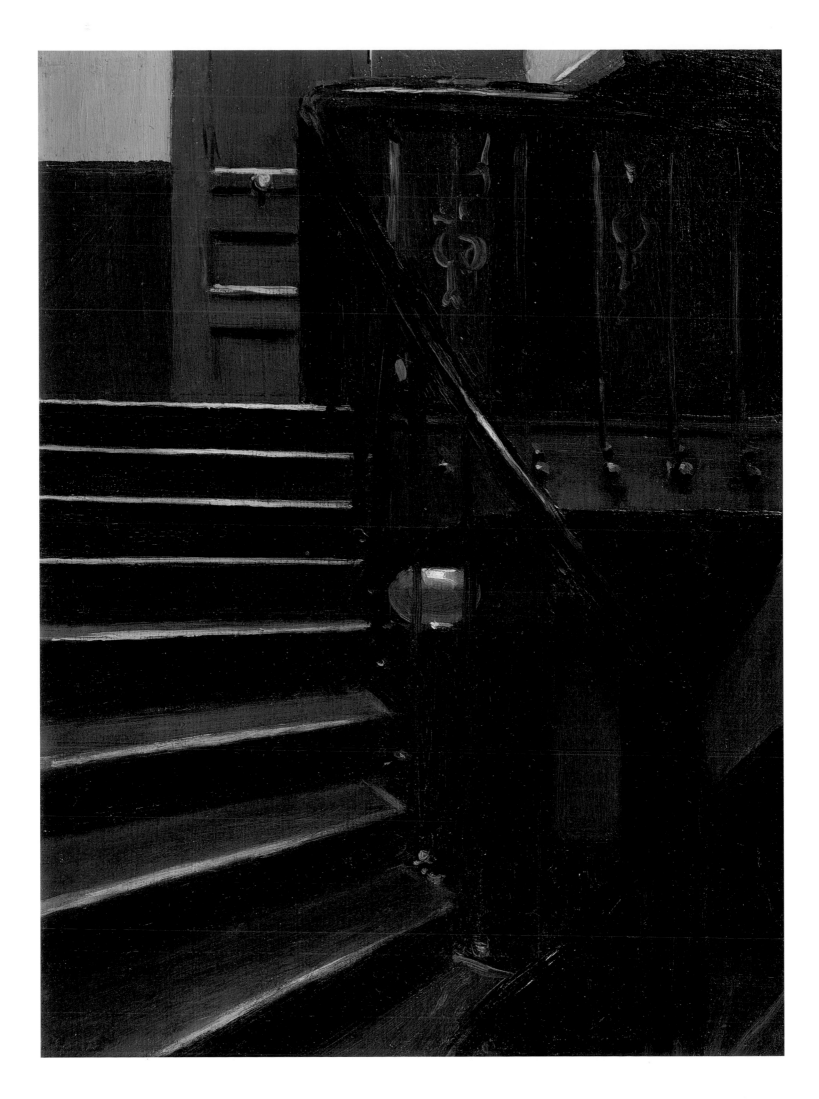

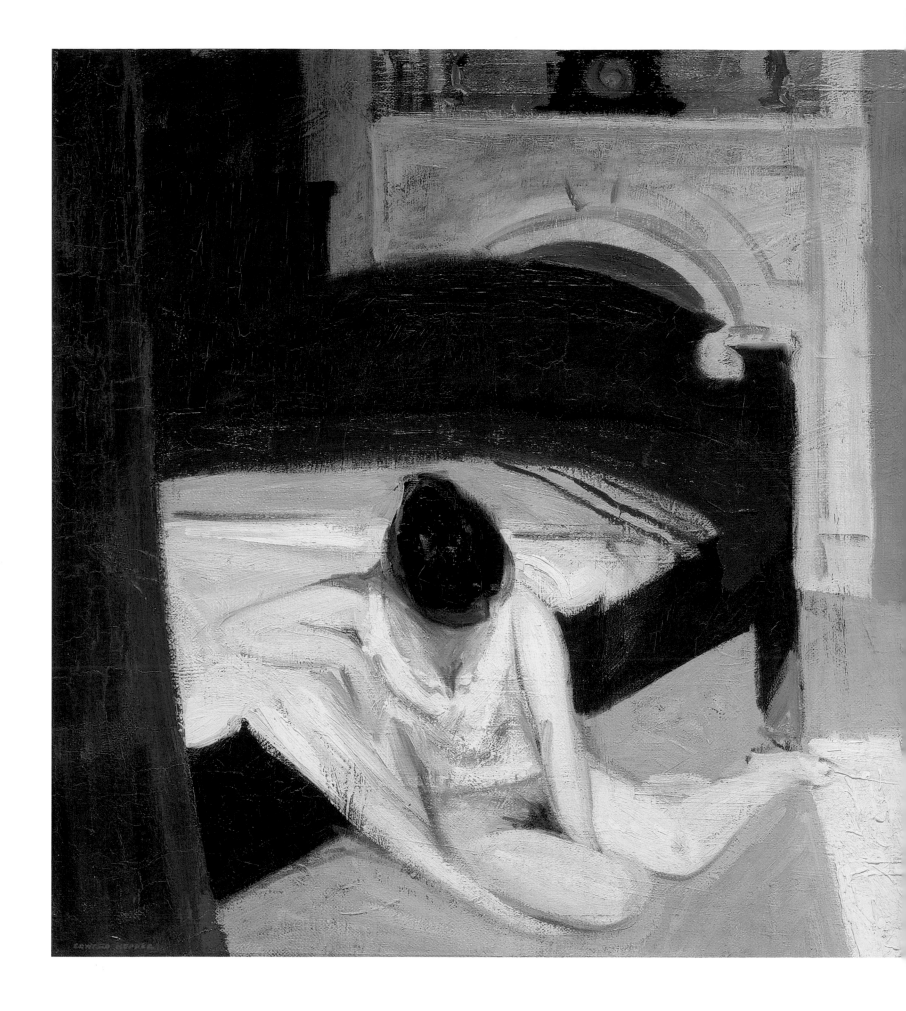

114

Summer Interior
1909
Oil on canvas
61 x 73.7 (24 x 29)
Whitney Museum of American Art,
New York;
Josephine N. Hopper Bequest 70.1197
O-175
Cologne only

American Village
1912
Oil on canvas
65.7 x 96.2 (25$^7/_8$ x 37$^7/_8$)
Whitney Museum of American Art,
New York;
Josephine N. Hopper Bequest 70.1185
O-183
Cologne only

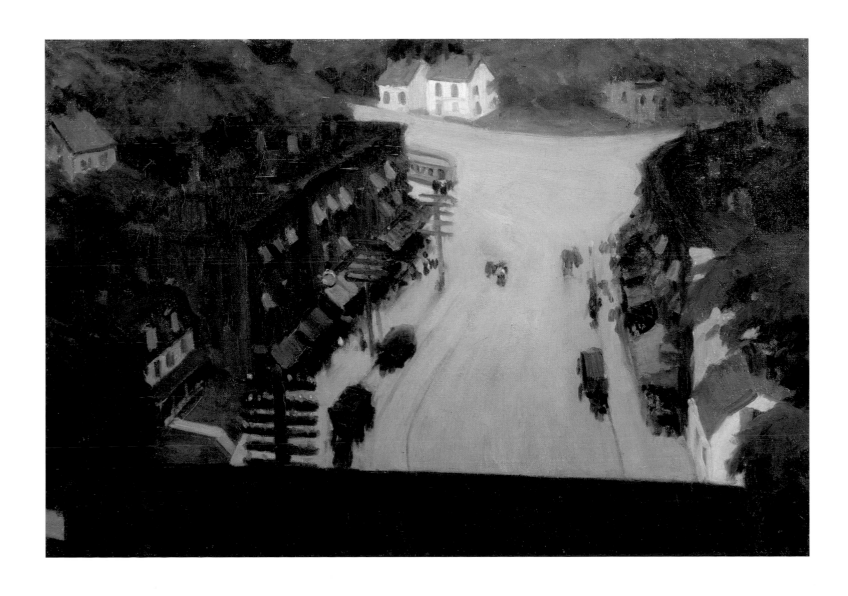

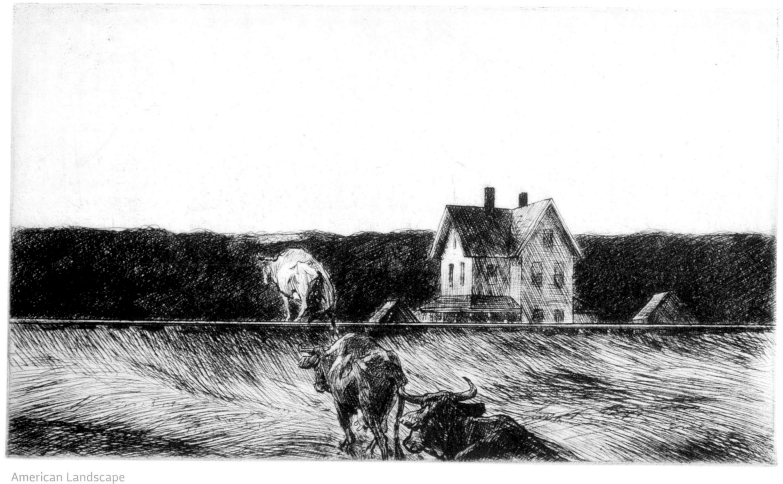

American Landscape
1920
Etching
19.7 x 32.9 (7 3/4 x 12 15/16)
Whitney Museum of American Art,
New York;
Purchase 31.690
PL. 69

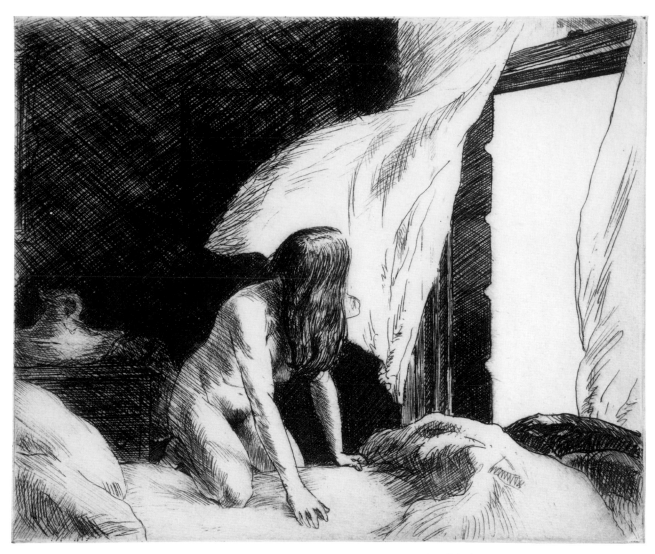

Evening Wind
1921
Etching
17.5 x 21 (6$^7/_8$ x 8$^1/_4$)
The British Museum, London
PL. 77

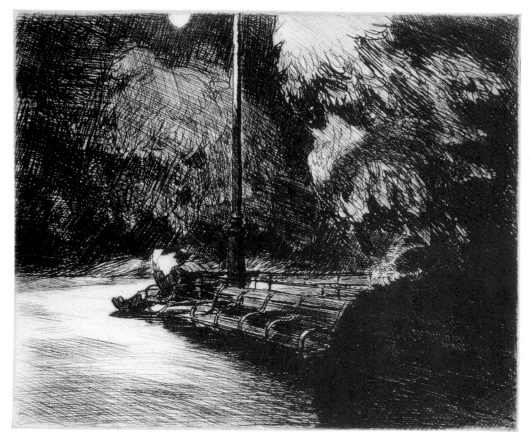

Night in the Park
1921
Etching
17.3 x 21 (6⅞ x 8¼)
The British Museum, London
PL. 80

East Side Interior
1922
Etching
20 x 25.1 (7⁷/₈ x 9⁷/₈)
Private Collection
PL. 85

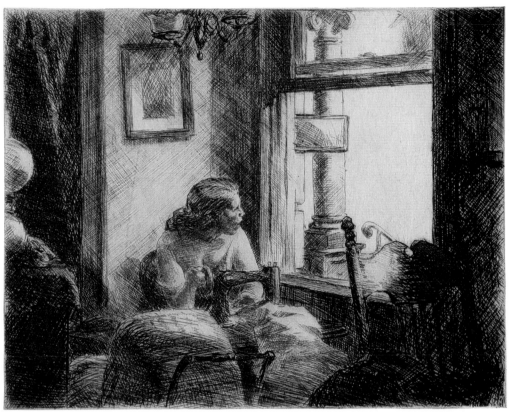

The Lonely House
1923
Etching
20 x 25.1 (7⁷/₈ x 9⁷/₈)
Whitney Museum of American Art,
New York;
Josephine N. Hopper Bequest 70.1040
PL. 102

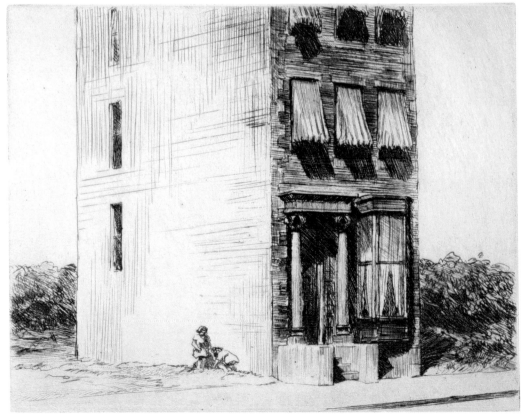

Girl at Sewing Machine
*c.*1921
Oil on canvas
48.3 x 45.7 (19 x 18)
Museo Thyssen–Bornemisza, Madrid
O-237

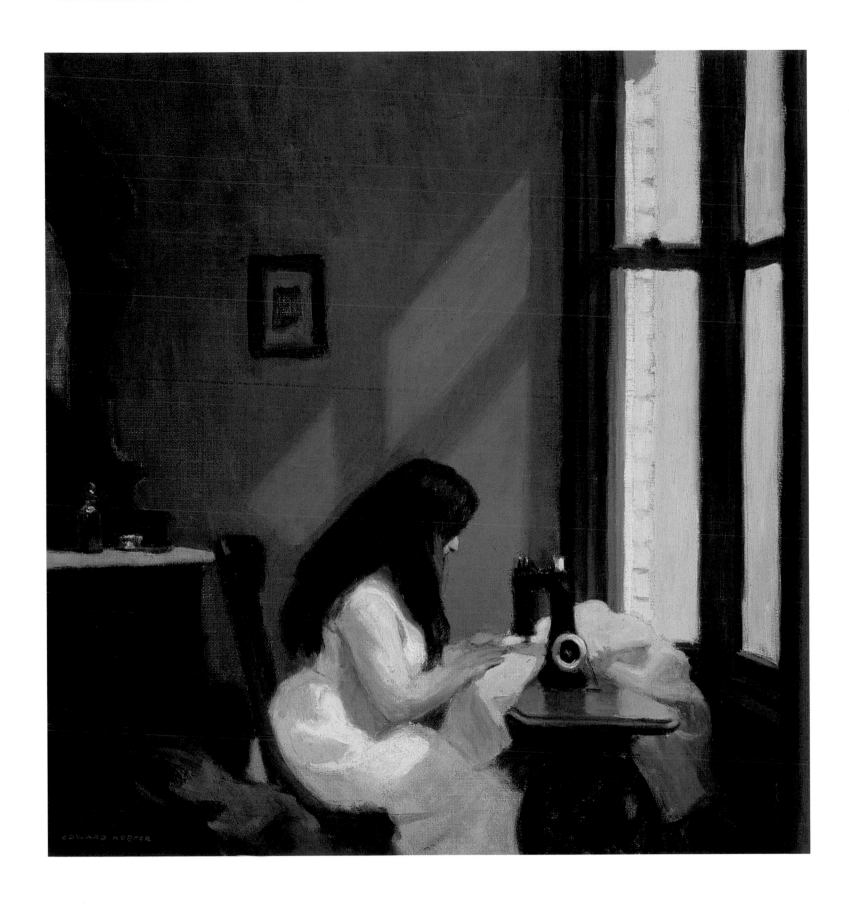

New York Interior
*c.*1921
Oil on canvas
61.6 x 74.3 (24¼ x 29¼)
Whitney Museum of American Art,
New York;
Josephine N. Hopper Bequest 70.1200
O–238

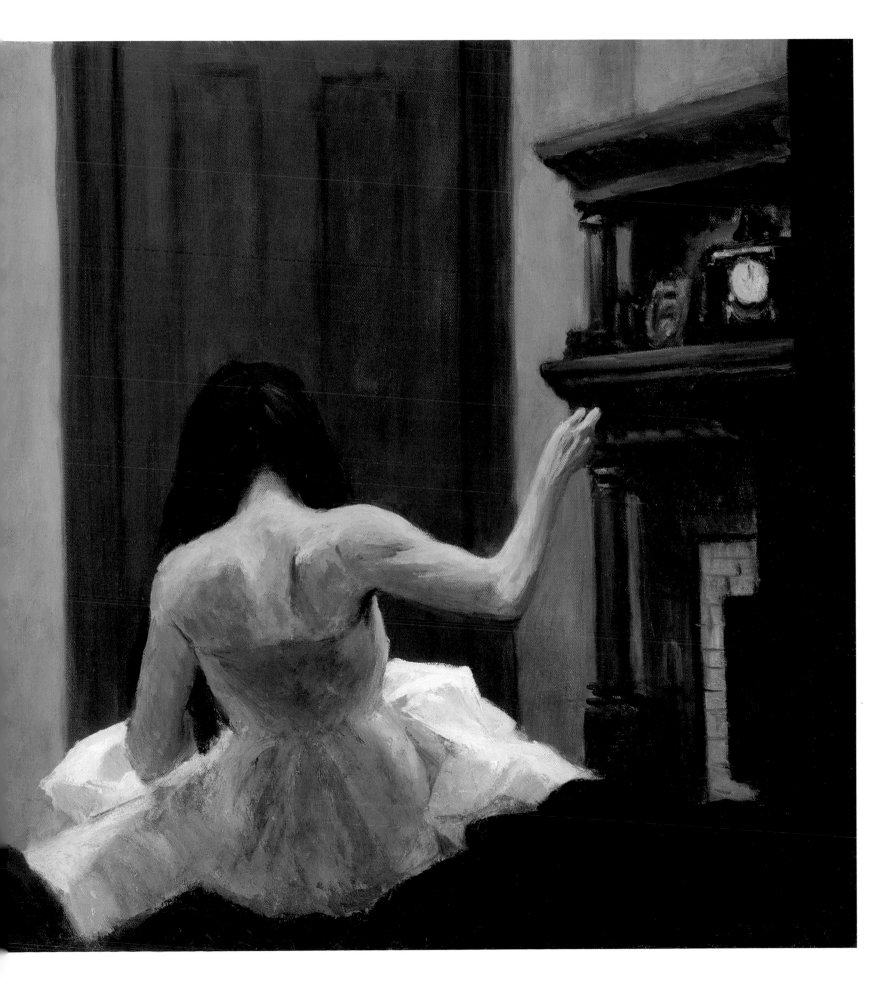

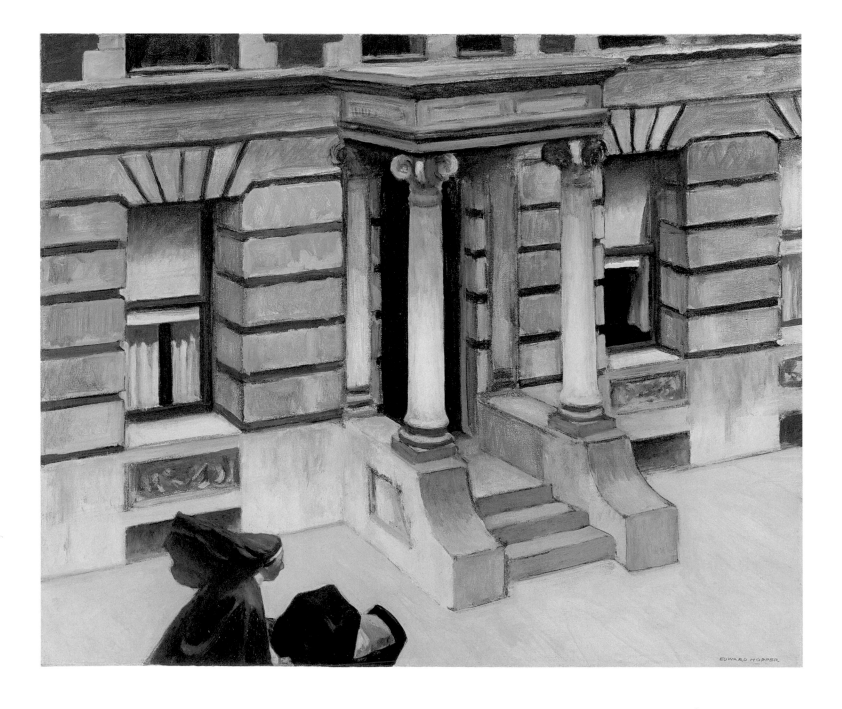

New York Pavements
1924 or 1925
Oil on canvas
62.9 x 75.6 (24³/₄ x 29³/₄)
Chrysler Museum of Art,
Norfolk, Virginia;
Gift of Walter P. Chrysler, Jr
O-243

[Self-Portrait]
1925–30
Oil on canvas
64.1 x 52.4 (25¼ x 20⅝)
Whitney Museum of American Art,
New York;
Josephine N. Hopper Bequest 70.1165
O-246

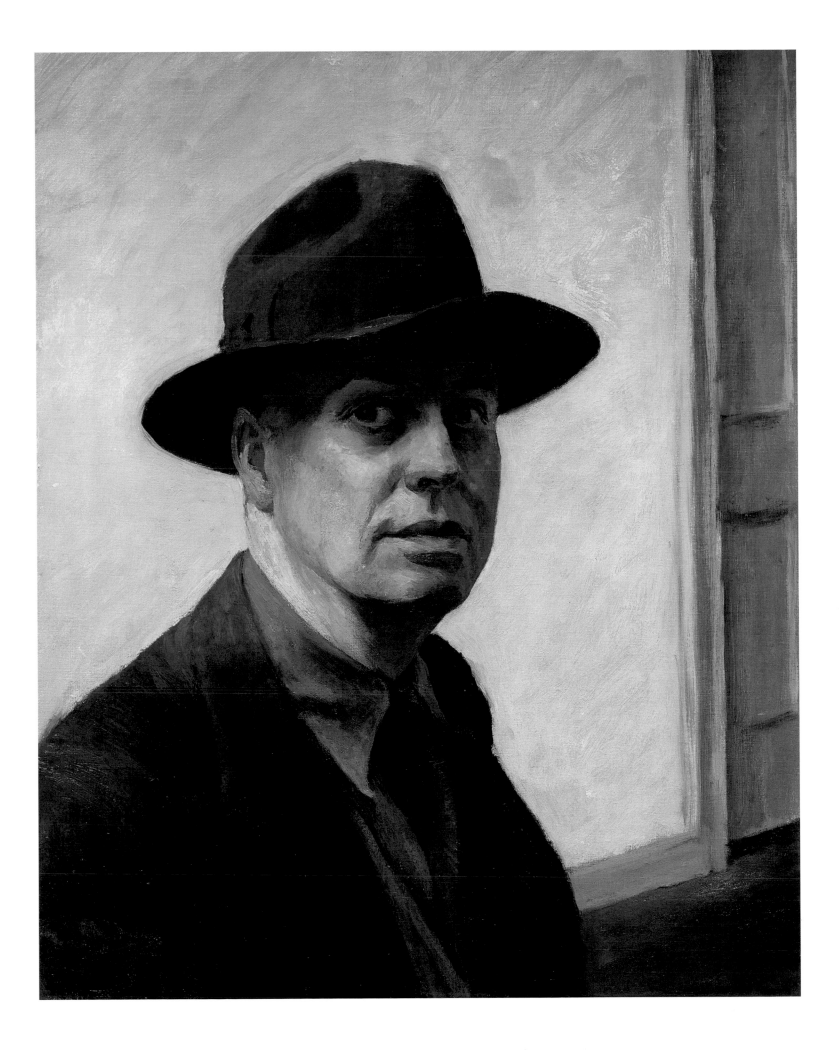

Sunday
1926
Oil on canvas
73.7 x 86.4 (29 x 34)
The Phillips Collection,
Washington, DC
O-247

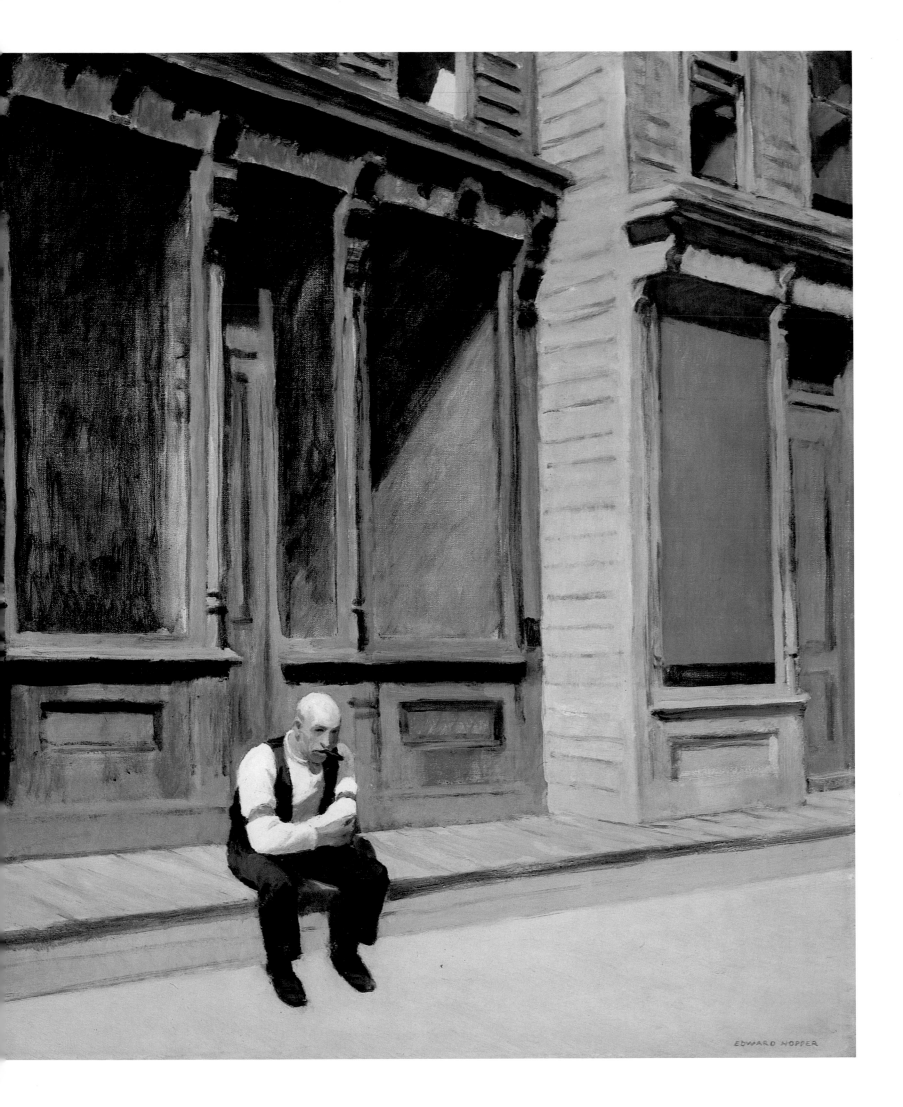

Eleven A.M.
1926
Oil on canvas
71.4 x 91.8 (28 1/8 x 36 1/8)
Hirshhorn Museum and Sculpture Garden,
Smithsonian Institution;
Gift of the Joseph H. Hirshhorn
Foundation, 1966
O-248

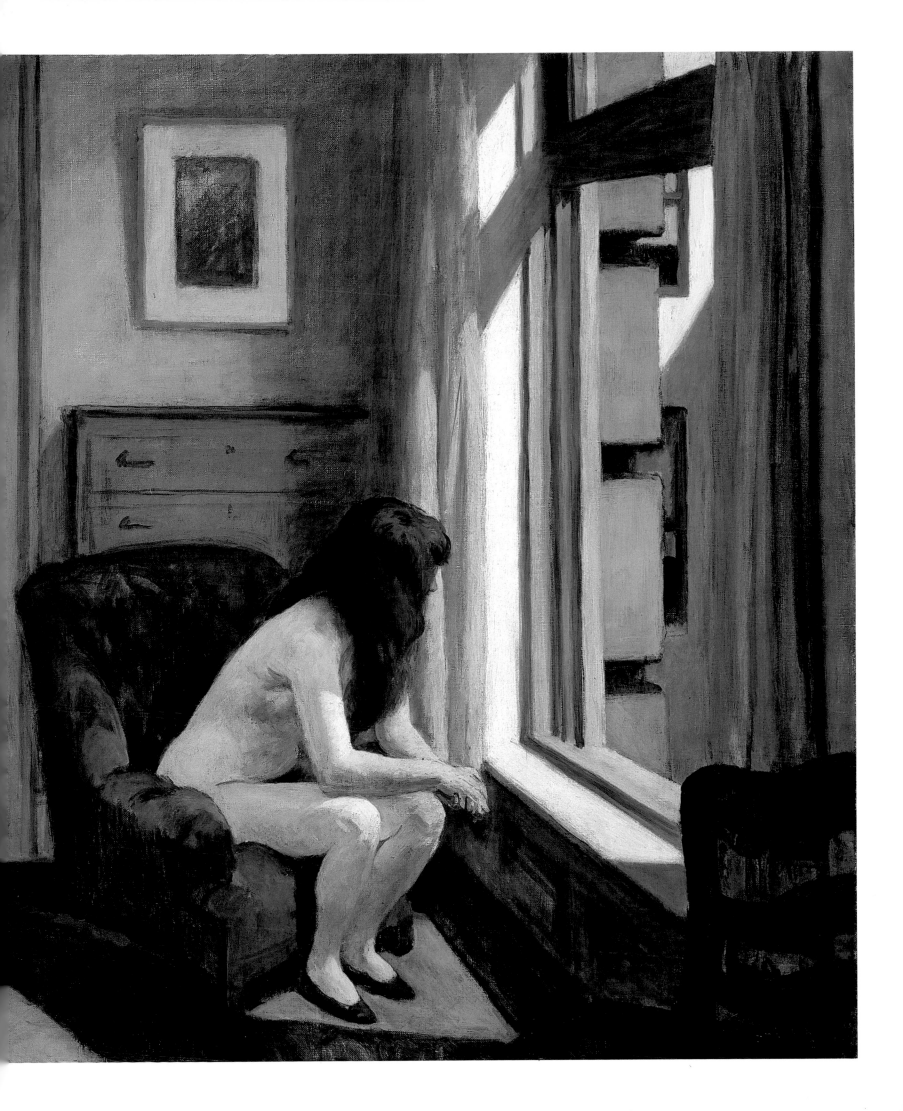

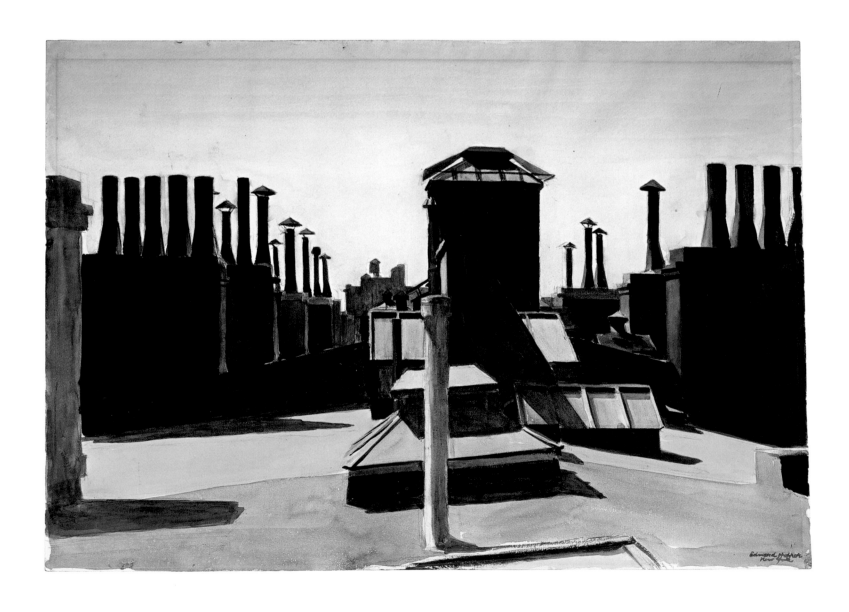

Roofs of Washington Square
1926
Watercolour over charcoal on paper
35.2 x 50.5 (13^{7}/$_{8}$ x 19^{7}/$_{8}$)
Carnegie Museum of Art,
Pittsburgh;
Bequest of Mr and Mrs James H. Beal, 1993
W-135

Haunted House
1926
Watercolour on paper
33.6 x 50.8 (14 x 20)
Collection of the Farnsworth Art Museum;
Museum Purchase, 71.1775
W-139
Cologne only

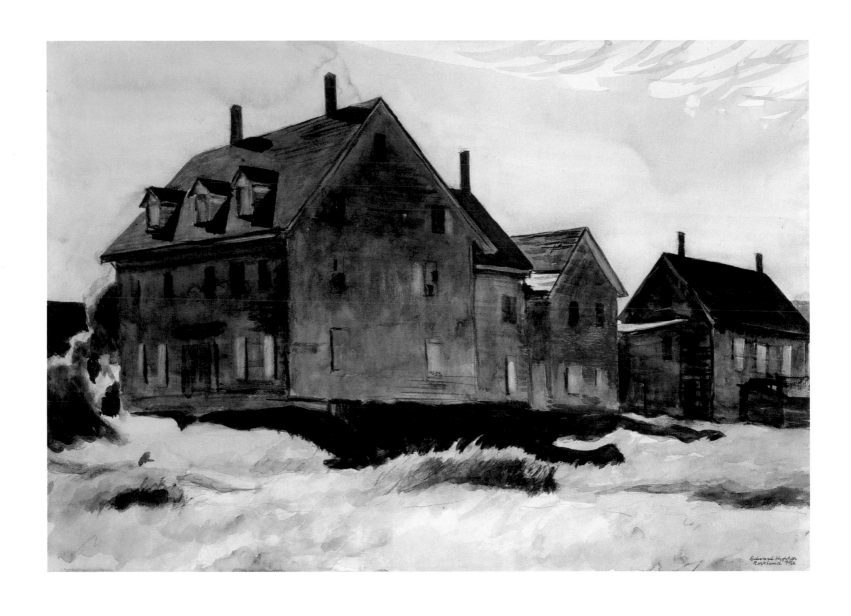

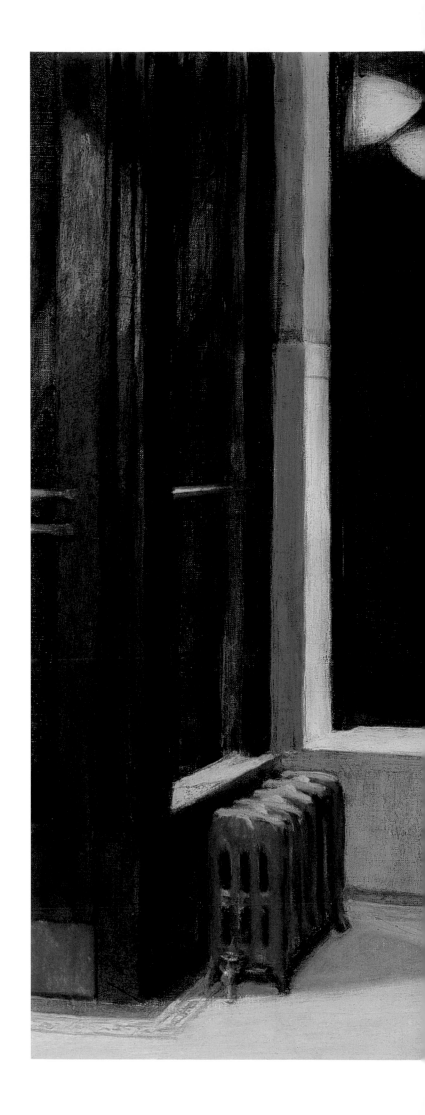

Automat
1927
Oil on canvas
71.4 x 91.4 (28 1/8 x 36)
Des Moines Art Center Permanent
Collections; Purchased with funds from
the Edmundson Art Foundation, Inc., 1958.2
O–251

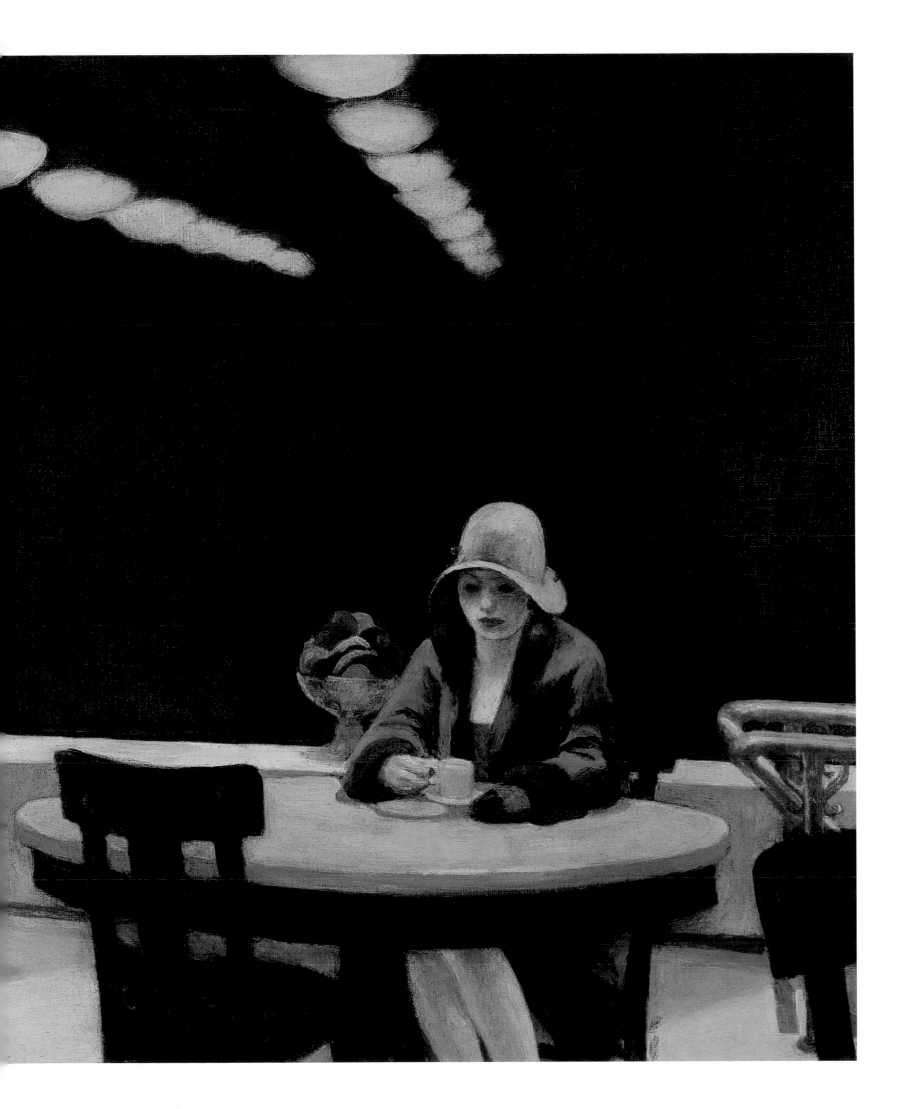

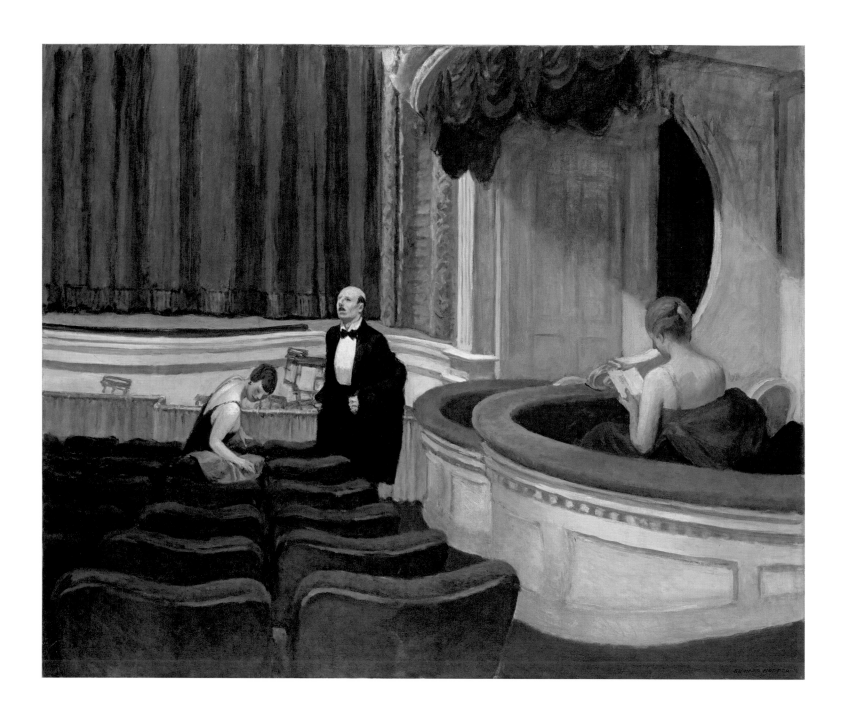

Two on the Aisle
1927
Oil on canvas
102.2 x 122.6 (40¼ x 48¼)
Toledo Museum of Art;
Purchased with funds from
the Libbey Endowment,
Gift of Edward Drummond Libbey
O-253

Lighthouse Hill
1927
Oil on canvas
73.8 x 102.2 (29 1/16 x 40 1/4)
Dallas Museum of Art;
Gift of Mr and Mrs Maurice Purnell
O-254

Captain Upton's House
1927
Oil on canvas
72.4 x 92.1 (28½ x 36¼)
Collection of Steve Martin
O-255

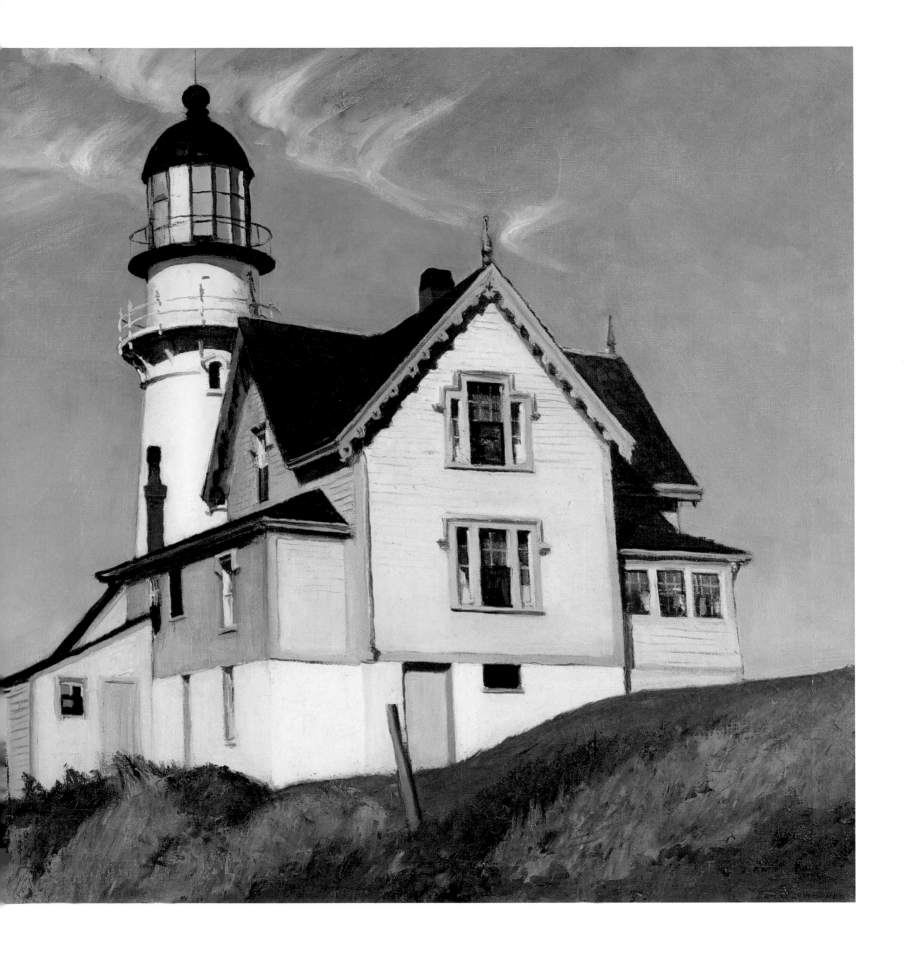

Drug Store
1927
Oil on canvas
73 x 101 (28 3/4 x 39 3/4)
Museum of Fine Arts,
Boston; Bequest of
John T. Spaulding
O-256

Two Lights Village
1927
Watercolour on paper
34 x 48.9 (13³/₈ x 19¹/₄)
Fitchburg Art Museum,
Massachusetts;
Bernadine K. Scherman Bequest, 1974.4
W-175

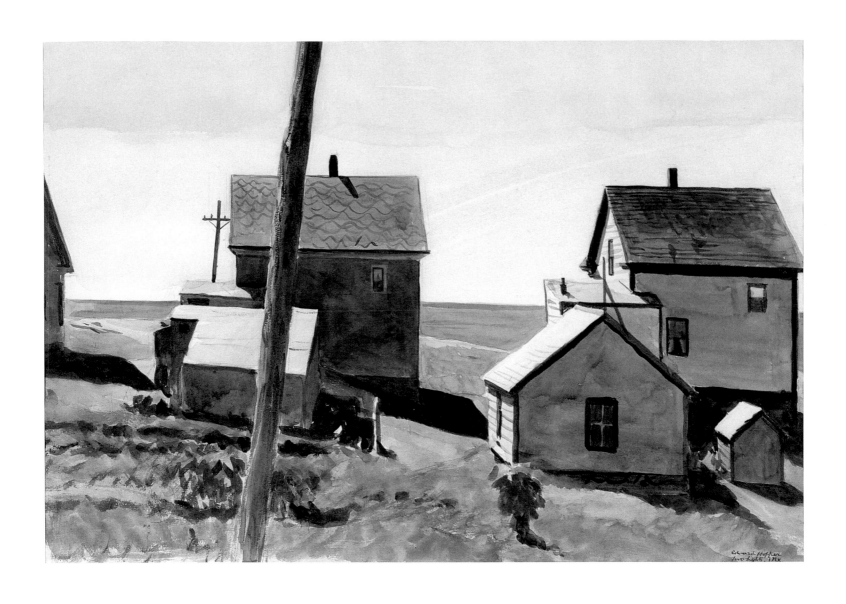

Williamsburg Bridge
1928
Oil on canvas
73.7 x 109.2 (29 x 43)
The Metropolitan Museum of Art;
George A. Hearn Fund, 1937 (37.44)
O-258

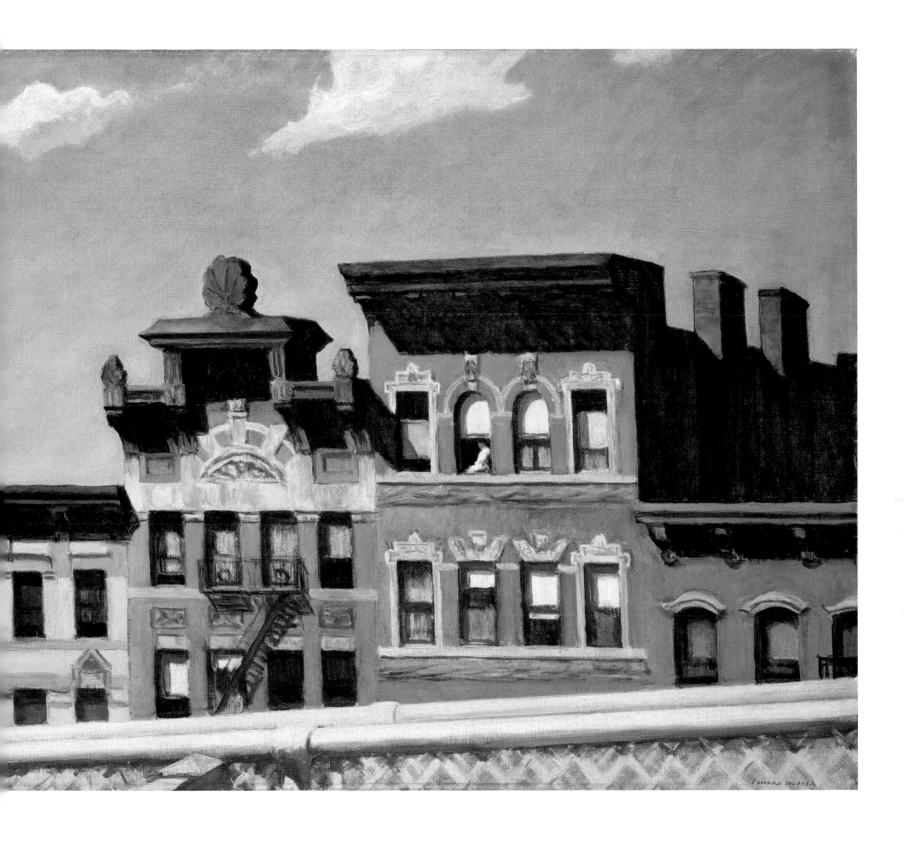

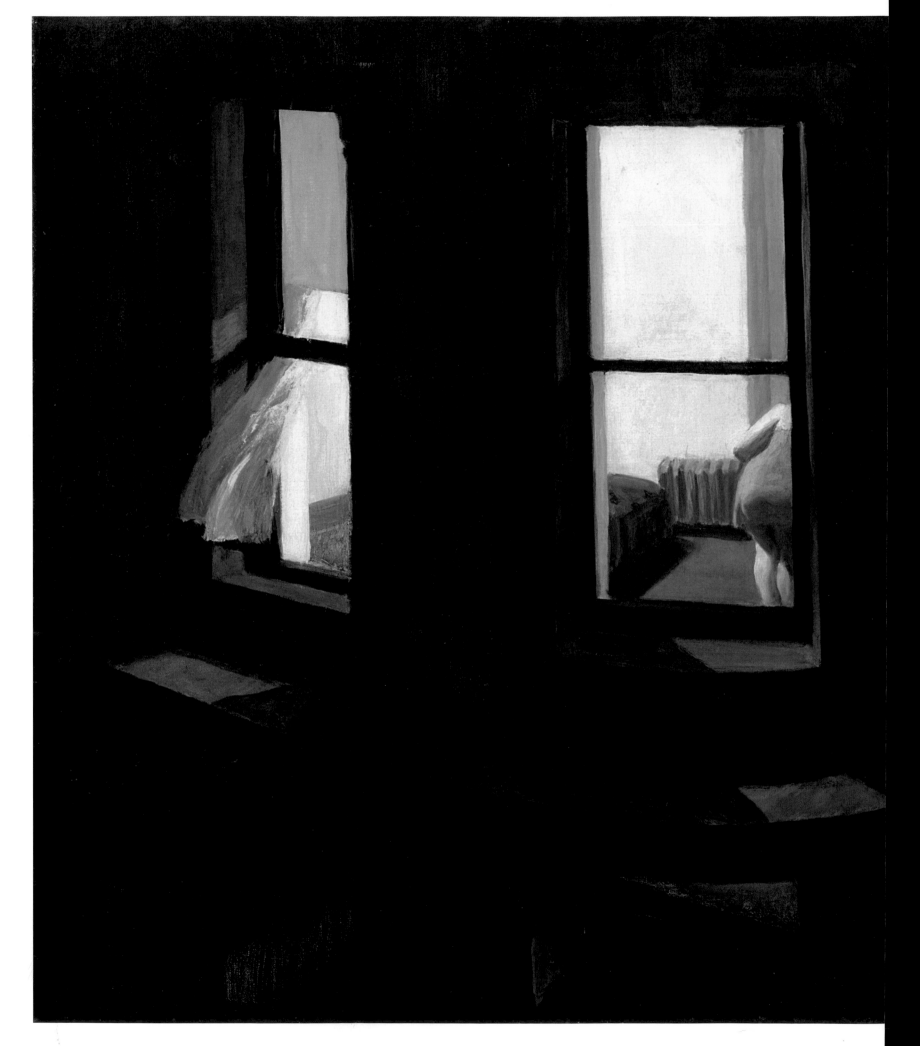

Night Windows
1928
Oil on canvas
73.7 x 86.4 (29 x 34)
The Museum of Modern Art,
New York;
Gift of John Hay Whitney, 1940
O-264

Methodist Church
1929
Watercolour on paper
35.4 x 50.6 (13 $^7/_8$ x 19 $^3/_4$)
Tacoma Art Museum;
Gift of Mrs Corydon Wagner, Sr
W-239

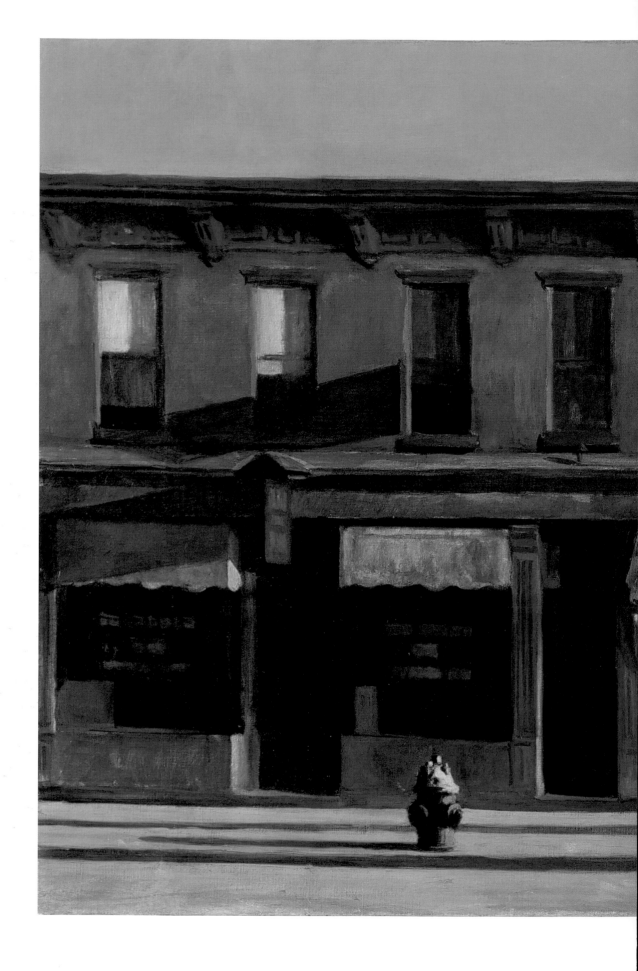

Early Sunday Morning
1930
Oil on canvas
89.4 x 153 (35³/₁₆ x 60¹/₄)
Whitney Museum of American Art,
New York;
Purchase, with funds from
Gertrude Vanderbilt Whitney 31.426
O-270

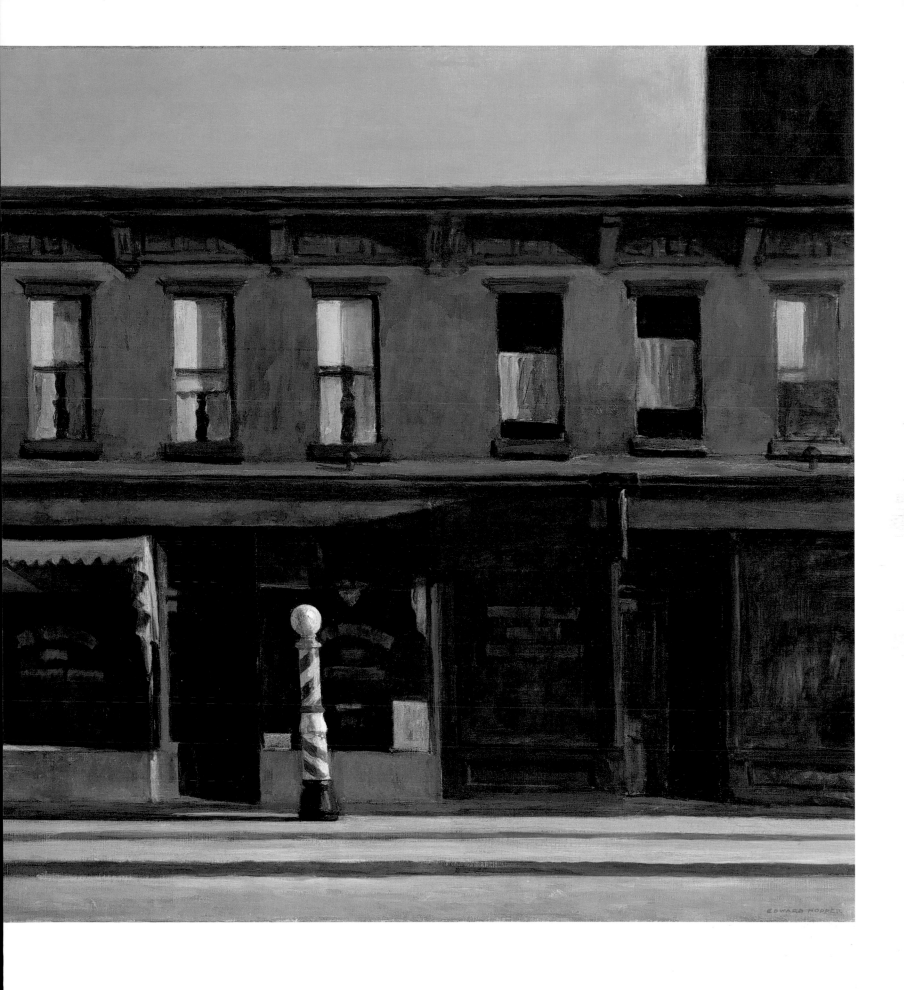

Hills, South Truro
1930
Oil on canvas
69.5 x 109.5 (27 1/8 x 42 3/4)
The Cleveland Museum of Art;
Hinman B. Hurlbut Collection, 2647.1931
O-273

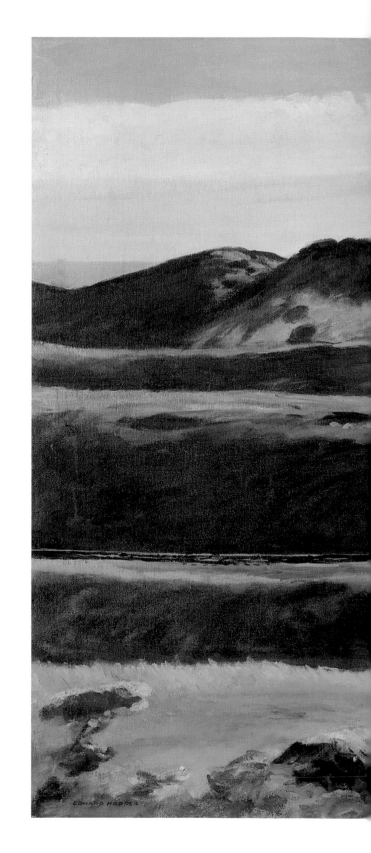

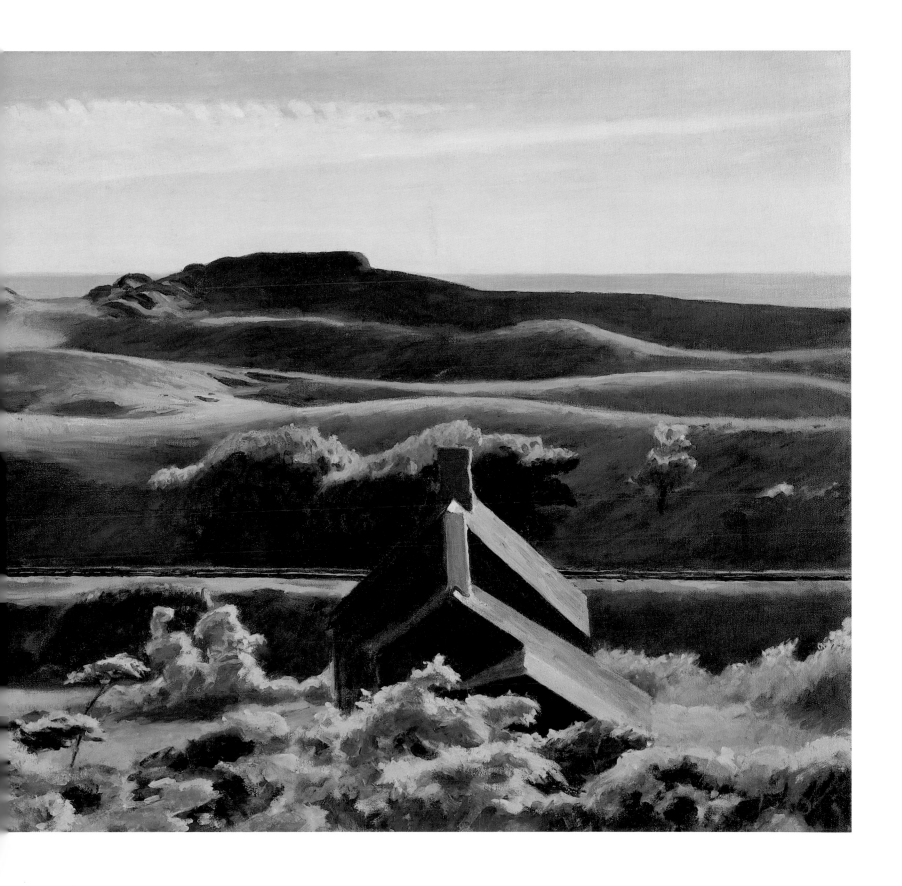

[Burly Cobb's House, South Truro]
1930–3
Oil on canvas
64.1 x 91.9 (25¼ x 36³/₁₆)
Whitney Museum of American Art,
New York;
Josephine N. Hopper Bequest 70.1210
O-276

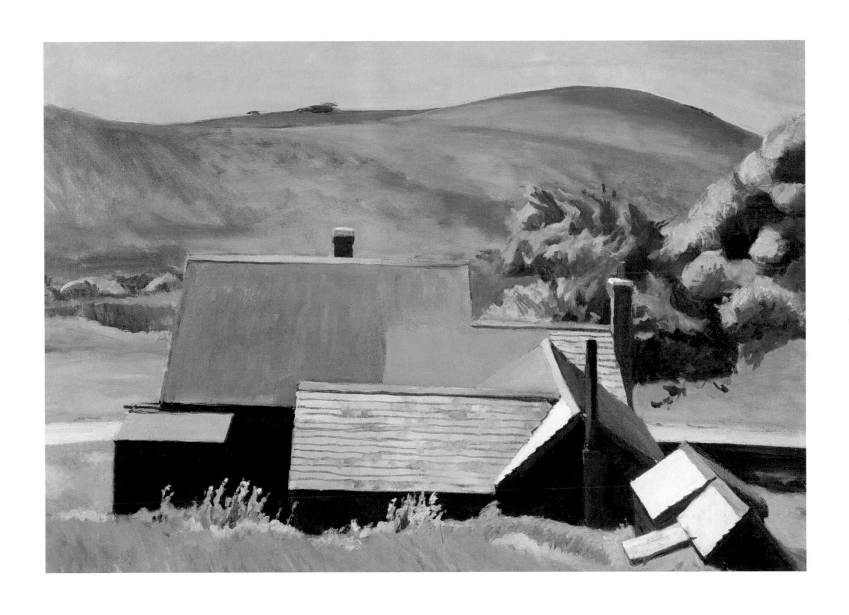

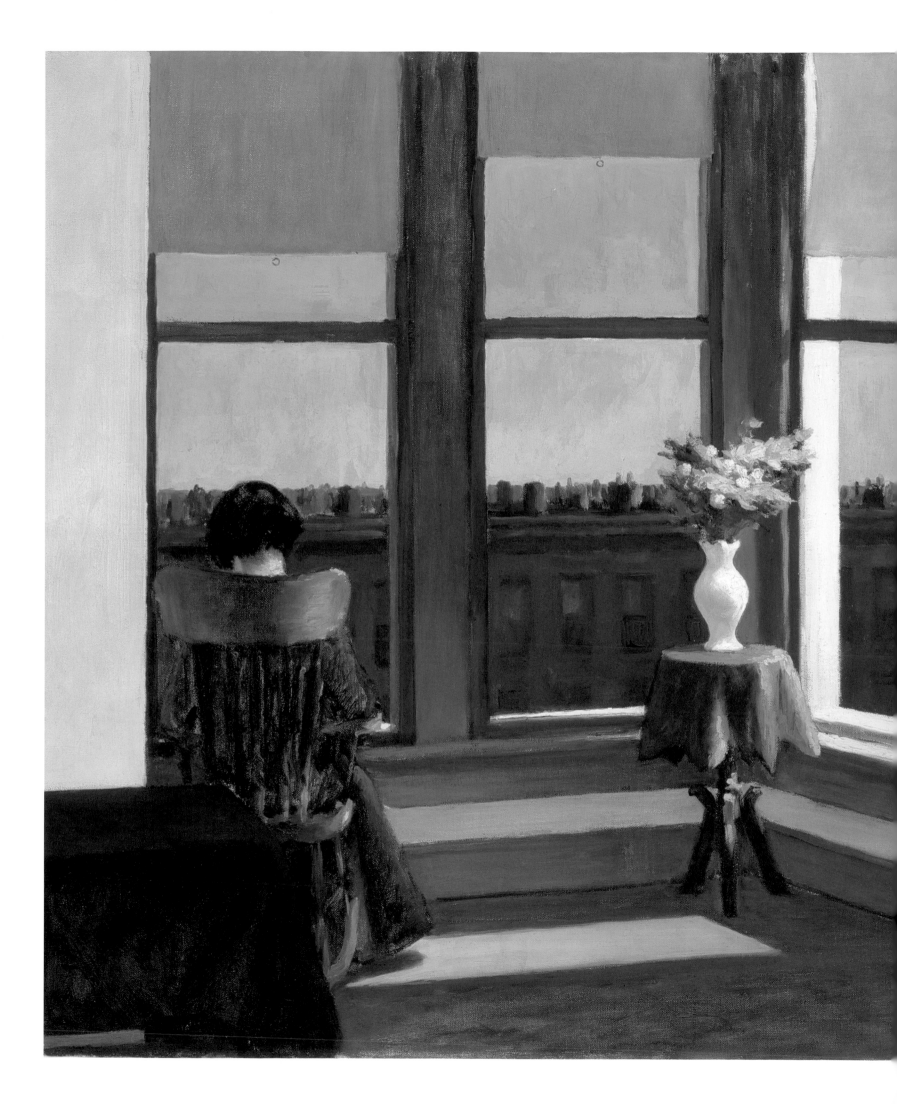

Room in Brooklyn
1932
Oil on canvas
73.3 x 85.7 (28$^7/_8$ x 33$^3/_4$)
Museum of Fine Arts,
Boston; The Hayden Collection –
Charles Henry Hayden Fund
O-284

Cape Cod Sunset
1934
Oil on canvas
74.3 x 91.9 (29¼ x 36³/₁₆)
Whitney Museum of American Art,
New York;
Josephine N. Hopper Bequest 70.1166
O-291

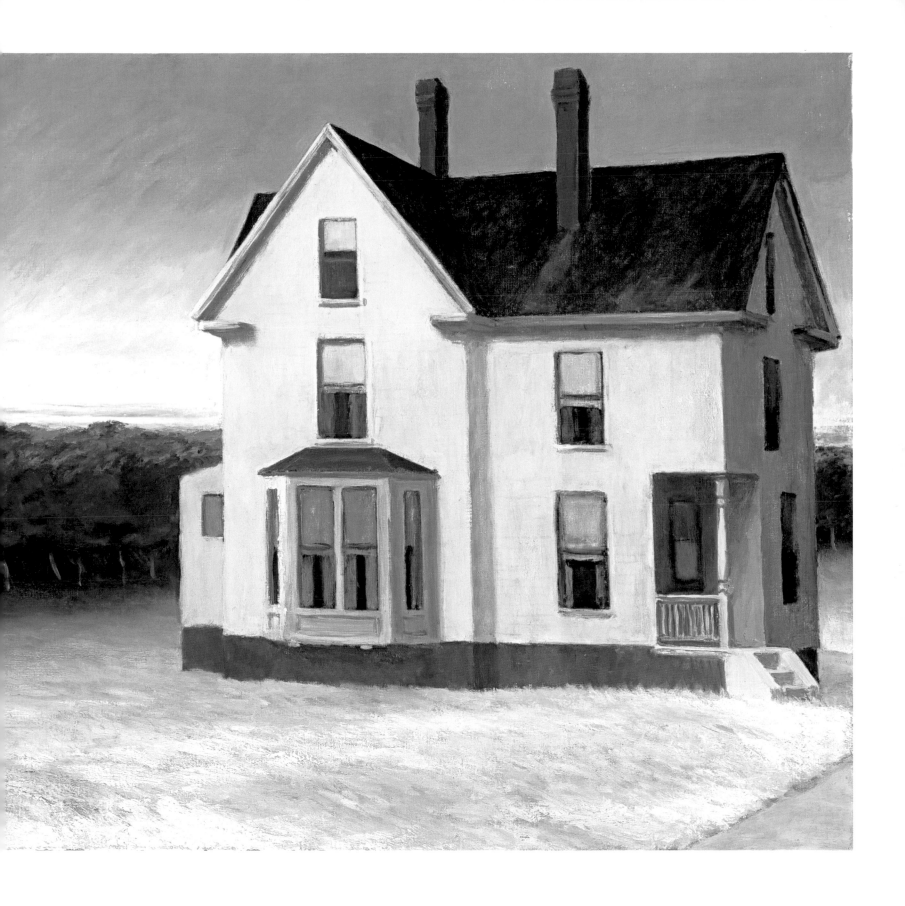

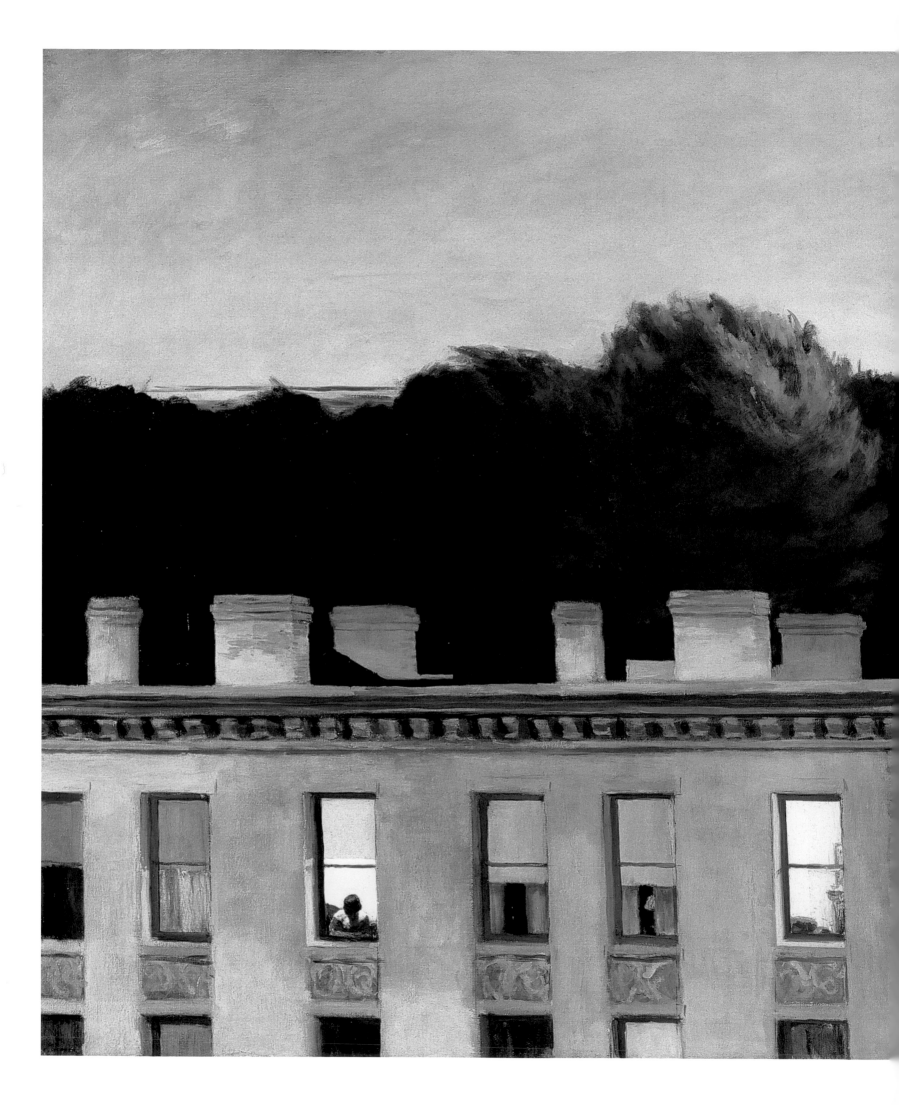

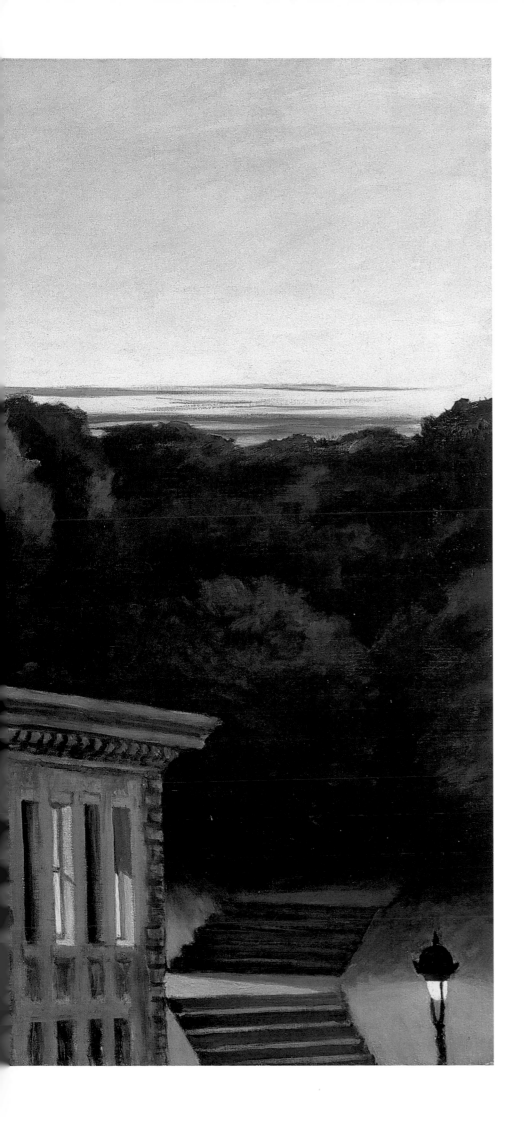

House at Dusk
1935
Oil on canvas
92.1 x 127 (36¼ x 50)
Virginia Museum of Fine Arts,
Richmond;
The John Barton Payne Fund
O-295

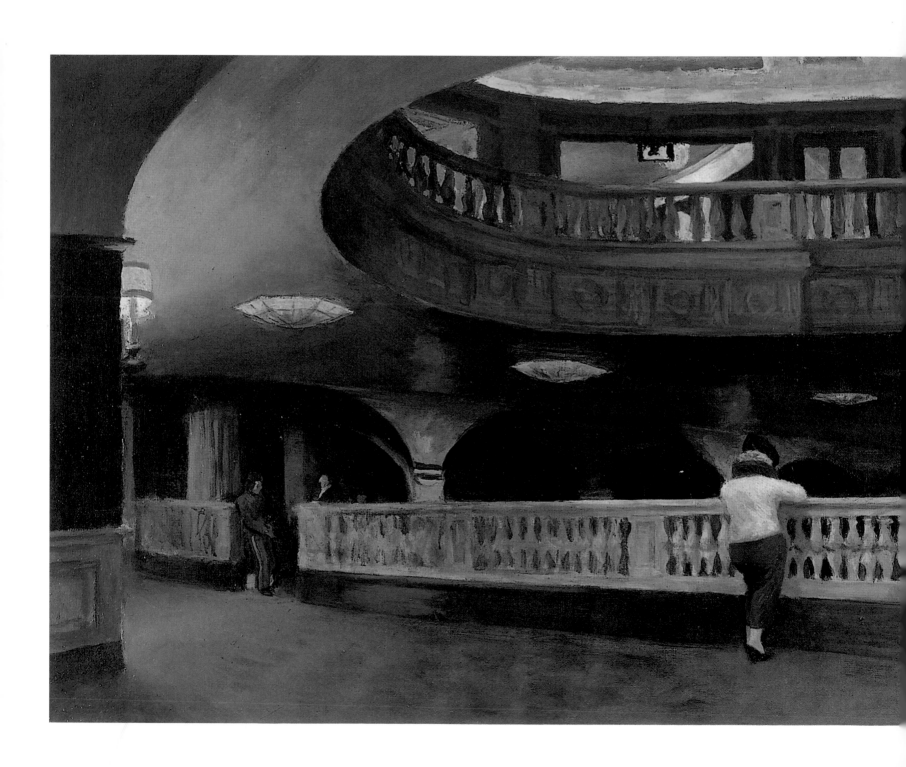

The Sheridan Theatre
1937
Oil on canvas
43.2 x 63.5 (17 x 25)
Collection of The Newark Museum;
Purchase 1940 Felix Fuld Bequest Fund
O-303

Cape Cod Evening
1939
Oil on canvas
76.2 x 101.6
(29 3/4 x 39 5/8)
National Gallery of Art,
Washington; John Hay
Whitney Collection 1982.76.6
O-309

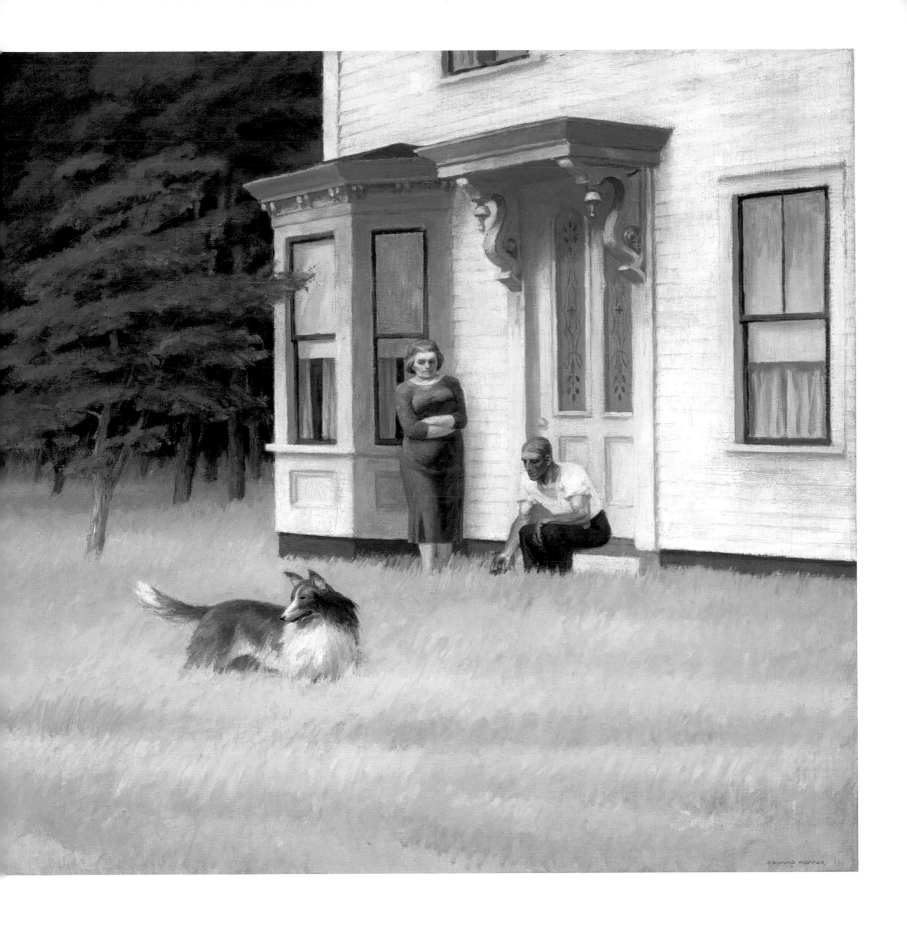

Office at Night
1940
Oil on canvas
56.4 x 63.8 (22 3/16 x 25 1/8)
Collection Walker Art Center,
Minneapolis;
Gift of the T.B. Walker Foundation,
Gilbert M. Walker Fund, 1948
O-312

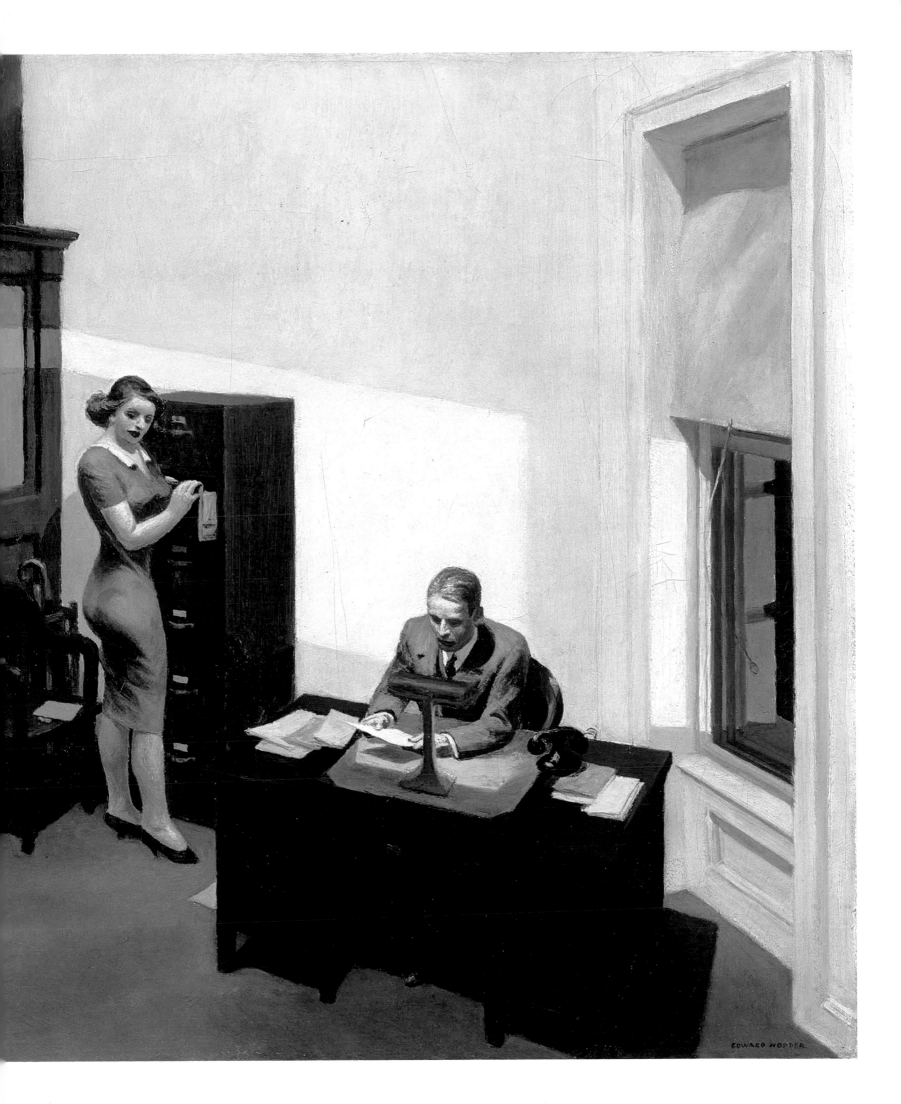

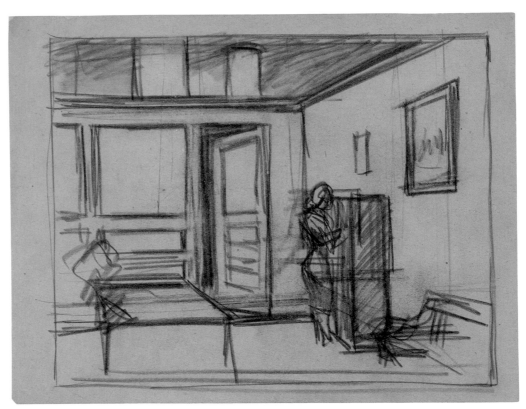

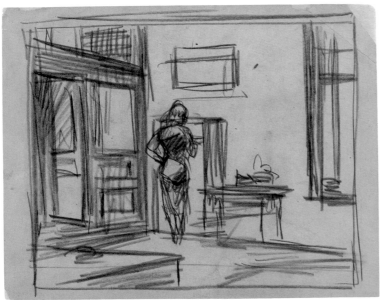

fig.87
Study for Office at Night
1940
Conté crayon on paper
21.59 x 27.94 (8 1/2 x 11)
Whitney Museum of
American Art, New York;
Josephine N. Hopper
Bequest 70.166a

fig.88
Study for Office at Night
1940
Conté crayon and graphite
on paper
21.59 x 27.94 (8 ½ x 11)
Whitney Museum of
American Art, New York;
Josephine N. Hopper
Bequest 70.168

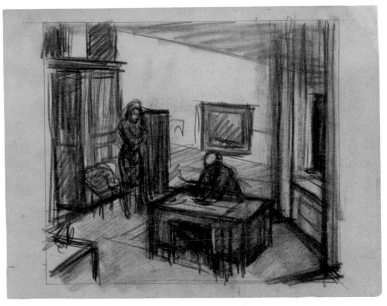

Study for Office at Night
1940
Conté crayon, charcoal
and chalk on paper
38.1 x 49.85 (15 x 19⅝)
Whitney Museum of
American Art, New York;
Josephine N. Hopper
Bequest 70.340

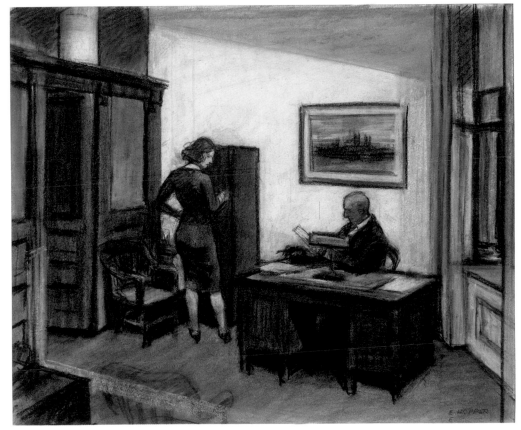

House by a Road
1940
Oil on canvas
48.3 x 68.6 (19 x 27)
Arizona State University Art Museum;
Gift of Oliver B. James
O-314

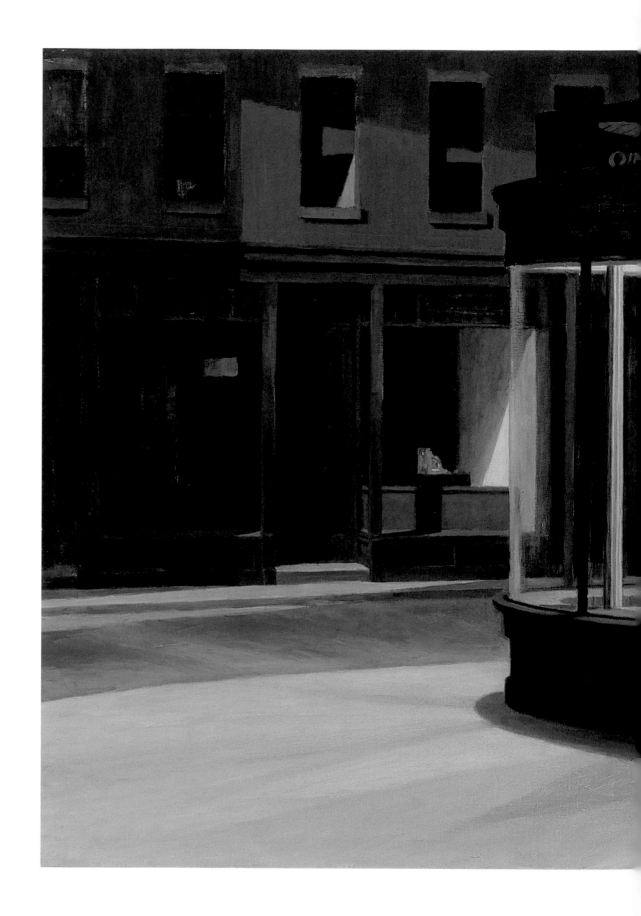

Nighthawks
1942
Oil on canvas
84.1 x 152.4 (33 1/8 x 60)
The Art Institute of Chicago;
Friends of American Art Collection
O–322

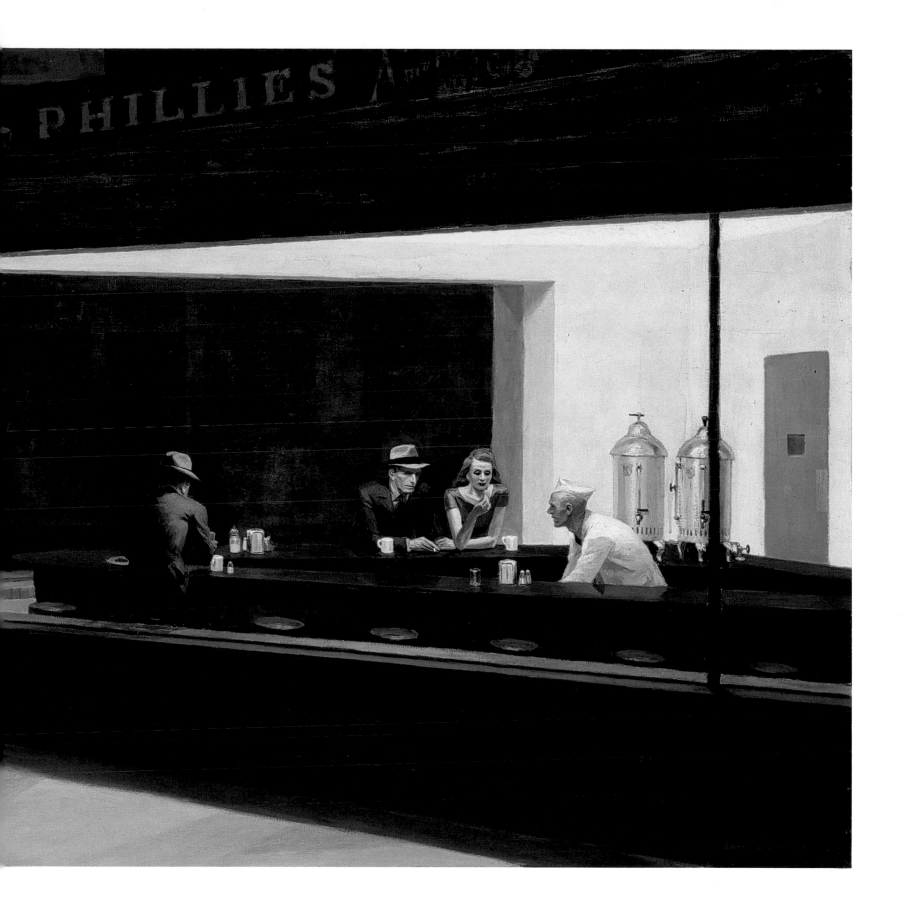

Study for Nighthawks
1942
Conté crayon on paper
18.42 x 11.43 (7 1/4 x 4 1/2)
Whitney Museum of
American Art, New York;
Josephine N. Hopper
Bequest 70.190

Study for Nighthawks
1942
Conté crayon on paper
21.59 x 27.94 (8 1/2 x 11)
Whitney Museum of
American Art, New York;
Josephine N. Hopper
Bequest 70.193

Study for Nighthawks
1942
Conté crayon on paper
11.43 x 18.42 (4 1/2 x 7 1/4)
Whitney Museum of
American Art, New York;
Josephine N. Hopper
Bequest 70.192

Study for Nighthawks
1942
Conté crayon on paper
38.42 x 28.1 (15 1/8 x 11 1/16)
Whitney Museum of
American Art, New York;
Josephine N. Hopper
Bequest 70.256

Study for Nighthawks
1942
Conté crayon on paper
20.32 x 20.32 (8 x 8)
Whitney Museum of
American Art, New York;
Josephine N. Hopper
Bequest 70.253

Study for Nighthawks
1942
Conté crayon on paper
18.42 x 11.43 (7 1/4 x 4 1/2)
Whitney Museum of
American Art, New York;
Josephine N. Hopper
Bequest 70.189

Study for Nighthawks
1942
Conté crayon on paper
21.59 x 27.94 (8 1/2 x 11)
Whitney Museum of
American Art, New York;
Josephine N. Hopper
Bequest
70.195

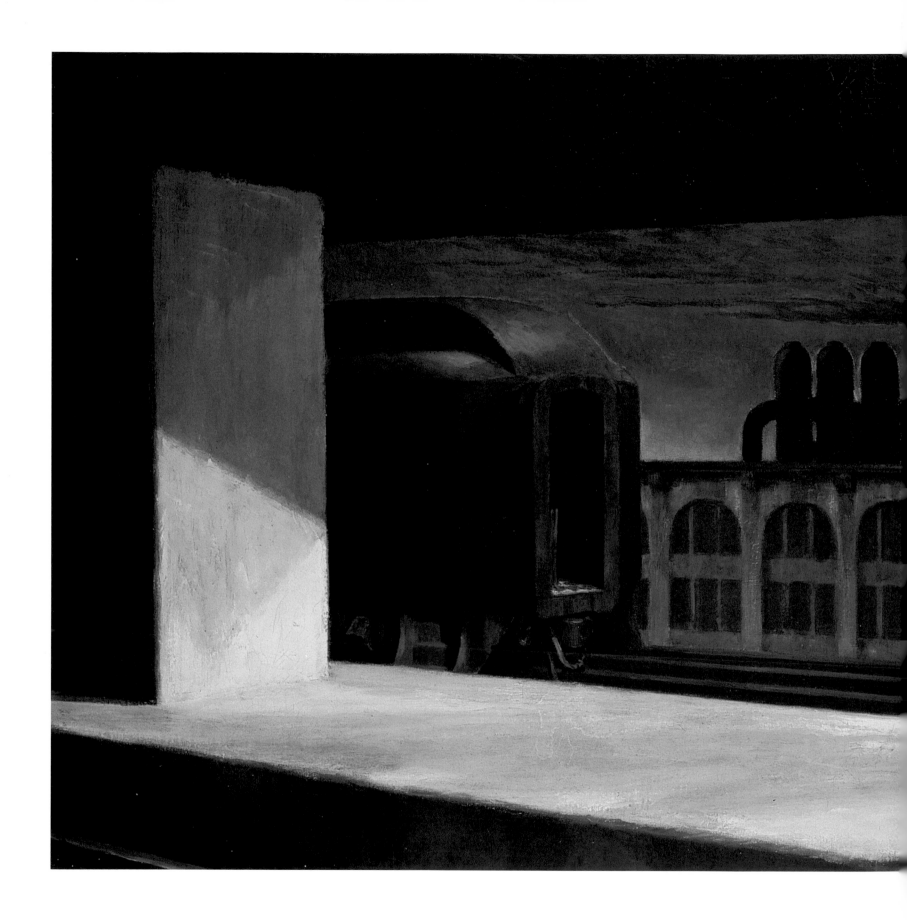

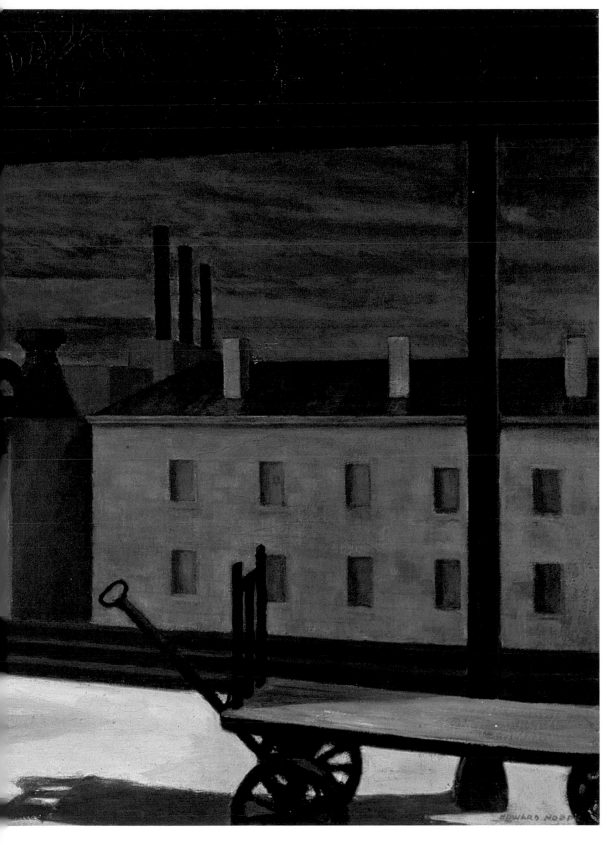

Dawn in Pennsylvania
1942
Oil on canvas
61.9 x 112.4 (24 3/8 x 44 1/4)
Terra Foundation for the Arts;
Daniel J. Terra Collection
O-323

Hotel Lobby
1943
Oil on canvas
82.6 x 103.5 (32 1/2 x 40 3/4)
Indianapolis Museum of Art;
William Ray Adams Memorial Collection
O-324
Cologne only

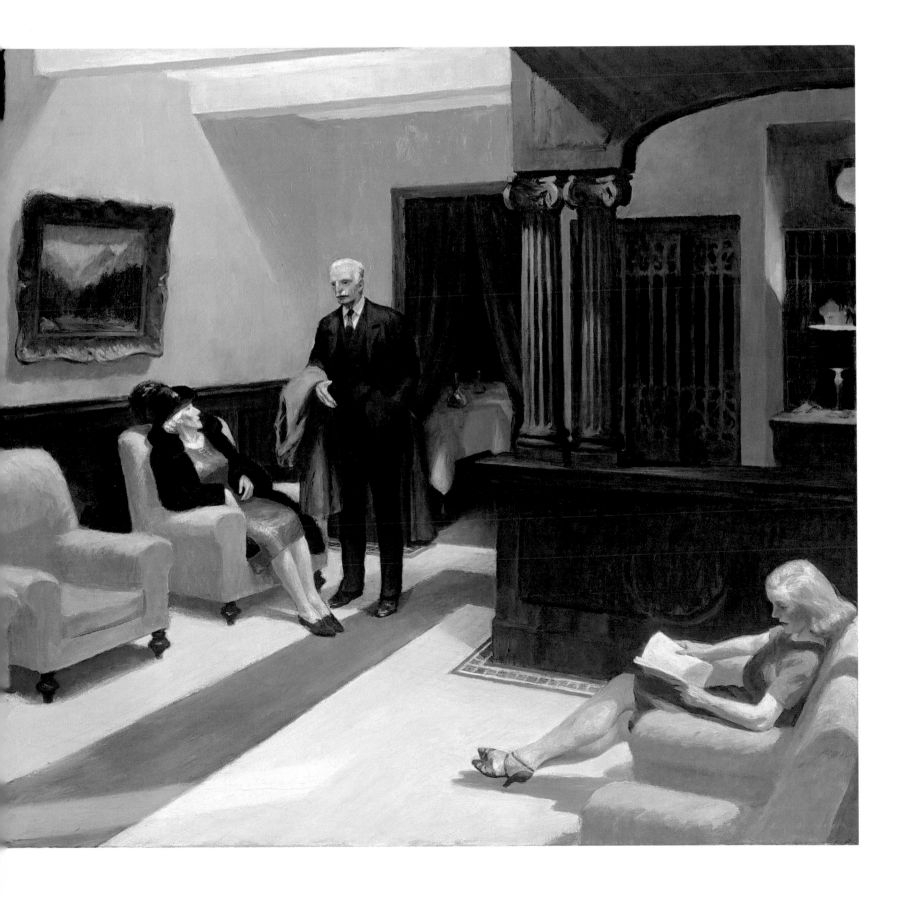

Summertime
1943
Oil on canvas
74 x 111.8 (29 ⅛ x 44)
Delaware Art Museum;
Gift of Dora Sexton Brown, 1962
O-325

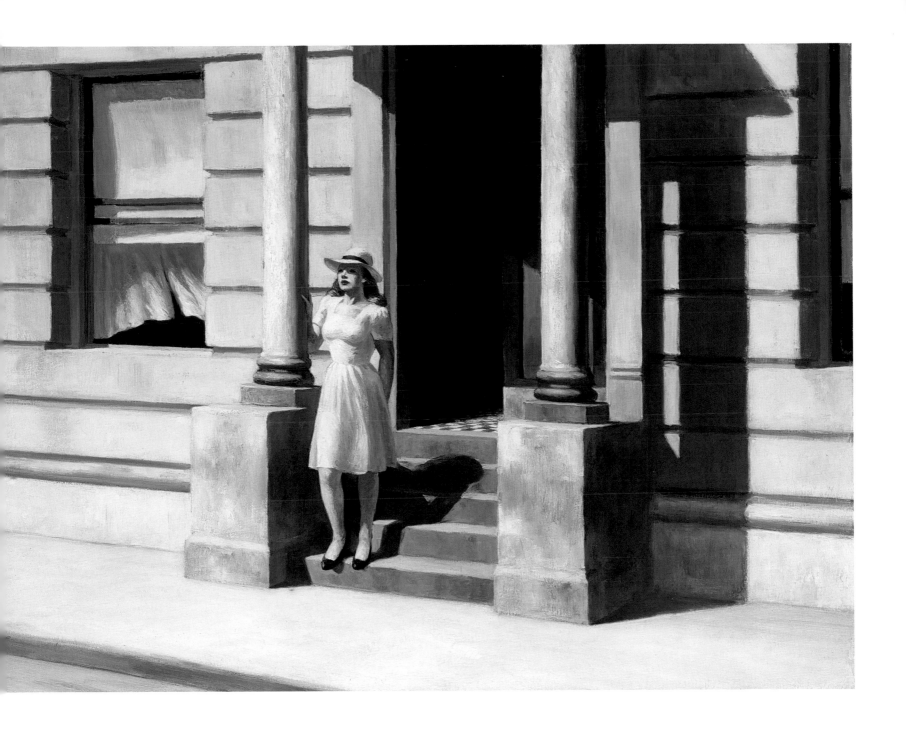

Two Puritans
1945
Oil on canvas
76.2 x 101.6 (30 x 40)
Private Collection, courtesy of Ronald
Feldman Fine Arts, Inc., New York
O-331

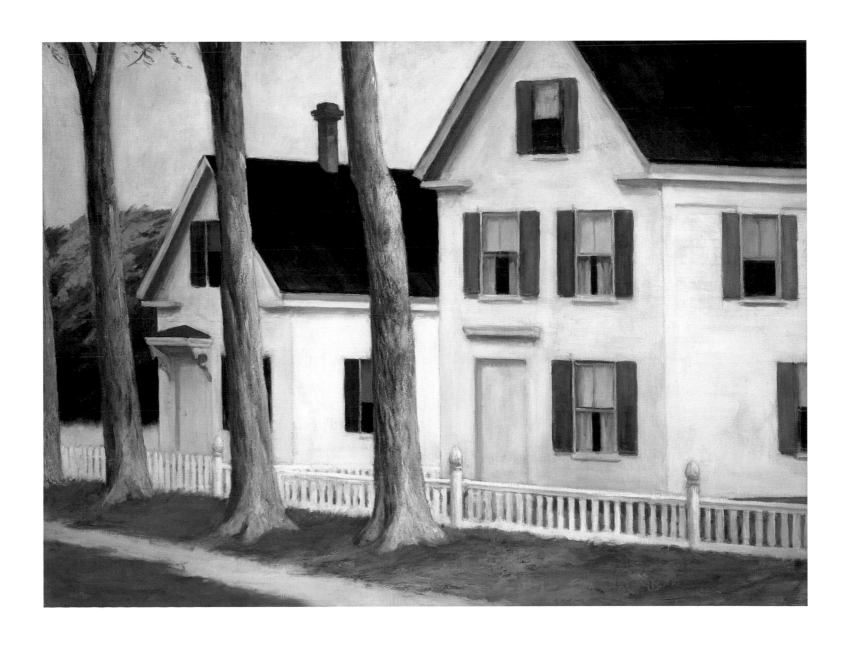

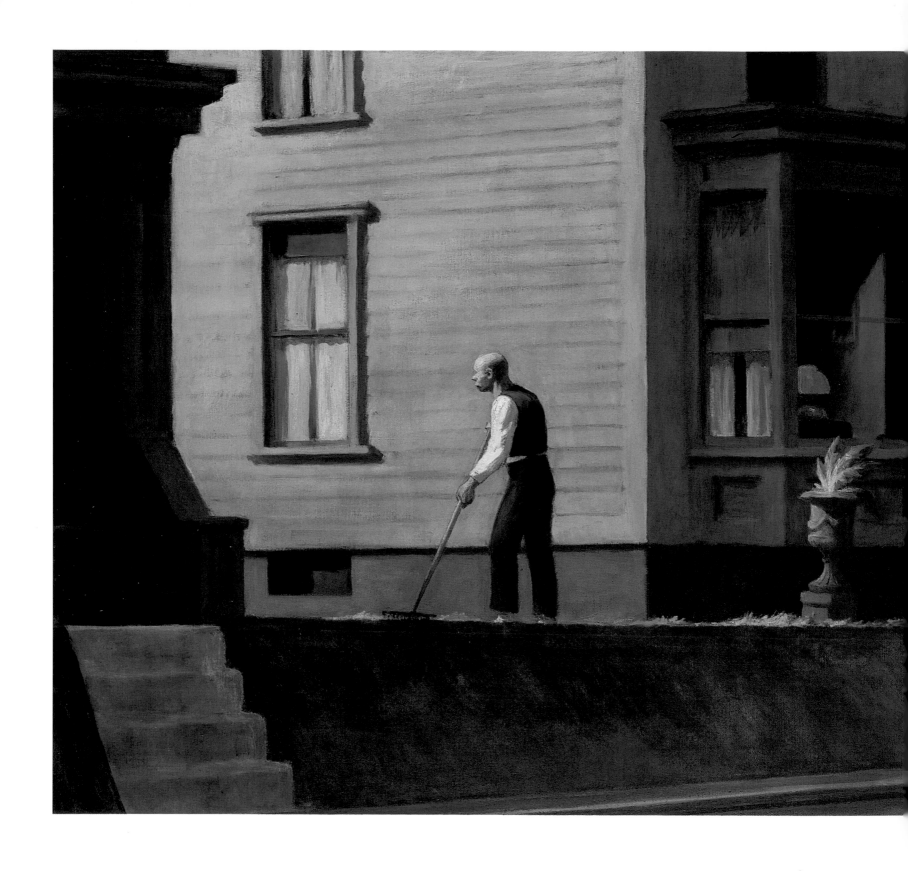

Pennsylvania Coal Town
1947
Oil on canvas
71.1 x 101.6 (28 x 40)
The Butler Institute of American Art,
Youngstown, Ohio
O-335

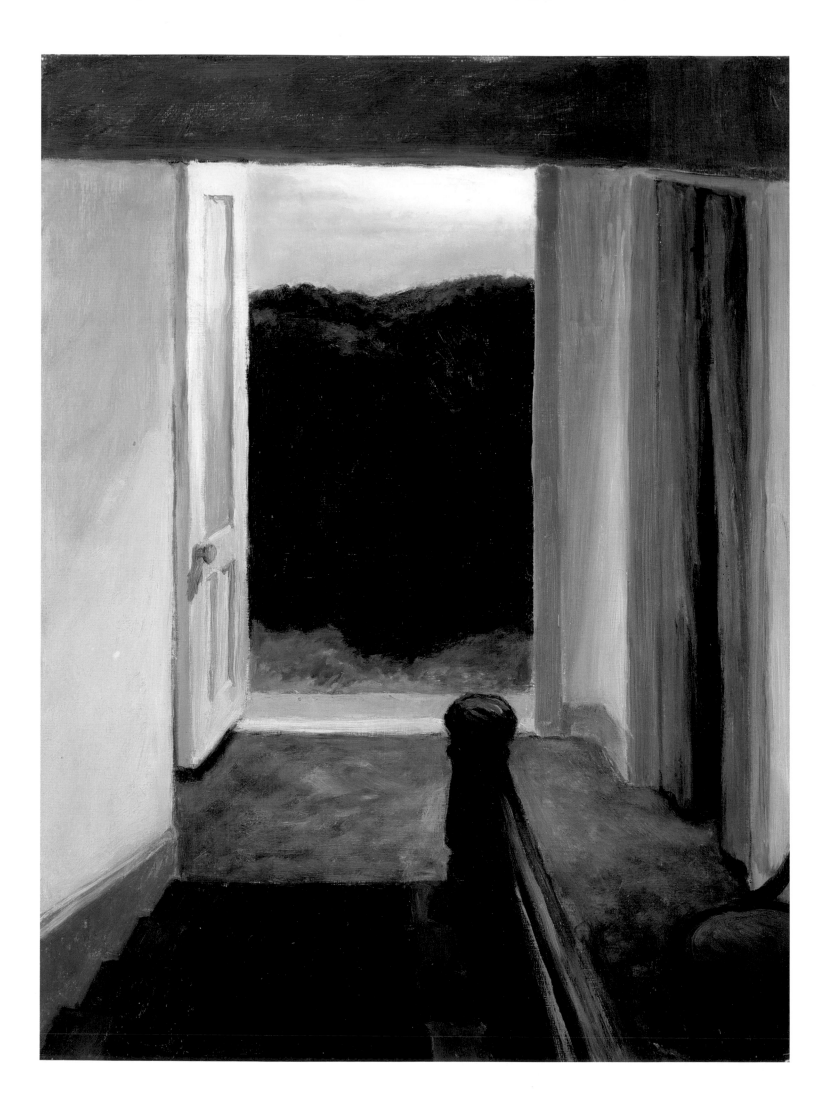

[Stairway]
1949
Oil on wood
40.6 x 30.2 (16 x 11$^{7}/_{8}$)
Whitney Museum of American Art,
New York;
Josephine N. Hopper Bequest 70.1265
O-339

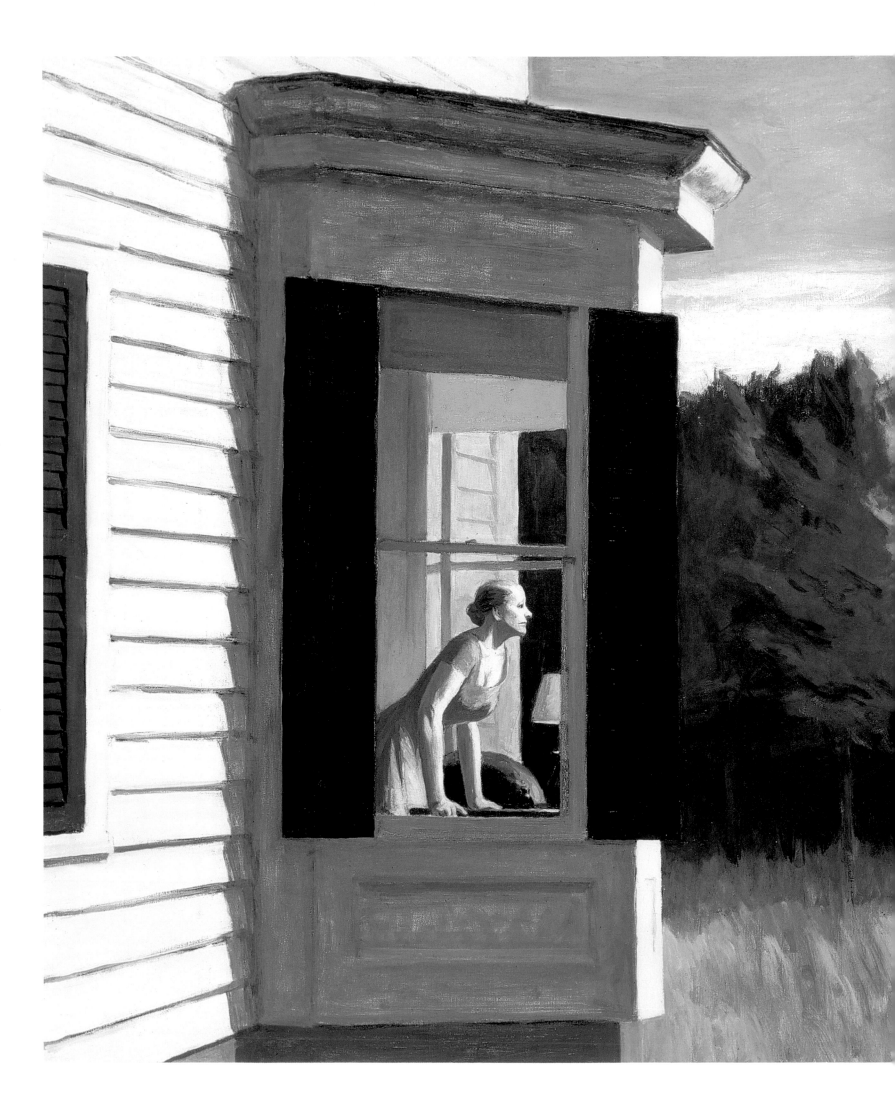

Cape Cod Morning
1950
Oil on canvas
86.7 x 102.2 (34⅛ x 40¼)
Smithsonian American Art
Museum;
Gift of the Sara Roby Foundation
0-343

First Row Orchestra
1951
Oil on canvas
79 x 101.9 (31⅛ x 40⅛)
Hirshhorn Museum and Sculpture Garden,
Smithsonian Institution;
Gift of the Joseph H. Hirshhorn
Foundation, 1966
O-344

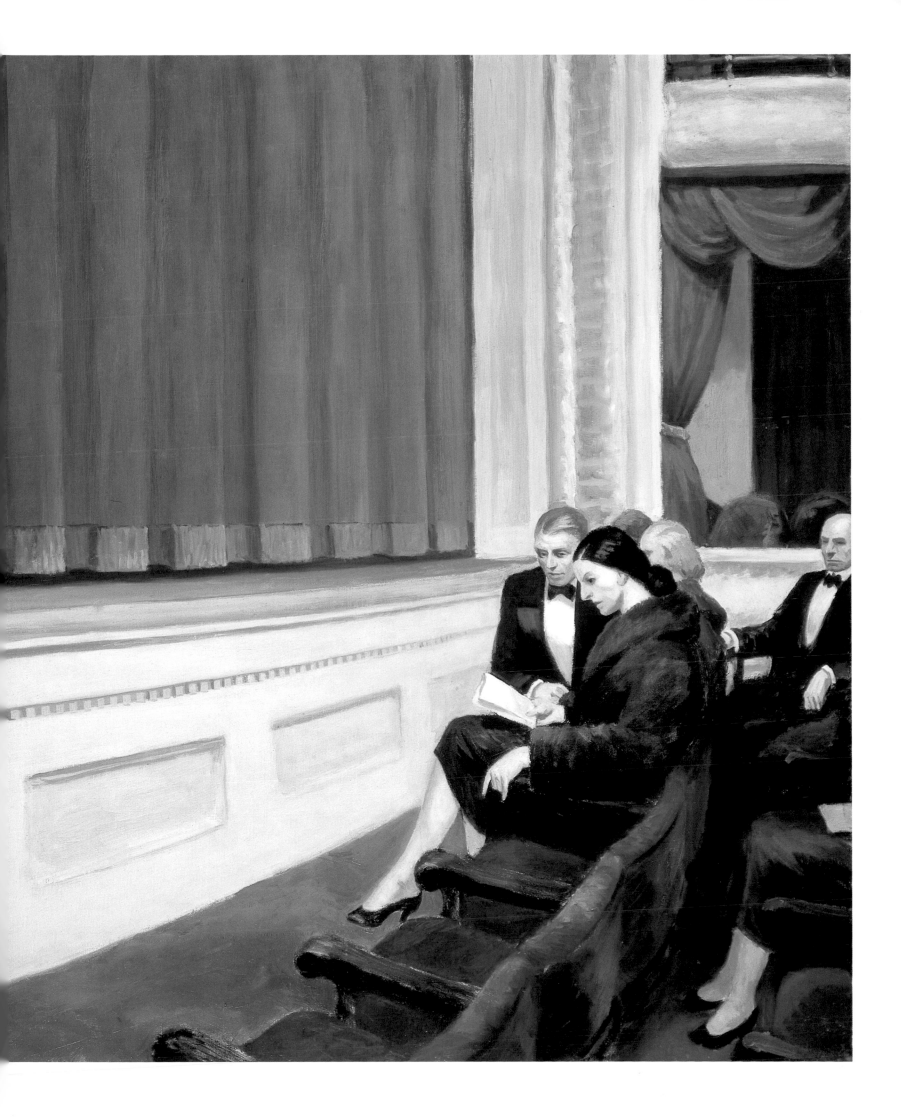

Morning Sun
1952
Oil on canvas
71.4 x 101.9 (28 ⅛ x 40 ⅛)
Columbus Museum of Art;
Museum Purchase, Howald Fund
O-346

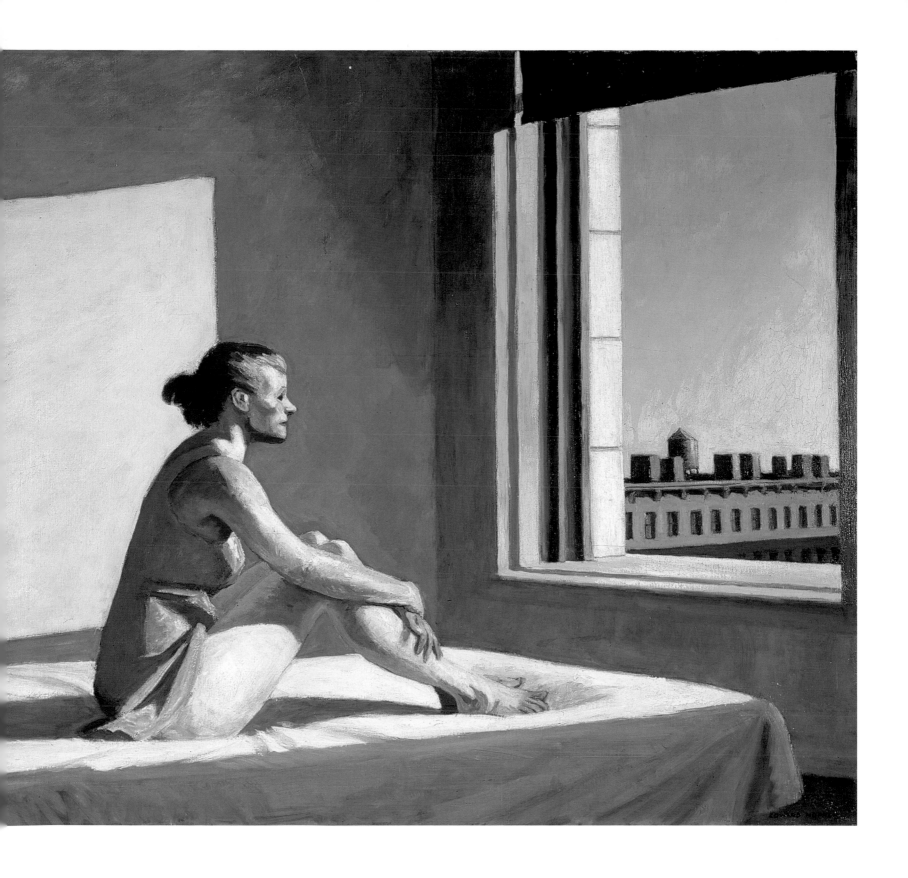

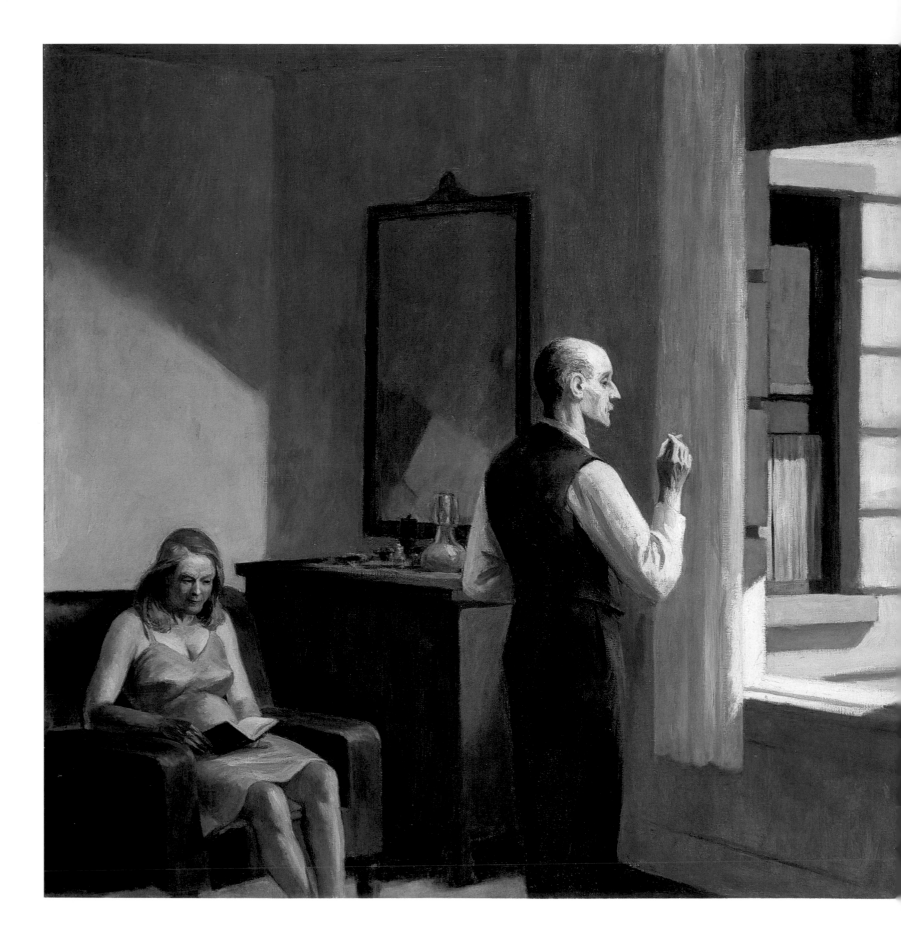

Hotel by a Railroad
1952
Oil on canvas
79.4 x 101.9 (31 1/4 x 40 1/8)
Hirshhorn Museum and Sculpture Garden,
Smithsonian Institution;
Gift of the Joseph H. Hirshhorn
Foundation, 1966
O-347

Sea Watchers
1952
Oil on canvas
76.2 x 101.6 (30 x 40)
Private Collection
O-348

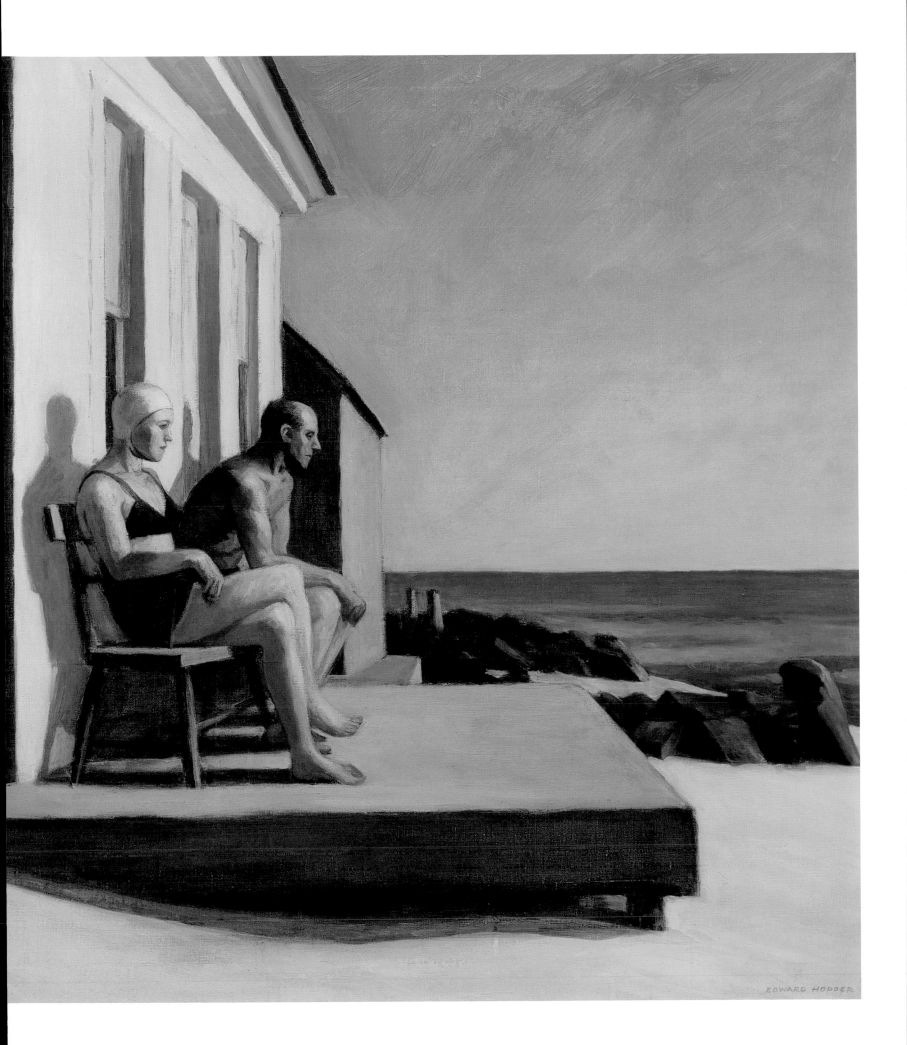

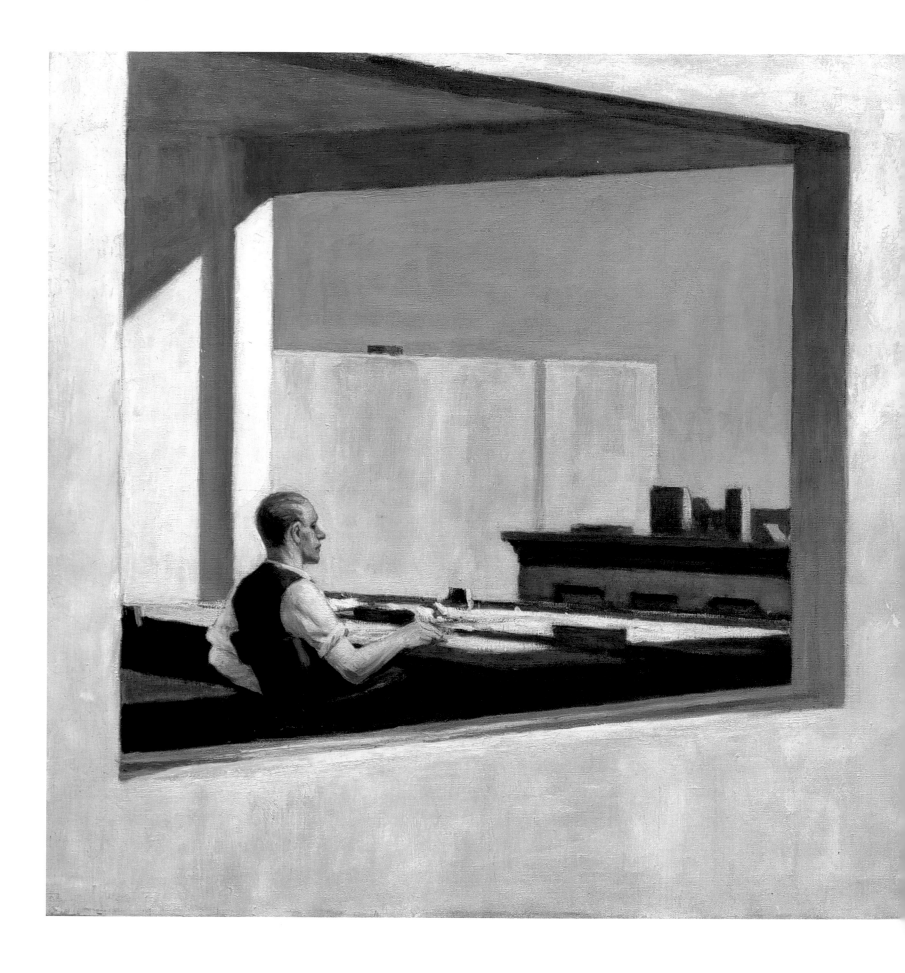

Office in a Small City
1953
Oil on canvas
71.1 x 101.6 (28 x 40)
The Metropolitan Museum of Art;
George A. Hearn Fund, 1953 (53.183)
O-349

205

City Sunlight
1954
Oil on canvas
71.6 x 101.9 (28 3/16 x 40 1/8)
Hirshhorn Museum and Sculpture Garden,
Smithsonian Institution;
Gift of the Joseph H. Hirshhorn
Foundation, 1966
O-350

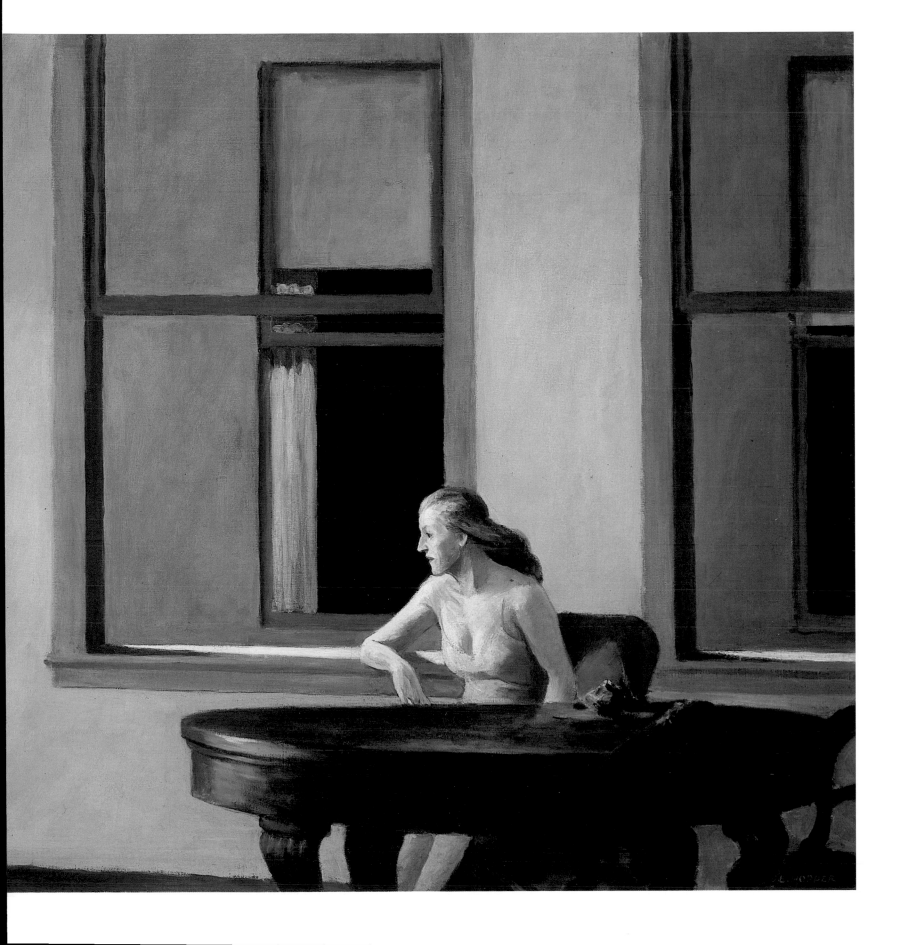

Hotel Window
1955
Oil on canvas
99.4 x 139.1 (39 1/8 x 54 3/4)
Collection of Steve Martin
O-352

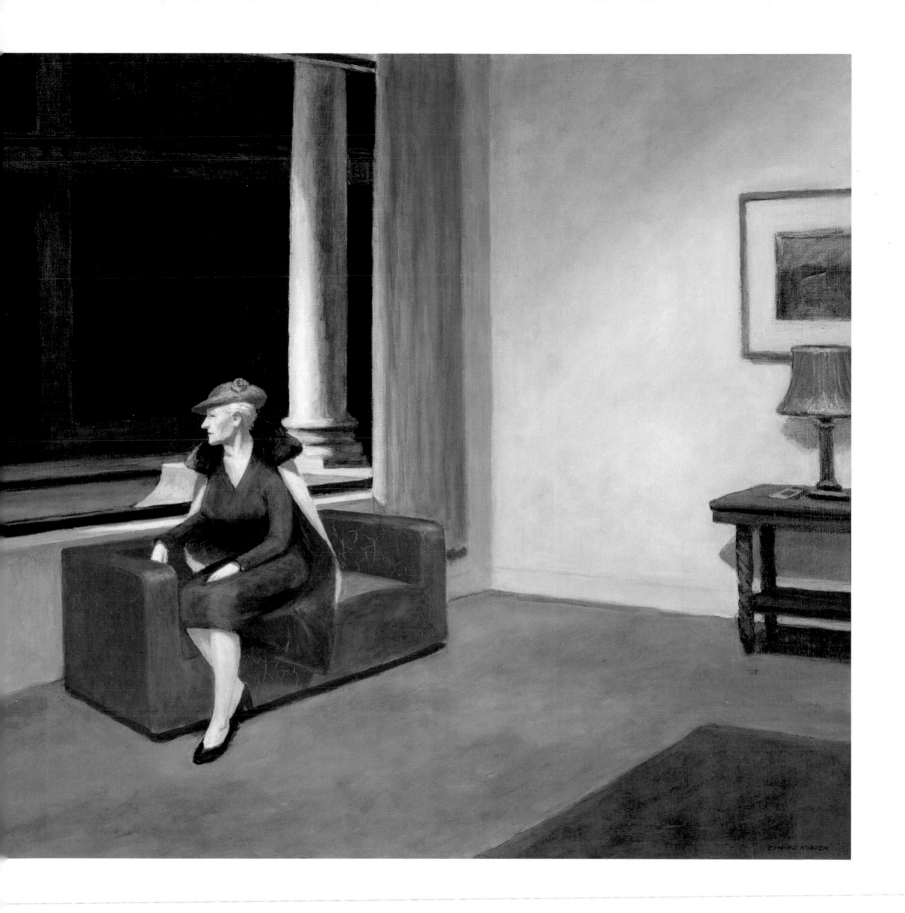

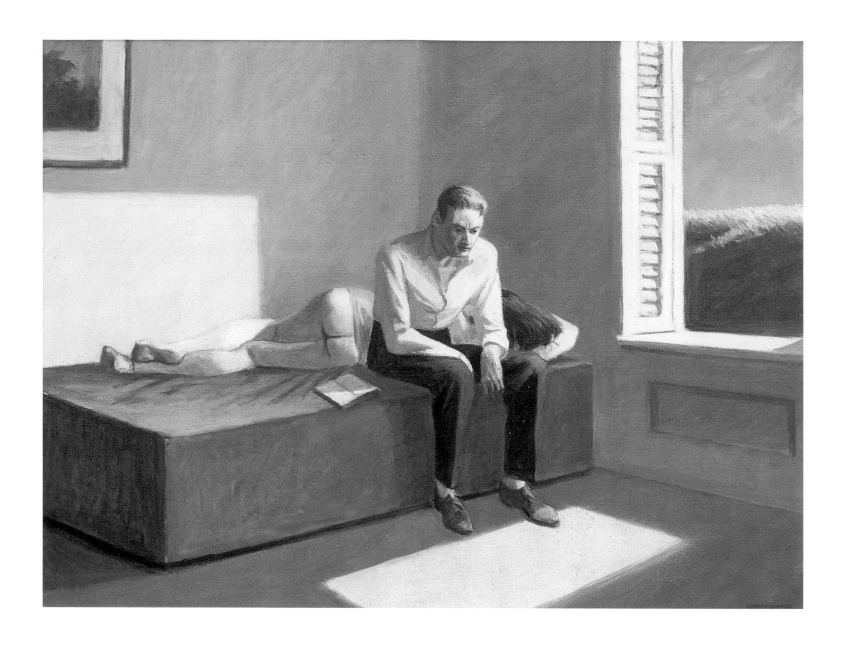

Excursion into Philosophy
1959
Oil on canvas
76.2 x 101.6 (30 x 40)
Private Collection
O-357

Second Story Sunlight
1960
Oil on canvas
101.9 x 127.5 (40 1/8 x 50 3/16)
Whitney Museum of American Art,
New York;
Purchase, with funds from the
Friends of the Whitney Museum
of American Art 60.54
O–359

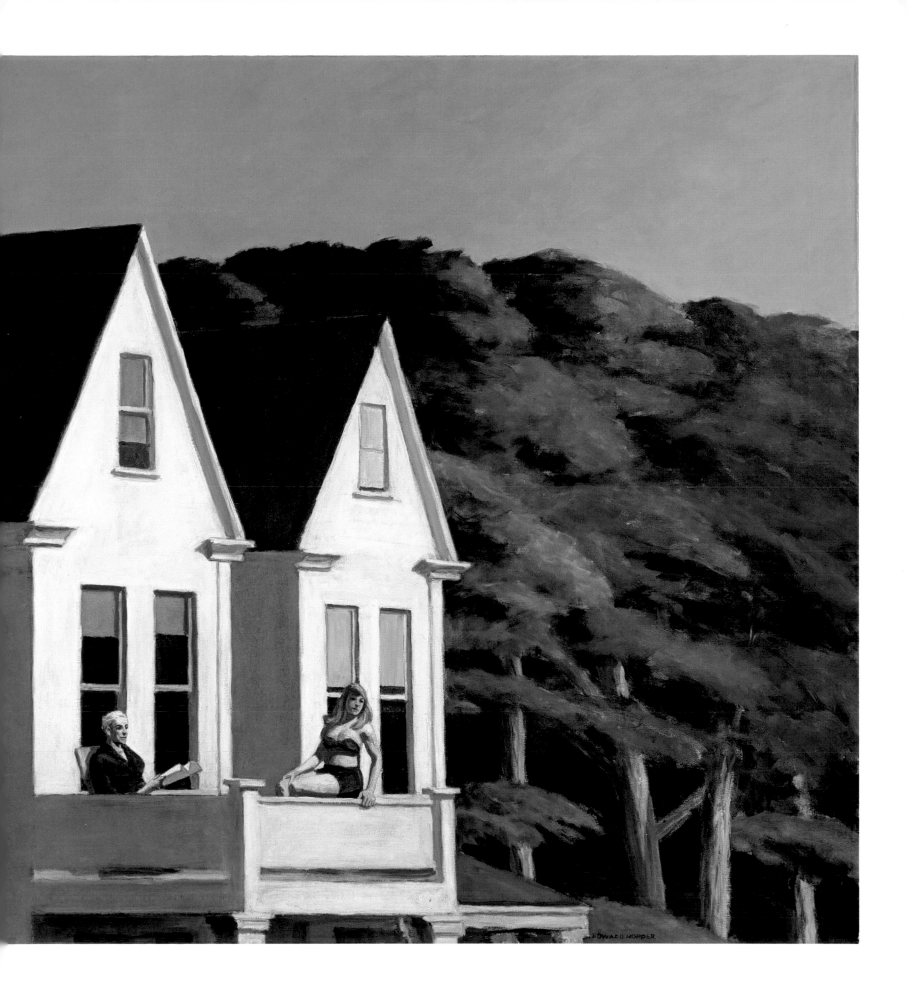

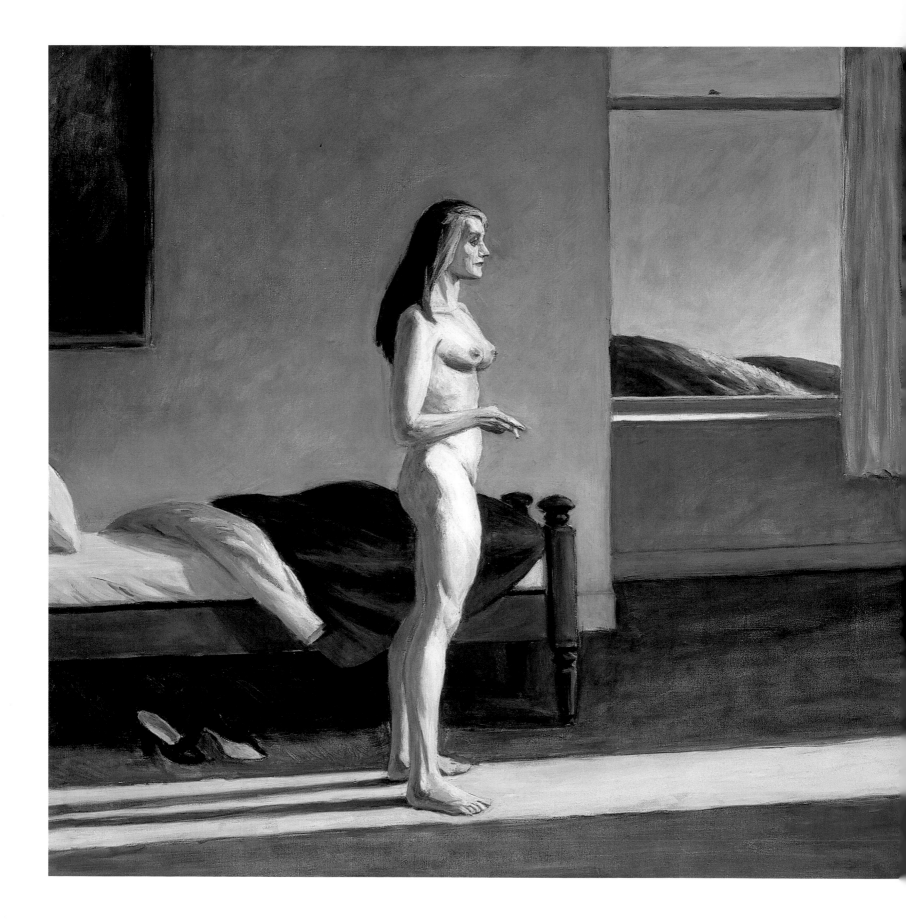

EDWARD HOPPER

A Woman in the Sun
1961
Oil on canvas
101.9 x 155.6 (40 1/8 x 61 1/4)
Whitney Museum of American Art,
New York;
50th Anniversary Gift of
Mr and Mrs Albert Hackett in honour of
Edith and Lloyd Goodrich 84.31
O-360

New York Office
1962
Oil on canvas
101.6 x 139.7 (40 x 55)
Montgomery Museum of Fine Arts,
Montgomery, Alabama;
The Blount Collection 1989.2.24
O-361

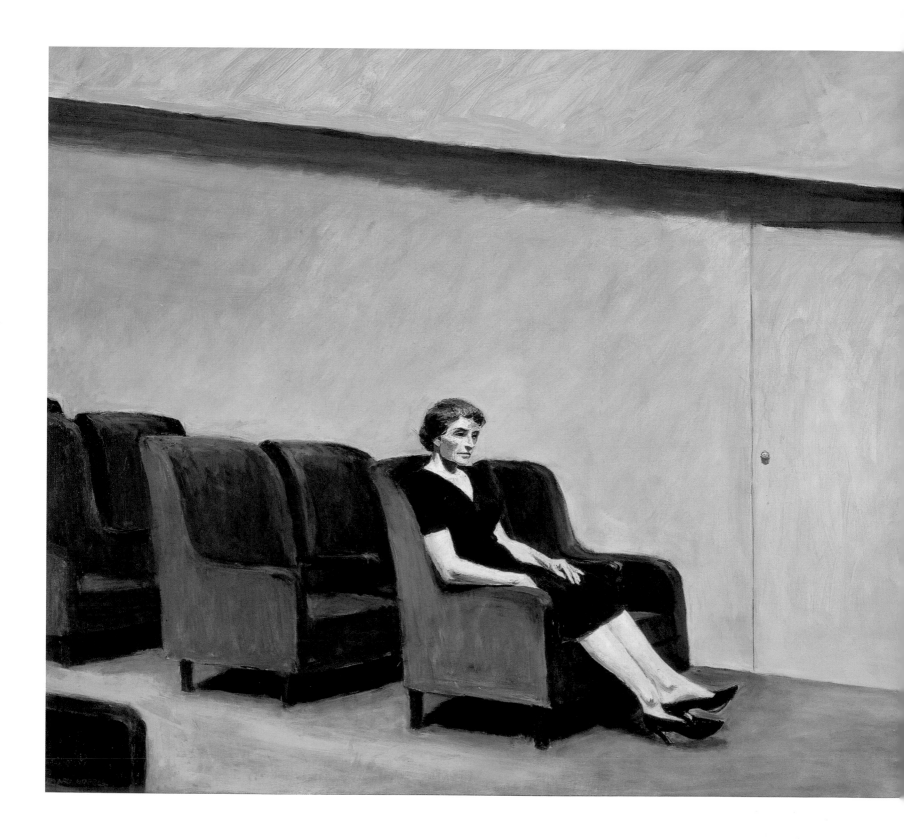

Artist's Ledger – Book III,
Page 81: Intermission
1963
Ink, graphite and coloured
pencil on paper
31 x 19.4 (12 ³/₁₆ x 7 ⁵/₈)
Whitney Museum of
American Art, New York;
Gift of Lloyd Goodrich
96.210a–jjjj

Intermission
1963
Oil on canvas
101.6 x 152.4 (40 x 60)
Private Collection;
Courtesy Fraenkel Gallery, San Francisco
O-363

Sun in an Empty Room
1963
Oil on canvas
73.7 x 101.6 (29 x 40)
Private Collection
O-364

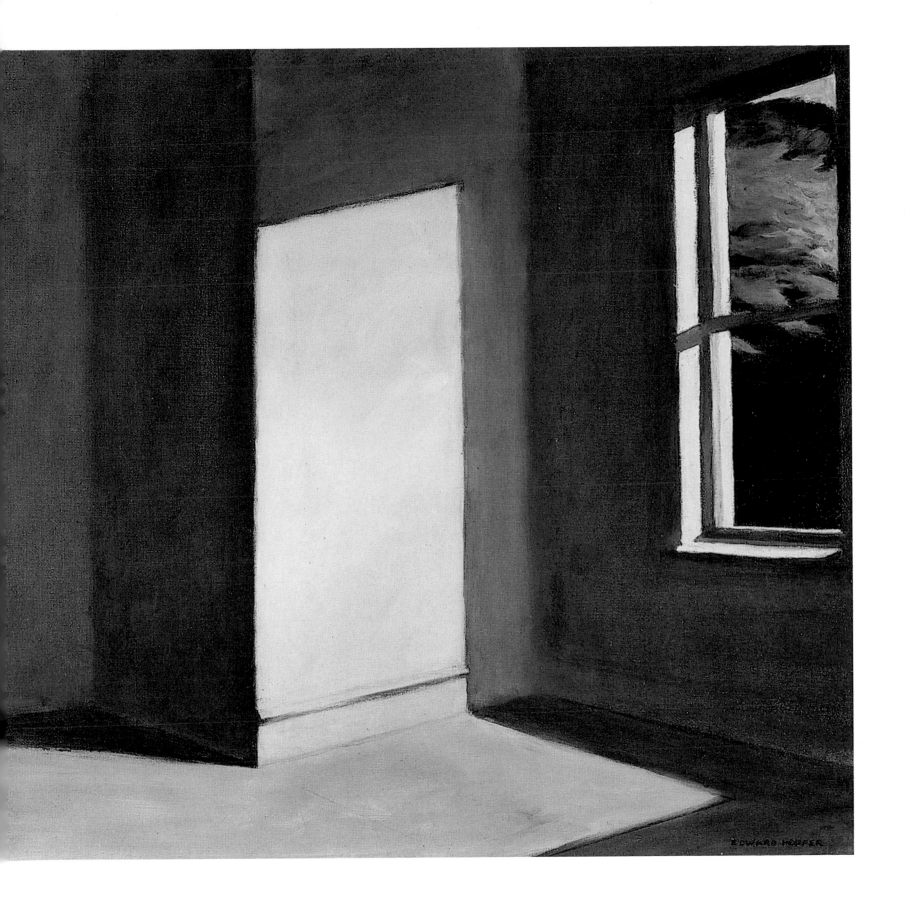

Two Comedians
1966
Oil on canvas
74.9 x 104.1 (29¹/₂ x 41)
Barbara Sinatra
O-366

I'm a realist and I react to
natural phenomena. As a child
I felt that the light on the
upper part of a house was
different than that on the
lower part. There is a sort of
elation about sunlight on the
upper part of a house. You
know, there are many thoughts,
many impulses, that go into a
picture – not just one. Light is
an important expressive for
me, but not too consciously so.
I think it is a natural expression
for me.

Edward Hopper, interviewed by
Katharine Kuh, *The Artist's Voice.*
Talks with Seventeen Artists,
New York 1962, p.140

Chronology
Compiled by Maeve Polkinhorn and Kathleen Madden

	Edward Hopper	Political and Cultural Events
1879		Art Institute of Chicago founded. Thomas Edison develops light bulb.
1882	Edward Hopper born 22 July in Nyack, New York, to Garret Henry Hopper, proprietor of dry-goods store, and Elizabeth Griffiths Smith Hopper (born 1853 and 1856 respectively). His older sister, Marion Louise, was born 8 August 1880.	Chinese Exclusion Act passed.
1883		US Supreme Court voids Civil Rights Act of 1875. Unveiling of Metropolitan Opera House in New York.
1885		Mark Twain's *Huckleberry Finn* published.
1886	Attends Miss Dickie's, a private school, and later the local public school, Nyack High School, on Liberty Street.	American Federation of Labor (AFL) founded. Frederic Bartholdi's *Statue of Liberty* unveiled.
1890		Defeat of Lakota at Battle of Wounded Knee, South Dakota.
1893		Hawaii becomes US Protectorate.
1896		US Supreme Court upholds 'separate but equal' doctrine of segregation.
1898	In February, fifteen-year-old Hopper makes pen and ink drawings of destruction of the *Maine* and also portrays *Shelling Havana*.	Sinking of US battleship *Maine* in Havana Harbour with loss of 266 men leads to Spanish-American War; US annexes Hawaii; Puerto Rico, Guam and Philippines ceded to the US by Spain in Treaty of Paris.
1899–1900	Graduates from Nyack High School. With his parents' support, begins formal training in art. Believing a painter's career to be insecure, chooses course at Correspondence School of Illustrating, directed towards commercial work.	
1900–6	New York School of Art, also called The Chase School, studies illustration with Arthur Keller and Frank Vincent DuMond, then painting under William Merritt Chase, Robert Henri and Kenneth Hayes Miller. Classmates include George Bellows, Guy Pène du Bois, Patrick Henry Bruce, Walter Pach, Walter Tittle and Rockwell Kent. Works principally on life-drawing.	
1902		Cuba becomes Republic, with US reserving right to intervene.
1903	Wins scholarship in life-drawing and first prize in painting.	On 17 December, Wright brothers inaugurate aerial age with first successful flight of flying machine at Kitty Hawk, North Carolina. Henry Ford founds Ford Motor Company. Jack London's *The Call of the Wild* published.
1904	In the autumn, chosen to teach Saturday classes in life-drawing, painting, sketching and composition at New York School of Art.	
1905	Begins to work part-time as illustrator for C.C. Phillips and Company, a New York advertising agency.	
1906	With support from his parents, travels to Paris, lodging at 48 rue de Lille. Does not attend formal classes, but works independently, drawing and painting Parisian street scenes, influenced by the Impressionists.	President Theodore Roosevelt receives Nobel Peace Prize for mediation in Russo-Japanese War. Earthquake in San Francisco. Henrik Ibsen dies. American press hails his 'modernity and universality'.
1907	Travels to London on 27 June, staying at cheap hotel on Gower Street to be near British Museum. Also visits National Gallery, Wallace Collection and Westminster Abbey. On 19 July leaves London for Holland, visiting Amsterdam, where he is impressed by Rembrandt's *Nightwatch* 1642. Travels on to Haarlem, Berlin and Brussels before returning to Paris to sail for New York, where he resumes commercial illustration work.	Alfred Stieglitz opens his Gallery 291 in New York with exhibition of modern European and American art. Americans whose works are shown for first time include Arthur G. Dove, Marsden Hartley, John Marin and Georgia O'Keefe.
1907–23	For sixteen years, works as a freelance commercial illustrator, a job he finds degrading. Solicits advertising companies, eventually producing covers for trade periodicals, including *Tavern Topics* and *Hotel Management*, and illustrating fiction for magazines such as *Adventure* and *Scribner's.* Common motifs and themes such as trains, boats and cinema interiors	

appear in both his commercial and artistic work, especially his etchings. Ensures that he reserves time for his own work, taking summers off and returning twice to Europe.

1908

Aged twenty-six, moves to New York City.
Participates in his first exhibition, organised by fifteen of Robert Henri's students, in the old Harmonie Club building, 43–5 West Forty-second Street, New York. Shows three oil paintings from 1907 of Parisian scenes, as well as a drawing. Review of show in *New York American* heralds exhibition as 'one step nearer a national art'.

Exhibition of 'The Eight' at Macbeth Gallery, New York, mounted in protest against conservative teaching in art schools, receives critical derision for depictions of 'ash-can' urban life. Leader of group is Hopper's old teacher Robert Henri; other members include Arthur B. Davies, William Glackens, Ernest Lawson, George Luks, Maurice Prendergast, Everett Shinn and John Sloan.
Mary Pickford makes film debut in D.W. Griffith's *Mrs Jones Entertains* (1908).

1909

Makes second trip to Paris in March, painting out-of-doors, frequently along the Seine. Continuing exploration of light on the landscape, paints *Valley of the Seine*, an expansive vista of a distant meandering river recalling *The Oxbow* 1836 by the Hudson River School painter, Thomas Cole, a recent acquisition of the Metropolitan Museum of Art in New York. Also paints *Le Bistro* and *Summer Interior* and makes study after Manet's *Olympia* 1863.
Returns to New York in August.

National Association for the Advancement of Colored People (NAACP) founded.
Model T-Ford, 'first car for all', mass-produced, selling 10,000 in first year.

1910

Participates in non-juried *Exhibition of Independent Artists* organised by Henri, John Sloan and Arthur B. Davies in vacant commercial warehouse on West Thirty-fifth Street. Using his savings from his commercial work, makes final trip to Europe. Travels from Paris to Madrid and Toledo, returning to Paris for three weeks before departing in early July. On his return to New York he later admits: 'It seemed awfully crude here when I got back. It took me ten years to get over Europe.'
Takes a studio at 53 East Fifty-ninth Street. Spends much of his time alone, reading and going to movies.

Urban League founded to help African Americans from rural areas adjust to city life.

1910–17

Mexican Revolution (US sends in troops in 1913 and 1916).

1911

Hamilton Easter Field, wealthy painter, critic and collector of modern art, founds the Ogunquit Art School.

1912

Sends five oil paintings – *Sailing* 1911, *River Boat* 1909, *Valley of the Seine* 1909, *Le Bistro* 1909 and *Tramp Steamer* 1908 – to second non-juried exhibition organised by Henri. Sells nothing and receives no significant press mention. Travels in summer to Gloucester, Massachusetts, with art-school friend Leon Kroll.

Sinking of *Titanic* off coast of Newfoundland.

1913

At the *Armory Show*, makes first sale of oil painting: *Sailing* 1911 for 250 dollars. Begins ledger, which he will maintain for the rest of his life, detailing his sales and income, recording a written and schematic description of each work as it leaves his studio.
Paints *New York Corner*.
On 18 September his father, Garret Hopper, dies in Nyack. In December moves to top-floor studio at 3 Washington Square North, Greenwich Village, where he will live for fifty-four years until his death. It is the domain of artists, writers and intellectuals, but Hopper does not become involved in the bohemian life of Washington Square. His art-school friends Walter Tittle and Rockwell Kent live and work in the building, along with two of 'The Eight', Ernest Lawson and William Glackens. New York art magazine of the 1920s and 1930s, *The Dial*, is started here. It is also where Thomas Eakins painted his last painting, a portrait of ex-president Rutherford B. Hayes, in 1912 and John Dos Passos writes *Three Soldiers* in 1921. Henry James was born next door.

Armory Show, New York, introduces European avant-garde to America. Artists include Brancusi, Braque, Cézanne, Duchamp, Gauguin, Kandinsky, Picabia, Picasso, Redon, Renoir and Van Gogh. Duchamp's *Nude Descending a Staircase (No.2)* 1912 provokes scandal. 'The Eight' also shown, amongst other American artists.

1914

Commissioned by US Printing & Litho Co to make movie posters.
Becomes member of Whitney Studio Club, which allows him to participate in annual group exhibitions.
Paints *Soir Bleu*, his largest work to date.
Spends first summer at Ogunquit Art School, where he paints the rocky coastline.
In autumn, Hopper has first opportunity to show work in commercial gallery, the Montross at 550 Fifth Avenue. Shows *Road in Maine*, which is singled out for illustration and comment by du Bois in October issue of *Arts and Decoration*, of which du Bois is editor.

World War I breaks out.
Publication of *Art* by Clive Bell.
Whitney Studio Club established by Gertrude Vanderbilt Whitney and Juliana Force, with galleries at 8 West Eighth Street. They acquire works by new artists that will eventually make up the nucleus of Whitney Museum of American Art when founded in 1931. It is one of the liveliest centres in the country for independent artists, and many have their first solo exhibitions there.

1915	Learns to etch, and begins to make prints. *New York Corner* and *Soir Bleu* exhibited at MacDowell Club in February. Distressed by poor reception of *Soir Bleu*, Hopper relegates it to storage. Turns away from French themes in his paintings, although he continues to explore them in his etchings. Returns to Ogunquit for summer, meeting Kroll, Henri, Bellows and others with whom he has regularly exhibited. To supplement his income he gives Saturday morning art classes at his mother's house.	Ocean liner *Lusitania* sunk off Irish coast by German submarine. 1,198 passengers lose their lives, of whom 128 are US citizens, leading to demands from many in the US for an immediate declaration of war. People's Art Guild founded in New York. Marcel Duchamp, Francis Picabia and Man Ray establish anarchist art movement, the New York Dada. D.W. Griffith's *The Birth of the Nation* released, causing riots due to racist overtones.
1915–18	Concentrates on printmaking, producing an outstanding array of etchings and drypoints, which are admitted to exhibitions beginning in 1918, and will remain his medium until 1924.	
1916	Du Bois chooses eight of Hopper's Parisian caricatures for publication in *Arts and Decoration*. Purchases printing press. Spends second summer on Monhegan Island, Maine, where he will frequently return to paint coastline and town scenes.	Society of Independent Artists founded in New York. Thomas Eakins dies.
1917	As a consequence of US entering World War I, Hopper's movie poster commissions cease.	US enters World War I. Russian Revolution. Marcus Garvey brings Universal Negro Improvement Association (UNIA, founded Jamaica, 1914) to Harlem. Marcel Duchamp's ready-made, *Fountain* 1917, rejected by Society of Independent Artists. Memorial exhibition of Thomas Eakins held at Metropolitan Museum.
1918	Shows eight etchings in April at the MacDowell Club; du Bois singles out Hopper's work for comment in newspaper review. His poster entry for US Shipping Board Poster Prize Competition, 'Smash the Hun', receives 300 dollar first prize award. In keeping with nationalistic spirit of the times, it excites considerable interest. Along with Arthur B. Davies, Maxfield Parrish, Walt Kuhn and others, he is invited to support Red Cross's fundraising efforts by painting a seven-by-five foot 'poster' to be part of Christmas window display on Fifth Avenue.	Whitney Studio Club moves to 147 West Fourth Street. Die Neue Sachlichkeit (The New Objectivity), an Expressionist movement characterised by realistic style combined with cynical, socially critical stance, founded in Germany in aftermath of World War I by Otto Dix and George Grosz. Other artists associated with movement include Max Beckmann and Christian Schad.
1919	During summer, du Bois and Clarence Chatterton join Hopper on Monhegan Island. Dealers in Kansas and New York request etching consignments. Hopper also contributes etchings to exhibitions at Art Institute of Chicago, National Arts Club, Touchstone Galleries in New York, and Print Makers of Los Angeles. Reviewers note his interest in architectural subjects.	President Woodrow Wilson receives Nobel Peace Prize for contribution to Versailles Treaty. Wave of white-on-black violence across US. Senate votes against ratification of Versailles agreement. Benito Mussolini founds the Fascist Party in Italy.
1920	Makes etching *American Landscape*, depicting cows crossing a railroad track in an isolated spot near a solitary house. This type of classic, late nineteenth-century clapboard building will reappear in Hopper's later works. Through du Bois's efforts, Juliana Force offers Hopper his first solo exhibition at Whitney Studio Club. Shows sixteen oils, eleven of which are Parisian scenes. Exhibition receives brief but complimentary reviews in two newspapers and in *Art News*. None of the paintings sell, and at thirty-seven, still dependent on commercial illustration to earn his living, Hopper begins to doubt whether he will achieve success as an artist. Through the mid-1920s, regularly attends Whitney Studio Club's evening life-drawing sessions.	Nineteenth Amendment to Constitution grants women the vote. National Socialist German Workers' Party formed in Germany. Prohibition introduced in US as a result of the Volstead Act.
1921	Paints *New York Interior* and *Moonlight Interior*. The latter, representing a nude female on a bed in front of an open window, develops theme of his etching *Evening Wind*, which sells well and is regularly requested for exhibitions. *Night Shadows* also printed this year. *Statue at Park Entrance* 1918–20 rejected for annual exhibition at Pennsylvania Academy of the Fine Arts, but accepted for members' annual exhibition at Whitney Studio Club, along with *Le Pont Royal* 1909. Prints consigned to Weyhe Gallery and Frank K.M. Rehn Gallery.	José Vasconcelos, Secretary of Education, initiates public mural programme in Mexico.
1922	Shows ten Parisian caricatures and group of prints at Whitney Studio Club. *New York Restaurant* accepted for *Ninth Biennial*	Mussolini is appointed Prime Minister of Italy.

of American Paintings at Corcoran Gallery of Art, Washington.
Du Bois publishes first critical article devoted entirely to Hopper: 'Edward Hopper, Draughtsman', in *Shadowland*.
Hopper gets to know John Dos Passos, who moves into rooms three floors below him on Washington Square. Hopper will see John and Katy Dos Passos regularly during summers on Cape Cod, and a friendship develops despite Hopper's conservatism and Dos Passos's sympathy for the Left.

1923	Completes final body of etchings, although he will briefly return to the medium in 1928. Returns to Gloucester, where he courts Josephine Verstille Nivison, a painter who had been a co-student at the Chase School. Paints watercolours in back streets, avoiding the harbour where other summer painters congregate. These include *Eastern Point Light*, *Haskell's House*, several trawler pictures, and works depicting houses in the Portuguese and Italian quarters. Awarded prizes for etching in exhibitions in Chicago and Los Angeles. Exhibits at National Arts Club, New York, in *Humorist's Exhibition*.	George Gershwin composes *Rhapsody in Blue* for piano and orchestra.
1924	Nivison invited to show six of her watercolours in an international group show at Brooklyn Museum of Art. Through her connection Hopper is also invited to show a group of watercolours, which results in the museum's purchase of his work *The Mansard Roof* 1923 for 100 dollars. On 9 July, at the Eglise Evangèlique on West Sixteenth Street, Hopper and Jo are married. Du Bois is best man, and he and his wife join the Hoppers on their honeymoon in Gloucester. On return to New York approaches Frank Rehn, who offers Hopper his first solo exhibition at a commercial art gallery and will remain his dealer throughout his life. At forty-two Hopper enjoys belated success. The eleven works in the exhibition all sell, and five more are sold from the back room.	National Origins Act (Immigration Restriction Act) passed, excluding Asian immigration and limiting European immigration by nationality. André Breton publishes 'The Surrealist Manifesto'. Surrealist movement in visual art and literature flourishes in Europe between World Wars I and II.
1925	Dispenses with commercial illustration work. British Museum purchases the etching *Night Shadows* 1921, Metropolitan Museum of Art acquires fifteen etchings, and Pennsylvania Academy of Fine Arts purchases his oil painting *Apartment Houses* 1923. Paints *The Bootleggers*. Hoppers make first cross-country train trip, stopping in Colorado and Santa Fe, New Mexico, where he paints seven watercolours. Paints *House by the Railroad*, generally acknowledged as his first mature painting. Enjoys performance of Ibsen's *The Master Builder* (1892) on 15 December.	F. Scott Fitzgerald's *The Great Gatsby* published. In February, the Attorney General denounces large number of foreign vessels smuggling liquor into US.
1926	In January, he is one of ten non-members invited to participate in New Society of Artists' Seventh Exhibition at Anderson Galleries, where he shows *New York Pavements* 1924 or 1925 and *House by the Railroad*. Lloyd Goodrich, a young critic, praises the latter as 'the most striking picture in the exhibition ... it succeeded in being one of the most poignant and desolating pieces of realism that we have ever seen.' Goodrich was to become a leading proponent of Hopper's work. Paints *Eleven A.M.* and *Sunday*. In February he shows *Sunday* in Rehn Gallery exhibition *Today in American Art* and in November the painting is bought by the Washington collector Duncan Phillips for 600 dollars. Hoppers spend the summer season in Rockland, Maine, and Gloucester.	
1927	On 4 January sees Sergei Eisenstein's film *Battleship Potemkin* (1925). In February exhibits four oils, a dozen watercolours and a group of drawings at Rehn Gallery. Paints *Automat* and *Two on the Aisle*. Lloyd Goodrich publishes 'The Paintings of Edward Hopper' in March issue of *The Arts*, of which Goodrich was an editor, calling Hopper an 'eminently native painter'. Hopper writes 'John Sloan and the Philadelphians' for April's *The Arts*.	Charles Lindberg flies non-stop across Atlantic and is hailed as national hero.

With sale of *Two on the Aisle* for 1,500 dollars (the highest price paid to date) Hopper buys his first automobile, a two-year-old Dodge. Hoppers spend the summer at Two Lights, Cape Elizabeth, Maine, where Hopper paints the solitary beacons *Lighthouse Hill* and *Captain Upton's House*. With ease of car transport he is able to paint in remote places in both Ogunquit and Gloucester.
Paints *Drug Store*. Originally called *Ex-Lax*, its title is changed after Rehn's wife Peggy suggests that: 'Ex Lax might have indelicate implications.'

1928	Completes his final drypoints, *The Balcony* (or *The Movies*) on 15 January and *Portrait of Jo* on 20 January. Writes 'Charles Burchfield: American', for *The Arts* July issue, stressing that Burchfield's work is 'decidedly founded not on art, but on life' and includes quotes from Thomas Emerson's essay 'Self Reliance'. Paints *Night Windows*.	Walt Disney makes first Mickey Mouse film. Herbert Hoover elected President of US.
1929	Paints *Chop Suey*. In April Hoppers visit Charleston, South Carolina, which since its renaissance during the 1920s has attracted writers and artists. They spend the summer in Two Lights, Cape Elizabeth, Maine. Paints *Railroad Sunset*. Included in MoMA's second exhibition, *Paintings by Nineteen Living Americans*. Hopper sells two oils, fourteen watercolours and eighty prints for a total of 6,211 dollars during this year.	29 October: Stock-market crash, Wall Street, creates Great Depression. Unemployed figures rise to 15 million. The Museum of Modern Art (MoMA) opens with exhibition of Cézanne, Gauguin, Seurat and Van Gogh. Robert Henri dies.
1930	Paints *Early Sunday Morning*. Hoppers spend first summer in South Truro, Cape Cod, Massachusetts, renting a farmer's house called Bird Cage Cottage, to which they will return for next three summers. Hopper's *House by the Railroad*, donated by Stephen C. Clark, is the first painting to enter the Museum of Modern Art's permanent collection. An influential American collector, he will also donate *Manhattan Bridge Loop* 1928 to Addison Gallery at Phillips Academy, Andover.	First television broadcast. MoMA presents major exhibition of Eakins, Ryder and Homer. Lloyd Goodrich curates Eakins section. Sinclair Lewis wins Nobel Prize for Literature. During the 1930s, Thomas Hart Benton, Grant Wood and John Steuart Curry attempt to depict an 'American Scene' that is, they believe, likely to disappear in face of modernity. Sometimes associated by critics with these Midwestern Regionalists, Hopper publicly states his opposition to their reactionary nationalism, calling it a caricature of America.
1931	Hopper's stature subsequently confirmed by major museum acquisitions. Whitney Museum of American Art purchases *Early Sunday Morning* for 3,000 dollars; Metropolitan Museum of Art acquires *Tables for Ladies* 1930 for 4,500 dollars and will later buy *Williamsburg Bridge* 1928. During year, Hopper sells thirty artworks, of which thirteen are watercolours, for a total of 8,728 dollars. Success inspires more ambitious canvases such as *Hotel Room*. In its first *Pan-American Exhibition of Contemporary Paintings* the Baltimore Museum of Art awards Hopper 'honorable mention' and 100 dollars for *Night Windows*. Du Bois writes monograph on Hopper in new American Artists Series, published by Whitney Museum.	During visit to Alexander Calder's studio, Duchamp coins term 'mobile' for his moving sculptures. November: Whitney Museum of American Art in New York founded by Gertrude Vanderbilt Whitney. MoMA holds memorial exhibition of Henri's work.
1932	Paints *Room in Brooklyn,* immediately followed by *Room in New York*. Declines nomination to National Academy of Design because it had earlier rejected his work. Participates in first Biennial of Whitney Museum of American Art, as he will in nearly every Biennial and Annual until his death.	Franklin D. Roosevelt elected president. Aldous Huxley's *Brave New World* published.
1933	Travels to Quebec, Ogunquit and Two Lights, Maine. Returning to South Truro, purchases land overlooking Cape Cod Bay. At age of fifty-one, receives first large-scale solo exhibition. Alfred H. Barr, Director of MoMA, curates retrospective, writing and editing catalogue for which Hopper contributes 'Notes on Painting'. Hopper is third American artist in MoMA's programme after Max Weber and Maurice Sterne.	New Deal launched. Adolf Hitler becomes Chancellor of Germany. Prohibition lifted. Artists Group of Emergency Work Bureau founded, becoming Unemployed Artists Group and finally Artist's Union (1934); Public Works of Art Project (PWAP) founded. Lloyd Goodrich's book on Thomas Eakins published by Whitney Museum. Gertrude Stein's *The Autobiography of Alice B. Toklas* published.
1934	Retrospective show travels to Arts Club of Chicago. Designs house and studio in South Truro, completed on 9 July. Hoppers take up residence and remain there until late November, an arrangement they repeat each summer until late in life. *Early Sunday Morning* exhibited in American pavilion at	With the rise of Nazism, László Moholy-Nagy, amongst many other artists, flees Germany, emigrating first to Amsterdam, and later to London. Federal Communications Commission (FCC), an independent executive agency of the US government, established to regulate interstate and foreign communications.

Venice Biennale, along with one watercolour and two prints. Income from sales is less than half that of 1931 and is exclusively from watercolours.

Time publishes cover story, 'The American Scene', quoting Hopper: 'The American quality is *in* a painter – he doesn't have to strive for it.'

1935	Paints *House at Dusk* and *Shakespeare at Dusk*. On 25 January awarded Temple Gold Medal from Pennsylvania Academy of the Fine Arts. Elizabeth, Hopper's mother, dies in March. Included in twenty-three exhibitions, but achieves very few sales. In November, *New York Post* carries rare intimate article on Hopper and his studio. By December, Hoppers reduced to drawing on savings and having to cut expenses. Nevertheless, neither seriously considers working on any of the arts projects of the PWAP. Hopper condemns Roosevelt, believing that government funding will encourage artistic mediocrity.	Soviet Leader Josef Stalin calls for a Popular Front of democracies against fascism. Treasury Relief Art Project (TRAP) and the Federal Art Project of the Works Progress Administration (FAP/WPA) established, remaining in place until outbreak of World War II. Clarence Brown's *Anna Karenina* starring Greta Garbo released.
1936	Jo records in her diary on 27 October that she and Edward regret being unable to register 'to vote against Roosevelt' because they were still on Cape Cod. Hoppers see *Fantastic Art, Dada, and Surrealism* organised by Alfred Barr at MoMA in December. Reads George Santayana's *The Last Puritan* (1935) in July. Although their finances are stretched, Hopper rejects proposal by American Artists Group, a leading manufacturer of greeting cards, to let his etchings be mass-marketed. Through October Hopper works on *Cape Cod Afternoon*. In November while Hoppers are in Cape Cod their New York studio is burgled; the art is untouched. Whitney purchases *The Circle Theatre* in December and Rehn sells an oil, *Dawn before Gettysburg*. Total sales for the year amount to 7,050 dollars.	American Artists' Congress founded in response to the call of the Popular Front and the American Communist Party for formation of literary and artistic groups against fascism. American Abstract Artists group founded to promote abstract art. Eugene O'Neill wins Nobel Prize for Literature. Charlie Chaplin's *Modern Times* caricatures modern business. Margaret Mitchell's *Gone with the Wind* published.
1936–9		Spanish Civil War breaks out.
1937	Admires ten-minute Walt Disney animation *Three Little Pigs* (1933). Paints *The Sheridan Theatre,* for which he makes fifteen preparatory sketches while visiting this theatre located on Sheridan Square in Greenwich Village. Hoppers are enraged by Roosevelt's proposal regarding the Supreme Court. In spring Carnegie Institute gives Hopper solo exhibition in Pittsburgh. *Cape Cod Afternoon* wins first W.A. Clarke Prize (2,000 dollars) and Gold Medal from Corcoran Gallery of Art.	Changes to Supreme Court proposed by President Roosevelt. Solomon R. Guggenheim Museum opens in New York. Through assistance of Walter Gropius, Moholy-Nagy invited to Chicago to direct new design school. The New Bauhaus lasts only one year, closing in 1938. *Degenerate Art* exhibition organised by Nazis in Munich. John Steinbeck's *Of Mice and Men* published.
1937–8		Congress of Industrial Organizations (CIO) formed.
1938	Paints *Compartment C, Car 293*. Shows *Jo Painting* 1936 in *The 133rd Annual Exhibition* at the Pennsylvania Academy of the Fine Arts, Philadelphia. Hoppers see Orson Welles's *Julius Caesar* (1937), a production that emphasises the evolving fascist threat by presenting Caesar as Mussolini figure. Hoppers write letters protesting against 'astounding pump priming expenditures of billions' by Roosevelt. Acquires rear studio at 3 Washington Square for Jo at no extra cost, due to new rent regulations. In December makes many sketches of Palace Theatre in preparation for *New York Movie*.	After Munich uprising, US prepares to arm and pledges support to Great Britain and its allies. Pearl S. Buck receives Nobel Prize for literature. Aaron Copland composes *Billy the Kid*.
1939	Continues preparatory sketches for *New York Movie* at Strand, Republic and Globe theatres. Jo poses as usherette by standing in hallway outside apartment. In July at South Truro works on *Cape Cod Evening*. In November, back in New York, Hoppers see *Three Hundred Years of American Painting* at the Metropolitan Museum and *Picasso: Forty Years of his Art* at MoMA, and are amazed by Picasso's prolific output.	Outbreak of World War II. Steinbeck's *Grapes of Wrath* published. *Gone With the Wind* released, starring Vivian Leigh and Clark Gable. Moholy-Nagy and other New Bauhaus members open The School of Design, now the Institute of Design at Illinois Institute of Technology, Chicago.
1940	Paints *Office at Night*. Paints *Gas*. Sales for the year total 3,866 dollars, slightly better than previous year.	Ernest Hemingway's *For Whom the Bell Tolls* published. Charlie Chaplin's *The Great Dictator* satirises Hitler.

Having recently received a Hopper work donated by Clark, Addison Gallery mounts *The Plan of a Painting: Edward Hopper's Manhattan Bridge Loop*, detailing his creative process.

Hoppers drive back to New York from South Truro, expressly to register to vote against Roosevelt.

1941 Paints *Girlie Show*.
Hoppers take trip to West Coast, spending three months on road, passing through California, Oregon, Nevada, Wyoming, Utah and Colorado. At Rehn's suggestion they visit museums and clients throughout trip, including collector Walter Arensberg in Los Angeles.
In November the young photographer and former painter Arnold Newman photographs Hopper, reflecting his growing celebrity.
Sales drop to 1,560 dollars, their lowest point since 1933, in part because of the effect on Frank Rehn of his wife's death.

Japan bombs Pearl Harbor; US enters war.

1942 Paints *Nighthawks*, followed by *Dawn in Pennsylvania*. *Nighthawks* is purchased by Art Institute of Chicago, and is an overnight success, becoming signature work for Hopper and an iconic American image.
Hoppers see John Gielgud in J.B. Priestley's *The Good Companions* (1933).
Hoppers attend funeral of Gertrude Vanderbilt Whitney on 20 April.
In Truro during the summer, volunteers to serve as air-raid warden.
Awarded Ada S. Garrett Prize, Art Institute of Chicago.

President Roosevelt issues Executive Order 9066, authorising internment of Japanese Americans.
Peggy Guggenheim opens The Art of the Century Gallery, a meeting point for European and American artists during the war.
Artists for Victory, Inc. formed as a non-profit group, comprising over 10,000 international artists, to support US involvement in war.

1943 Paints *Hotel Lobby* and *Summertime*.
Wartime gas shortages prevent drive to Cape Cod; instead Hoppers take first train trip to Mexico, staying in Mexico City, Saltillo and Monterrey.
MoMA purchases *Gas*.

Allies begin offensive in South West Pacific.
Jackson Pollock's first exhibition held at Art of the Century.
Barnett Newman, Mark Rothko and Adolph Gottlieb write letter to the *New York Times* outlining their aesthetic beliefs: 'There is no such thing as good painting about nothing. We assert that the subject is crucial and only that subject-matter is valid which is tragic and timeless.'

1944 Paints *Morning in a City* and *Solitude #56*.

Premiere of Leonard Bernstein's ballet *Fancy Free*.

1945 Anticipating another trip to Mexico, Hoppers enrol in weekly Spanish lessons, memorising passages from Cervantes.
In May, Hopper elected to National Institute of Arts and Letters and exhibits fourteen pictures.
Suffers from period of inactivity, retreating into movies, books and crosswords. Amongst films he sees are John M. Stahl's *Keys of the Kingdom* (1944), Elia Kazan's *A Tree Grows in Brooklyn* (1945) and Albert Lewin's *The Picture of Dorian Gray* (1945).
Paints *Rooms for Tourists* and *Two Puritans*.
Hotel Lobby wins Logan Institute Medal and 500-dollar prize in Chicago Art Institute's Annual Exhibition.

President Roosevelt dies and is replaced by Harry S. Truman.
On 6 August and 9 August US drops atomic bombs on Hiroshima and Nagasaki, Japan.
World War II ends.
United Nations formed.
US Federal Communications Commission (FCC) approves twelve channels of commercial television.
Solo exhibition of Mark Rothko held at Art of the Century.
Salvador Dalí designs dream sequence for Alfred Hitchcock's *Spellbound*, one of the first films to deal with psychoanalysis.

1946 Hoppers watch victory parade on Fifth Avenue on 12 January.
Hoppers travel to Mexico, staying in Saltillo, returning through Grand Titons and staying in South Truro until November.
Returning to New York they learn their building has been purchased by New York University. They fight eviction and win right to stay.

Winston Churchill's famous 'Sinews of Peace' speech on 5 March during visit to Fulton, Missouri, marks first public recognition of the 'iron curtain' dividing Cold War Europe.
The critic Robert Coates uses term 'Abstract Expressionism' to describe works by Jackson Pollock, Willem de Kooning, Franz Kline, Clyfford Still and Adolph Gottlieb.
Otto Kallir publishes *Grandma Moses, American Primitive*.

1947 On 23 April finishes *Pennsylvania Coal Town*.
Completes *Summer Evening*.
Katy Dos Passos killed and John Dos Passos loses eye in car crash. Hoppers attend Katy's funeral.
According to Jo's diary Hopper suffers from depression and frequently reads poems of Robert Frost.

Loyalty oath instituted for all government employees.
State Department exhibition *Advancing American Art* cancelled.
André Gide receives Nobel Prize for Literature.

1948 In January, Hopper has first exhibition at Rehn Gallery since 1941. The January issue of *Time* features Hopper in a cover story that presents him as the apotheosis of American painters. In it, Hopper admits: 'I wish I could paint more. I get sick of reading and going to the movies.'
In February Hopper admitted to hospital for prostate surgery. In convalescence reads Van Wyck Brooks, Whitman and Melville, particularly enjoying collection of short pieces by E.B. White: *One Man's Meat* (1944).

On 3 April Harry Truman signs European Recovery Act, which becomes known as The Marshall Plan. Over next four years Congress appropriates 13.3 billion dollars to rebuild Europe.
Willem de Kooning receives first solo exhibition.
William Baziotes, David Hare, Robert Motherwell, Mark Rothko establish co-operative art school named 'Subjects of the Artist', emphasising importance of subject matter in abstract art. Friday night lecturers include Jean Arp, John Cage and Joseph Cornell. (School dissolves 1949.)

Paints *Seven A.M.*
Walker Art Center purchases *Office at Night*.

Kinsey Report on sexuality published.
Norman Mailer's first novel, *The Naked and the Dead*, published.

1949 Paints *Conference at Night*.
Photographed by Berenice Abbott in New York studio to mark retrospective exhibition at Whitney Museum of American Art, which will open the following year.
In April returns to hospital for further prostate surgery.
Paints *High Noon* and *Summer in the City*.
Reads Thomas Mann's *The Magic Mountain* (1924).

NATO (North Atlantic Treaty Organisation) founded. Member nations are Belgium, Canada, Denmark, France, Great Britain, Iceland, Italy, Luxembourg, the Netherlands, Norway, Portugal and the US.
William Faulkner awarded Nobel Prize for Literature.
Release of *The Third Man*, directed by Carol Reed and starring Orson Welles.

1950 Retrospective at Whitney Museum of American Art, touring to Museum of Fine Arts, Boston and Detroit Institute of Arts.
Escaping pressure of retrospective, Hoppers attend theatre and movies four times in nine days, seeing Carson McCullers's play *The Member of the Wedding* (1946) and Jean Giraudoux's *The Enchanted* (1950), as well as William Wyler's film *The Heiress* (1949) based on Henry James's *Washington Square* (1880).
February, Hopper in hospital again, too weak to attend Whitney opening. More than 24,000 people see retrospective.
Reads André Gide.
In September during trip to Orleans, Cape Cod, Hoppers see Michael Powell's *The Red Shoes* (1948).
Paints *Cape Cod Morning*.
Awarded honorary degree, Doctor of Fine Arts, by Art Institute of Chicago.
On 28 December, Hoppers see Joseph L. Mankiewicz's *All About Eve* (1950) for second time; Hopper thinks it the 'best thing to come out of Hollywood'.

Korean War breaks out.
Barnett Newman's first solo exhibition at the Betty Parsons Gallery receives largely negative response. One painting sold.
Joseph McCarthy states belief that American Government is riddled with Communism.
Arshile Gorky, de Kooning and Pollock represent US at Venice Biennale.

1951 Hopper accepts invitation to serve on jury of 1951 Corcoran Biennial and in January tours New York galleries to select artists.
Paints *First Row Orchestra* and *Rooms by the Sea*.
Disappointed by Jean Cocteau's Surrealist film *Orpheus* (1950), Hopper prefers British realism of two films by Carol Reed: *The Third Man* (1949) starring Orson Welles and *The Fallen Idol* (1948) starring Ralph Richardson.
Hoppers make third trip to Mexico, stopping in Chattanooga, Tennessee, and returning by way of Santa Fe, New Mexico.

Premiere of Elia Kazan's *A Streetcar Named Desire* with Vivien Leigh and Marlon Brando.

1952 Paints *Morning Sun* and *Hotel by a Railroad*.
Hoppers take first plane trip, from Truro to New York, where Hopper sits on selection committee, along with Charles Burchfield and Andrew Wyeth, for a watercolour exhibition at Metropolitan Museum of Art.
Joins 'Reality', a group formed to protest against abstract art in museums, especially MoMA.
Is one of four artists chosen by American Federation of Arts to represent US at Venice Biennale. Does not go to Venice, but returns with Jo to Mexico, via El Paso, Texas, spending a month in Mitla, near Oaxaca, visiting Puebla and Laredo.

Greece and Turkey enter the NATO alliance.
Dwight D. Eisenhower elected president.
The critic Harold Rosenberg coins term 'Action Painting' to describe expressive painting style of Pollock, Still, de Kooning and Kline.
Hemingway's *The Old Man and the Sea* published, for which he receives Pulitzer Prize in 1953.

1953 Hoppers return from Mexico to New York.
With Raphael Soyer, Joseph Solman and other representational painters, works on editorial committee of *Reality* magazine, promoting realist art.
Completes *Office in a Small City*.
Sees *Come Back, Little Sheeba* (1952), directed by Daniel Mann, and insists that Jo see it at once.
The Metropolitan Museum, about to open new American wing, purchases *Office in a Small City*.
Awarded Honorary degree, Doctor of Letters, Rutgers University.

End of Korean War; Korea divided into North and South.

1954 Undergoes two operations for hernia. Only in June does he feel well enough to paint again.
John Clancy, now managing Rehn Gallery, sells more than 30,000 dollars worth of Hopper's paintings. His work has attracted attention of two major private collectors and several museums. Joseph Hirshhorn buys four oils: *Gloucester Street* 1926, *Eleven A.M.*, *First Row Orchestra* and *Hotel by a Railroad* 1952. Roy Neuberger purchases *Barber Shop* 1931 and the watercolour *Gravel Bar, White River* 1937.

The US Supreme Court's decision in *Brown v. Board of Education* bans racial segregation in US schools.
French lose Dien Bien Phu in Vietnam, dividing Vietnam into North and South. Start of American involvement in war.
Whitney Museum of American Art relocates to 22 West Fifty-fourth Street.
Jasper Johns makes breakthrough painting *Flag* 1954–5, instigating a series of paintings of Stars and Stripes and of targets.

1955	While Hoppers are on the Cape, *Hotel Room* is sold to Nathan B. Spingold.	*Family of Man* exhibition at MoMA of 503 photographs from sixty-eight countries promoting equality of humankind.

1955 While Hoppers are on the Cape, *Hotel Room* is sold to Nathan B. Spingold.
Receives Gold Medal for Painting from National Institute of Arts and Letters in name of American Academy of Arts and Letters.
Paints *Hotel Window*: 'It's no particular hotel lobby, but many times I've walked through the Thirties from Broadway to Fifth Avenue and there are a lot of cheesy hotels in there. That probably suggested it. Lonely? Yes, I guess it's lonelier than I planned it, really.'

Family of Man exhibition at MoMA of 503 photographs from sixty-eight countries promoting equality of humankind.
West Germany enters NATO alliance.
Robert Frank sets out to observe and photograph the US.

1956 Frank Rehn dies in March.
Even before *Sunlight on Brownstones* can be framed, it is purchased by Wichita Art Museum in Kansas, a week after Hopper delivers it to Rehn Gallery.
Early Sunday Morning included in Venice Biennale, along with works by Willem de Kooning.
Amongst films that Hopper sees are: Nicholas Ray's *Rebel Without a Cause* (1955), *Mister Roberts* (1955) directed by John Ford and Mervyn LeRoy, Henri-Georges Clouzot's *Les Diaboliques* (1955), Joshua Logan's *Bus Stop* (1956) and John Huston's *Moby Dick* (1956).
Receives Huntington Hartford Foundation fellowship and stays at foundation's headquarters in Pacific Palisades, California, for six months. His arrival in California chronicled in *Time* cover story, which dubs him 'The Silent Witness'. While there, retrospective exhibition opens at Boston's Museum of Fine Arts.

Jackson Pollock killed in car crash.
Elvis Presley releases 'Heartbreak Hotel', selling 300,000 copies in first three weeks, beginning Rock'n'Roll era.
Alan Ginsberg publishes *Howl and Other Poems*, despite obscenity charges.
Premiere of Eugene O'Neill's play *A Long Day's Journey into Night*.

1957 At Foundation paints *California Hills* and *Western Motel*, the latter inspired by Frank Lloyd Wright guest house.

Soviet Union successfully launches Sputnik, world's first artificial satellite, initiating the 'Space Race'.
Metropolitan Museum of Art purchases Jackson Pollock's *Autumn Rhythm* 1950 for 30,000 dollars.

1958 Paints *Four Lane Road*.
Admitted to hospital in January for prostate surgery.
Finishes *Sunlight in a Cafeteria* on 13 June, bought by John Clancy the following autumn for 9,000 dollars.
Re-admitted to hospital in December for more prostate surgery.

NASA (National Aeronautics and Space Administration) founded.
Jasper Johns's first solo exhibition held in January at new Leo Castelli Gallery, New York.
Abstract Expressionism captures public attention and becomes dominant international style after MoMA's exhibition, *The New American Painting*, which tours Europe 1958–9.

1959 Solo exhibition at Currier Gallery of Art, travels to Rhode Island School of Design in December and Wadsworth Atheneum, Hartford, Connecticut in January 1960.
Poor health and bad weather reduce his summer production, but paints *Excursion into Philosophy*, finished on 26 August. Jo records in ledger: 'Real Hopper landscape out of window: A.M. Sun in blue sky touching green dune top, window sill, rug, man, leg of female in pink shirt & back wall. The open book is Plato, re-read too late. Walls neutral greenish. Man in white shirt'.

Second Congress of Black Artists and Writers held in Rome.
After three years of guerrilla war, Fidel Castro overturns Batista regime in Cuba, which becomes socialist one-party state.
Frank Lloyd Wright's building for the Solomon R. Guggenheim Museum opens.
The Americans, the American edition of Robert Frank's photography book, is published, pioneering the 'snap-shot aesthetic'.
Buddy Holly killed in aeroplane crash.
Allan Kaprow installs *18 Happenings in Six Parts* in Reuben Gallery, New York.

1960 On 18 January Hoppers go twice to see Marcel Carné's film *Les Enfants du Paradis* (1945), followed the next day by Claude Chabrol's *Les Cousins* (1959).
People in the Sun completed on 4 February.
At end of March Hopper and other painters from 'Reality' sign a protest to the Whitney over the emphasis given to Non-Objective art.
Interviewed by John Morse for Spring issue of *Art in America*, which presents Hopper with its annual award in December 'for an Outstanding Contribution to American Art'.
Hoppers are delighted to learn from *New York Evening Post* that Alfred Hitchcock credited *House by the Railroad* as inspiration for house in *Psycho* (1960).
Arnold Newman photographs Hopper and his house in South Truro.
Paints *Second Story Sunlight*.

John F. Kennedy elected US president.

1961 In March Brian O'Doherty interviews Hopper in 'Invitation to Art', an educational television series.
Paints *A Woman in the Sun*.

Berlin Wall erected.
Exiled Cubans undertake unsuccessful invasion in The Bay of Pigs.
Hemingway commits suicide.
Joseph Heller's *Catch 22* is published.

Henry Miller's *Tropic of Cancer* published thirty years after its banning on charge of obscenity.
At MoMA *The Art of Assemblage* opens with works by Robert Rauschenberg, Louise Nevelson, Jean Tinguely, Richard Stankiewicz, Cesar, Edward Kienholz and Arman.

1962 Paints *New York Office*.
Hoppers attend debate 'Is Modern Art Decadent?' with critics John Canaday and Thomas Hess at MoMA.
From October to November *The Complete Graphic Work of Edward Hopper* is presented at Philadelphia Museum of Art.
In December, Hopper tells Brian O'Doherty: 'If anyone wants to see what America is, go and see a movie called *The Savage Eye*', directed by Sidney Meyers and Ben Maddow (1959).

Cuban Missile Crisis.
Geometric Abstraction in America opens at Whitney Museum of American Art, New York.
First Pop art exhibition in New York: *The New Realists* at the Sidney Janis Gallery.
Marilyn Monroe dies.

1963 Paints *Sun in an Empty Room* and *Intermission*.
In June, Brian O'Doherty visits Truro accompanied by photographer Hans Namuth, who makes series of portraits.
Retrospective exhibition at Arizona Art Gallery, South Truro.
Amongst films the Hoppers see are: Henri Colpi's *The Long Absence* (1962), Sidney Lumet's *Twelve Angry Men* (1957) and Jacques Tati's *Mon Oncle* (1958).

March on Washington led by the Revd Martin Luther King, Jr.
Assassination of President John F. Kennedy; Lyndon B. Johnson becomes president.
US, Soviet Union and Great Britain sign Nuclear Weapons Treaty.
Andy Warhol opens his studio, The Factory.
Duchamp retrospective held at Pasadena Museum, Los Angeles.
Beatles release first album *Please Please Me*, and Rolling Stones release first single 'Come On'.
Warhol substitutes silkscreen process for hand painting.
Betty Friedan publishes *The Feminine Mystique*.

1964 In February O'Doherty visits again.
Prevented from painting by protracted illness.
Hopper receives M.V. Khonstamn Prize for Painting from Art Institute of Chicago.
Hans Namuth visits Washington Square North, making portfolio of photographs.
From September to November Whitney Museum of American Art mounts retrospective, which travels to Art Institute of Chicago and is well received by critics.

Martin Luther King receives Nobel Peace Prize.
Civil Rights Act passed.
Robert Rauschenberg wins Grand Prize at Venice Biennale.
Marshall McLuhan publishes *Understanding Media: The Extensions of Man*.
Post-Painterly Abstraction (named after phrase coined by Clement Greenberg) held at Los Angeles County Museum, including Elsworth Kelly, Sam Francis, Al Held, Frank Stella, Kenneth Noland, Morris Louis, Jack Youngerman, Larry Poons and Jules Olitsky.
Premiere of Stanley Kubrick's *Dr Strangelove*.

1964–75

Vietnam War.

1965 In January Hopper declines invitation to attend inauguration of Democrat president Lyndon B. Johnson.
Whitney retrospective tours to Detroit Institute of Arts and City Art Museum of St Louis.
Awarded Honorary degree, Doctor of Fine Arts, Philadelphia College of Art.
Paints final work, *Two Comedians*.
On 16 July, Hopper's sister Marion dies in Nyack, New York.

Passage of Voting Rights Act.
Assassination of Malcolm X.
Passage of National Foundation on the Arts and Humanities Act, leading to establishment of National Endowment for the Arts (NEA) and National Endowment for the Humanities (NEH).
Exhibition on Op art, *The Responsive Eye*, held at MoMA.

1966 Awarded Edward MacDowell Medal on 27 August for outstanding contributions to arts. Too ill to travel, Hopper elects Lloyd Goodrich to receive it on his behalf.

National Organization for Women founded.
Peace Tower constructed by Artists' Protest Committee, Los Angeles.
Huey P. Newton and Bobby Seal form the Black Panther Party for Self-Defence in October and launch party newspaper, *The Black Panther*, the following spring.
Minimalism introduced through *Primary Structures* show at Jewish Museum, New York and *Systematic Painting* at Solomon R. Guggenheim Museum, with works by Tony Smith, Donald Judd, Robert Morris, Dan Flavin and Sol LeWitt.
Robert Venturi publishes *Complexity and Contradiction in Architecture*, which becomes manifesto of Postmodernism.

1967 After long hospitalisation, Hopper dies in Washington Square studio on 15 May, and is buried two days later in the family plot in Oak Hill Cemetery, Nyack, New York, overlooking the Tappan Zee. Funeral attended by Jo, John Clancy, Henry Varnum Poor, his daughter Ann Poor, Brian O'Doherty, Barbara Novak, Mrs Clarence (Peggy) Day and Lloyd Goodrich.

Huge demonstrations against Vietnam War take place.
Race riots break out in over one hundred American cities.
Angry Art Week organised in New York by Artists and Writers Protest.

1968 Jo Hopper dies on 6 March.

If you could say it in words,
there'd be no reason to paint.

Edward Hopper, 'The Silent
Witness', *Time*, 24 December
1956, p.38

Edward Hopper
Bibliography

Books, Monographs and Exhibition Catalogues

Exhibition by Edward Hopper, exh. cat., Rehn Gallery, New York 1929
Paintings by Nineteen Living Americans, exh. cat., Museum of Modern Art, New York 1929
Exhibition of Contemporary American Prints, exh. cat., Victoria and Albert Museum, London 1929
Watson, Forbes (ed.), The Arts Portfolio Series: Edward Hopper, The Arts Publishing Corporation, New York 1930
du Bois, Guy Pène, Edward Hopper: American Artists Series, Whitney Museum of American Art, New York 1931
Barr, Alfred H., Jr (ed.), Edward Hopper: Retrospective Exhibition, with essays by Alfred H. Barr Jr, Charles Burchfield and Edward Hopper, exh. cat., Museum of Modern Art, New York 1933
Exhibition of Paintings by Edward Hopper, exh. cat., Arts Club of Chicago, Chicago 1934
An Exhibition of Paintings, Watercolors and Etchings by Edward Hopper, exh. cat., Carnegie Institute, Pittsburgh 1937
du Bois, Guy Pène, Artists Say the Silliest Things, American Artists Group, New York 1940
Edward Hopper, American Artists Group, New York 1945
Read, Helen Appleton, Robert Henri and Five of his Pupils: George Bellow, Eugene Speicher, Guy Pène du Bois, Rockwell Kent, Edward Hopper, exh. cat., Century Art Association, New York 1946
Goodrich, Lloyd, Edward Hopper, Penguin, Harmondsworth 1949
Goodrich, Lloyd, Edward Hopper Retrospective Exhibition, exh. cat., Whitney Museum of American Art, New York 1950
American Pavilion, XXVI Venice Biennale, Venice 1952
Brown, Milton W., American Painting from the Armory Show to the Depression, Princeton University Press, Princeton 1955
Watercolors by Edward Hopper with a Selection of His Etchings, exh. cat., Currier Gallery of Art, Manchester, NH 1959

Denniston, Douglas, A Retrospective Exhibition of Oils and Watercolors by Edward Hopper, exh. cat., University of Arizona Art Gallery, Tucson 1963
Brown, Milton W., The Story of the Armory Show, Joseph H. Hirshhorn Foundation/New York Graphic Society, New York 1963
Goodrich, Lloyd, Edward Hopper, exh. cat., Whitney Museum of American Art, New York 1964
Trovato, Joseph S., Edward Hopper: Oils, Watercolors, Prints, exh. cat., The Edward W. Root Art Center, Clinton, NY 1964
Five Distinguished American Artists: Dickinson, Hofmann, Hopper, Shahn, Soyer, exh. cat., New York State Exposition's Art Advisory Committee/Art & Home Center, Exhibition Grounds, Syracuse 1965
São Paulo 9: United States of America, with essay by William C. Seitz, exh. cat., Museu de Arte Moderna, São Paulo 1967
O'Doherty, Brian, Object and Idea: An American Art Critic's Journal 1961–1967, Simon and Schuster, New York 1967
Homer, William B., Robert Henri and his Circle, Cornell University Press, Ithaca 1969
Goodrich, Lloyd, Edward Hopper: Selections from the Hopper Bequest, exh. cat., Whitney Museum of American Art, New York 1971
McCoy, John W., Edward Hopper, 1882–1967: Oils, Watercolors, Etchings, exh. cat., William Farnsworth Library and Art Museum, Rockland, Maine 1971
Memorial Exhibition: Lee Gatch, Hans Hofmann, Edward Hopper, Henry Schnackenberg, Charles Scheeler, exh. cat., American Academy of Arts and Letters, New York 1971
Goodrich, Lloyd, Edward Hopper, Harry N. Abrams, New York 1971
Gussow, Alan, A Sense of Place: The Artist and the American Land, exh. cat., Joslyn Art Museum, Omaha, NE 1973
Sound and Silence: Charles E. Burchfield/Edward Hopper, exh. cat., The New Britain Museum of American Art, New Britain, CT 1973

America Observed: Edward Hopper, Walker Evans, exh. cat., The Fine Arts Museum of San Francisco/California Palace of the Legion of Honor, San Francisco 1976
Edward Hopper at Kennedy Galleries, with essay by Gail Levin, exh. cat., Kennedy Galleries, New York 1977
By the Side of the Road, exh. cat., Currier Gallery of Art, Manchester, NH 1978
Levin, Gail, Edward Hopper: Prints and Illustrations, exh. cat., Whitney Museum of American Art, New York 1979
Levin, Gail, Edward Hopper as Illustrator, W.W. Norton and Company, New York 1979
Levin, Gail, Edward Hopper: The Complete Prints, W.W. Norton and Company, New York 1979
Ritter, Patricia C., Edward Hopper: The Early Years, exh. cat., Brevard Art Center & Museum, Melbourne, FL 1980
Levin, Gail, Edward Hopper: The Art and the Artist, exh. cat., Whitney Museum of American Art in association with W.W. Norton and Company, New York 1980 (touring to: Hayward Gallery, London; Stedelijk Museum, Amsterdam; Städtlische Kunsthalle, Düsseldorf; The Art Institute of Chicago; San Francisco Museum of Modern Art)
Edward Hopper: The Formative Years, exh. cat., Scottish and Welsh Arts Councils 1981 (organised by the Whitney Museum of American Art and touring to: Newport Museum and Art Gallery, Gwent; Fruitmarket Art Gallery, Edinburgh; Mostyn Art Gallery, Llandudno)
Edward Hopper: Das Frühwerk, with essays by Ernst-Gerhard Güse and Nicola Borger-Keweloh, exh. cat., Westfälisches Landesmuseum für Kunst und Kulturgeschichte, Münster 1981
Edward Hopper Works on Paper: A Personal Collection, exh. cat., Guildhall Museum, Hampton, NY 1982
The World of Edward Hopper: Selections from the Collection of the Whitney Museum of American Art, exh. cat., Art Gallery of

Australia, Adelaide 1982 (touring to: National Art Gallery of Victoria, Melbourne; Queensland Art Gallery, Brisbane; Art Gallery of New South Wales, Sydney)
Berman, Greta and Jeffrey Wechsler, Realism and Realities: The Other Side of American Painting, 1940–1960, exh. cat., Rutgers University Art Gallery, New Brunswick, NJ 1982
Cinquante ans de dessins américains: 1930–1980, exh. cat., École Nationale Supérieure des Beaux Arts, Paris 1985
Levin, Gail, Hopper's Places, Knopf, New York 1985
Liesbrock, Heinz, Edward Hopper, die Wahrheit des Lichts, Trikont, Duisburg 1985
Ward, J.A., American Silences: The Realism of James Agee, Walker Evans, and Edward Hopper, Louisiana State University Press, Baton Rouge 1985
Blum, Shirley Neilsen and Suzanne Delehanty, The Window in Twentieth Century Art, exh. cat., Neuberger Museum SUNY at Purchase, New York 1986
Lyons, Deborah, Edward Hopper: City, Country, Town, exh. cat., Whitney Museum of American Art, New York 1986
Polan, Dana, Power and Paranoia: History, Narrative, and the American Cinema, 1940–1950, Columbia University Press, New York 1986
Hobbs, Robert, Edward Hopper, Harry N. Abrams/Smithsonian Institution, New York 1987
Levin, Gail, Homage to Edward Hopper: Quoting the American Realist, exh. cat., Baruch College Gallery, New York 1988
Schjeldahl, Peter, Edward Hopper: Light Years, exh. cat., Hirschl & Adler Galleries, New York 1988
Beck, Hubert, Der Melancolische Blick: Die Grossstadt im Werk des amerikanischen Malers Edward Hopper, P. Lang, Frankfurt 1988
Liesbrock, Heinz, Edward Hopper: Forty Masterworks, Schirmer, Munich 1988
Edward Hopper, exh. cat., Musée Cantini, Marseilles 1989

Edward Hopper: Selections from the Permanent Collection, exh. cat., Whitney Museum of American Art, New York 1989

Hopper Drawings: 44 Works from the Permanent Collection of the Whitney Museum of American Art, Dover Publications, New York 1989

Edward Hopper, 1882–1967: sélections de la collection permanente du Whitney Museum of American Art, New York, et autres collections, exh. cat., Musée Rath, Geneva 1991

Edward Hopper, 1882–1967: eine Austellung in Zusammenarbeit mit dem Whitney Museum of American Art, New York, exh. cat., Schirn Kunsthalle, Frankfurt 1992

Edward Hopper und die Fotografie: die Wahrheit des Sichtbaren, with essays by Georg Költzsch, Heinz Liesbrock, Gerd Blum, Bernd Growe, Vince Leo, Joel Meyerowitz, Michael Rutschky, and Eva Schmidt, exh. cat., Museum Folkwang, Essen 1992

Marling, Karal Ann, Edward Hopper, Rizzoli, New York 1992

Debecque-Michel, Laurence, Hopper, Hazan, Paris 1992

Hameury, Jean-Paul, Edward Hopper, Editions Folle Avoine, Romillé 1992

Fragen an vier Bilder: Edward Hopper, Ad Reinhardt, Giorgio Morandi, Agnes Martin, exh. cat., Westfälischer Kunstverein Münster, Münster 1993

Little, Carl, Edward Hopper's New England: Essential Paintings, Pomegranate, San Francisco 1993

Renner, Rolf Gunter, Edward Hopper, 1882–1967: Transformation of the Real, trans. Michael Hulse, Taschen, Cologne 1993

Taggart, John, Remaining in Light: Ant Meditations on a Painting by Edward Hopper, State University of New York, Albany 1993

Kertess, Klaus, Collection in Context: Edward Hopper and Jack Pierson, American Dreaming, exh. cat., Whitney Museum of American Art, New York 1994

The Early Drawings of Edward Hopper, exh. cat., Kennedy Galleries, New York 1995

Edward Hopper and the American Cinema, with essay by Robert B. Ray, exh. cat., Whitney Museum of American Art, New York 1995

Lyons, Deborah, Adam D. Weinberg and Julie Grau (eds.), Edward Hopper and the American Imagination, with contributions by Paul Auster, Anne Beattie, Tess Gallagher, Thom Gunn, John Hollander, William Kennedy, Galway Kinnell, Ann Lauterbach, Gail Levin, Norman Mailer, Leonard Michaels, Walter Mosley, Grace Paley, and James Salter, exh. cat, Whitney Museum of American Art, New York 1995

Levin, Gail, Edward Hopper: An Intimate Biography, Knopf, New York 1995

Levin, Gail, Edward Hopper: A Catalogue Raisonné, Whitney Museum of American Art/ W.W. Norton and Company, New York and London 1995

Perez, Rolando, The Lining of our Souls: Excursions into Selected Paintings of Edward Hopper, Stranger Books, New York 1995

Schmied, Wieland, Edward Hopper: Portraits of America, trans. John William Gabriel, Prestel, Munich and New York c.1995

Serota, Nicholas, Sandy Nairne and Adam D. Weinberg, Views from Abroad: European Perspectives on American Art 3: American Realities, with essays by Andrew Brighton and Peter Wollen, exh. cat., Whitney Museum of American Art, New York, in collaboration with Stedelijk Museum, Amsterdam 1997

City of Ambition: Artists and New York, 1900–1960, exh. cat., Whitney Museum of American Art, New York 1996

Carney, Ray, American Vision: The Films of Frank Capra, Wesleyan University Press/ University Press of New England, Hanover, NH 1996

Gross, Ita, Edward Hopper: A Modern Master, Smithmark, New York 1996

Lyons, Deborah (ed.), Edward Hopper: A Journal of His Work, Whitney Museum of American Art/W.W. Norton and Company, New York 1997

Renner, Rolf Gunter, Edward Hopper: Transformation of the Real, Thunder Bay Press, San Diego 1997

Koob, Pamela N., Edward Hopper's New York Movie, exh. cat., The Bertha and Karl Leubsdorf Art Gallery, Hunter College of The City University of New York, New York 1998

Bon, François, Dehors est la ville: Edward Hopper, Charenton, Flohic 1998

Fresnault-Deruelle, Pierre, Des images lentement stabilisées: quelques tableaux d'Edward Hopper, L'Harmatton, Paris 1998

Kranzfelder, Ivo, Edward Hopper, 1882–1967: Vision of Reality, trans. John William Gabriel, Taschen, Cologne 1998

Spring, Justin, Essential Hopper, Wonderland Press/Harry N. Abrams, New York 1998

Zambon, Mara, Pittura e crisi dell'uomo contemporaneo: Edward Hopper e Francis Bacon. Storia dell'arte e della critica d'arte, Liguori, Naples 1998

Mecklenburg, Virginia M., Edward Hopper: The Watercolors, exh. cat., National Museum of American Art, Smithsonian Institution, Washington, DC 1999

Robertson, Bruce, Twentieth-Century American Art: The Ebsworth Collection, exh. cat., National Gallery of Art, Washington, DC 2000

Borghesi, Silvia, Hopper: realtà e poesia del mito americano, Leonardo Arte, Milan 2000

Levin, Gail, Silent Places: A Tribute to Edward Hopper, Universe, New York 2000

American Visionaries: Selections from the Whitney Museum of American Art, Whitney Museum of American Art/Harry N. Abrams, New York 2001

Levin, Gail, The Complete Watercolors of Edward Hopper, Whitney Museum of American Art/Harry N. Abrams, New York 2001

Levin, Gail, The Complete Oil Paintings of Edward Hopper, Whitney Museum of American Art/Harry N. Abrams, New York 2001

Strand, Mark, Hopper, Knopf, New York 2001

Spangenburg, Ray, Edward Hopper: The Life of an Artist, Enslow Publishers, Berkeley Heights, NJ 2002

Foa, Emma, Edward Hopper, Franklin Watts, New York 2003

Fryd, Vivien Green, Art and the Crisis of Marriage: Edward Hopper and Georgia O'Keeffe, University of Chicago Press, Chicago 2003

Holmes, Burnham, Edward Hopper, Raintree, Chicago 2003

Berman, Avis, Edward Hopper's New York, Pomegranate, San Francisco 2005

Writings by Edward Hopper

'Books' (review of Malcolm C. Salaman, Fine Prints of the Year, 1925), The Arts, vol.9, no.3, March 1926, pp.172–4

'John Sloan and the Philadelphians', The Arts, vol.11, no.4, April 1927, pp.168–78

'Books' (review of Vernon Blake, The Art and Craft of Drawing), The Arts, vol.11, no.6, June 1927, pp.333–4

'Charles Burchfield: American', The Arts, vol.14, no.1, July 1928, pp.5–12

'Notes on Painting', in Alfred H. Barr Jr (ed.), Edward Hopper Retrospective Exhibition, exh. cat., Museum of Modern Art, New York 1933, pp.17–18

'Edward Hopper Objects' (letter to the editor, Nathaniel Pousette-Dart), The Art of Today, vol.6, February 1935, p.11

'Statements by Four Artists', Reality, no.1, Spring 1953, p.8

'Letter to the Editor', Art Times, vol.2, October 1959, n.p.

Film, and television and radio broadcasts

Ozenfant, Amedée, 'Edward Hopper', Voice of America, 7 March 1950

Hopper, Edward, 'Invitation to Art', interview by Brian O'Doherty, Museum of Fine Art, Boston/ WGBH-TV, 10 April 1961

Hopper, Edward, 'Edward Hopper', interview with Aline Saarinen, Sunday Show, NBC, 1964

Hopper's Silence, dir. Brian O'Doherty, Whitney Museum of American Art, New York, 1980

Edward Hopper, dir. Ron Peck, Arts Council of Great Britain/ Westfälisches Landesmuseum für Kunst und Kulturgeschichte, 1981

Hollander, John, 'The Art of Edward Hopper, 1882–1967', BBC Radio Talks & Commentaries, 8 February 1981

'Edward Hopper, 1882–1967', dir. Carol Bell, *Arena*, BBC2, 21 February 1981

'Imagine: Edward Hopper'. dir. Ian Macmillan, *Imagine*, BBC1, 2 June 2004

Reviews and Articles

du Bois, Guy Pène, 'Edward Hopper, Draughtsman', *Shadowland*, no.7, October 1922, pp.22–3

'George Hart and Edward Hopper', *New York Times*, 11 February 1923, section 7, p.7

McBride, Henry, 'Hopper's Watercolors', *The Dial*, May 1924, pp.201–3

Barker, Virgil, 'The Etchings of Edward Hopper', *The Arts*, vol.5, no.6, June 1924, pp.322–5

Goodrich, Lloyd, 'The Paintings of Edward Hopper', *The Arts*, vol.11, no.3, March 1927, pp.134–8

'Edward Hopper', *Wadsworth Atheneum Bulletin*, vol.6, April 1928, pp.13–14

Watson, Forbes, 'A Note on Edward Hopper', *Vanity Fair*, no.31, February 1929, pp.64, 98, 107

McBride Henry, 'Works of Nineteen Best American Artists Exhibited in New Museum's Second Show', *New York Sun*, 14 December 1929, p.8

Watson, Forbes, 'The All American Nineteen', *The Arts*, vol.16, no.4, January 1930, pp.301–11

Taylor, Francis Henry, 'The Romantick Revival of 1930', *Parnassus*, vol.2, no.6, October 1930, pp.3–7

du Bois, Guy Pène, 'The American Paintings of Edward Hopper', *Creative Art*, vol.8, no.3, March 1931, pp.187–91

Barr, Alfred H. Jr, 'Post-War Painting in Europe', *Parnassus*, vol.3, no.5, May 1931, pp.20–2

Crowninshield, Frank, 'A Series of American Artists, No.3: Edward Hopper', *Vanity Fair*, no.38, June 1932, pp.30–1

'Hopper Show at Modern Museum', *Art News*, vol.32, no.4, 28 October 1933, p.11

Read, Helen Appleton, 'Edward Hopper', *Parnassus*, vol.5, no.6, November 1933, pp.8–10, 30

Morsell, Mary, 'Hopper Exhibition Clarifies a Phase of American Art', *Art News*, vol.32, no.5, 4 November 1933, p.12

Gregory, Horace, 'A Note on Hopper', *New Republic*, 13 December 1933, p.132

'We Nominate for the Hall of Fame: Edward Hopper', *Vanity Fair*, no.41, January 1934, p.27

Benson, E.M., 'Of Many Things', *American Magazine of Art*, vol.27, no.1, January 1934, p.21

Barker, Virgil, 'The Search for Americanism', *Magazine of Arts*, vol.26, no.2, February 1934, p.51

Poussette-Dart, Nathaniel, 'Editorial Comment' (response to letter from Hopper), *Art of Today*, vol.6, February 1935, p.11

'Such Is Life', *Life*, 15 August 1935, pp.6, 48

Brace, Ernest, 'Edward Hopper', *Magazine of Art*, vol.30, May 1937, pp.274–8

'Hopper Is a Realist', *Life*, 3 May 1937, pp.44–7

Reece, Childe, 'Edward Hopper's Etchings', *Magazine of Art*, vol.31, no.4, April 1938, pp.226–8

Jewell, Edward Adler, 'Early Art Shown of Edward Hopper', *New York Times*, 11 January 1941, p.18

Greenberg, Clement, 'Review of the Whitney Annual', *The Nation*, 28 December 1946, reprinted in John O'Brian (ed.), *Clement Greenberg: The Collected Essays and Criticism*, University of Chicago Press, Chicago 1986

Brown, Milton W., 'The Early Realism of Hopper and Burchfield', *College Art Journal*, vol.7, Autumn 1947, pp.3–11

Soby, James Thrall, 'Max Weber and Edward Hopper', in *Contemporary Painters*, Museum of Modern Art/Simon and Schuster, New York 1948 pp.28, 39

Louchheim, Aline B., 'Realism and Hopper', *New York Times*, 11 January 1948, section 2, p.9

Coates, Robert, 'The Art Galleries: Edward Hopper and Jackson Pollock', *New Yorker*, 17 January 1948, pp.56–7

'Are These Men the Best Painters in America Today?', *Look*, February 1948, p.44

Tyler, Parker, 'Edward Hopper: Alienation by Light', *Magazine of Art*, vol.41, no.12, December 1948, pp.290–5

'Edward Hopper', *Current Biography*, vol.11, 1950, pp.256–8

Burrows, Carlyle, 'Hopper: A Steady Climb to Eminence', *New York Herald Tribune*, 12 February 1950, section 5, p.6

Devree, Howard, 'Hopper since 1907', *New York Times*, 12 February 1950, section 2, p.9

'Relentless Realist', *Newsweek*, 20 February 1950, p.84

Burchfield, Charles, 'Hopper: Career of Silent Poetry', *Art News*, vol.49, no.8, March 1950, pp.14–17, 62–3

Soby, James Thrall, 'Arrested Time by Edward Hopper', *Saturday Review*, 4 March 1950, pp.42–3

'Edward Hopper: Famous American Realist Has Retrospective Show', *Life*, 17 April 1950, pp.100–5

'Edward Hopper Drawings from the Artist's Portfolio', *American Artist*, vol.14, May 1950, pp.28–33

Kneeland, Paul F., ' "Some Artists Dote on Interviews; They All but Kill Me" – Edward Hopper' *Boston Sunday Globe*, 12 July 1953, p.A-7

Poor, Henry Varnum, 'Presentation to Edward Hopper of the Gold Medal for Painting', *Proceedings of The American Academy of Arts and Letters in the National Institute of Arts and Letters, 1956*, 1955, pp.34–6

Burrey, Suzanne, 'Edward Hopper: The Emptying Spaces', *Arts Digest*, 1 April 1955, pp.8–10, 33

Richardson, E.P., 'Three American Painters: Sheeler-Hopper-Burchfield', *Perspective U.S.A.*, vol.16, 1956, pp.111–19

Smith, Jacob Getlar, 'Edward Hopper', *American Artist*, vol.20, January 1956, pp.22–7

'The Silent Witness', *Time*, 24 December 1956, pp.28, 36–9

Goodrich, Lloyd, 'Edward Hopper', in John I.H. Baur (ed.), *New Art in America:*

Fifty Painters of the Twentieth-Century, Praeger, New York 1957, pp.144–9

Rodman, Selden, 'Edward Hopper', in *Conversations with Artists*, Devin-Adair, New York 1957, pp.198–9

Tyler, Parker, 'Hopper/ Pollock', *Art News Annual*, vol.26, 1957, pp.86–107

Morse, John, 'Edward Hopper: An Interview', *Art in America*, vol.48, no.2, March 1960, pp.60–3

'The Art in America Annual Award', *Art in America*, vol.48, no.6, December 1960, p.3

Preston, Stuart, 'Art: Award to Hopper', *New York Times*, 16 December 1960, p.45

Kuh, Katharine, 'Edward Hopper', in *The Artist's Voice. Talks with Seventeen Artists*, Harper & Row, New York 1962, pp.131–42

Geldzahler, Henry, 'Edward Hopper', *Metropolitan Museum of Art Bulletin*, vol.21, November 1962, pp.113–17

Zigrosser, Carl, 'The Etchings of Edward Hopper', in Carl Zigrosser (ed.), *Prints*, Holt, Rhinehart and Winston, New York 1962

Zigrosser, Carl, 'The Prints of Edward Hopper', *American Artist*, vol.27, November 1963, pp.38–43, 64–5

Canaday, John, 'Art: Edward Hopper, American Realist 55 Years', *New York Times*, 29 September 1964, p.47

Campbell, Lawrence, 'Hopper: Painter of "Thou Shalt Not" ', *Art News*, vol.63, October 1964, pp.42–5, 58

Bisaccio, Philip, 'Edward Hopper', *Art Times*, vol.3, October/ November 1964, pp.8–9

Canaday, John, 'The Art of Edward Hopper: Some Notes on the Loneliness of a Long Distance Runner', *New York Times*, 4 October 1964, p.21

Genauer, Emily, ' "Cleansed Perceptions" of Hopper and Albers', *New York Herald Tribune*, 4 October 1964, p.27

Kramer, Hilton, 'Edward Hopper: An American Vision', *New Leader*, vol.47, 12 October 1964, pp.23–4

Tillim, Sidney, 'Edward Hopper and the Provincial Principle', *Arts Magazine*,

vol.39, November 1964, pp.24–31

Rose, Barbara, 'New York Letter: The Hopper Retrospective', *Art International*, vol.8, no.9, 25 November 1964, p.52

O'Doherty, Brian, 'Portrait: Edward Hopper', *Art in America*, vol.52, no.6, December 1964, pp.68–88

O'Doherty, Brian, 'Instants in Time: Review of Edward Hopper at the Whitney Museum of American Art', *Newsweek*, 7 December 1964

Lanes, Jerrold, 'Retrospective of Edward Hopper at the Art Institute of Chicago and at the Whitney Museum in New York', *Burlington Magazine*, vol.107, no.742, January 1965, pp.42–6

Bernard, Sidney, 'Edward Hopper, Poet-Painter of Loneliness', *Literary Times*, vol.4, April 1965, p.11

Canaday, John, 'It Went Something Like This in 1964–65', *New York Times*, 16 May 1965, section 2, p.19

Squirru, Raphael, 'Edward Hopper', *Americas*, 17 May 1965, pp.11–17

Glueck, Grace, 'For São Paulo – Some Pop, Lots of Hop(per)', *New York Times*, 19 March 1967, section D, p.29

Seitz, William C., 'An Evaluation: Edward Hopper, Painter of the American Scene', Associated Press article, May 1967

Goodrich, Lloyd, 'Edward Hopper: 1882–1967', *Villager*, 25 May 1967, pp.1–3

Kroll, Jack, ' "I Want to Paint Sunlight" ', *Newsweek*, 29 May 1967, pp.88–9

'São-Paulo: Homage to Hopper', *Art in America*, vol.55, no.5, September/October 1967, pp.84–5

Lanes, Jerrold, 'Edward Hopper: French Formalist, Ash Can Realist, Neither, or Both?', *Artforum*, vol.7, no.2, October 1968, pp.44–9

Goodrich, Lloyd, 'The Hopper Bequest', *Whitney Review* 1970/71, pp.22–3

Glueck, Grace, 'Art Is Left by Hopper to the Whitney', *New York Times*, 19 March 1971, pp.1, 28

Kramer, Hilton, 'Hopper: An Integrity in Realism', *New York Times*, 19 March 1971, p.28

Kramer, Hilton, 'The Hopper Bequest: Selling a Windfall', *New York Times*, 28 March 1971, p.25

Baur, John I.H., 'Hopper's Art: Happy Ending?' (letter to the editor), *New York Times*, 25 April 1971, section 2, p.20

Getlein, Frank, 'The Legacy of Edward Hopper: Painter of Light and Loneliness', *Smithsonian*, vol.2, September 1971, pp.60–7

O'Doherty, Brian, 'The Hopper Bequest at the Whitney', *Art in America*, vol.59, no.5, September 1971, pp.68–72

Rose, Barbara, 'Edward Hopper, Great American Realist of the 20th Century', *Vogue*, vol.158, September 1971, pp.284–5

Mellow, James R., 'The World of Edward Hopper: The Drama of Light, the Artificiality of Nature, the Remorseless Human Comedy', *New York Times Magazine*, 5 September 1971, pp.14–16, 18–19, 21–3

Kramer, Hilton, 'Art: Whitney Shows Items from Hopper Bequest', *The New York Times*, 11 September 1971, p.23

Stevens, Elisabeth, 'Hopper: Fascination with Light', *Wall Street Journal*, 22 September 1971, p.16

Harnett, Lila, 'Weekend in New York: Whitney Museum Unveils Edward Hopper's Legacy', *Riverdale Press*, 23 September 1971, p.19

Davis, Douglas, 'A Master's Legacy', *Newsweek*, 27 September 1971, pp.98–9

Campbell, Lawrence, 'Edward Hopper and the Melancholy of Robinson Crusoe', *Art News*, vol.70, no.6, October 1971, pp.36–9, 78

'The Hopper Legacy', *New York Daily News*, 3 October 1971, pp.32–3

Strand, Mark, 'Crossing the Tracks to Hopper's World', *New York Times*, 17 October 1971, section 2, p.26

Kramer, Hilton, 'Edward Hopper', *New York Times Book Review*, 21 November 1971, pp.72–3

Robertson, Bryan, 'Hopper's Theater', *New York Review of Books*, vol.17, no.10, 16 December 1971, pp.38–40

Hollander, John, 'An American Painter' (review of Lloyd Goodrich, *Edward Hopper*, New York 1971), *Commentary*, January 1972, pp.94–9

Gillies, Jean, 'The Timeless Space of Edward Hopper' (excerpt from unpublished PhD dissertation, Northwestern University, Chicago 1970), *Art Journal*, vol.32, Summer 1972, pp.404–12

Mellow, James R., 'Hopper: More Than a Great American Realist', *New York Times*, 16 July 1972, section 2, p.17

Kuh, Katharine, 'Edward Hopper in Mexico', *World*, 15 August 1972, pp.54–5

O'Doherty, Brian, 'Hopper's Voice', in *American Masters: The Voice and Myth*, Random House, New York 1973, pp.10–43

Baldwin, Carl, 'Realism, The American Mainstream', *Réalités*, November 1973, pp.42–51

Baigell, Matthew, 'The Silent Witness of Edward Hopper', *Arts Magazine*, vol.49, no.1, September 1974, pp.29–33

Derfner, Phyllis, 'New York Letter', *Art International*, vol.18, nos.5–6, September 1974, pp.35–6

Heller, Nancy and Julia Williams, 'Edward Hopper: Alone in America', *American Artist*, vol.40, January 1976, pp.70–5, 103–6

Russell, John, 'The Truth in Hopper's Art', *New York Times*, 13 May 1977, pp.C-1, C-22

Cline, Frances X., 'About New York: Painting Sunlight on the Side of a House', *New York Times*, 31 May 1977, p.26

Harnett, Lila, 'Hopper Haunts a Gallery', *Cue Magazine*, 10 June 1977, p.32.

Levin, Gail, 'Edward Hopper's Office at Night', *Arts Magazine*, vol.52, no.5, January 1978, pp.134–7

Domecq, Jean-Philipe, 'Edward Hopper, ou l'énigme à plat', *XXe Siècle*, vol.50, June 1978, pp.18–23

Levin, Gail, 'Edward Hopper, Francophile', *Arts Magazine*, vol.53, June 1979, pp.114–21

Deschamps, Madeleine, 'Autour d'Edward Hopper, les États-Unis vers 1930', *Art Press*, July 1979, pp.22–3

Levin, Gail, 'Hopper's Etchings: Some of the Finest Examples of American Printmaking', *Art News*, vol.78, no.7, September 1979, pp.90–3

Levin, Gail, 'Edward Hopper as Printmaker and Illustrator: Some Correspondences', *Print Collector's Newsletter*, vol.10, September/October 1979, pp.121–3

Kramer, Hilton, 'Art: Another Side of Edward Hopper', *New York Times*, 28 September 1979, section C, p.18

Berman, Avis, 'A Master Artist and the "Secret" of his Past', *Baltimore Sun*, 28 October 1979, section D, pp.1–3

Canaday, John, 'The Avant-Garde a Half-Century Ago: What it Produced', *Smithsonian*, vol.10, November 1979, pp.108–15

Eliot, Alexander, 'Edward Hopper's Most Interested Vision', *Atlantic Monthly*, vol.24, December 1979, pp.48–53

Goodrich, Lloyd, 'Lloyd Goodrich Reminiscences: Part I', *Archives of American Art Journal*, vol.20, no.3, 1980, pp.3–18

Silberman, Robert, 'Prints, Edward Hopper: Becoming Himself', *Art in America*, vol.68, January 1980, pp.45–7

Stein, Susan Alyson, 'Edward Hopper: The Uncrossed Threshold', *Arts Magazine*, vol.54, no.7, March 1980, pp.156–60

Billeter, Erika, 'Edward Hopper und die amerikanische Szene', *du*, April 1980, pp.20–37

Paulson, Ronald, 'Backs and Bedclothes: Lautrec and Hopper,' *Bennington Review*, April 1980, pp.60–73

Canaday, John, 'The Solo Voyage of Edward Hopper, American Realist', *Smithsonian*, vol.11, September 1980, pp.126–33

Hooton, Bruce Duff, 'America's Creative Realist', *Horizon*, vol.23, September 1980, pp.44–5

Jodidio, Philip, 'Edward Hopper: Poet of the American Void', *Connaissance des Arts*, no.333, September 1980, pp.78–85

Levin, Gail, 'Edward Hopper's Evening', *Connoisseur*, vol.205, no.823, September 1980, pp.56–63

Levin, Gail, 'Hopper and the Whitney', *Horizon*, vol.23, September 1980, pp.52–3

Silberman, Robert, 'Edward Hopper on America', *Diversion*, September 1980, pp.148–51, 166–7

Forgey, Benjamin, 'Hopper's America', *Portfolio*, vol.2, September/October 1980, pp.46–53

Levin, Gail, 'Edward Hopper: An American Original – The Artist', *Museum Magazine*, vol.1, September/October 1980, pp.66–7

Monte, James, 'Edward Hopper: An American Original – The Art', *Museum Magazine*, vol.1, September/October 1980, pp.68–71

Kazin, Alfred, 'Hopper's Vision of New York', *New York Times Magazine*, 7 September 1980, pp.48–62

Barry, Ann, 'The Full Range of Edward Hopper', *New York Times*, 21 September 1980, section 2, pp.1, 29–30

Kramer, Hilton, 'Art: Whitney Recognizes Hopper's Special Place', *New York Times*, 26 September 1980, pp.C-1, C-26

Stevens, Mark, 'Hopper: The Artist as Voyeur', *Newsweek*, 27 September 1980, pp.90–1

Levin, Gail, 'Edward Hopper: The Influence of Theater and Film', *Arts Magazine*, vol.55, no.2, October 1980, pp.123–7

Levin, Gail, 'Edward Hopper's Process of Self-Analysis,' *Art News*, vol.79, no.8, October 1980, pp.144–7

Hughes, Robert, 'The Realist at the Frontiers', *Time*, 6 October 1980, pp.88–9

Hoelterhoff, Manuela, 'Art: The Solitude and Silence of Edward Hopper', *Wall Street Journal*, 17 October 1980, p.31

Roud, Richard, 'American Scene Stealer', *Guardian*, 8 November 1980, pp.10–11

Tomkins, Calvin, 'The Art World: Sun in an Empty Room', *New Yorker*, 10 November 1980, pp.188–9, 191

Clark, John, 'Edward Hopper: Beyond Style', *Artscribe*, vol.26, no.6, December 1980, pp.28–31

Taylor, John Russell, 'Hopper & Cornell in All their Elusive Americanism', *The Times*, 2 December 1980, p.9

Guegan, Gerard, 'Hopper, l'Amerique en vrai', *Les Nouvelles Litteraires*, 18 December 1980, pp.228–9

French-Franzier, Nina, 'New York's Winterset: Edward Hopper', *Art International*, vol.24, nos.5–6, January/February 1981, pp.128–30

Goldberg, Vicki, 'Edward Hopper: The Art and the Artist', *International Herald Tribune*, 10–11 January 1981, p.7W

Mills, Nicolaus, 'Man/Made Eternity, Edward Hopper's Heavenly City', *Commonweal*, 16 January 1981, pp.18–20

Wiegand, Wilfried, 'Die Einsamkeit des Edward Hopper', *Frankfurter Allgemeine Magazin*, 23 January 1981, pp.18–24

Siciliano, Enzo, 'La pittura americana ha un papa: Hopper', *Corriere della Sera*, 24 January 1981, pp.12–15

Frank, Elizabeth, 'Edward Hopper: Symbolist in a Hardboiled World', *Art News*, vol.80, no.2, February 1981, pp.100–3

Russell, John, 'American Light Show', *The Times Magazine*, 1 February 1981, pp.34–9, 41, 43

Campbell, Peter, 'The Loneliness Thing', *London Review of Books*, 5 February 1981, pp.20–1

Fuller, Peter, 'The Loneliness Thing', *New Society*, 5 February 1981, pp.245–7

Packer, William, 'Edward Hopper', *Financial Times*, 17 February 1981, p.15

Spurling, John, 'Standing Still', *New Statesman*, 20 February 1981, p.22

Bernlef, Henk J., 'Edward Hopper: In Dienst Van Het Licht', *Kunst Beeld*, March 1981, pp.18–21

Levin, Gail, 'Hopper's America', *Bijutsu Techo*, vol.33, March 1981, pp.162–86

Young, Mahonri Sharp, 'Edward Hopper: The Ultimate Realist', *Apollo*, vol.113, no.229, March 1981, pp.185–9

Bernlef, Henk J. and Siet Zuyderland, 'Edward Hopper Schilder Van Licht en Realiteit', *Avenue*, April 1981, pp.132–9, 142–3, 148

Larson, Kay, 'He who Laughs Less', *New York Magazine*, 20 April 1981, pp.50–1

Levin, Gail, 'Edward Hopper's Nighthawks', *Arts Magazine*, vol.55, no.2, May 1981, pp.154–61

'Edward Hopper Symposium at the Whitney Museum of American Art', *Art Journal*, vol.41, no.2, Summer 1981, pp.115–60:

— Hanson, Anne Coffin, 'Edward Hopper, American Meaning and French Craft', pp.142–9

— Hollander, John, 'Hopper and the Figure of Room', pp.155–60

— Levin, Gail, 'Editor's Statement', pp.115–17

— Levin, Gail (moderator), 'Artists' Panel: Joel Meyerowitz, George Segal, William Bailey', pp.150–4

— Nochlin, Linda, 'Edward Hopper and the Imagery of Alienation', pp.136–41

— 'Six who Knew Edward Hopper: Lloyd Goodrich, John Clancy, Helen Hayes, Raphael Soyer, Brian O'Doherty, James Thomas Flexner', pp.125–35

Silberman, Robert, 'Edward Hopper and the Implied Observer', *Art in America*, vol.69, no.7, September 1981, pp.148–54

Millard, Charles W., 'Edward Hopper', *Hudson Review*, 1 October 1981, pp.390–6

Anfam, David, 'Edward Hopper: Recent Studies', *Art History*, vol.4, no.4, December 1981, pp.457–61

Levin, Gail, 'Symbol and Reality in Edward Hopper's Room in New York', *Arts Magazine*, vol.56, no.5, January 1982, pp.148–53

Pellegrini, Giorgio, 'Edward Hopper tra realismo e metafisica', *Bollettino d'Arte*, April/June 1982, pp.145–58

Levin, Gail, 'In the Footsteps of Edward Hopper', *Geo*, vol.5, February 1983, pp.36–45

Doss, Erika, 'Edward Hopper, Nighthawks, and Film Noir', *Postscript: Essays in Film and the Humanities*, vol.2, Winter 1983, pp.14–36

Levin, Gail, 'The Office Image in the Visual Arts', *Arts Magazine*, vol.59, no.1, September 1984, pp.98–103

Strand, Mark, 'Hopper: The Loneliness Factor', *Antaeus*, vol.54, Spring 1985, pp.182–4

Manilla, Morton, 'Edward Hopper: The Religion of the Ego', *C Magazine*, no.8, Winter 1985, pp.25–8

Burgin, Victor, in *Between*, exh. cat., Institute of Contemporary Arts, London 1986, pp.182–9

Raynor, Vivien, 'Hopper at Stamford Whitney: Scenes of Calm and Menace', *New York Times*, 14 September 1986, p.26

Berman, Avis, 'An Interview with Katharine Kuh', *Archives of American Art Journal*, vol.27, no.3, 1987, pp.2–36

Munhall, Edgar, 'Edward Hopper und die grösse Krise', *du*, April 1988, pp.50–9

Marling, Karal Ann, 'Early Sunday Morning', *Smithsonian Studies in American Art*, vol.2, no.3, Fall 1988, pp.23–53

Wiegenstein, R.H., 'Edward Hopper, 1882–1967: Quadri di Architettura', *Domus*, no.703, March 1989, pp.74–80

Viatte, G., 'Hopper face au temps', *Connaissance des Arts*, no.448, June 1989, pp.72–9

Engel, Charlene S., 'On the Art of Seeing Feelingly: Intaglio Prints by Edward Hopper', *Print Collector's Newsletter*, vol.20, January/February 1990, pp.209–11

Mitchell, D., 'Edward Hopper's Gas: Two Roads Diverge', *RACAR*, vol.17, no.1, 1990, pp.71–6

Burgin, Victor, '*Office at Night*, 1985–86', in *Victor Burgin: Passages*, exh. cat., Musée d'Art Moderne de la Communauté Urbaine de Lille, Villeneuve d'Ascq 1991, pp.77–95

Todd, Ellen Wiley, 'Will (s)he Stoop to Conquer? Preliminaries toward a Reading of Edward Hopper's *Office at Night*', in Norman Bryson, Michael Ann Holly and Keith Moxey (eds.), *Visual Theory: Painting and Interpretation*, Polity Press, Cambridge 1991, pp.47–53

Hemingway, Andrew, 'To "Personalize the Rainpipe": The Critical Mythology of Edward Hopper', *Prospects*, 1992, pp.379–404

Fryd, Vivien Green, 'The Object in the Age of Theory', *American Art*, vol.8, no.2, Spring 1994, pp.2–5

Bonnefoy, Yves, 'The Photosynthesis of Being: Edward Hopper', in *The Lure and the Truth of Painting: Selected Essays on Art*, University of Chicago Press, Chicago 1995, pp.141–60

Hughes, Robert, 'Under the Crack of Reality', *Time*, 17 July 1995, pp.54–6

Michaels, Leonard, 'The Power of Silence', *Vogue*, June 1995, pp.207–9, 248

Murat, L., 'Edward Hopper, l'Amerique à Huis Clos', *Beaux Arts Magazine*, no.136, July/August 1995, pp.96–102

Rubin, K., 'Edward Hopper and the American Imagination', *Magazine Antiques*, vol.148, August 1995, pp.166–75

Updike, John, 'The Proper Hopper', *Guardian*, 8 August 1995, Arts section, pp.6–7

Jenkins, N., 'Edward Hopper and the American Imagination', *Art News*, vol.94, no.8, October 1995, p.145

Kammen, Michael, 'The Hopper Wars', *New York Times Book Review*, 8 October 1995, pp.15–16

Novak, Barbara with Brian O'Doherty, 'Defending Hopper' (letter in response to Michael Kammen), *New York Times Book Review*, 29 October 1995, pp.4, 48

Sullivan, T., 'The Indelible Influence of Edward Hopper', *American Artist*, 1995, pp.60 et seq.

Levin, Gail, 'Edward Hopper and the Democratic Tradition', in Alfred Hornung, Reinhard R. Doerries and Gerhard Hoffman (eds.), *Democracy and the Arts in the United States*, Wilhelm Fink, Munich 1996, pp.85–7

Levin, Gail, 'Reply to a letter from Barbara Novak and Brian O'Doherty', *New York Times Book Review*, 10 December 1995, p.25

Levin, Gail, 'Edward Hopper's *Nighthawks*, Surrealism and the War', *Museum Studies*, vol.22, no.2, 1996, pp.181–92

Levin, Gail, 'Hopper and the Art Institute of Chicago: An Overview', *Museum Studies*, vol.22, no.2, 1996, pp.193–5

Robertson, Bryan, 'Edward Hopper: Reality and Artifice', *Modern Painters*, vol. 9, Spring 1996, pp.40–5

Novak, Barbara, 'The Posthumous Revenge of Josephine Hopper', *Art in America*, vol.84, June 1996, pp.27–31

Levin, Gail, 'Hopper Portrait: Pro and Con' (letter in response to Barbara Novak), *Art in America*, vol.84, no.9, September 1996, p.27

Lewis, Michael J., 'Homer, Hopper & the Critics', *New Criterion*, vol.15, September 1996, p.74–80

Lyons, Deborah, 'By Necessity or Invention: The Record-book Sketches of Edward Hopper', *Drawing*, vol.18, Spring 1997, pp.101–6

Reutersward, P., 'Edward Hopper', *Konsthistorisk Tidskrift*, vol.66, no.4, 1997, pp.196–206

Solomon, Deborah, 'Edward Hopper on Cape Cod: The Artist's House and Studio in Truro', *Architectural Digest*, vol.54, August 1997, pp.44–51

Iversen, Margaret, 'In the Blind Field: Hopper and the Uncanny', *Art History*, vol.21, no.3, September 1998, pp.409–29

Reutersward, P., 'One More Hopper: *Tables for Ladies* (1930)', *Konsthistorisk Tidskrift*, vol.68, no.4, 1999, pp.270–3

Anfam, David, 'Edward Hopper', *Burlington Magazine*, vol.141, no.1159, October 1999, pp.630–1

Mecklenburg, Virginia M., 'Edward Hopper's Houses', *Magazine Antiques*, vol.156, no.5, November 1999, pp.718–25

Fischer, Lucy, 'The Savage Eye: Edward Hopper and the Cinema', in Ludington Townsend (ed.), *A Modern Mosaic: Art and Modernism in the United States*, University of North Carolina Press, Chapel Hill, NC 2000

Mecklenburg, V.M., 'Edward Hopper: The Watercolors', *American Art Review*, vol.12, no.1, January/ February 2000, pp.128–39

Fryd, Vivien Green, 'Edward Hopper's *Girlie Show*: Who is the Silent Partner?', *American Art*, vol.14, no.2, Summer 2000, pp.52–75

Rothstein, B., 'House, Home and Hopper', *Art & Antiques*, vol.23, no.8, September 2000, pp.102–9

Leider, Philip, 'Vermeer and Hopper', *Art in America*, vol.89, no.3, March 2001, pp.96–103

Pohl, Frances K., 'Art for the People, Art against Fascism', in Frances K. Pohl, *Framing America: A Social History of American Art*, Thames and Hudson, London 2002, pp.363–428

Silberman, Robert, 'Edward Hopper and the Theater of the Mind: Vision, Spectacle, and the Spectator', in Patricia McDonnell (ed.), *On the Edge of your Seat: Popular Theater and Film in Early Twentieth-Century American Art*, exh. cat., Frederick R. Weisman Art Museum, Minneapolis 2002

Paton, Priscilla, 'Gothic Loneliness: The Different Cases of Edward Hopper and Andrew Wyeth,' in Priscilla Paton, *Abandoned New England*, University of New England Press, Hanover, NE, and London 2003, pp.133–68

Hankins, Evelyn, 'Edward Hopper: The Paris Years', *American Art Review*, vol.15, no.1, January/ February 2003, pp.168–73

Boyd, William, 'The Woman on the Beach with a Dog', *Modern Painters*, vol.16, no.1, Spring 2003, pp.100–3

Heffner, M., 'Edward Hopper and Urban Realism,' *American Art Review*, vol.15, no.3, May/June 2003, pp.100–5

Wherever possible the titles given are those found in the original entry for the work in Hopper's record books. If no definite title appears, or if the record-book designation seemed to be only a description, the title given is that found in the early exhibition history of the work. Titles of works that are not in the record books and have no exhibition history appear between square brackets; these were assigned after the artist's death. Those given for Whitney Museum of American Art works from the Hopper Bequest, which were largely untitled, were either assigned by Lloyd Goodrich and research assistant Elizabeth Tweedy Streibert when the Bequest was accessioned in 1970, or by Gail Levin, author of *Edward Hopper: A Catalogue Raisonné*, New York 1995.

Works in oil and watercolour are followed by catalogue numbers from Gail Levin's *Edward Hopper: A Catalogue Raisonné* in the form O-XXX for oils and W-XXX for watercolours. Etchings are followed by the plate number from Gail Levin's *Edward Hopper: The Complete Prints*, New York 1979.

Measurements are in centimetres, followed by inches in brackets, height before width.

[Solitary Figure in a Theatre]
*c.*1902–4
Oil on board
31.8 x 23.3 (12 1/2 x 9 3/16)
Whitney Museum of American Art,
New York; Josephine N. Hopper Bequest
70.1418
O-37
See p.101

[Self-Portrait]
1903–6
Oil on canvas
66 x 55.9 (26 x 22)
Whitney Museum of American Art,
New York; Josephine N. Hopper Bequest
70.1253
O-69
See p.103

[Man Seated on Bed]
*c.*1905–6
Oil on canvas mounted on wood
28.4 x 23.2 (11 3/16 x 9 1/8)
Whitney Museum of American Art,
New York; Josephine N. Hopper Bequest
70.1424
O-123
See p.104

[Steps in Paris]
1906
Oil on wood
33 x 23.3 (13 x 9 3/16)
Whitney Museum of American Art,
New York; Josephine N. Hopper Bequest
70.1297
O-128
Cologne only
See p.107

[View Across Interior Courtyard at
48 rue de Lille, Paris]
1906
Oil on wood
33 x 23.5 (13 x 9 1/4)
Whitney Museum of American Art,
New York; Josephine N. Hopper Bequest
70.1307
O-131
Cologne only
See p.108

[Interior Courtyard at 48 rue de Lille, Paris]
1906
Oil on wood
30.5 x 23.5 (12 x 9 1/4)
Whitney Museum of American Art,
New York; Josephine N. Hopper Bequest
70.1304
O-132
See p.111

[Stairway at 48 rue de Lille, Paris]
1906
Oil on wood
33 x 23.5 (13 x 9 1/4)
Whitney Museum of American Art,
New York; Josephine N. Hopper Bequest
70.1295
O-133
See p.113

Summer Interior
1909
Oil on canvas
61 x 73.7 (24 x 29)
Whitney Museum of American Art,
New York; Josephine N. Hopper Bequest
70.1197
O-175
Cologne only
See pp.114–15

American Village
1912
Oil on canvas
65.7 x 96.2 (25 7/8 x 37 7/8)
Whitney Museum of American Art,
New York; Josephine N. Hopper Bequest
70.1185
O-183
Cologne only
See p.117

American Landscape
1920
Etching
19.7 x 32.9 (7 3/4 x 12 15/16)
Whitney Museum of American Art,
New York; Purchase 31.690
PL. 69
See p.118

Evening Wind
1921
Etching
17.5 x 21 (6 7/8 x 8 1/4)
The British Museum, London
PL. 77
See p.119

Night in the Park
1921
Etching
17.3 x 21 (6 7/8 x 8 1/4)
The British Museum, London
PL. 80
See p.120

East Side Interior
1922
Etching
20 x 25.1 (7 7/8 x 9 7/8)
Private Collection
PL. 85
See p.121

The Lonely House
1923
Etching
20 x 25.1 (7 7/8 x 9 7/8)
Whitney Museum of American Art,
New York; Josephine N. Hopper Bequest
70.1040
PL. 102
See p.121

Girl at Sewing Machine
c.1921
Oil on canvas
48.3 x 45.7 (19 x 18)
Museo Thyssen-Bornemisza, Madrid
O-237
See p.123

New York Interior
c.1921
Oil on canvas
61.6 x 74.3 (24 1/4 x 29 1/4)
Whitney Museum of American Art,
New York; Josephine N. Hopper Bequest
70.1200
O-238
See pp.124–5

New York Pavements
1924 or 1925
Oil on canvas
62.9 x 75.6 (24 3/4 x 29 3/4)
Chrysler Museum of Art, Norfolk, Virginia;
Gift of Walter P. Chrysler, Jr
O-243
See p.126

[Self-Portrait]
1925–30
Oil on canvas
64.1 x 52.4 (25 1/4 x 20 5/8)
Whitney Museum of American Art,
New York; Josephine N. Hopper Bequest
70.1165
O-246
See p.129

Sunday
1926
Oil on canvas
73.7 x 86.4 (29 x 34)
The Phillips Collection, Washington, DC
O-247
See pp.130–1

Eleven A.M.
1926
Oil on canvas
71.4 x 91.8 (28 1/8 x 36 1/8)
Hirshhorn Museum and Sculpture Garden,
Smithsonian Institution; Gift of the Joseph
H. Hirshhorn Foundation, 1966
O-248
See pp.132–3

Roofs of Washington Square
1926
Watercolour over charcoal on paper
35.2 x 50.5 (13 7/8 x 19 7/8)
Carnegie Museum of Art, Pittsburgh;
Bequest of Mr and Mrs James H. Beal, 1993
W-135
See p.134

Haunted House
1926
Watercolour on paper
33.6 x 50.8 (14 x 20)
Collection of the Farnsworth Art Museum;
Museum Purchase, 71.1775
W-139
Cologne only
See p.137

Automat
1927
Oil on canvas
71.4 x 91.4 (28 1/8 x 36)
Des Moines Art Center Permanent
Collections; Purchased with funds from the
Edmundson Art Foundation, Inc., 1958.2
O-251
See pp.138–9

Two on the Aisle
1927
Oil on canvas
102.2 x 122.6 (40 1/4 x 48 1/4)
Toledo Museum of Art; Purchased with
funds from the Libbey Endowment,
Gift of Edward Drummond Libbey
O-253
See p.140

Lighthouse Hill
1927
Oil on canvas
73.8 x 102.2 (29 1/16 x 40 1/4)
Dallas Museum of Art;
Gift of Mr and Mrs Maurice Purnell
O-254
See pp.142–3

Captain Upton's House
1927
Oil on canvas
72.4 x 92.1 (28 1/2 x 36 1/4)
Collection of Steve Martin
O-255
See pp.144–5

Drug Store
1927
Oil on canvas
73 x 101 (28 3/4 x 39 3/4)
Museum of Fine Arts, Boston;
Bequest of John T. Spaulding
O-256
See pp.146–7

Two Lights Village
1927
Watercolour on paper
34 x 48.9 (13 3/8 x 19 1/4)
Fitchburg Art Museum, Massachusetts;
Bernadine K. Scherman Bequest, 1974.4
W-175
See p.149

Williamsburg Bridge
1928
Oil on canvas
73.7 x 109.2 (29 x 43)
The Metropolitan Museum of Art,
George A. Hearn Fund, 1937 (37.44)
O-258
See pp.150–1

Night Windows
1928
Oil on canvas
73.7 x 86.4 (29 x 34)
The Museum of Modern Art, New York;
Gift of John Hay Whitney, 1940
O-264
See pp.152–3

Methodist Church
1929
Watercolour on paper
35.4 x 50.6 (13 7/8 x 19 3/4)
Tacoma Art Museum;
Gift of Mrs Corydon Wagner, Sr
W-239
See p.155

Early Sunday Morning
1930
Oil on canvas
89.4 x 153 (35 3/16 x 60 1/4)
Whitney Museum of American Art,
New York; Purchase, with funds from
Gertrude Vanderbilt Whitney 31.426
O-270
See pp.156–7

Hills, South Truro
1930
Oil on canvas
69.5 x 109.5 (27 1/8 x 42 3/4)
The Cleveland Museum of Art,
Hinman B. Hurlbut Collection, 2647.1931
O-273
See pp.158–9

[Burly Cobb's House, South Truro]
1930–3
Oil on canvas
64.1 x 91.9 (25 1/4 x 36 3/16)
Whitney Museum of American Art,
New York; Josephine N. Hopper Bequest
70.1210
O-276
See p.161

Room in Brooklyn
1932
Oil on canvas
73.3 x 85.7 (28 7/8 x 33 3/4)
Museum of Fine Arts, Boston;
The Hayden Collection – Charles Henry
Hayden Fund
O-284
See pp.162–3

Cape Cod Sunset
1934
Oil on canvas
74.3 x 91.9 (29 1/4 x 36 3/16)
Whitney Museum of American Art,
New York; Josephine N. Hopper Bequest
70.1166
O-291
See pp.164–5

House at Dusk
1935
Oil on canvas
92.1 x 127 (36 1/4 x 50)
Virginia Museum of Fine Arts, Richmond;
The John Barton Payne Fund
O-295
See p.166–7

The Sheridan Theatre
1937
Oil on canvas
43.2 x 63.5 (17 x 25)
Collection of The Newark Museum;
Purchase 1940 Felix Fuld Bequest Fund
O-303
See pp.168–9

Cape Cod Evening
1939
Oil on canvas
76.2 x 101.6 (29 3/4 x 39 5/8)
National Gallery of Art, Washington;
John Hay Whitney Collection 1982.76.6
O-309
See pp.170–1

Office at Night
1940
Oil on canvas
56.4 x 63.8 (22 3/16 x 25 1/8)
Collection Walker Art Center, Minneapolis;
Gift of the T.B. Walker Foundation,
Gilbert M. Walker Fund, 1948
O-312
See pp.172–3

Study for Office at Night
1940
Conté crayon on paper
21.59 x 27.94 (8 1/2 x 11)
Whitney Museum of American Art,
New York; Josephine N. Hopper Bequest
70.169
See p.174

Study for Office at Night
1940
Conté crayon, charcoal and chalk on paper
38.1 x 49.85 (15 x 19 5/8)
Whitney Museum of American Art,
New York; Josephine N. Hopper Bequest
70.340
See p.175

House by a Road
1940
Oil on canvas
48.3 x 68.6 (19 x 27)
Arizona State University Art Museum;
Gift of Oliver B. James
O-314
See pp.176–7

Nighthawks
1942
Oil on canvas
84.1 x 152.4 (33 1/8 x 60)
The Art Institute of Chicago;
Friends of American Art Collection
O-322
See pp.178–9

Study for Nighthawks
1942
Conté crayon on paper
18.42 x 11.43 (7 1/4 x 4 1/2)
Whitney Museum of American Art,
New York; Josephine N. Hopper Bequest
70.189
See p.181

Study for Nighthawks
1942
Conté crayon on paper
18.42 x 11.43 (7 1/4 x 4 1/2)
Whitney Museum of American Art,
New York; Josephine N. Hopper Bequest
70.190
See p.180

Study for Nighthawks
1942
Conté crayon on paper
11.43 x 18.42 (4 1/2 x 7 1/4)
Whitney Museum of American Art,
New York; Josephine N. Hopper Bequest
70.192
See p.180

Study for Nighthawks
1942
Conté crayon on paper
21.59 x 27.94 (8 1/2 x 11)
Whitney Museum of American Art,
New York; Josephine N. Hopper Bequest
70.193
See p.180

Study for Nighthawks
1942
Conté crayon on paper
21.59 x 27.94 (8 1/2 x 11)
Whitney Museum of American Art,
New York; Josephine N. Hopper Bequest
70.195
See p.181

Study for Nighthawks
1942
Conté crayon on paper
20.32 x 20.32 (8 x 8)
Whitney Museum of American Art,
New York; Josephine N. Hopper Bequest
70.253
See p.181

Study for Nighthawks
1942
Conté crayon on paper
38.42 x 28.1 (15 1/8 x 11 1/16)
Whitney Museum of American Art,
New York; Josephine N. Hopper Bequest
70.256
See p.181

Dawn in Pennsylvania
1942
Oil on canvas
61.9 x 112.4 (24 3/8 x 44 1/4)
Terra Foundation for the Arts,
Daniel J. Terra Collection
O-323
See pp.182–3

Hotel Lobby
1943
Oil on canvas
82.6 x 103.5 (32 1/2 x 40 3/4)
Indianapolis Museum of Art;
William Ray Adams Memorial Collection
O-324
Cologne only
See p.184–5

Summertime
1943
Oil on canvas
74 x 111.8 (29 1/8 x 44)
Delaware Art Museum;
Gift of Dora Sexton Brown, 1962
O-325
See pp.186–7

Two Puritans
1945
Oil on canvas
76.2 x 101.6 (30 x 40)
Private Collection, courtesy of Ronald
Feldman Fine Arts, Inc., New York
O-331
See p.189

Pennsylvania Coal Town
1947
Oil on canvas
71.1 x 101.6 (28 x 40)
The Butler Institute of American Art,
Youngstown, Ohio
O-335
See pp.190–1

[Stairway]
1949
Oil on wood
40.6 x 30.2 (16 x 11 7/8)
Whitney Museum of American Art,
New York; Josephine N. Hopper Bequest
70.1265
O-339
See p.192

Cape Cod Morning
1950
Oil on canvas
86.7 x 102.2 (34 1/8 x 40 1/4)
Smithsonian American Art Museum;
Gift of the Sara Roby Foundation
O-343
See pp.194–5

First Row Orchestra
1951
Oil on canvas
79 x 101.9 (31⅛ x 40⅛)
Hirshhorn Museum and Sculpture Garden,
Smithsonian Institution;
Gift of the Joseph H. Hirshhorn Foundation,
1966
O-344
See pp.196–7

Morning Sun
1952
Oil on canvas
71.4 x 101.9 (28⅛ x 40⅛)
Columbus Museum of Art;
Museum Purchase, Howald Fund
O-346
See pp.198–9

Hotel by a Railroad
1952
Oil on canvas
79.4 x 101.9 (31¼ x 40⅛)
Hirshhorn Museum and Sculpture Garden,
Smithsonian Institution; Gift of the Joseph
H. Hirshhorn Foundation, 1966
O-347
See pp.200–1

Sea Watchers
1952
Oil on canvas
76.2 x 101.6 (30 x 40)
Private Collection
O-348
See pp.202–3

Office in a Small City
1953
Oil on canvas
71.1 x 101.6 (28 x 40)
The Metropolitan Museum of Art;
George A. Hearn Fund, 1953 (53.183)
O-349
See pp.204–5

City Sunlight
1954
Oil on canvas
71.6 x 101.9 (28 ³/₁₆ x 40⅛)
Hirshhorn Museum and Sculpture Garden,
Smithsonian Institution; Gift of the Joseph
H. Hirshhorn Foundation, 1966
O-350
See pp.206–7

Hotel Window
1955
Oil on canvas
99.4 x 139.1 (39⅛ x 54¾)
Collection of Steve Martin
O-352
See pp.208–9

Excursion into Philosophy
1959
Oil on canvas
76.2 x 101.6 (30 x 40)
Private Collection
O-357
See p.210

Second Story Sunlight
1960
Oil on canvas
101.9 x 127.5 (40⅛ x 50 ³/₁₆)
Whitney Museum of American Art,
New York; Purchase, with funds from the
Friends of the Whitney Museum of
American Art 60.54
O-359
See pp.212–13

A Woman in the Sun
1961
Oil on canvas
101.9 x 155.6 (40⅛ x 61¼)
Whitney Museum of American Art,
New York; 50th Anniversary Gift of
Mr and Mrs Albert Hackett in honour of
Edith and Lloyd Goodrich 84.31
O-360
See pp.214–5

New York Office
1962
Oil on canvas
101.6 x 139.7 (40 x 55)
Montgomery Museum of Fine Arts,
Montgomery, Alabama; The Blount
Collection 1989.2.24
O-361
See pp.216–17

Intermission
1963
Oil on canvas
101.6 x 152.4 (40 x 60)
Private Collection; Courtesy Fraenkel Gallery,
San Francisco
O-363
See pp.218–19

Artist's Ledger – Book III
1924–67
Ink, graphite and coloured pencil on paper
31 x 19.4 x 1.3 (12 ³/₁₆ x 7⅝ x ½)
Whitney Museum of American Art,
New York; Gift of Lloyd Goodrich 96.210a–jjjj
See p.219

Sun in an Empty Room
1963
Oil on canvas
73.7 x 101.6 (29 x 40)
Private Collection
O-364
See pp.220–1

Two Comedians
1966
Oil on canvas
74.9 x 104.1 (29½ x 41)
Barbara Sinatra
O-366
See pp.222–3

Lenders

Public Collections

Montgomery Museum of Fine Arts, Alabama
Arizona State University Art Museum
Museum of Fine Arts, Boston
The Art Institute of Chicago
Terra Foundation for the Arts, Chicago
The Cleveland Museum of Art
Columbus Museum of Art, Ohio
Dallas Museum of Art
Delaware Art Museum
Fitchburg Art Museum, Massachusetts
Des Moines Art Center, Iowa
The British Museum, London
Museo Thyssen-Bornemisza, Madrid
Walker Art Center, Minneapolis
Whitney Museum of American Art, New York
The Metropolitan Museum of Art, New York
The Museum of Modern Art, New York
The Newark Museum
Chrysler Museum of Art, Norfolk, Virginia
The Butler Institute of American Art, Ohio
Carnegie Museum of Art, Pittsburgh
Virginia Museum of Fine Arts, Richmond
Tacoma Art Museum
Toledo Museum of Art
The Phillips Collection, Washington, DC
Hirshhorn Museum and Sculpture Garden,
 Smithsonian Institution, Washington, DC
National Gallery of Art, Washington, DC
Smithsonian American Art Museum,
 Washington, DC

Private Collections

Private Collection, courtesy of Ronald
 Feldman Fine Arts, Inc., New York
Private Collection, courtesy Fraenkel Gallery,
 San Francisco
Collection of Steve Martin
Barbara Sinatra
*and all other private lenders who wish to
remain anonymous*

Edward Hopper
Index

Photographic Credits

Supporting Tate

Tate relies on a large number of supporters – individuals, foundations, companies and public sector sources – to enable it to deliver its programme of activities, both on and off its gallery sites. This support is essential in order to acquire works of art for the Collection, run education, outreach and exhibition programmes, care for the Collection in storage and enable art to be displayed, both digitally and physically, inside and outside Tate. Your donation will make a real difference and enable others to enjoy Tate and its Collections both now and in the future. There are a variety of ways in which you can help support the Tate and also benefit as a UK or US taxpayer. Please contact us at:

The Development Office
Tate
Millbank
London SWIP 4RG

Tel: 020 7887 8942
Fax: 020 7887 8738

Tate American Fund
1285 Avenue of the
Americas (35th fl)
New York
NY 10019

Tel: 001 212 713 8497
Fax: 001 212 713 8655

Donations

Donations, of whatever size, from individuals, companies and trusts are welcome, either to support particular areas of interest, or to contribute to general running costs.

Gifts of Shares

Since April 2000, we can accept gifts of quoted shares and securities. These are not subject to capital gains tax. For higher rate taxpayers, a gift of shares saves income tax as well as capital gains tax. For further information please contact the Campaigns Section of the Development Office.

Tate Annual Fund

A donation to the Annual Fund at Tate benefits a variety of projects throughout the organisation, from the development of new conservation techniques to education programmes for people of all ages.

Gift Aid

Through Gift Aid, you can provide significant additional revenue to Tate. Gift Aid applies to gifts of any size, whether regular or one-off, since we can claim back the tax on your charitable donation. Higher rate taxpayers are also able to claim additional personal tax relief. Contact us for further information and a Gift-Aid Declaration.

Legacies

A legacy to Tate may take the form of a residual share of an estate, a specific cash sum or item of property such as a work of art. Legacies to Tate are free of Inheritance Tax.

Offers in lieu of tax

Inheritance Tax can be satisfied by transferring to the Government a work of art of outstanding importance. In this case the rate of tax is reduced, and it can be made a condition of the offer that the work of art is allocated to Tate. Please contact us for details.

Tate American Fund and Tate American Patrons

The American Fund for the Tate Gallery was formed in 1986 to facilitate gifts of works of art, donations and bequests to Tate from United States residents. United States taxpayers who wish to support Tate on an annual basis can join the American Patrons of the Tate Gallery and enjoy membership benefits and events in the United States and United Kingdom (single membership $1000 and double $1500). Both organisations receive full tax exempt status from the IRS. Please contact the Tate American Fund for further details.

Membership Programmes

Tate Members enjoy unlimited free admission throughout the year to all exhibitions at Tate Britain, Tate Liverpool, Tate Modern and Tate St Ives, as well as a number of other benefits such as exclusive use of our Members' Rooms and a free annual subscription to Tate: The Art Magazine.

Whilst enjoying the exclusive privileges of membership, you are also helping secure Tate's position at the very heart of British and modern art. Your support actively contributes to new purchases of important art, ensuring that the Tate's Collection continues to be relevant and comprehensive, as well as funding projects in London, Liverpool and St Ives that increase access and understanding for everyone.

Patrons

Tate Patrons are people who share a strong enthusiasm for art and are committed to giving significant financial support to Tate on an annual basis. The Patrons support the Tate Collection, helping Tate acquire works from across its broad collecting remit: historic British art, modern international art and contemporary art. Tate welcomes Patrons into the heart of its activities. The scheme provides a forum for Patrons to share their interest in art and to exchange knowledge and information in an enjoyable environment.

Corporate Membership

Corporate Membership at Tate Britain, Tate Modern and Tate Liverpool and support for the Business Circle at Tate St Ives, offer companies opportunities for corporate entertaining and the chance for a wide variety of employee benefits. These include special private views, special access to paying exhibitions, out-of-hours visits and tours, invitations to VIP events and talks at members' offices.

Corporate Investment

Tate has developed a range of imaginative partnerships with the corporate sector, ranging from international interpretation and exhibition programmes to local outreach and staff development programmes. We are particularly known for high-profile business to business marketing initiatives and employee benefit packages. Please contact the Corporate Fundraising team for further details.

Charity Details

The Tate Gallery is an exempt charity; the Museums & Galleries Act 1992 added the Tate Gallery to the list of exempt charities defined in the 1960 Charities Act. The Friends of the Tate Gallery is a registered charity (number 313021). Tate Foundation is a registered charity (number 1085314).

254

255